ALGONQUIN WILD

ALGONQUIN WILD

A Naturalist's Journey Through The Seasons

MICHAEL RUNTZ

Fitzhenry & Whiteside

Published in Canada by Fitzhenry & Whiteside,

195 Allstate Parkway, Markham, ON L3R 4T8

Published in the United States by Fitzhenry & Whiteside

311 Washington Street, Brighton, MA 02135

Library and Archives Canada Cataloguing in Publication

Runtz, Michael W. P., author, photographer

Algonquin wild : a naturalist's journey through the seasons / Michael Runtz.

ISBN 978-1-55455-437-9 (softcover)

1. Algonquin Provincial Park (Ont.). 2. Algonquin Provincial Park

(Ont.)--Pictorial works. I. Title.

FC3065.A65R92 2018 971.3'147 C2018-904037-8

Publisher Cataloging-in-Publication Data (U.S.)

Names: Runtz, Michael W. P., author.

Title: Algonquin Wild : a Naturalist's Journey Through the Seasons / Michael Runtz.

Description: Markham, Ontario : Fitzhenry & Whiteside, 2018. | Includes index. | Summary:"The history, environment, nature, plants, animals and insects of Algonquin Park, including moose, wolves, owls and bears, are explored through this photographic journey covering all four seasons"– Provided by publisher.

Identifiers: ISBN 978-1-55455-437-9 (hardcover)

Subjects: LCSH: Algonquin Provincial Park (Ont.) – Description and travel – Pictorial works. | Seasons – Algonquin Provincial Park (Ont.) – Pictorial works.

| BISAC: NATURE / Environmental Conservation & Protection.

Classification: LCC F1059.A4R868 | DDC 917.13147 – dc23

ONTARIO ARTS COUNCIL
CONSEIL DES ARTS DE L'ONTARIO

Canada Council **Conseil des Arts**
for the Arts **du Canada**

Fitzhenry & Whiteside acknowledges with thanks the Canada Council for the Arts and the Ontario Arts Council for their support of our publishing program. We acknowledge the financial support of the Government of Canada through the Canada Book Fund (CBF) for our publishing activities.

Designed by Kerry Designs

2 4 6 8 10 9 7 5 3 1

For Dan Strickland and Ron Tozer,
whose genius paved my path.

CONTENTS

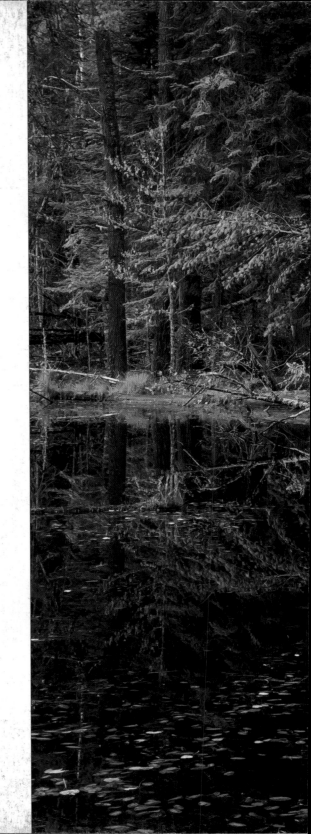

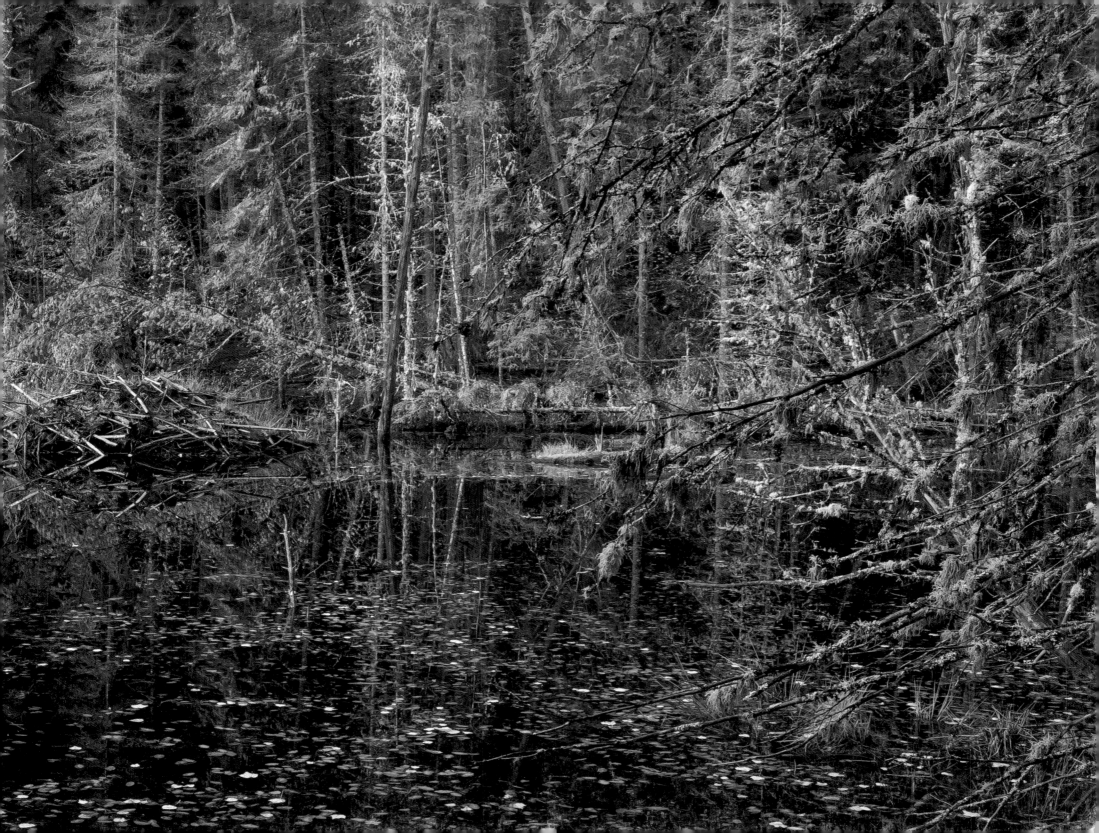

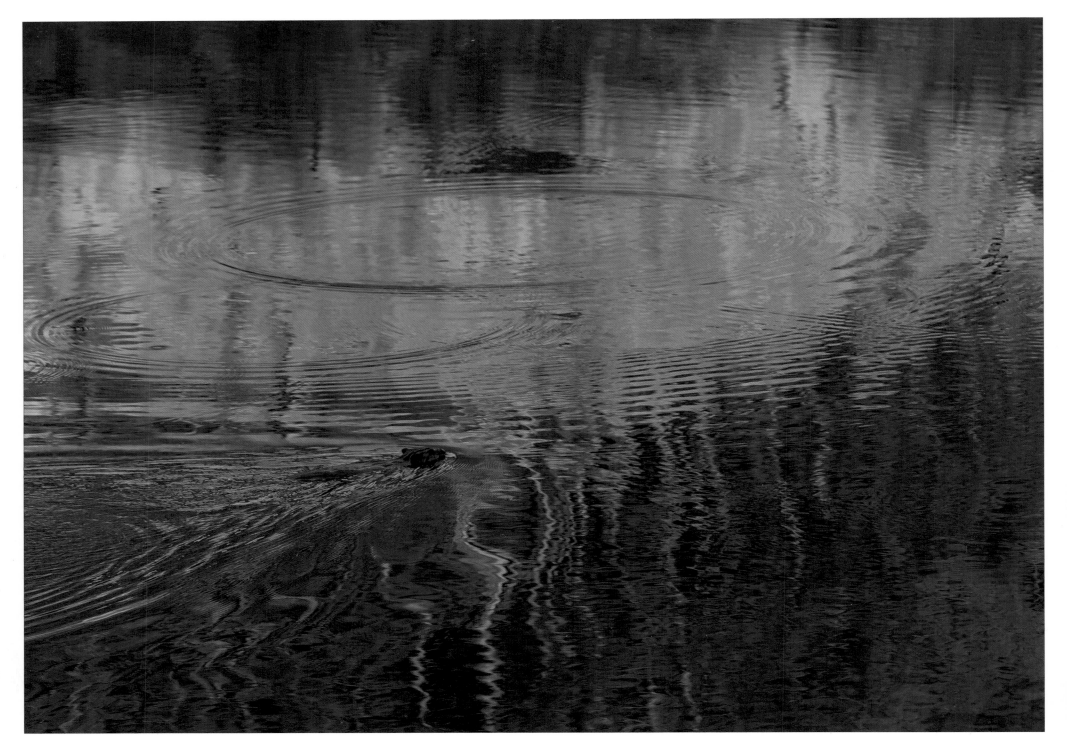

FOREWORD

Algonquin Wild by Michael Runtz brings delight and astonishment as I view each image. During my early years a number of summers and a few winter visits inscribed that part of the world deeply into my soul. I had many good chances to enjoy the landscape and the wildlife but the photography shown here is of a different league and intensity. The science and natural history shine on every page but each photo can be viewed as a work of art in its own right.

Robert Bateman
March 2018

PREFACE

My love affair with Algonquin Park began nearly six decades ago, and over those many years has developed in three distinct stages. The inaugural stage took place in the late 1950s when as an impressionable child my parents took me to Algonquin to hand-feed the numerous White-tailed Deer that panhandled along Highway 60. The memories of those gigantic animals tugging salted crackers from my hand, as well of finding hundreds of shiny coins adorning the bottom of the Park Museum's turtle ponds remain fresh today.

The second stage began in 1972 when I was hired to work in Algonquin as a Seasonal Interpretive Naturalist, a title that I went on to wear for 11 seasons stretching across four decades. For the record, I was hired in the early 1970s not for my public speaking skills (I was

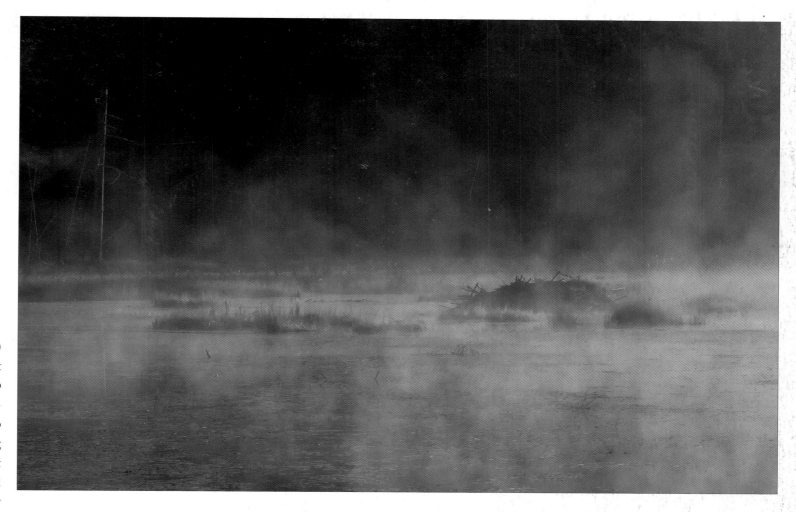

a shy, insecure, and introverted teenager) but for my alleged knowledge of birds. That dream job, which involved getting paid to learn first-hand about the Park's rich natural history, had one drawback: I had to speak face-to-face with people attending interpretive walks on trails, and talks at the Pog Lake Outdoor Theatre. Fresh still are memories of my heart pounding wildly while talking at the speed of sound to a hundred people on a Nature Walk, or standing with stomach in knots on a wooden stage in front of 600 attendees at the Pog Lake Outdoor Theatre. Little did I know that these terrifying situations were preparation for the future, that public speaking was to become an important component of my professional career.

But for every fear-filled memory of those early years, myriad others were pure

delight: quietly roaming through dark wooded peatlands looking for Spruce Grouse (unsuccessfully the first year) with Ron Pittaway, mentor, birder extraordinaire, and the main reason I was hired as an Algonquin naturalist; searching for wild orchids and finding many including Downy Rattlesnake Plantain with Bill Crins, who went on to become a world expert on sedges as well an important ecologist with the provincial government; canoeing

with Rory MacKay (teacher, author, and a living piece of Algonquin history) the full length of Grand Lake at night, ending our journey to the applause of thunder; gunnel-bobbing with accomplished naturalist and artist Howard Conybeare on Found Lake (Howie, I still feel bad about your boot sinking); assisting Dan Brunton and Paul Pratt on botanical inventories in remote parts of Algonquin (I was there not to help these expert botanists and outstanding

naturalists conduct the surveys—I had little botanical knowledge back then—but to carry their canoe and gear on portages and, sometimes, on non-portages); and howling for wolves with legendary Russ Rutter, whose inscription in his co-authored *The World of the Wolf* documented the sighting of my first wolf on August 21, 1972.

Equally precious are the memories of learning the essentials of nature interpretation from the masters of the trade,

Chief Park Naturalist Dan Strickland and Park Naturalist Ron Tozer (both now retired), teachers, mentors and friends who changed the course of my life.

The third stage continues today. Every excursion into Algonquin provides me with new and fascinating insights into the natural world. Even though time has provided a degree of familiarity with many of Algonquin's wild inhabitants, the excitement that arises from meeting each and every one of them is never lessened. Delight still fills me when a Canada Jay lands on my hand or a Beaver slaps its tail in front of my canoe. My soul still stirs when the howls of wolves rise from distant meadows and my heart still quickens when a great bull Moose emerges from the pre-dawn mist, its magnificent antlers swaying back and forth in time to its guttural declarations.

I have been fortunate—no, privileged is more accurate—to have through the years explored a significant portion of Algonquin Park. Oft times I did so in an official capacity; in addition to working in Algonquin as an interpretive naturalist, I conducted natural history surveys for dragonflies and damselflies, plants, turtles, butterflies, and birds including Peregrine Falcons and Kirtland's Warblers. For one glorious year I was involved with development of the exhibits in the world class Algonquin Visitor Centre, living with and working alongside Kevin Hockley, one of the top diorama specialists in North America, and Dwayne Harty, one of today's finest wildlife artists. My tasks included finding habitats for Dwayne to paint as backdrops for the exhibits and assisting Kevin in creating dioramas (such as fabricating cliffs and sewing up Moose). I also did background research for computer games and dug up plants to be replicated in Winnipeg for the exhibits. Oh, those were tough jobs but somebody had to do them!

Additionally, I have spent time in Algonquin taking images for some of the Park's publications including The Trees of Algonquin Provincial Park and a yet-to-be completed sedge guide (anytime, Bill!). I have acted as guide for numerous journalists and filmmakers, and was directly involved in a Royal Canadian Geographical Society wolf documentary. Several episodes of my television series Wild by Nature were filmed in Algonquin. Each August I conduct Public Wolf Howls in the Park, one near Basin Depot for Bonnechere Provincial Park (since 1993) and another near Achray for the Ontario Ministry of Natural Resources and Forestry. However, most of my time spent in Algonquin has been on my own as a curious naturalist.

The background preparation for this book involved thousands of hours canoeing Algonquin's mirror lakes and sidewinder rivers, roaming her towering forests of pine and maple, climbing her ageless Precambrian hills and cliffs, sloshing through her floating worlds of Sphagnum, and snowshoeing across her snow-blanketed landscapes. On those wonderful excursions I experienced first-hand Algonquin's extraordinary complexity and interacted with her inhabitants on the most intimate of levels, and not just by giving blood to biting insects, which I have done myriad times! I have howled with wolves and exchanged love calls with rutting Moose. I have chased speeding dragonflies and played with snorting otters. I have felt the warm touch of the autumn sun and the biting sting of winter's chill. Through those many years and plethora of experiences I believe I have come to really know Algonquin, and to know that Algonquin has become an important part of my essence.

Michael Runtz
March 2018

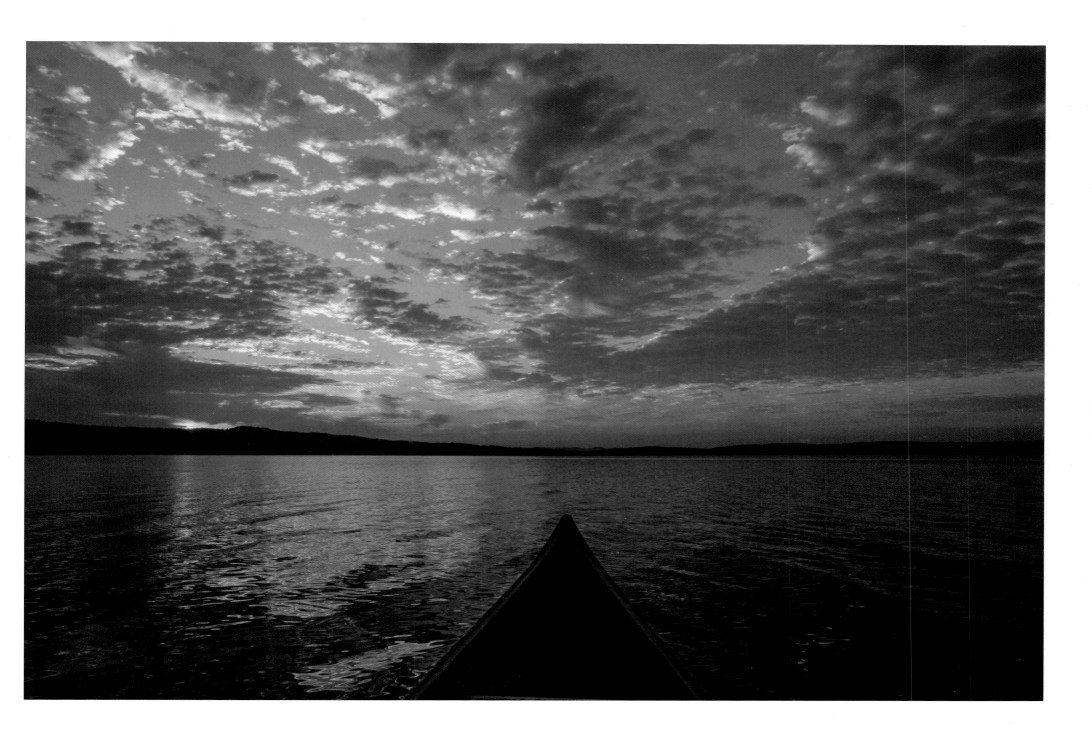

"ALGONQUIN WILD"

The correct expression, we believe, is "*a force of nature*". That's what Michael Runtz, the author/artist/photographer responsible for this wonderful book may fairly be called. Of course, if you have admired any of Mike's previous books or just finished marveling at this one, you will already know that he is an outstandingly knowledgeable naturalist and an equally talented photographer. But without knowing him personally, you might not guess that Mike also brings to his work incredible, "you've-got-to-see-it-to-believe-it" intensity, excitement, and enthusiasm that far exceeds what we see in ordinary mortals.

We know what we are talking about and one of us has the scars to prove it! Mike was

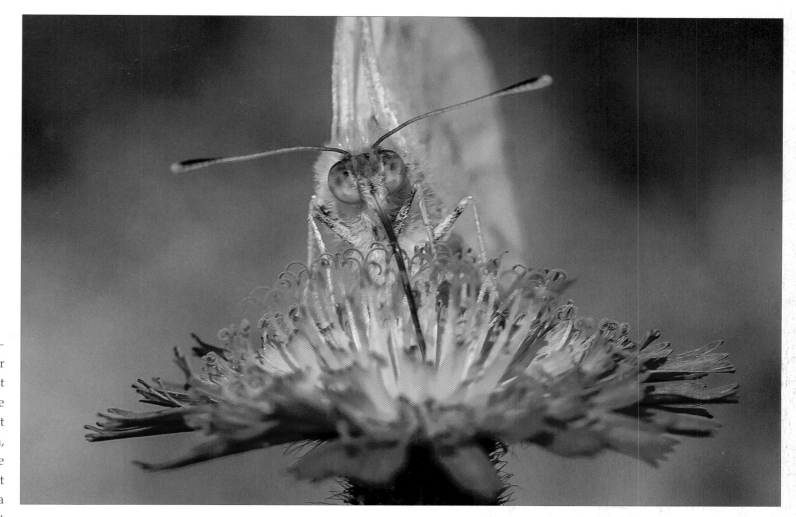

a, somewhat awkward, still-wet-behind-the-ears, 18-year old kid from Arnprior when we hired him as a summer naturalist in 1972. At first he seemed very much like the many other keen young naturalists that we employed in our program. But then, one August night in his first summer, we found out there was more to Mike than met the eye. He was a back seat passenger in a car with three other Park staff driving past Brewer Lake when, suddenly, Mike's first-ever wolf ran across the road in front of their vehicle. Instantly Mike exploded into unrestrained, super-intense excitement. "WOLF!!" he screamed at the top of his lungs while simultaneously grabbing the closest available object in an iron grip. That object was a human shoulder that belonged to one of us (RT), a passenger in the front seat. Mike did not succeed in crushing it

but, let's say the incident gave us a certain wariness while around our new hire.

Put this incident down to youthful exuberance if you will but, in fact, Mike has never changed. On July 8th, 1987, the other one of us also had a narrow escape from Mike's enthusiasm. DS was driving west on Highway 60, about to cross Sunday Creek near the Spruce Bog Boardwalk when he noticed Mike standing on the side of the road.

As soon as Mike saw who was in the car he charged across the highway while pointing with the most intense, catatonic urgency imaginable at a bird sitting on the wire and screamed (once again at the top of his lungs), "**SCISSOR-TAILED FLYCATCHER!!**" DS counts himself lucky that he was at the right place, at the right time, and with the right sharp-eyed naturalist to see Algonquin's first (and so far only) record of this very rare

A Clouded Sulphur, a native butterfly sips nectar from an orange Hawkweed, a non-native plant.

Beauty erupts in the autumn; western Algonquin's fall colours are unrivalled.
(opposite) Canada Jays, which are year-round residents, readily come to you for hand-outs.

bird from the U.S. southwest. But, based on RT's previous experience, he also considers himself lucky to have been in a car at the time and therefore safe from the potentially serious collateral damage remembered from the wolf incident.

The Scissor-tail was just one of seven bird species that Mike has added to the Park list over the years and this is another measure of his enthusiasm for everything to do with Algonquin Park natural history. He wants to see *everything* and will go to almost any length to accomplish this aim. That includes routinely leaving home at 4 a.m. in order to be in the Park by dawn or, on May 29, 1974, covering over 20 km entirely on foot in order to see as many birds as possible in just one day. He observed 106 species, an amazing Big Day total in Algonquin Park without using a vehicle.

Mike's outstanding talent and popularity with the public became apparent very early in his naturalist career. He became famous for enthusiastically greeting people coming to his conducted walks, often before they even had a chance to get out of their cars. His talks were outstandingly informative and entertaining—even with the bad puns—and, of course, he was making a name for himself outside the Park as well. He has given somewhere between 200 and 300 talks on natural history topics to audiences across Canada and in the United States, written a nature column for weekly newspapers for over 25 years, and taught enormously popular courses on or-

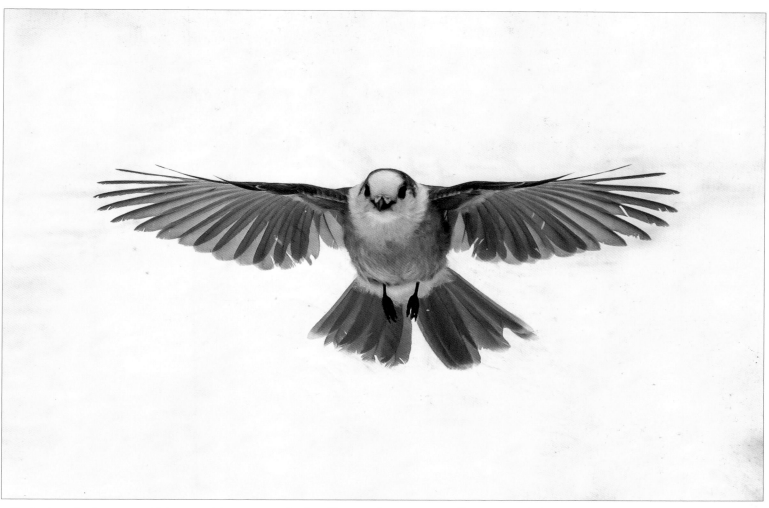

nithology and other natural history subjects at Carleton University in Ottawa to at least 50,000 students (in class and on-line) over the last 30 years.

Oh, and did we mention his books? This one, the one you are holding, is actually the twelfth that Mike has written and/ or illustrated with his own outstanding photographs. Which brings up an important point; many nature photographers can take beautiful pictures but Mike takes it a giant step further. Time and time again, Mike uses his photographic skills to reveal features of natural history or behaviour that few of us ever get to see for ourselves—the split claws Beavers use to comb their fur, for example (page 105), or the crossed bills that Crossbills use to pry open the scales of spruce or pine cones (page 216), or the gelatinous "cushions" that snow fleas deploy to make sure they "stick their landings" (page 217).

But of all Mike's photographic accomplishments none impresses more than his success with the animal whose midnight dash across Highway 60 back in 1972 sparked so much excitement in the then new young naturalist. In those days, people frequently wrote us asking where they could photograph wolves and we routinely wrote back that they would be extraordinarily lucky even to see a wolf in Algonquin, never mind get a photograph. Well, as you might guess, Mike is not one to shy away

from such an implied challenge. As of this writing he has photographed free ranging wolves in Algonquin on no fewer than 31 different occasions (involving at least 40 different animals).

This is incredible! No one we know has ever come close to such an astounding record. And please do not imagine that Mike has some magic technique for getting close to wolves or that his success has come easily. Indeed, Mike will be the first to tell you that for every wolf he has been fortunate enough to photograph, there were many more times when he went home empty-handed. But that just underscores what puts Mike in the one-of-a-kind category that he occupies; he just NEVER GIVES UP! Even with all his previous successes there is almost no privation he is not willing to endure if it gives him the slightest chance for another interesting experience with wolves or chance to photograph them.

We will close with a fine description of this unquenchable determination. What follows is an email Mike sent us in February, 2018 after spending all of a winter night and half the next day in a tiny shed so as to be hidden at dawn near a deer carcass near Paugh Lake north of Barry's Bay, not far from the Park boundary.

I spent Thursday night sleeping in a particle board shack six foot by six foot with two chairs and all my gear inside it. Door was a bit less than four feet high, ceiling five feet at the highest. Hoping to see wolves and a Golden Eagle that have been coming to a bait station all winter near Paugh Lake. Worst sleep of my life – wind blowing in (open windows, space below roof), no room to stretch out. But a wolf pack howled nearby at 9 p.m. and again at 10:30 so I was excited for the prospects. A Northern Saw-whet Owl called around 10. Began the watch at 5:30 a.m. and watched the carcass until 11 a.m.

NO wolves, NO eagles, NO mustelids, but a Red-backed Vole that seemed to be getting hairs from the deer for its den that appeared to be almost under the carcass.

Still recovering from that long uncomfortable night. (Luckily I borrowed Rory's arctic sleeping bag, which I was in by six p.m.). No power, of course, so had no lights, no heat, no music, etc.

But I am determined to go back so maybe next time!

Cheers! Michael

Note how Mike ended the email. With nothing to show for his 18 hours of misery, he still wanted to go back for more!! Now, THAT's determination!

No, we weren't exaggerating when we said Mike is *a force of nature*. Almost none of us would be willing to put up with what he does again and again (especially if we already had a track record like his). But all of us can benefit—and far more comfortably—from Mike's boundless energy and passion for the natural wonders of Algonquin Park. He has chosen almost 400 of his most beautiful and informative photos for *Algonquin Wild*. So now, sit back and enjoy this marvelous book by a truly exceptional naturalist. It will be time well rewarded.

Dan Strickland
Chief Park Naturalist (ret.)
Algonquin Park

Ron Tozer
Park Naturalist (ret.)
Algonquin Park
March 31, 2018

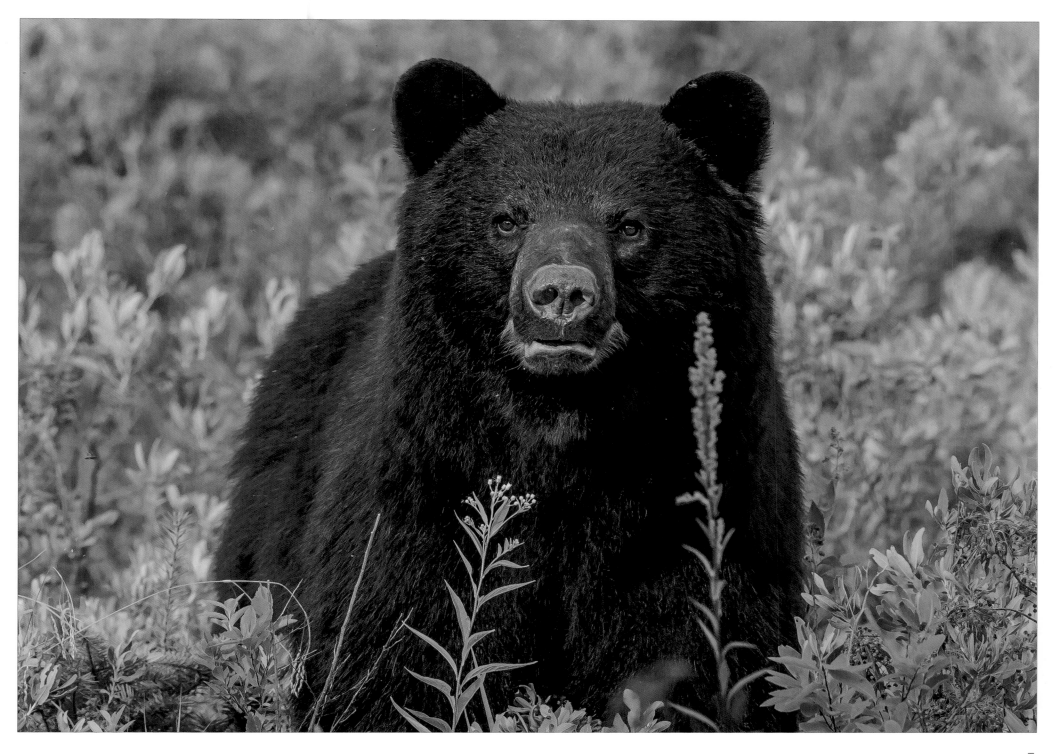

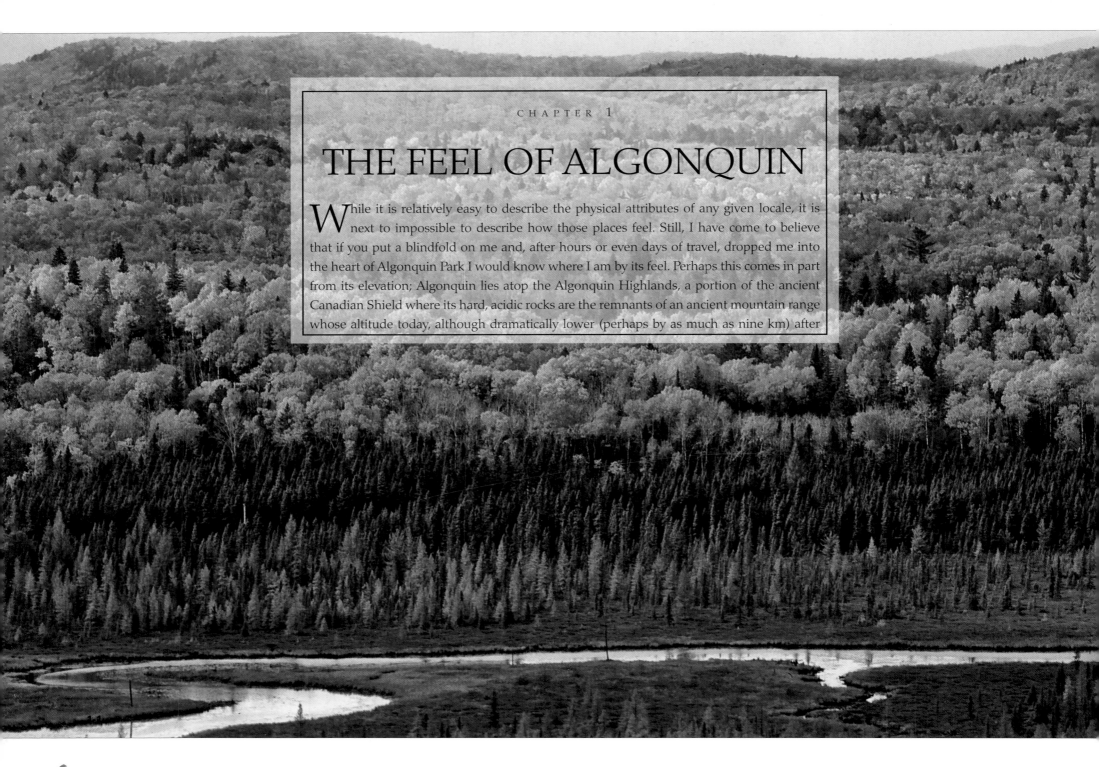

THE FEEL OF ALGONQUIN

While it is relatively easy to describe the physical attributes of any given locale, it is next to impossible to describe how those places feel. Still, I have come to believe that if you put a blindfold on me and, after hours or even days of travel, dropped me into the heart of Algonquin Park I would know where I am by its feel. Perhaps this comes in part from its elevation; Algonquin lies atop the Algonquin Highlands, a portion of the ancient Canadian Shield where its hard, acidic rocks are the remnants of an ancient mountain range whose altitude today, although dramatically lower (perhaps by as much as nine km) after

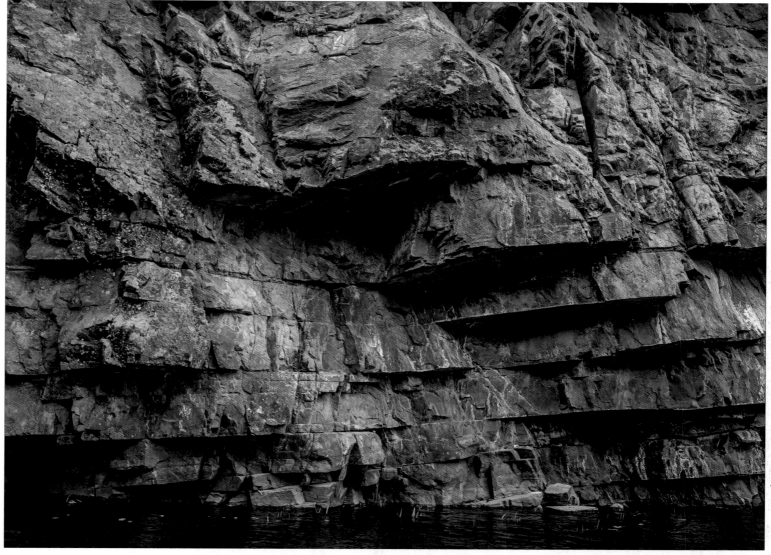

billions of years of abuse from wind, water, and glaciers, is still higher than the lands surrounding it. Due to its situation atop a dome, the Park bears the unusual distinction of having rivers flowing northward, southward, eastward, and westward out of its domain.

But it is more than height that gives Algonquin its perceptible identity. Perhaps it is the interweaving of elevation and agelessness with the scents and sounds that emanate from its living inhabitants. Algonquin's occupants include boreal species, many of which venture no farther south. They are present mainly because the Park's elevation provides cooler temperatures favourable for the establishment of their preferred habitats, the northern coniferous forests and peatlands. Added to this blend are the auras of towering hardwood forests, shallow ponds, deep-water lakes, and rambling rivers. Then of course there are the Park's sounds: the deafening din of Spring Peepers; the roar of cascading spring waterfalls; the exhilarating dawn chorus of warblers and thrushes; the lonesome wails of Common Loons; the stirring howls of Eastern Wolves; the lively chatter of winter

(opposite) This autumn view from Opeongo Lookout captures the essence of Algonquin. It is a unique blend of north and south, with hilltops exploding with the orange and red of southern maples above the yellows of sun-loving aspens. Below, an evergreen fringe of Black Spruce and Balsam Fir dotted with splashes of golden Tamarack ventures onto a floating mat of Sphagnum Moss. At the edge of this floating world, Costello Creek gently flows by. Even though it is early October, a snow flurry dusts the hilltops, which in western Algonquin are among the highest in Ontario.

(top) The landscape is rugged, with Precambrian rocks between 1 and 2 billion years old brazenly exposing their weathered faces in every corner of the Park.

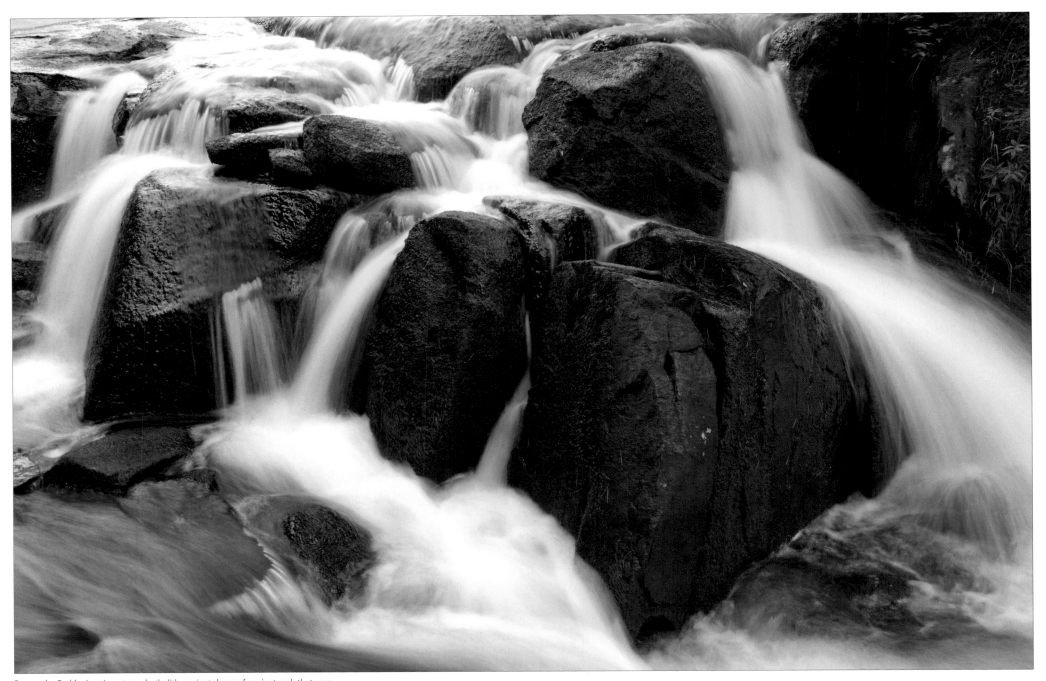

Due to the Park's situation atop a batholith, a giant dome of ancient rock that was once the base of towering mountains, water flows out of the Park in all directions.

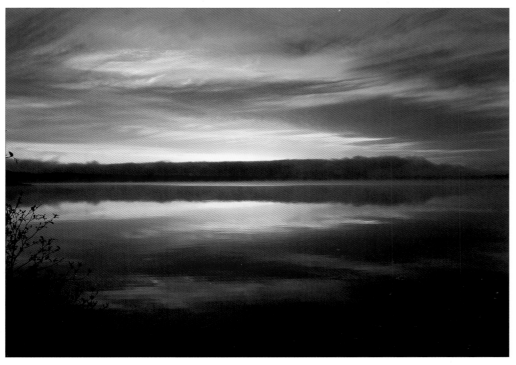

finches – all are music to the ear and tonic to the soul. At other times there is a complete absence of sound. On cold winter nights a deep silence envelops the Park while overhead hangs an endless blackness in which myriad stars burn brightly, pointing the way to another place and time. Perhaps it is the mixture of all these elements and more that give Algonquin its distinctive *feel*.

In terms of natural history, Algonquin has no equal. The Park lies in the heart of the Great Lakes - St. Lawrence Forest Region, an ecologically rich part of Ontario that is characterized by a mingling of northern species typical of the Boreal Forest (such as Black Spruce and Spruce Grouse) with southern species from the

(top left) Rock Tripe and other lichens are among the Park's most unusual residents, for they are not single organisms but two that live in unison. Lichens are symbiotic relationships between fungi and algae (or cyanobacteria), with neither partner occurring by itself, only in combination with the other.

(top right) Water comes in many forms and takes on many visages. With its emergent plant stems, this autumn pond presents a wonderful still life.

(bottom) When mists rise from the water in spring and late summer, sunsets and sunrises (like this one at Radiant Lake) are beyond breathtaking.

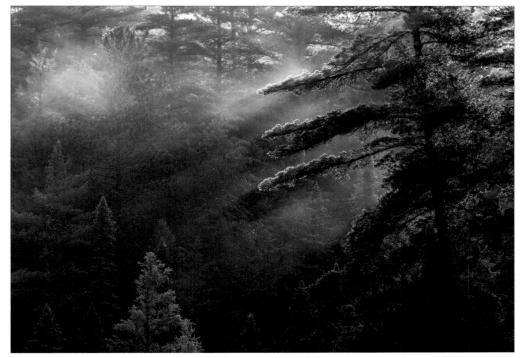

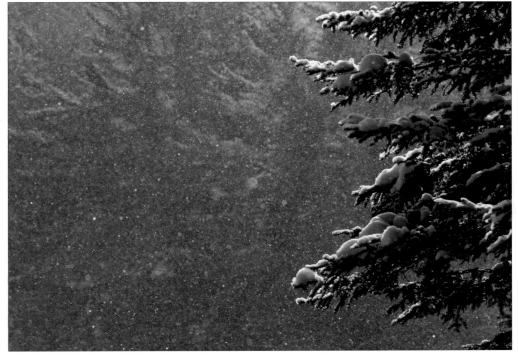

Swarms of midges in spring, shrouds of mist in late summer, and flakes of snow in winter are seasonal accessories for the Park's incomparable forests.

Carolinian Forest (such as Sugar Maple and Scarlet Tanager). There are remarkable differences in Algonquin's flora and fauna from west to east, and north to south. The western hills, overlain with a moisture-retaining mix of glacial deposits that range in size from boulders to silt, support forests of Sugar Maple, American Beech, Yellow Birch, and Eastern Hemlock, while the eastern reaches, largely due to vast, readily-drained sand deposits laid down by a glacial river, are cloaked with a forest in which Red and White pines dominate. In the east, Red Oaks cap the hills, which on average are nearly 400 metres lower in elevation than those in western Algonquin, a difference that creates a slight rain shadow effect with about ten per cent less precipitation falling in the east, not insignificant when the sand soil base already produces drier conditions. No doubt this dryness is one reason that in some regions of the East Side, younger, sun-loving forests of Trembling Aspen and White Birch grow where fires, some due to lightning strikes, others due to human carelessness, have opened up the land. The

southern "panhandle" contains a flush of southern flora that includes White Ash, Blue Cohosh, Canada Violet, and Christmas Fern. In low valleys and along the edges of lakes and creeks, floating worlds of Sphagnum peatland have developed with spindly Black Spruce and spear-topped Balsam Fir growing atop them wherever they gain a roothold. Each of the varied habitats supports its own specialized assemblage of inhabitants, resulting in a wonderfully rich diversity that makes Algonquin an exciting place to explore for naturalists of any age.

It is also a place where people can encounter a piece of the Canadian wild without venturing deep into uncharted wilderness. Of course, there are public campgrounds and a handful of stores and lodges along Highway 60 but even there one can encounter Moose and Beavers, River Otters and Black Bears, and hear Eastern Wolves and Common Loons fill the night air with their wild music. And one can always avoid that busy part of Algonquin by entering the Park through less used accesses such as the Barron Canyon, Basin Depot, and Brent roads, or slip away into the even less travelled backcountry for days on end, travelling by canoe or kayak, or by hiking one of its lengthy backpacking trails. In Algonquin, the wilderness experience is available to all.

Upon arriving in any part of Algonquin, one is immediately taken by its grand beauty. Late summer mists pirouette across lakes at dawn while the rugged face of the

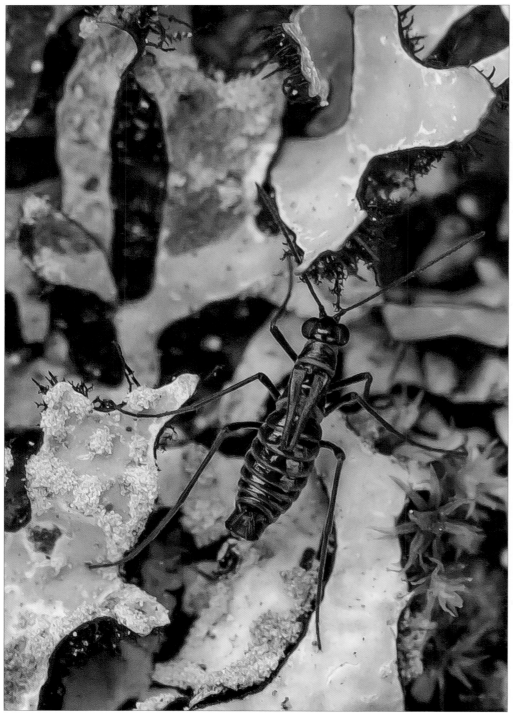

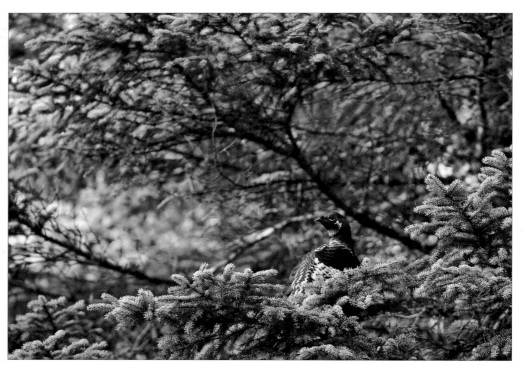

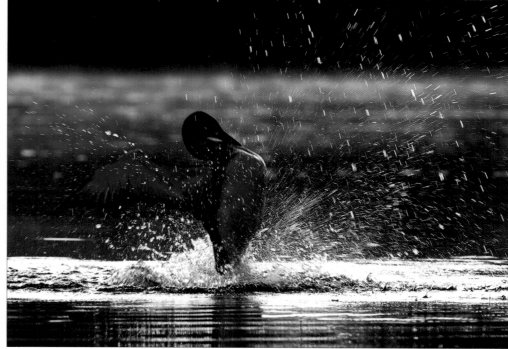

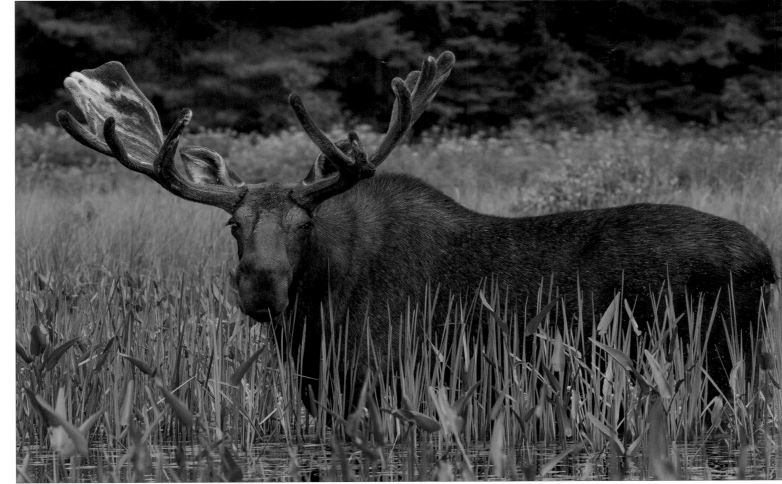

Canadian Shield stares in stoic admiration. Along lakeshores and on hilltops, pines whisper barely audible secrets to the wind as it gently caresses their elegant garb. In the autumn, hardwood hillsides erupt in colour, the water below holding a mirror to their magnificence. The beauty that transcends every inch of Algonquin and that appears in dramatic new manifestations through the four seasons inspired many of Canada's best-known artists including Tom Thomson and his friends who after his untimely death became the famous Group of Seven. That same enduring beauty has inspired and continues to inspire contemporary artists such as the late Ken Danby and the incomparable Robert Bateman.

On each and every excursion, Algonquin provides its visitors with vivid, lifelong memories. I hope that some day you will, if you have not already, experience the *feel* of this unparalleled vestige of the wild.

(opposite left) Far more abundant and every bit as fascinating as large animals are miniscule creatures like this male Snow Scorpionfly, a five millimetre-long, wingless insect most frequently encountered atop the snow in late winter. In other seasons, Snow Scorpionflies frequent the ground where they eat mosses. Interestingly, this individual was photographed two metres above the ground on the trunk of a lichen-coated Green Ash.

(opposite top right) A number of northern animals including Spruce Grouse are not found much farther south in Canada. They are present in Algonquin because its elevated position on the Algonquin Dome brings a cooler climate suitable for the development of the northern habitats these animals require.

(opposite bottom right) Many of Algonquin's iconic animals such as Common Loons are regularly encountered by sight and even more frequently, by sound.

(above) Algonquin is famous for its diverse animal life, especially large mammals like this gigantic bull Moose.

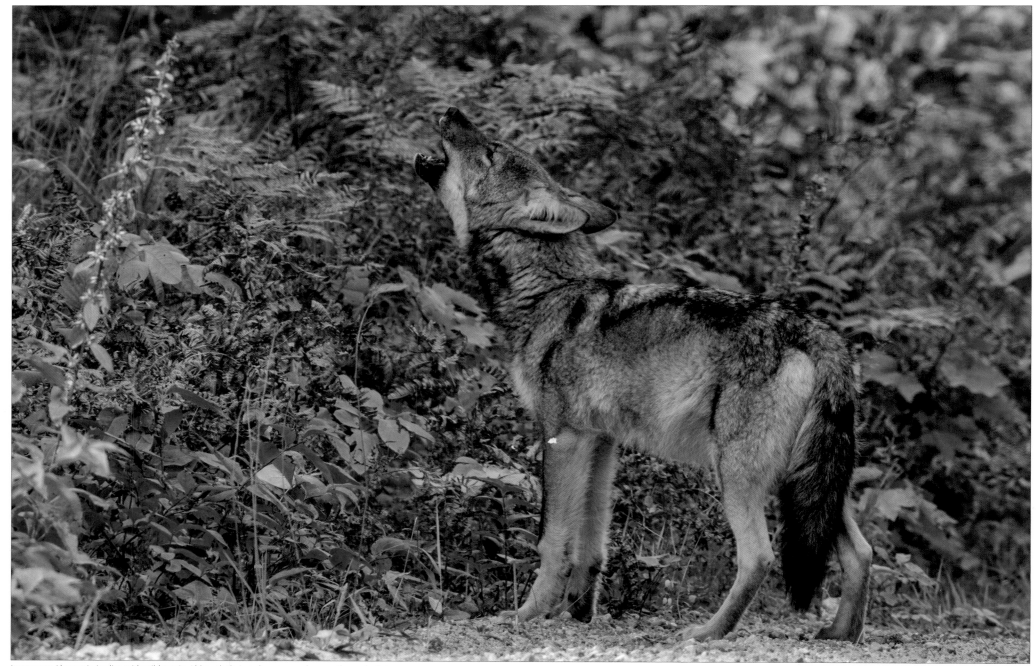

In summer, Algonquin is alive with wild music. Although their makers are rarely seen, the soul-stirring howls of Eastern Wolves have been heard by hundreds of thousands of Park visitors.

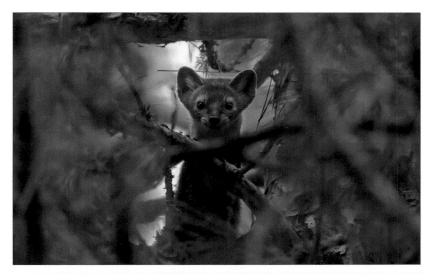

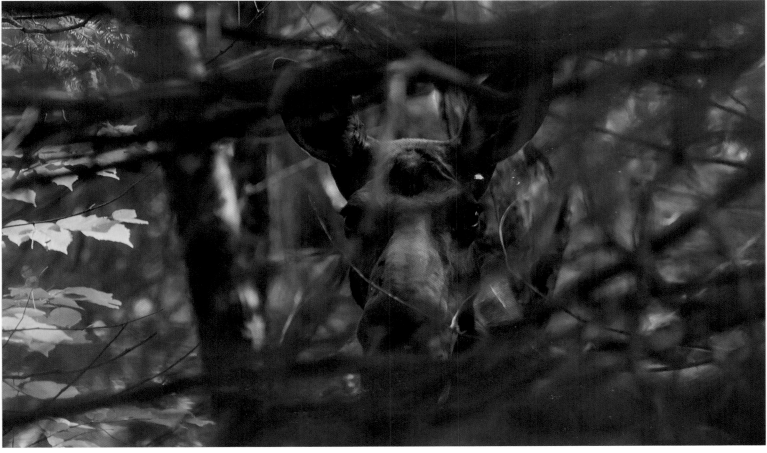

Even large animals can be invisible. Learning to look beyond the trees is a key to for seeing animals like this Moose (bottom) and a young American Marten (top) that at times blend in remarkably well with their background.

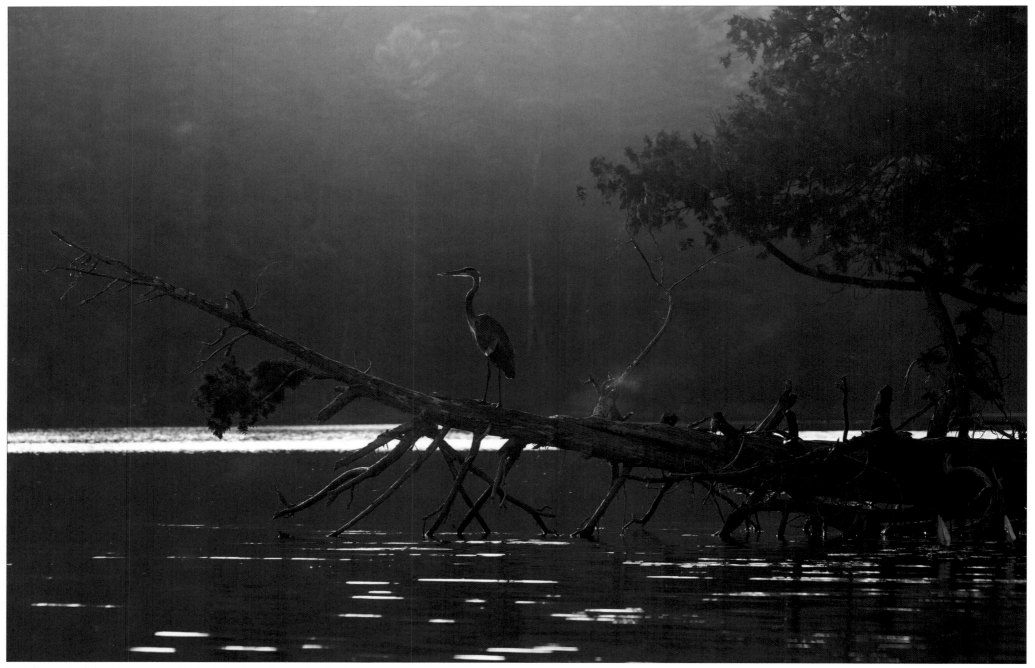

Even when one regularly encounters animals like Great Blue Herons, the varied combinations
of habitat and inhabitant give each meeting a fresh perspective and feel.

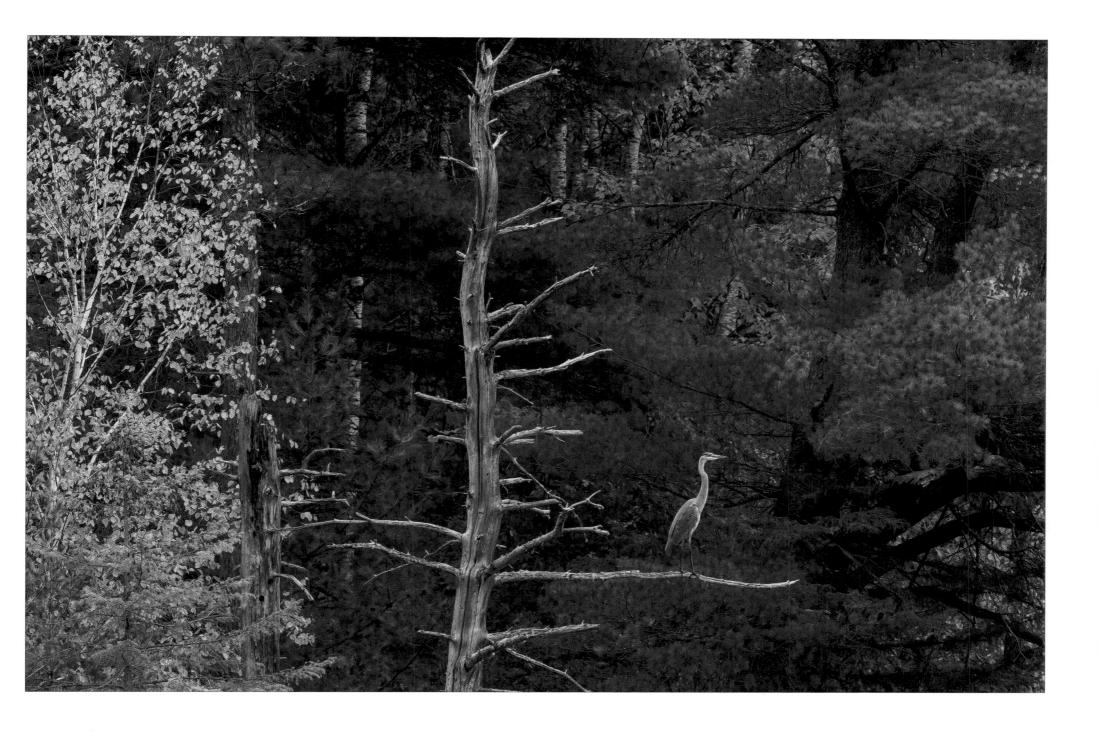

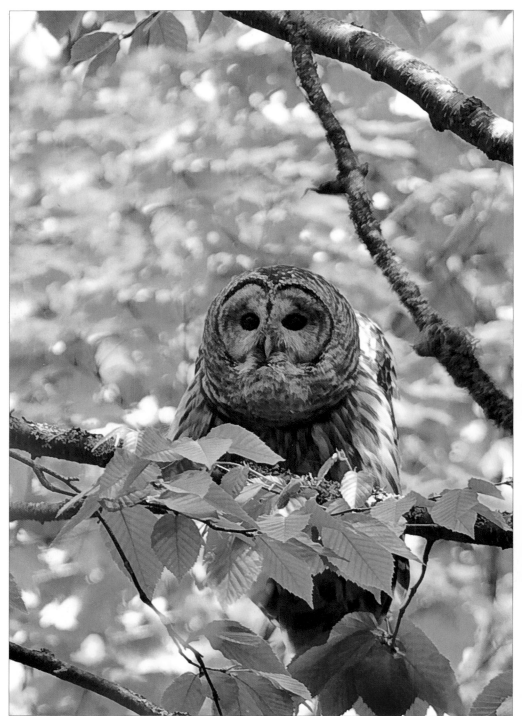

(opposite) A beaver pond, like all Algonquin habitats, is a world in its own right, harbouring a unique collage of plants and animals as well as possessing its own special beauty.

(left) The Barred Owl is Algonquin's only common owl. It nests in larger tree cavities and occasionally calls in daytime, as this one is doing.

(bottom) Much more difficult to detect are the soft lisps of a male Broad-winged Bush Katydid. Like other members of its group, its love songs are produced by rubbing together a file and scraper housed on the base of its wings.

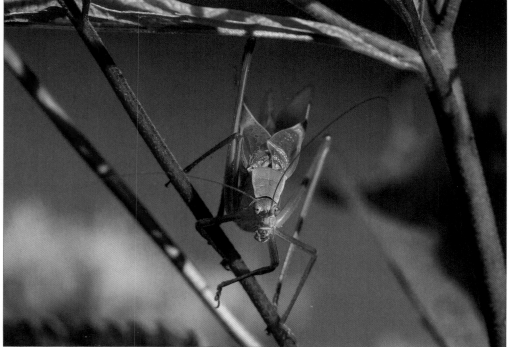

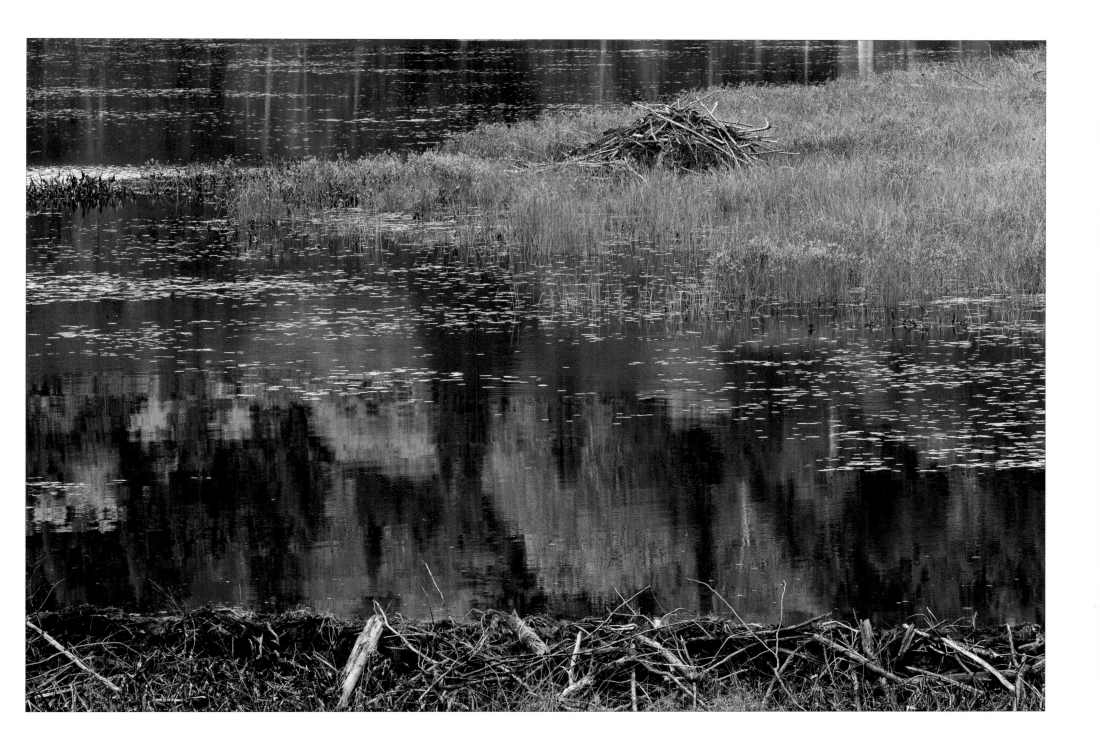

Algonquin's rich biodiversity is due in part to its variety of glacial "gifts." Rivers flowing from glacial lakes carry, sort, and deposit material by its size and weight, leaving behind sand plains, pebble beaches, and boulder gardens. Sand and till left by melting glaciers drain differently (till, being a mixture of particle sizes, holds moisture better than uniformly-sized sand grains), and that determines in part what plants grow atop them. Till is typical of West Side deposits while sandy outwash plains are common in eastern Algonquin.

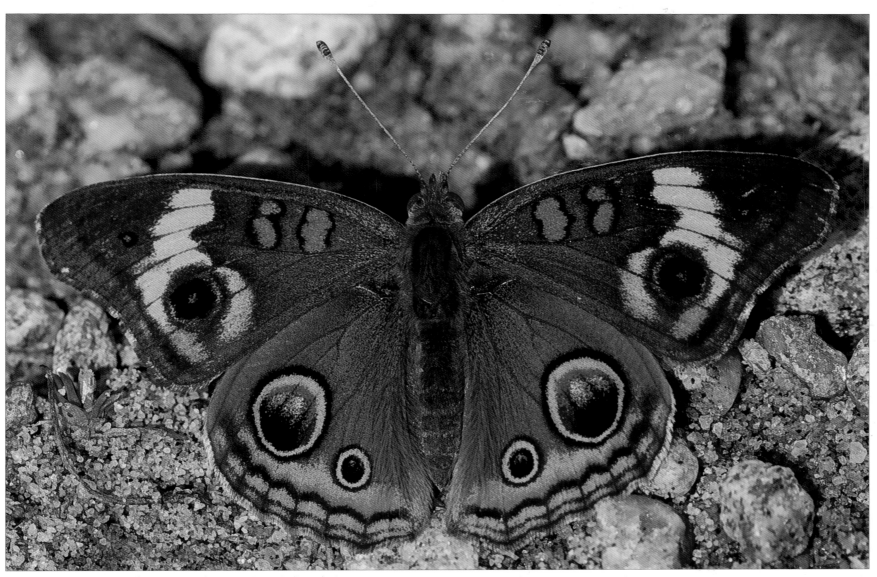

This Common Buckeye was one of two encountered in August 2012 at Radiant Lake. A rare vagrant from the south, this stunning butterfly is an excellent example of how political boundaries neither prevent animals from entering nor stop them from leaving the safe refuge of a Park.

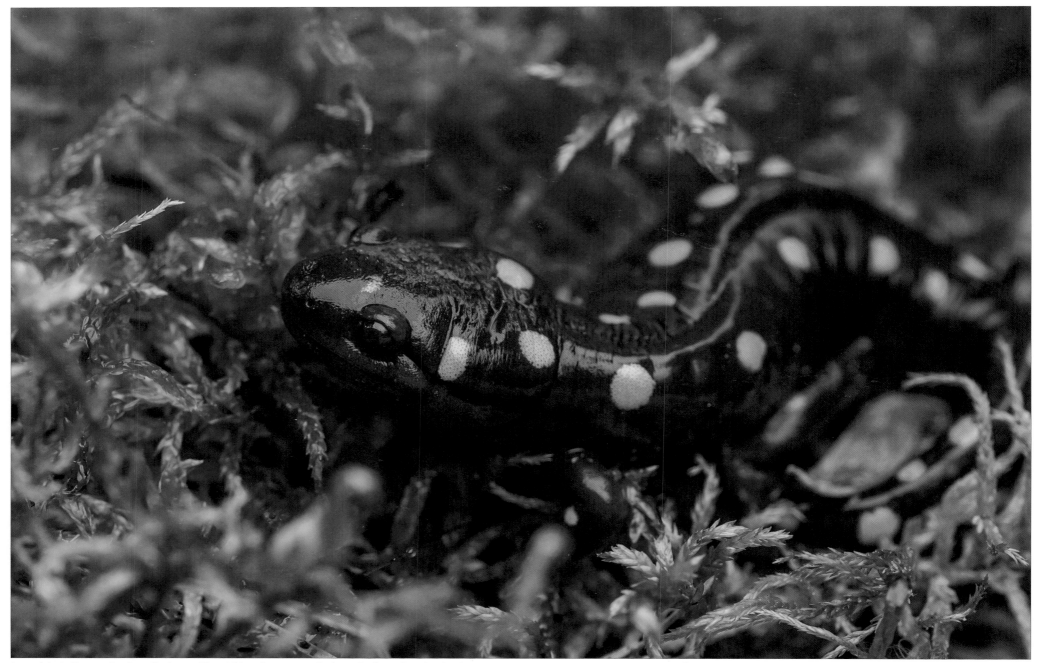

Some of the Park's most abundant animals are seldom visible to the eye. Spotted Salamanders live in the soil and on late April nights leave their subterranean burrows by the countless thousands to migrate overland through moss and snow to mate and lay their eggs in fishless waters. When mating is over, they return to their dark and hidden haunts.

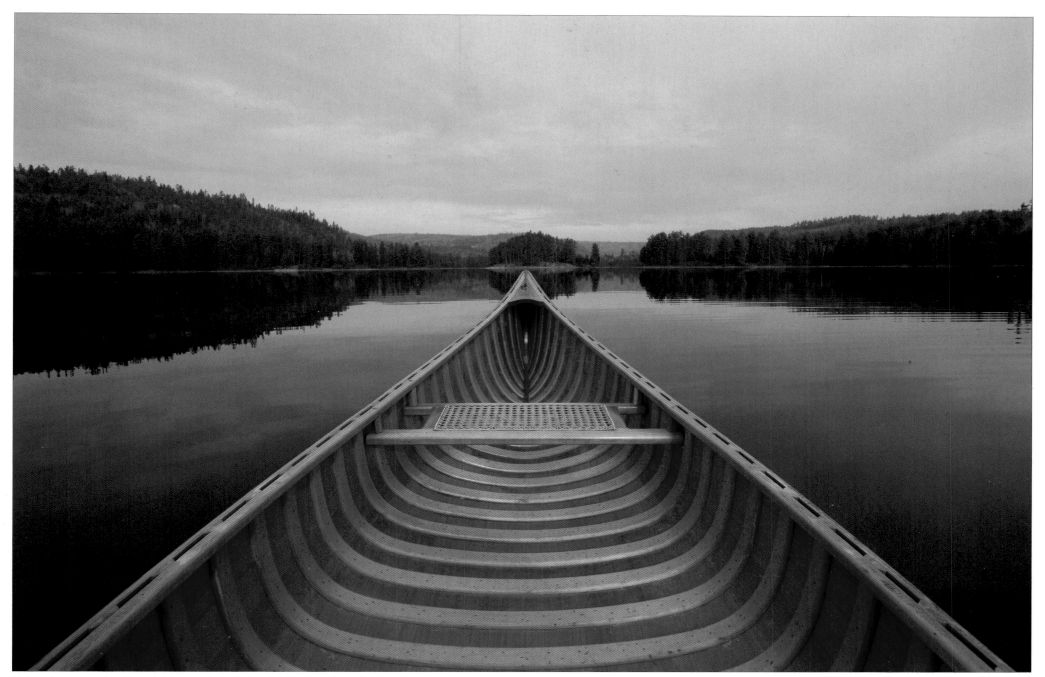

My favourite way to explore Algonquin is by canoe for it affords an intimate connection with the fascinating mixture of flora and fauna that inhabit the Park's countless waterways (here, Lake Travers).

SPRING

If Nature's calendar were to be consulted, it would be seen that spring in Algonquin arrives well in advance of the vernal equinox, coming at a time when winter's weight still resides on the land. It arrives when Canada Jays, those gentle birds from the North formerly known as Gray Jays, begin to nest. By early March, nest construction is well underway, with a few completed and already containing eggs. At this time Common Ravens are also busy constructing and/or refurbishing their bulky stick nests in trees and on cliff ledges.

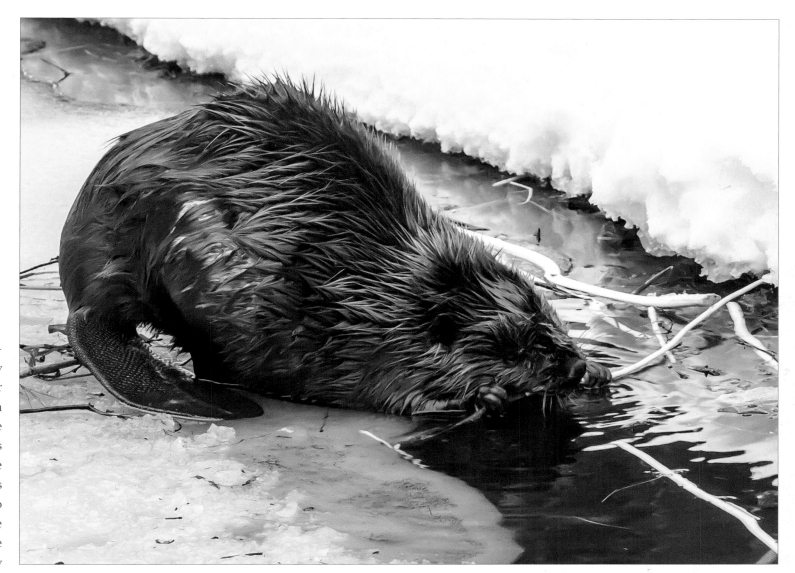

When the vernal equinox finally arrives, at dawn the snow's firm crust is a joy to travel across by snowshoe but only for a short time. The warm morning sun soon weakens its frozen resolve, giving notice that winter's grip is on the wane. Nights remain crisp but are no longer quiet for the booming cadence of Barred Owls breaks winter's vow of silence. The males call to announce their claim to territory and desire for a mate but when a female joins in, the resulting duet is an explosive cacophony perhaps more expected of animals residing deep in a jungle.

April brings rapid dramatic changes to the landscape. Early morning mists hang like death shrouds over the decaying ice of lakes. Creeks and rivers begin to flow more freely as they shed their restrictive coats of ice. Beavers and River Otters use the remaining ice as a dining table but while their seating arrangements might be the same, their menus differ greatly, with the aquatic weasels enthusiastically chomping on fish while the great rodents noisily nibble the bark off branches. Mergansers return to the liberated waters, many of them already in pairs. Later, once the females start the lengthy job of egg incubation, the males mysteriously vanish, leaving their mates with all responsibilities of parenthood.

While Canada Jays are busy feeding their young, other birds are performing spectacular courtship displays. Most no-

(opposite)) Larger bodies of water are reluctant to shed their frigid coats of winter. Cool nights and warm days result in early morning mists that hang like raised curtains over the lakes (here, Brewer).

(top) As soon as the ice starts retreating from their ponds, Beavers take advantage of the liberated water to enjoy meals in the fresh air.

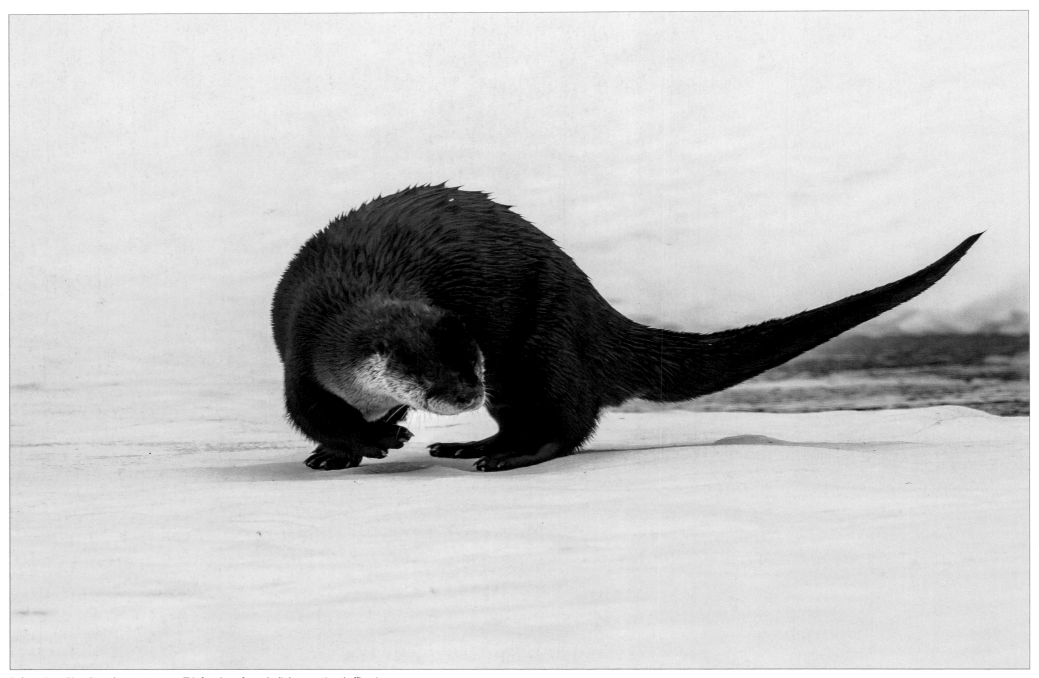

By late winter, River Otters become amorous. This female performed a little premating shuffle prior
to posting her personal advertisement in the form of sex pheromones on the ice.

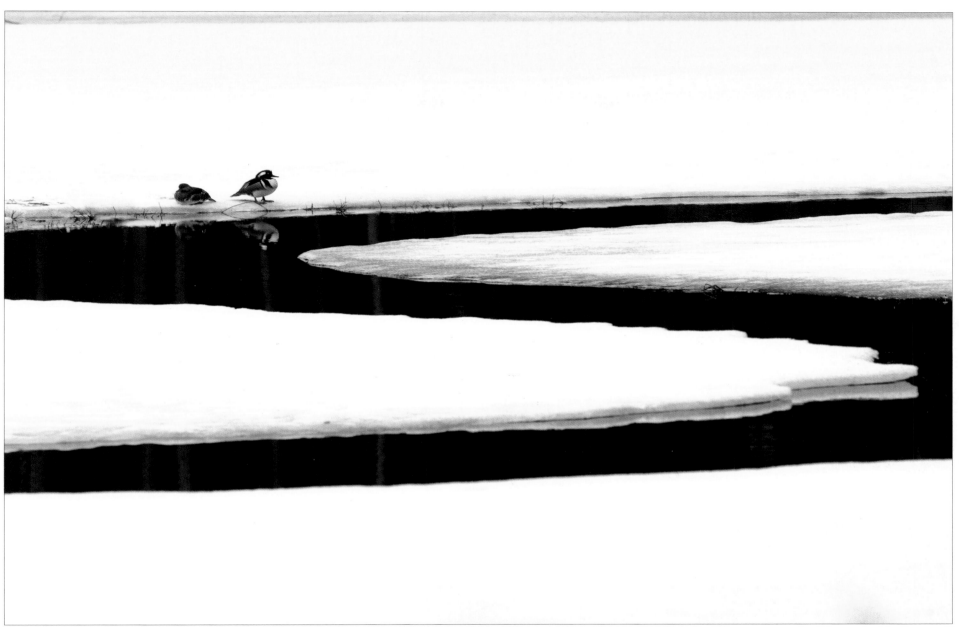

As soon as the creeks start flowing freely, ducks like this pair of Hooded Mergansers return from their winter hiatus..

ticeable are those of grouse for theirs contain audible as well as visual components. From atop moss-covered logs male Ruffed Grouse pound the air with their wings, beating it faster and faster, creating vacuums that suck in air in a series of "thumps" that culminate in a thunderous drumroll whose low frequency carries it far and wide. Spruce Grouse, their northern cousins, also use their wings but to perform noisy flutter flights up into spruces and back to the ground. Between flights, the males strut their stuff, their tail fanning open and closed with the barbs of the chestnut-tipped

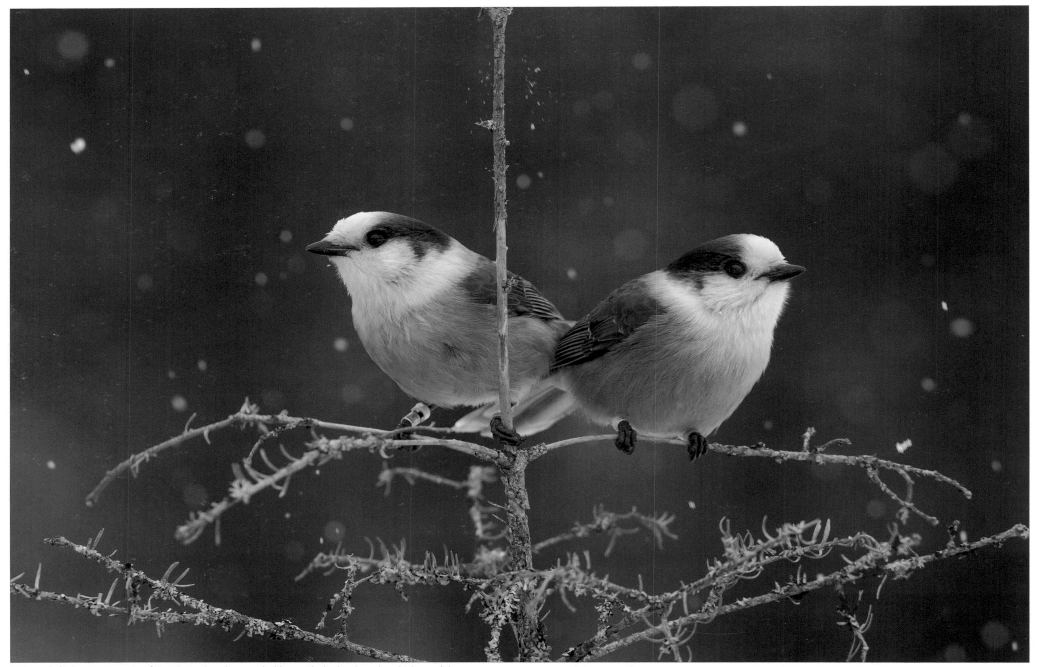

By the end of February, some pairs of Canada Jays have begun to build nests. The leg bands on these birds reveal that they were "volunteers" in Dan Strickland's long-term study on their species (a world record for its longevity).

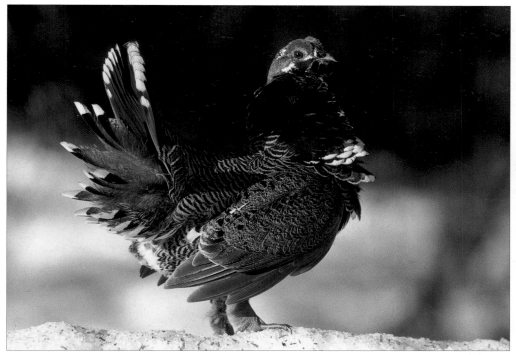

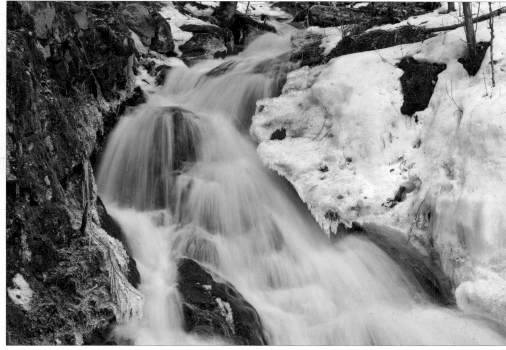

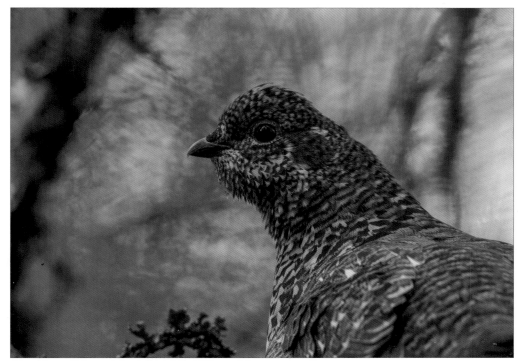

(top right) The melting snow gives purpose to myriad streams, many of which will go dry by the time summer arrives

(top left) Male Spruce Grouse perform eye-catching strut displays, their tails noisily fanning open and closed. The skin above their eyes inflates with blood, a vibrant indicator of their desire and perhaps their suitability as a mate. The males do "flutter flights" in which they noisily fly up to a low perch and, after a few moments of dramatic display, repeat the flight in reverse.

(bottom)) The flamboyant displays of a male Spruce Grouse are done solely to win the discriminating eye of a female.

feathers noisily rasping against each other. Skin papillae above the eyes glow red as they fill with blood, a visual indicator of their owner's health and vigour.

April days bring to life butterflies that spent winter as dormant adults hidden in tree crevices or under loose bark. Mourning Cloaks, Compton Tortoiseshells, and commas are the first to brighten the forest floor, but only when they open their wings to bask in the sun. When the wings are closed, their cryptic patterns and ragged shapes make the butterflies vanish into the background of dead leaves they mimic. In late summer, the eggs of these butterflies release another generation that will spend the ensuing winter in a death-like state, as did their progenitors.

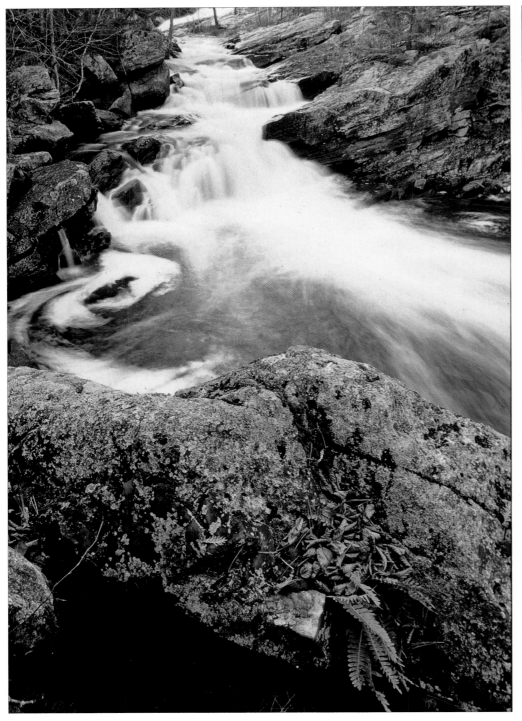
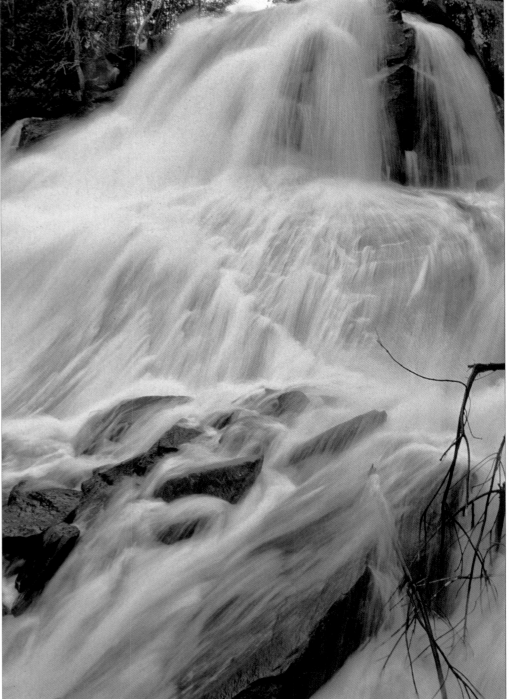

Moose also become quite visible in late spring, making regular appearances in ditches along Highway 60. Here, they drink the water and eat the mud, both of which are loaded with salt from winter road operations. It is not so much the salt they seek but its sodium component, something they crave after a winter's diet that is virtually free of this essential mineral. Moose may be easier to see but they are not at their photogenic best for they are shedding their winter coats, some showing excessive hair loss caused by their attempts to free themselves of bothersome Winter Ticks. Additionally, the great antlers of the bulls, their last year's models shed months before to lighten the load for the winter, are just

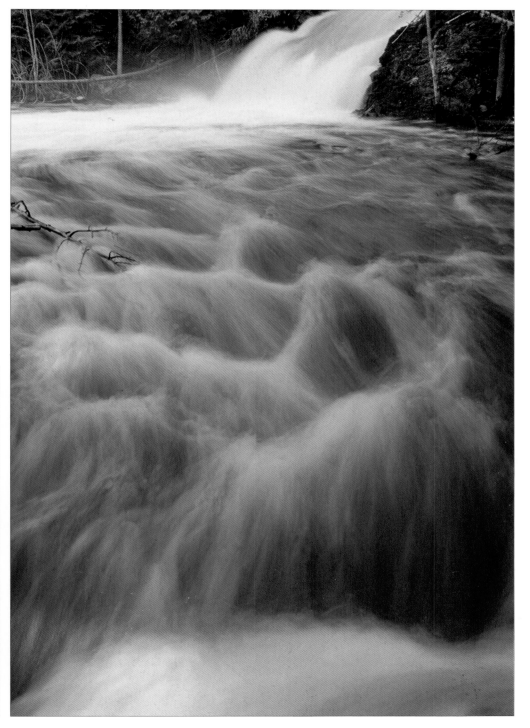

(bottom) Fallen trees lying across streams are perfect for showcasing icicles.

Waterfalls are spectacular features found on most of the major rivers. It seems there was a lack of originality in naming them, however, for there are "High Falls" on the Bonnechere (right), York (opposite left), Barron (opposite right), and Nipissing (next page) rivers.

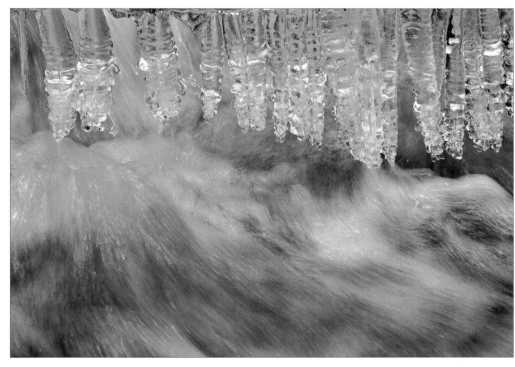

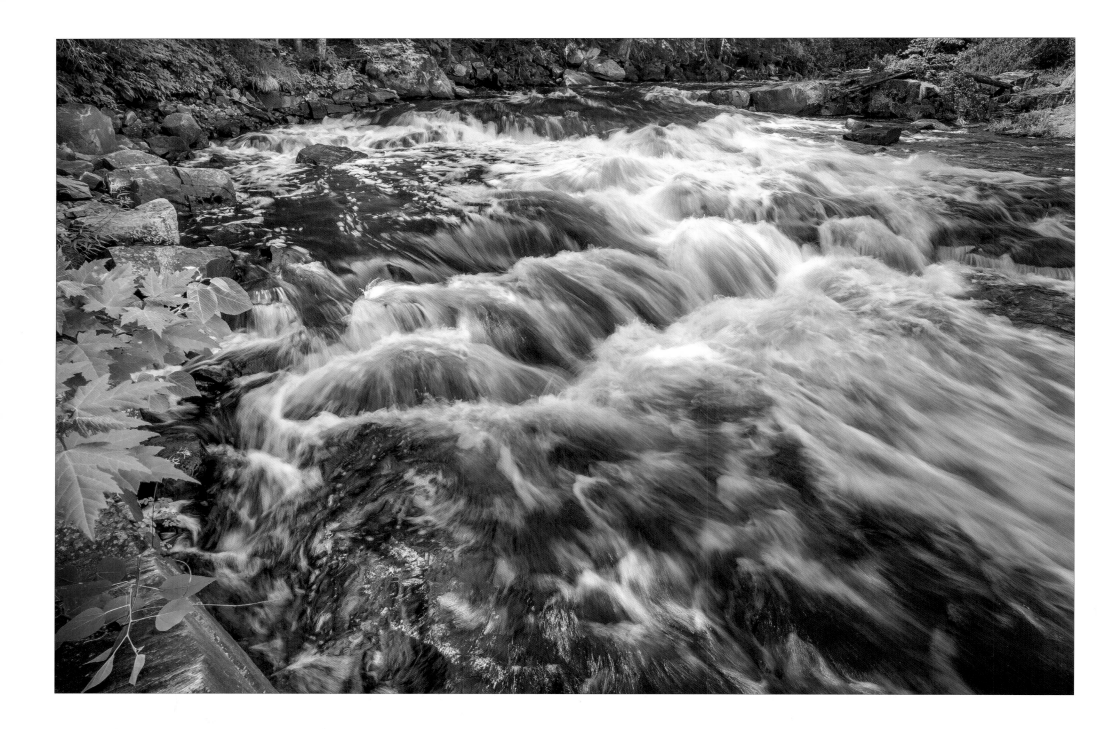

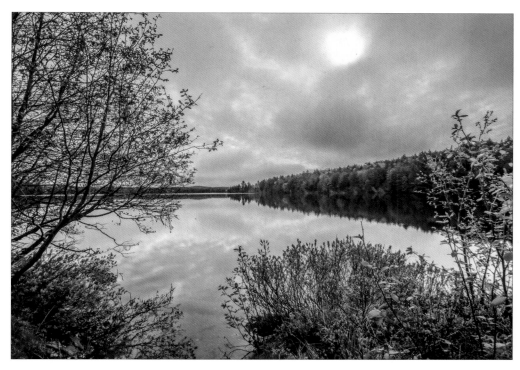

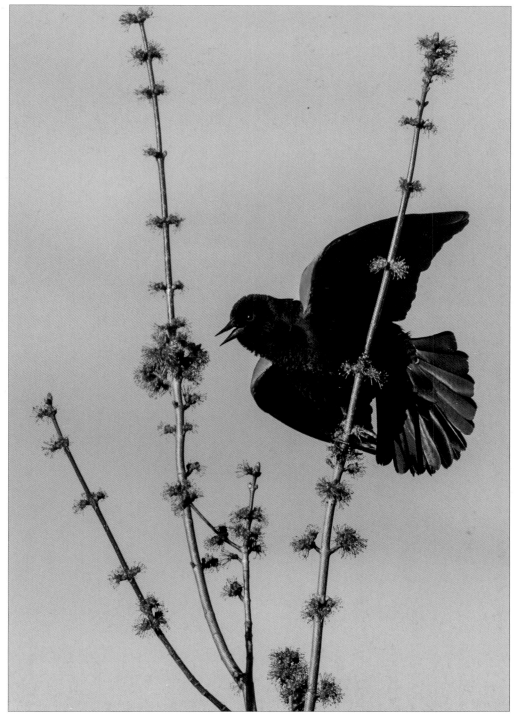

(top) By mid May new leaves adorn deciduous trees, adding varying shades of green to lakeside hills, (here, Kingscote Lake). Dan Strickland appropriately calls this annual display "the spring colours."

(right)) The arrival of this male Red-winged Blackbird coincided with the opening of the Red Maple's flowers, the only maple that boasts individual trees bearing flowers of only one sex (here, male flowers). Other maple species have flowers that contain both sexes (perfect flowers). Another unusual feature is that male Red Maples bear red leaves in the autumn while those on female trees turn yellow!

starting to grow anew. As the antlers grow, a plush skin called velvet feeds nourishment to the underlying bone, which happens to be the fastest growing bone tissue in the world.

The end of April brings the appearance of one of Algonquin's most common yet most infrequently encountered animals. On warm nights, like ghouls rising from their graves, armies of Spotted Salamanders emerge from the ground and silently march over leaves and snow to the nearest body of fishless water. Here, under only the illumination of the moon and stars (providing it is a clear night), they mate. When their nuptials are done and the gelatinous masses of eggs deposited in the water, they return to the land and once again vanish into the

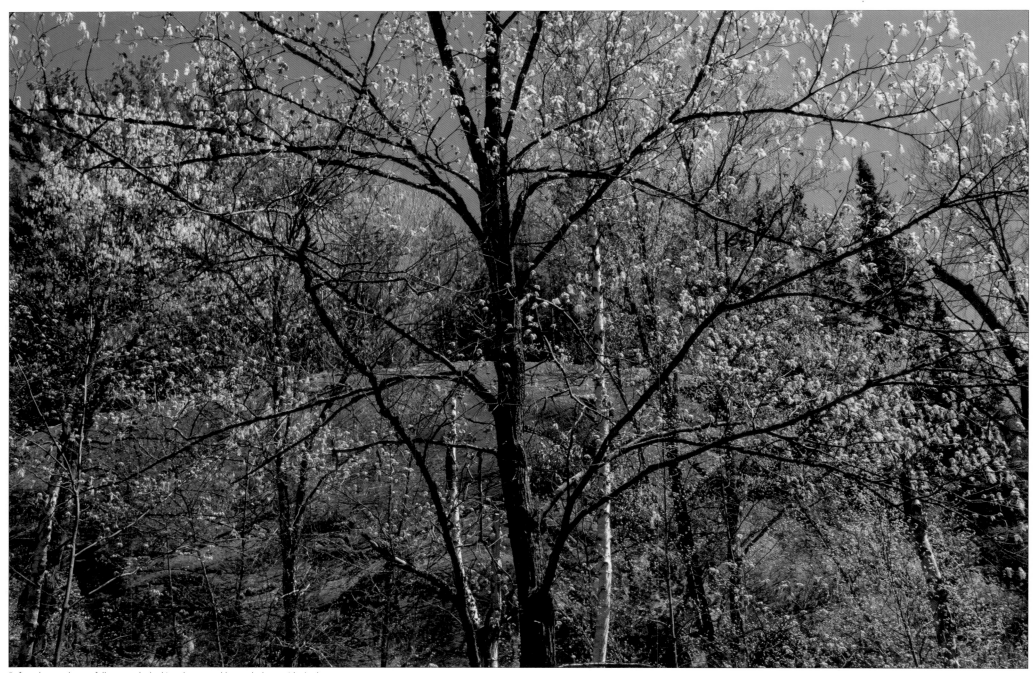

Before the tree leaves fully expand, cloaking the ground beneath them with shade,
sunlight warms the soil and inspires a burst of floral activity.

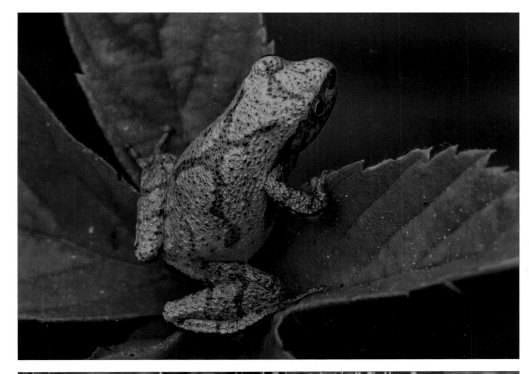

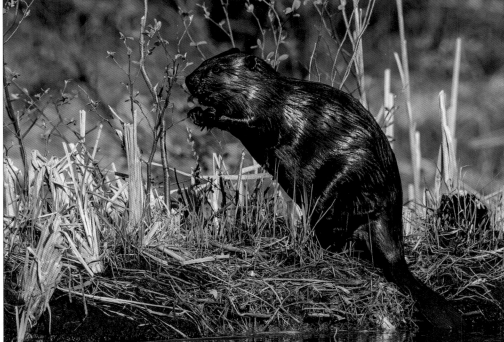

depths of the earth. Research in Algonquin has revealed that these colourful mole salamanders are laying their eggs earlier each year as the climate continues to warm.

April blends into May, with days becoming warmer and the night chill lessening. Uninhibited by the tree leaves that now are only buds swelling with optimism, the sun beams down on south-facing slopes, its warmth triggering the awakening of an army of spring wildflowers. Spring Beauty, Dutchman's-breeches, and Northern White Violets head the first wave, with Red and Painted trilliums and Yellow Trout-lilies bringing up the rear. By the time the tree leaves have fully opened, closing the shutters on the sun's strong influence, the flowers have completed their task, which was to attract pollinators and produce seeds, and so now they wilt. Many will have their seeds mature by mid-summer and get transported by ants to their underground haunts where they will eventually germinate. The ants do not perform this

(top) It may seem hard to believe that a tiny frog not much larger than your thumbnail can cause you pain. Immediately after thawing from their frozen slumber (peepers spend winter buried in shallow soil where half their body water turns to ice), thousands call for mates from beaver ponds and other shallow waters, their voices uniting to create ear-piercing dins.

(bottom) As soon as it is available, Beavers harvest fresh growth on the land.

dispersal act out of goodwill, however, for they are rewarded with a package of sweet protein that is attached to the seeds. Foamflower chooses a very different method for the dispersal of its seeds; they are splashed from little cups by raindrops that fall from the trees overhead.

Spring is alive with sound. First to be heard are the hollow drumrolls of woodpeckers that emanate from the treetops. Each species produces a distinct tempo of taps, which is done on dead branches for maximum resonance. Drumming, the woodpecker equivalent of song, announces territory ownership and sends out invitations to the opposite sex. Once paired, both sexes drum in response to the other.

Next comes the thunder of cascading waterfalls along rivers swollen with snowmelt and rain. From quieter waters comes the next burst of sound, the chorus of spring frogs. The first frogs to call are those that lay frozen in the forest soil with over half their body water turned to ice. Spring Peepers and Wood Frogs perform incredible Lazarus acts when after thawing back into life they head to the nearest unfrozen water to stake territorial claims and attract mates. Wood Frogs might fool many into thinking their clacking calls are made by ducks but Spring Peepers leave no doubt as to the makers of their songs. It might be difficult to imagine how tiny frogs the size of your little fingernail can cause great pain but if you venture too close to a pond full of Spring Peepers, their shrill, penetrating calls will quickly

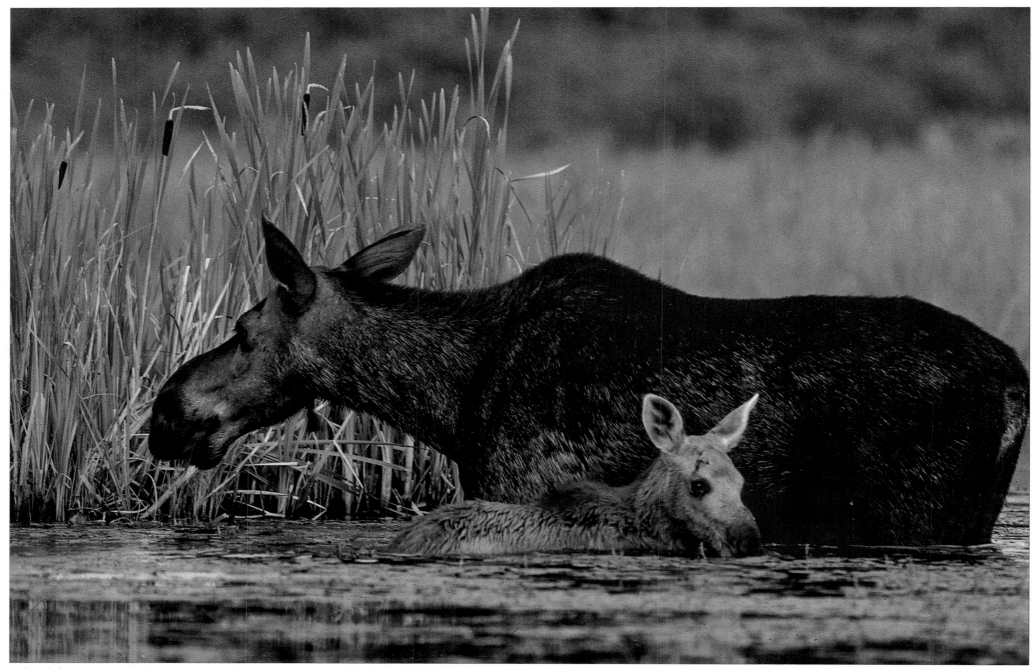

By the end of May most cow Moose have given birth, usually on peninsulas or islands where there are fewer predators and nearby water allows a safe escape. The water also offers sodium-rich plants for both the mother and her new calf.

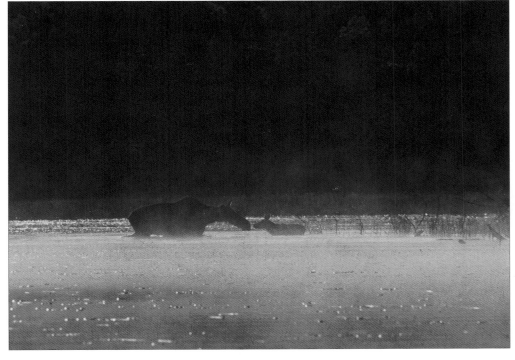

reveal that they can.

The last wave of sound coincides with the return of the tree leaves, for with their emergence comes the return of the songbirds. With the new vegetation providing food for caterpillars and other insects, there are now plenty of resources for birds to feed their young. As soon as they arrive in Algonquin, songbirds begin to sing and set up territories. By late May, no fewer than twenty species of Wood Warblers, the jewels of the bird world, and five species of woodland thrushes fill the dawn air with their magnificent music.

Not all animals welcome spring with joyful sounds. By the third week in May female Moose are giving birth, usually on the highest point on islands or peninsulas, sites that provide safe haven for their new young. Apart from the bleats of a new calf telling its mother it is hungry, Moose remain silent lest they attract unwanted attention.

The hours around dawn are the best times to enjoy a late spring day in Algonquin, for later in the morning under the sun's inspiring warmth squadrons of Black Flies take to the air. It is remarkable how quickly these tiny flies locate a carbon dioxide-releasing host and how pitilessly they swarm it, attacking any vulnerable site. Although it is only the females that seek blood (to be used as a protein supplement for their developing eggs), there seems to be an unlimited supply of that sex. Calm, humid evenings are peak activity times for these flies, whose tenacity can drive unpro-

(bottom)) A Mother Moose is always close at hand to assure that all is well.

(top right) Black Flies are one of the Park's most infamous inhabitants. As do most biting flies, only the females draw blood. After its razor mandibles slice flesh and anticoagulants are added to the wound, the tiny fly (a mere five millimetres in size) laps up blood for its egg development. When in late spring thousands swarm the poorly prepared, the experience is not pleasant. Perhaps foolishly, I don't use protection and consider the bites of these and other flies as being the price of admission to the greatest shows on Earth.

(top left) The Purple Tiger Beetle is the first of its group to make an appearance each spring. Tiger Beetles are skilful predators that frequent open terrain, running to capture their prey and dispatching them with their formidable mandibles.

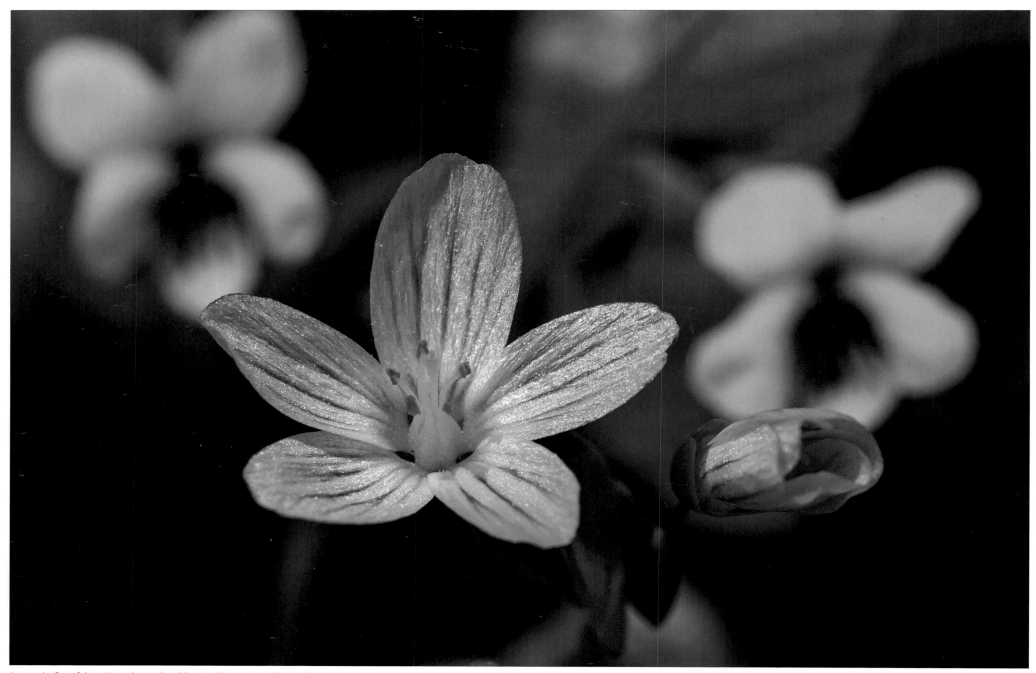

Among the first of the spring ephemerals to bloom is the appropriately named Spring Beauty. The floral patterns that so appeal to our eye are visual guides that show insects where to visit so that the flower gets pollinated. Looking on (perhaps in admiration) are some Northern White Violets.

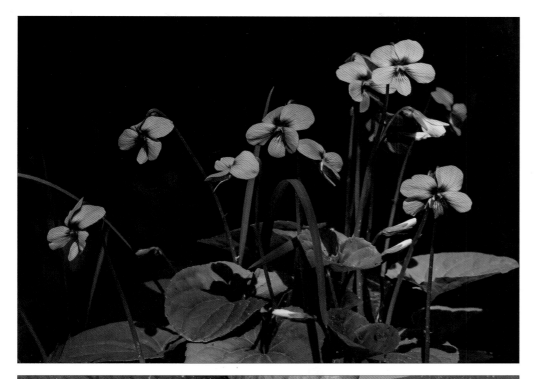

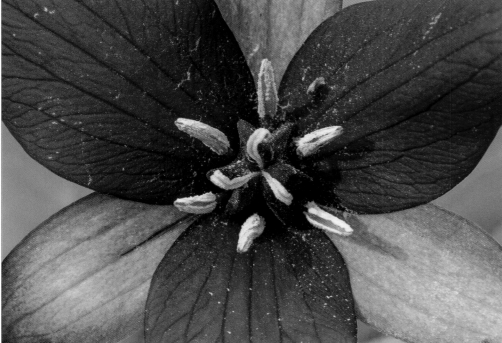

(top) Marsh Blue Violets like to have
wet feet where they bloom.

(bottom) They may be one of the prettiest spring
wildflowers but Red Trilliums are one of the worst smelling.
They use their odours to trick flesh-eating flies seeking
egg-laying sites into visiting (and thereby pollinating)
them. This trickery is known as brood site deception.

tected targets to near insanity.

As spring nears its finale, female turtles leave the safety of the water and seek dry sites in which they excavate pits in which they lay their eggs. The construction of railway beds (now all defunct) and a labyrinth of logging roads have no doubt benefited these reptiles by providing numerous new locations in which to dig their nests. Usually done under the cover of darkness, a female turtle methodically uses her back legs to excavate a hole in which her eggs are carefully dropped. When egg laying is finished and the nest hole filled in, the turtles return to their aquatic world, leaving their eggs, which they have never seen, to hatch months later. During the incubation period, at a critical time in the embryos' development, the soil temperature dictates what sex will emerge from the eggs; temperatures between 23°C and 27°C produce only males, with temperatures above and below this producing only females. However, if temperatures are excessively hot or cold in the summer, no young will be produced. Thus, increasingly warm summers due to climate change may hold serious implications for the fate of these ancient creatures.

But temperatures are usually the least of a turtle's concerns, for a number of animals love eating their eggs. Red Foxes, Raccoons, and Striped Skunks (which fortunately for turtles, are rare in Algonquin) are the main culprits. Once they discover an egg-laying site, they return to it annually to plunder the nests; in some years up to 100% of the

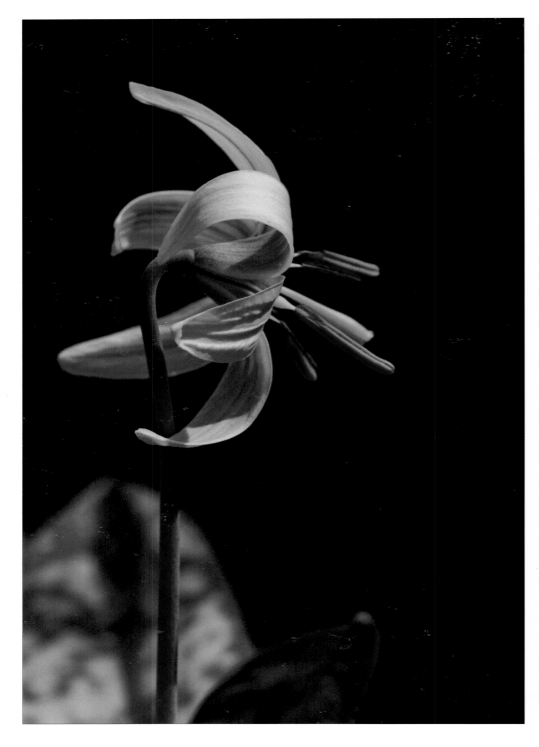
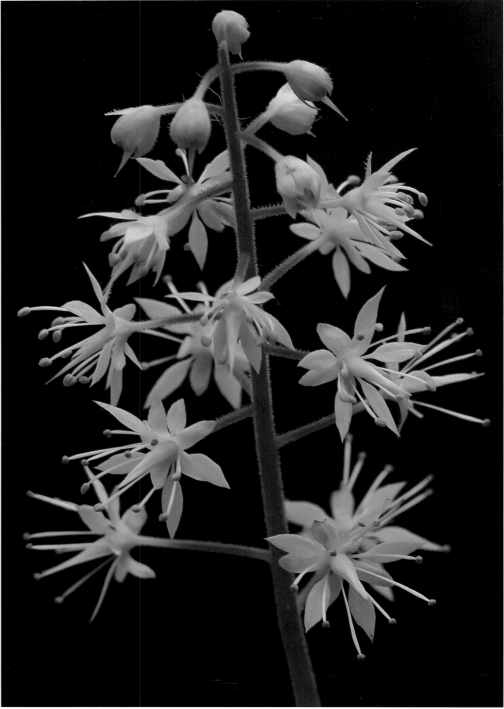

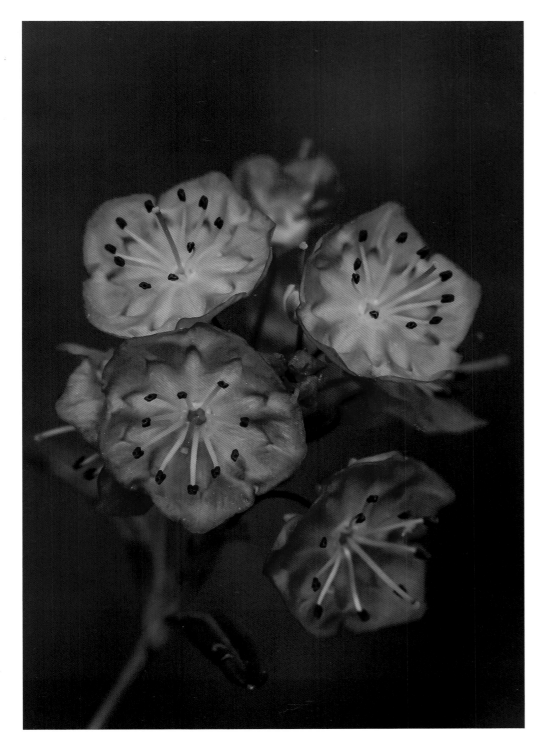

(opposite left) The flowers of Yellow Trout-lily dot western hardwood hillsides before the tree leaves open overhead. Their distinctive spotted leaves are sometimes more plentiful than their stunning flowers.

(opposite right) A number of early spring woodland wildflowers like this Foamflower are white, perhaps to make them stand out more strongly against their dark background, thereby enabling pollinators to quickly find them.

(left) Bog Laurels bloom at least a month before Sheep Laurels, their larger cousins, make an appearance in peatlands. Many peatland flowers are pink, a colour that Bumble Bees seem to find particularly attractive.

nests are depredated. Fortunately, turtles counter this loss by laying large numbers of eggs (Snapping Turtles can lay more than 50 in one nest) and possessing remarkable longevity (up to 100 years for a Snapping Turtle). In all of those years if one young hatches and survives to adulthood, a turtle will have succeeded in passing on its genes in a classic case of hedge betting!

Bird eggs also have their problems. Blue Jays, Common Ravens, Red Squirrels and tree-climbing weasels such as American Martens frequently raid the nests of smaller birds, and inclement weather presents other challenges. Fortunately, a lack of food in late spring is seldom a problem for birds because at that time the forests harbour battalions of caterpillars and other insects. Additionally, the sustenance for many birds comes indirectly from the water, and there is a lot of water present in Algonquin. Midges, dragonflies, caddisflies, and Mayflies are but a few of the insects that spend their larval stage in the Park's ponds, lakes, and rivers. In the water they are food for aquatic predators that include insects such as Diving Beetles and dragonfly nymphs, as well as turtles and Hooded Mergansers. When they abandon their aquatic quarters for a life in the air as flying adults they become available to other hungry mouths. As flying adults, dragonflies are speedsters that challenge most birds to capture them, but in their transitional stage they are extremely vulnerable. As the nymphs crawl from the water to transform on rocks or plant stems, or as the teneral adults emerge

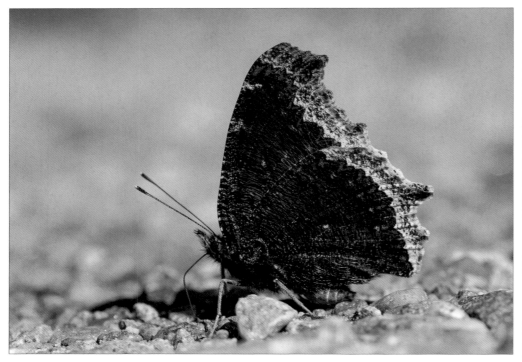

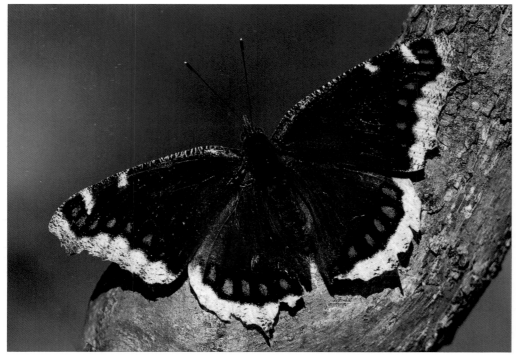

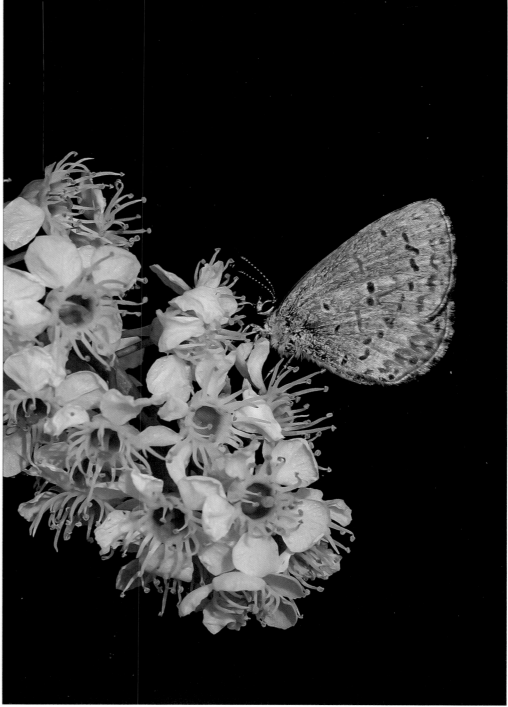

from their lifeless nymphal shells, countless numbers fall prey to Common Grackles and Red-winged Blackbirds, birds that are masters at finding them.

By spring's end, where ephemeral wildflowers once livened the forest floor with their colourful blooms, only dark shade cast down from the canopy of leaves resides. But as spring slips into summer, Algonquin is not without colour. It is found in the warblers that now tirelessly bring food to their young. It lives in the squadrons of dragonflies that rule the skies. It thrives in the troupes of butterflies that dance across flower-rich meadows. And it floats on the surfaces of ponds and shallow lake bays. Summer is indeed a colourful season.

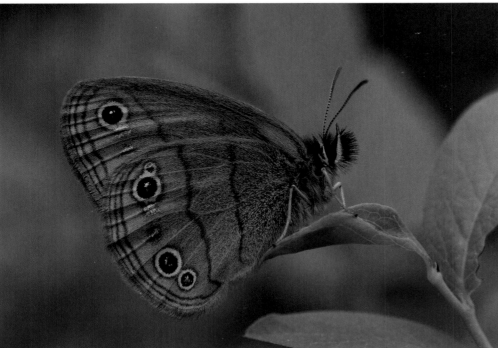

(opposite right) Spring Azures, one of the Park's smallest butterflies, sport a rather dull countenance until their wings open, revealing their stunning blue upper surface. Unfortunately, when they sip nectar, as this one is doing from a Chokecherry's flower, their wings remain closed.

(opposite top left) Mourning Cloaks are among the first butterflies to appear in spring because they overwinter in the adult stage (many butterflies spend winter as pupae).

(opposite bottom left) Their dead-leaf façade vanishes the instant they open their wings.

(bottom) Eyespots on Little Wood Satyrs may fool predators into thinking they are much larger animals, too formidable to tangle with.

(top) This Macoun's Arctic has two claims to fame in Algonquin: this northerner doesn't occur farther south in Ontario, and it only makes an appearance as a butterfly on even-numbered years, spending two years as a caterpillar. First discovered decades earlier in Jack Pine stands in eastern Algonquin, this species apparently went unnoticed until the author encountered it again in the late 1980s.

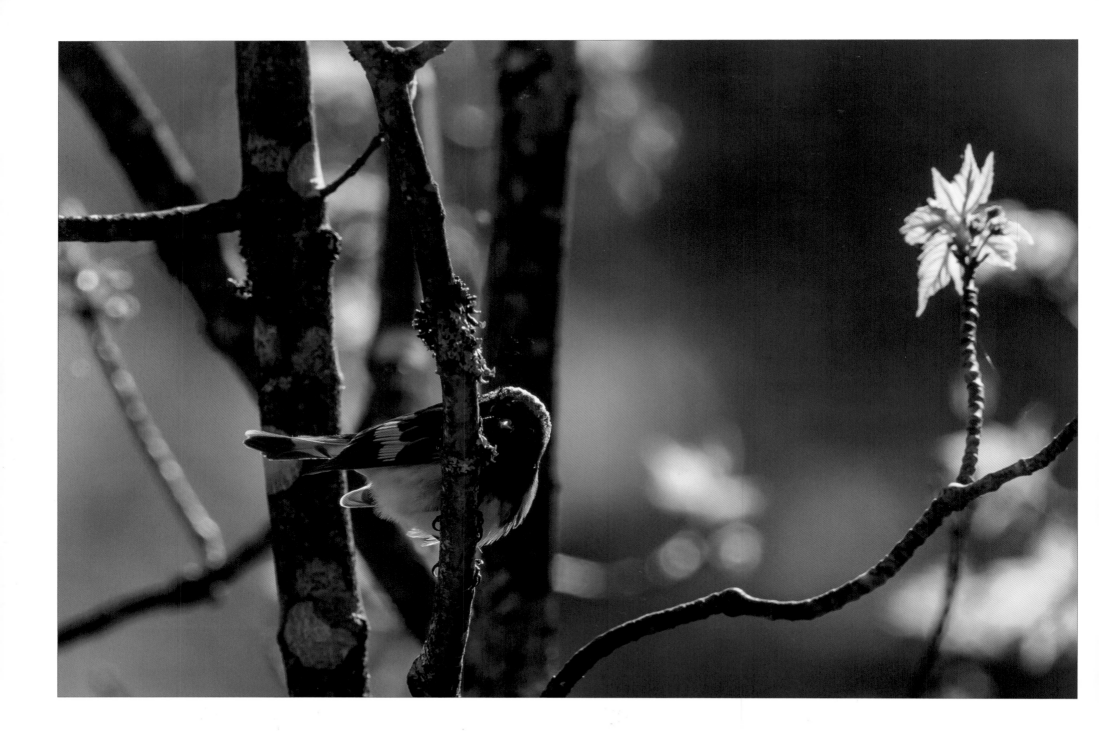

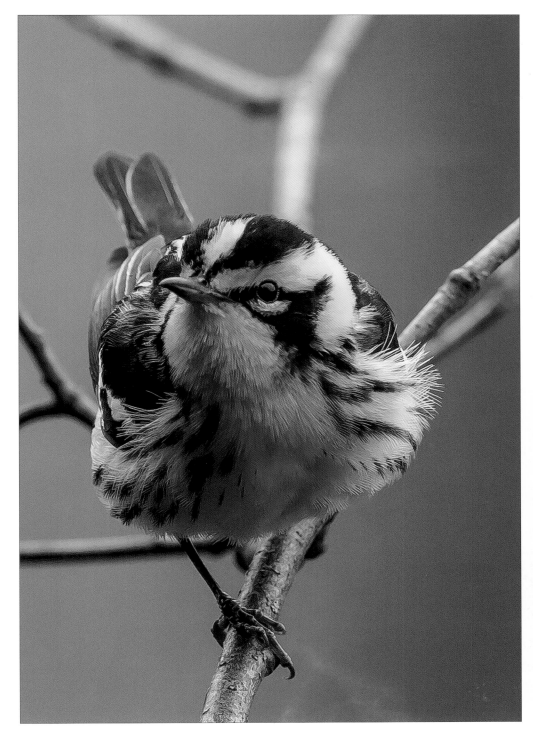

On May 19, 2017 Rory MacKay and the author encountered a warbler "fallout" on the Booth Rock Trail along Rock Lake. It was only a few degrees above freezing and 20 species of wood warblers were foraging at eye level or lower in the alders bordering about 100 metres of the historic OA & PS railway bed. This American Redstart (opposite) and these Blackburnian (left) and Magnolia warblers (below) were part of the bonanza.

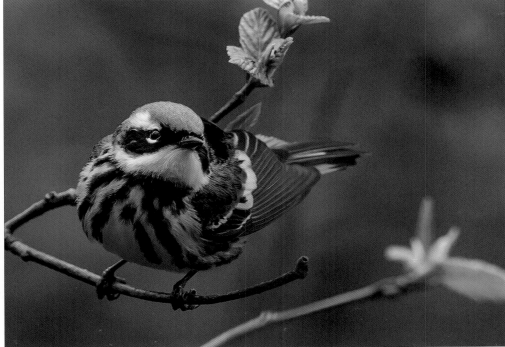

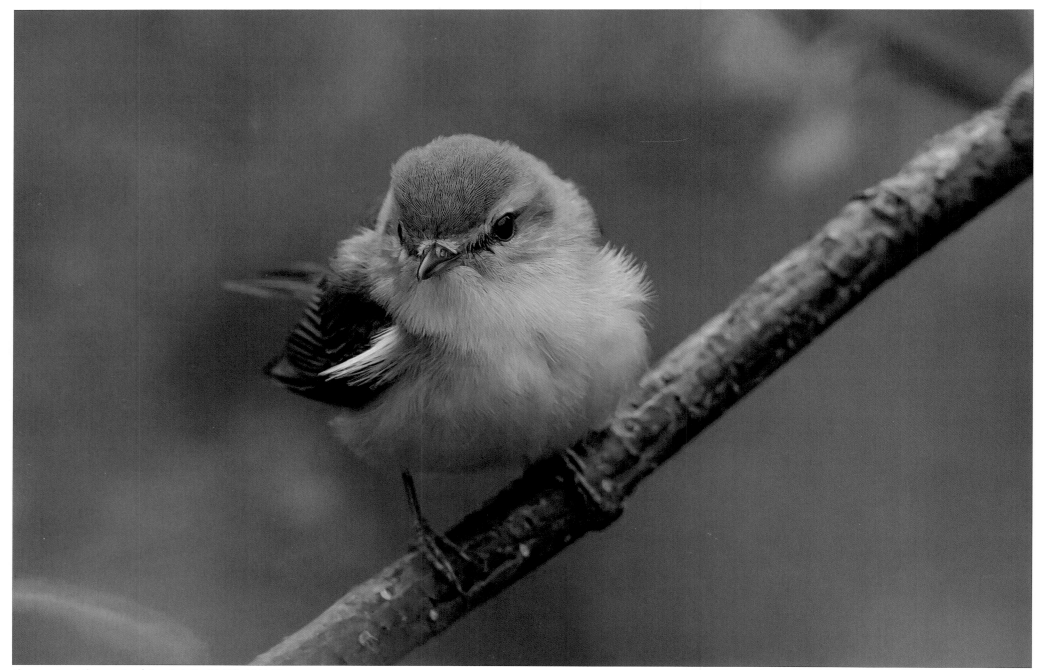

Also present were three species of vireos including this Philadelphia Vireo.

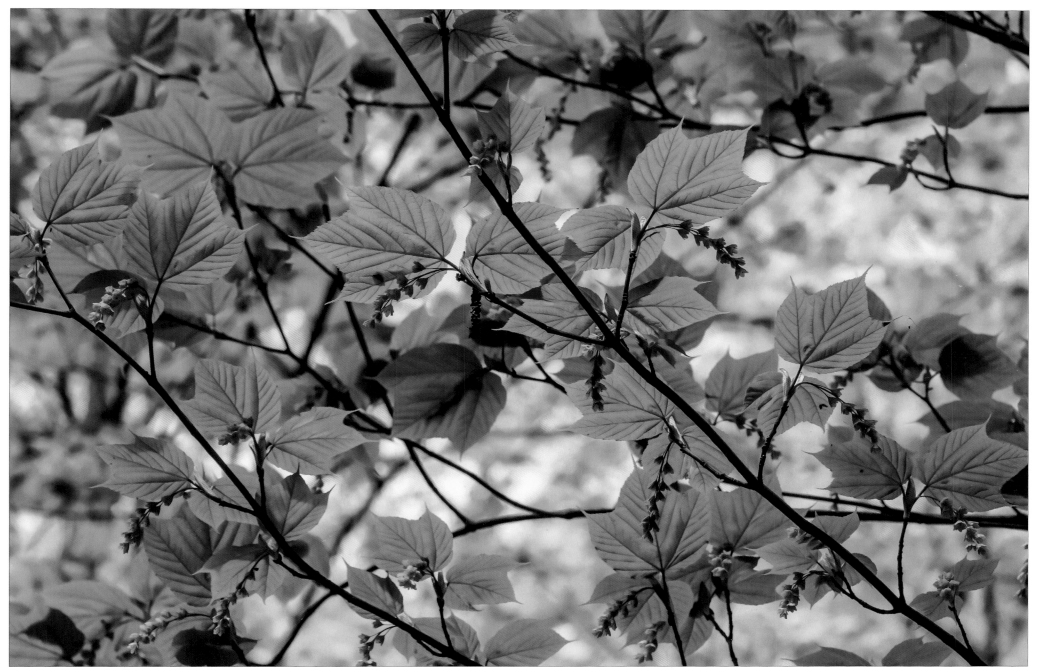

The number of seeds produced by trees varies through the years. In some years they unpredictably produce huge crops to overwhelm chipmunks and other seed predators by the sheer numbers of seeds. Here, the flowers of Striped Maples foretell a bountiful crop is to come.

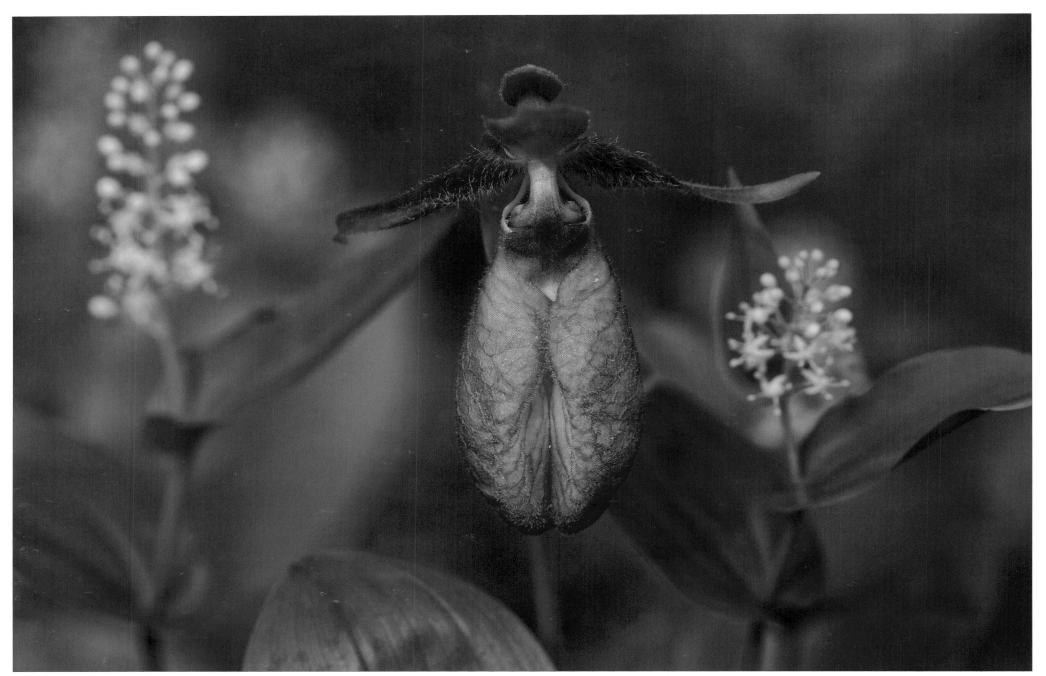

Particularly common in the acidic pine forests of eastern Algonquin are Pink Lady's-slippers. These lovely orchids bloom alongside Canada Mayflowers in late May and early June.

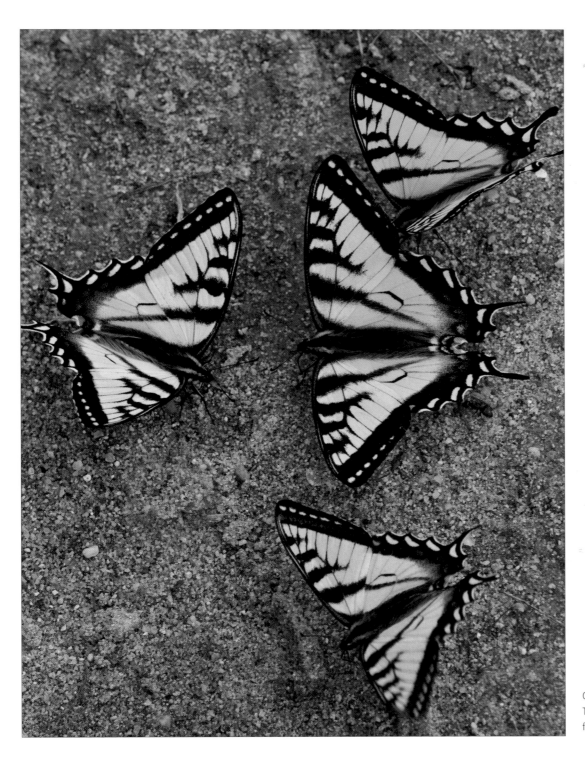

One of the most common and conspicuous butterflies in late spring is the Canadian Tiger Swallowtail. Like other butterflies, they often gather to sip minerals such as sodium from wet sand, a behaviour called "mud-puddling" or just "puddling."

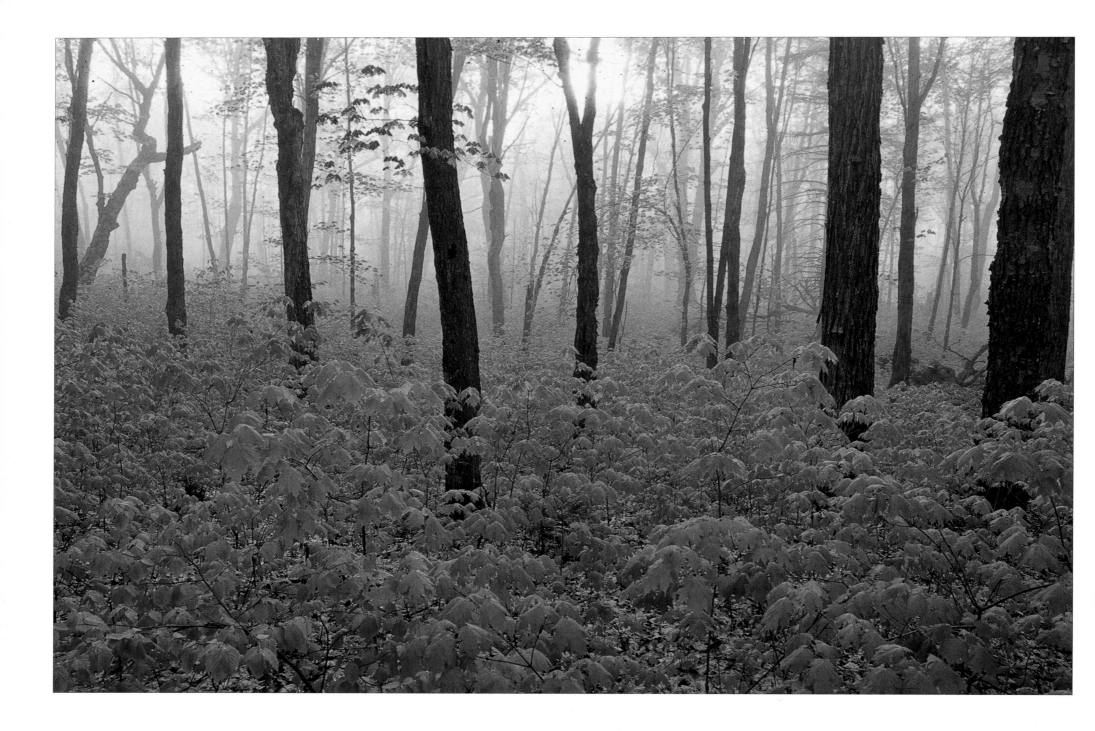

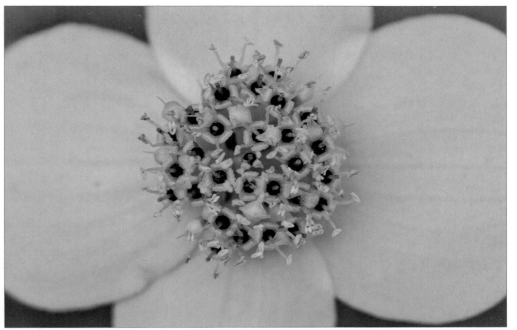

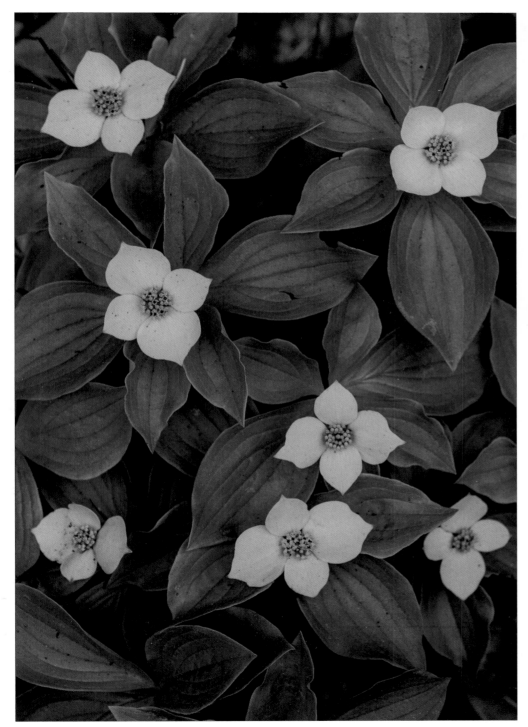

(left) Seldom do you find a single Bunchberry for they grow as colonies, using their many leaves to survive in the shade that dominates their coniferous habitat.

(top) Their explosive pollination biology (which earned them the nickname "Pop Flower") involves folded stamens that, when sprung free by an insect touching the hair trigger, become the world's fastest moving floral parts!

(opposite) By the time the army of young Sugar Maples open their leaves in the hardwood forest understory, spring wildflowers have already bid their farewells.

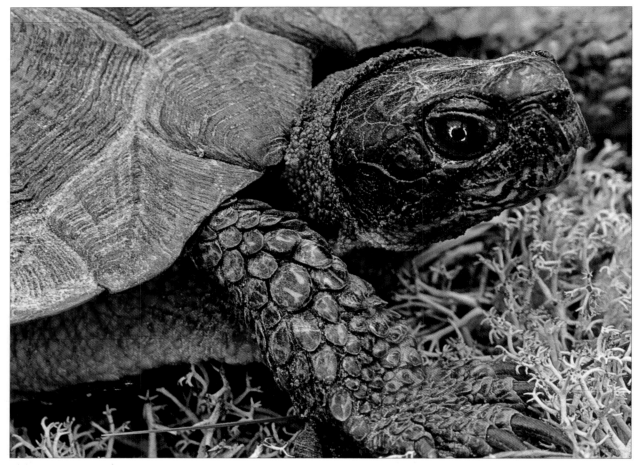

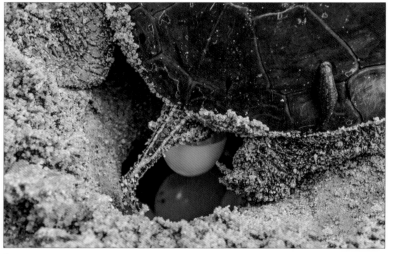

(top left) Wood Turtles, an endangered species and an East Side specialty, roam overland more so than other members of their group, eating earthworms, mushrooms, and berries in their travels.

(bottom left) Snapping Turtles are regularly encountered along roadsides when they leave the water to lay their eggs.

(top right) Painted Turtles, the most common turtle in Algonquin, usually lay fewer than two-dozen eggs in their nests.

(bottom right) Many turtles harbour harmless blood-sucking leeches, which leave the turtle's skin to find wetter sites when they start drying out.

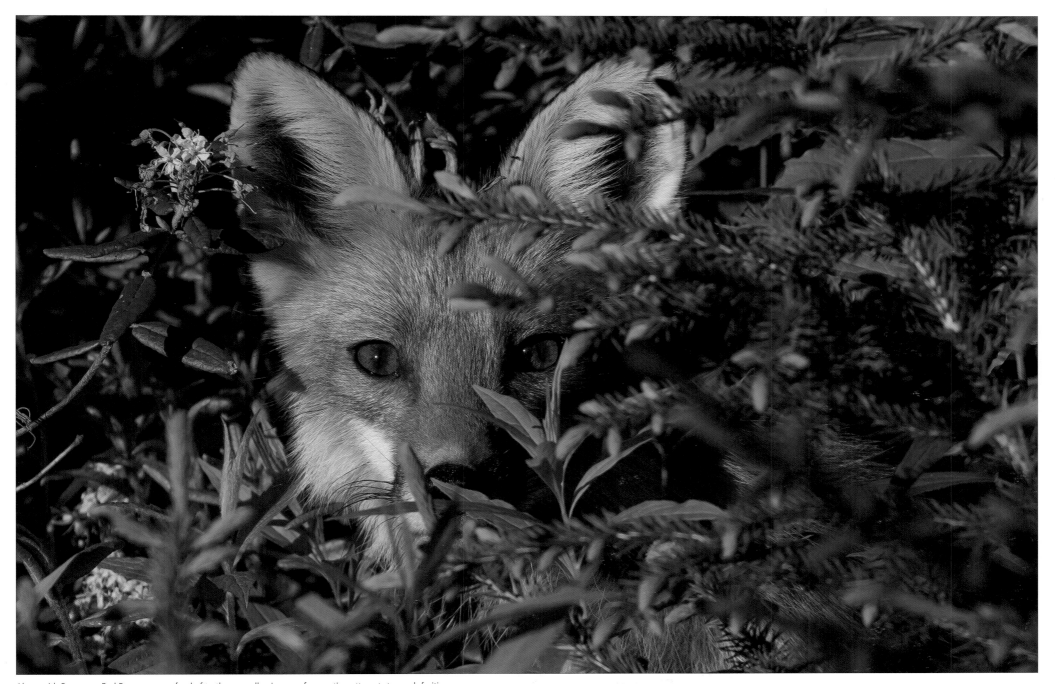

Along with Raccoons, Red Foxes are very fond of turtle eggs, allowing very few nesting attempts to reach fruition.

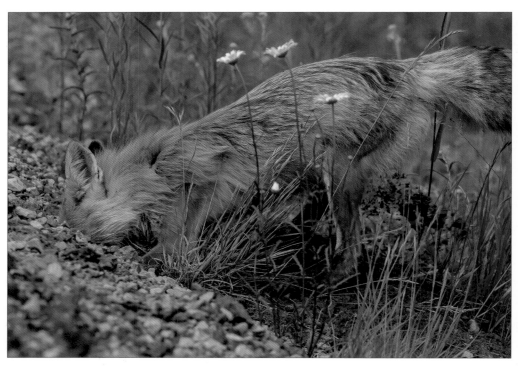

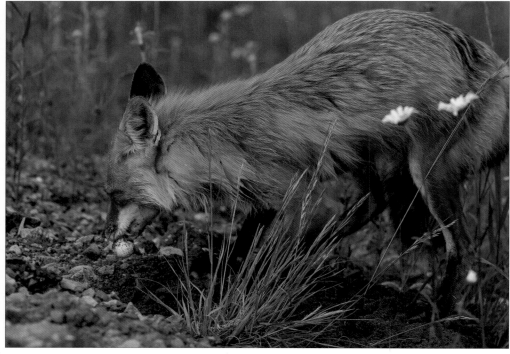

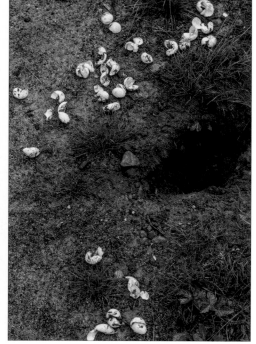

After using its nose to find buried treasure, this fox quickly began excavating a turtle nest, throwing back the dug earth between its legs. One by one the turtle eggs were lifted out and their contents devoured.

(bottom right)) Most turtle nests are depredated at night leaving scattered eggshells the next morning as evidence of the plundering. The number of eggs that were in this nest reveals that it belonged to a Snapping Turtle.

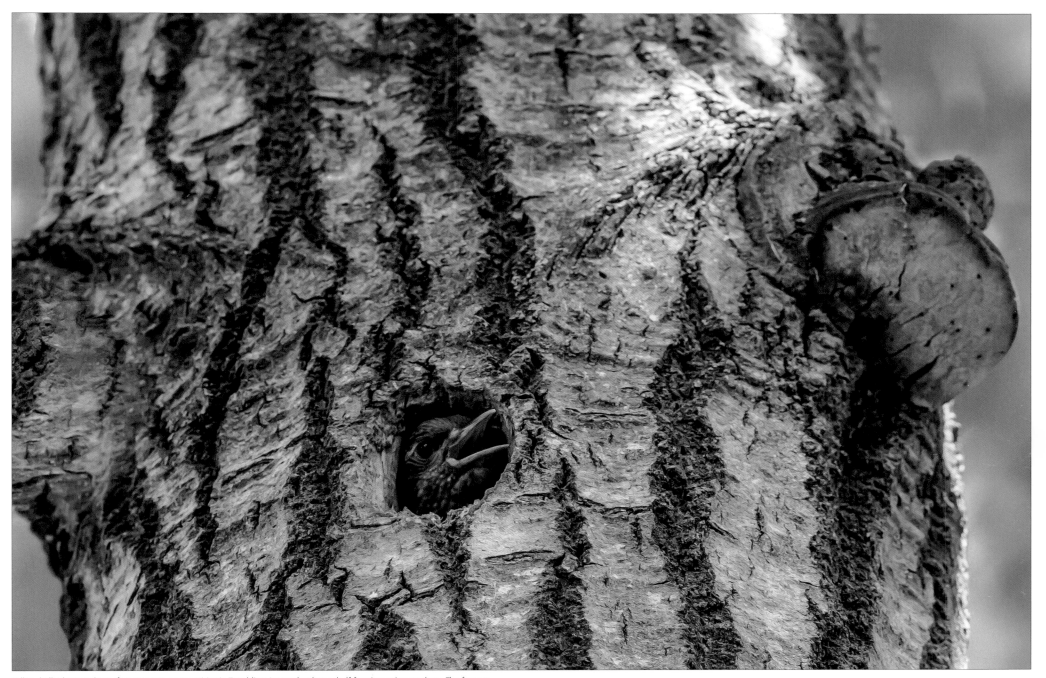

Yellow-bellied Sapsuckers often excavate nest cavities in Trembling Aspen that have shelf fungi growing on them. The fungus reveals the tree has weakened heartwood, which is easier for the woodpeckers to excavate. However, the outer sapwood remains relatively strong, making it difficult for predators to penetrate it and therefore safer for the young woodpeckers behind it.

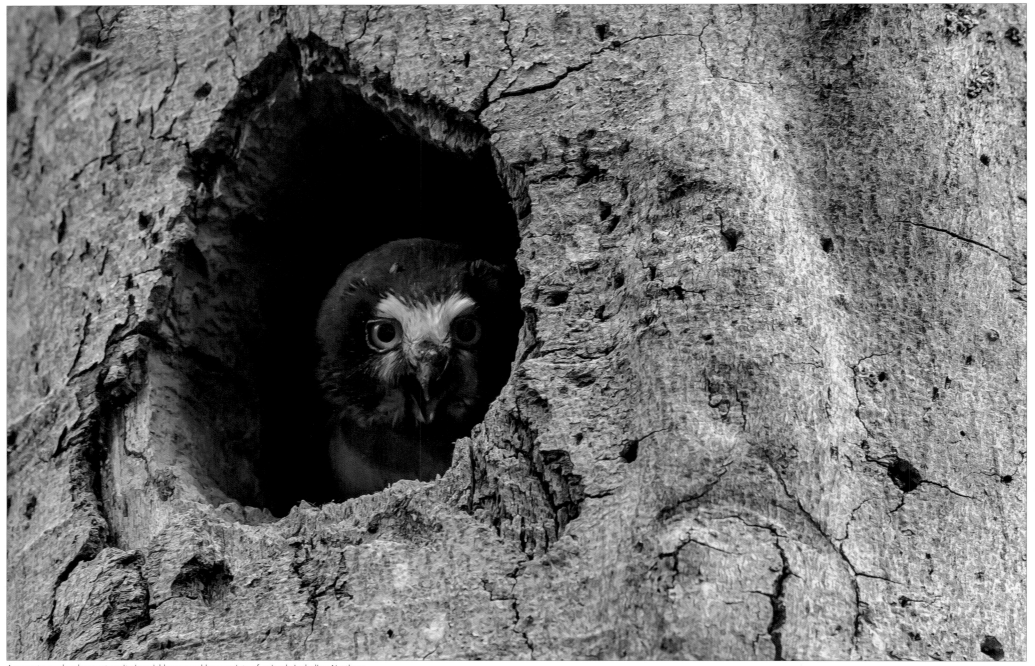

A vacant woodpecker nest cavity is quickly usurped by a variety of animals including Northern
Saw-whet Owls, the young of which bear little resemblance to their parents.

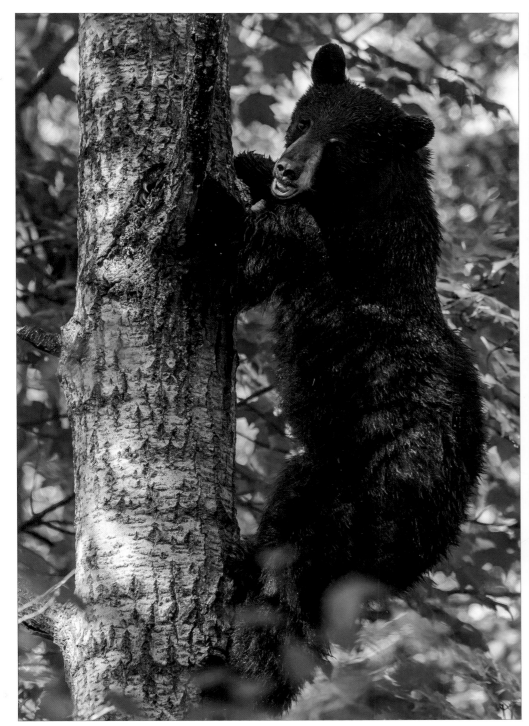

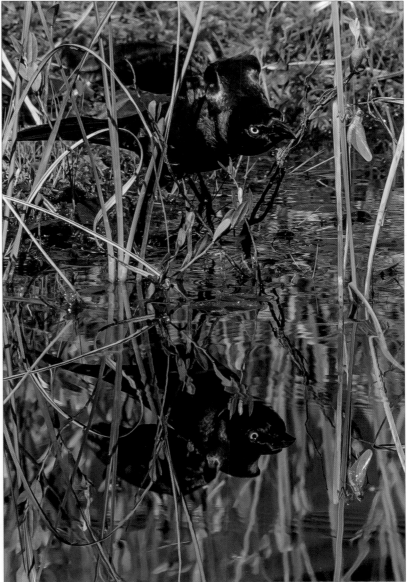

(left) Doug Tozer's landmark Doctoral study on sapsuckers in Algonquin revealed Black Bears to be a major cause of sapsucker nest failure in maple forests but not in aspen groves. That is because older maples contain softer outer wood that bears can easily bite through to access the baby woodpeckers. This Black Bear may well have another reason for climbing up a Trembling Aspen.

(right) This Common Grackle will soon be adding another dragonfly to the diet of its newly hatched young. Grackles and Red-winged Blackbirds harvest countless dragonflies as they emerge from the water as nymphs or as they struggle to free themselves from their nymph case.

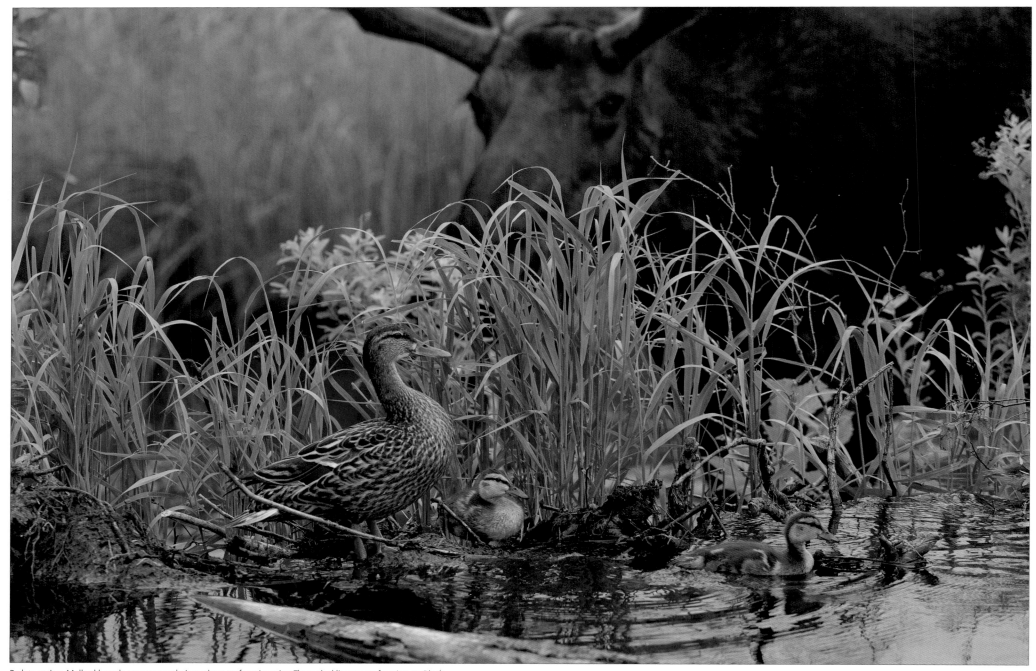

By late spring, Mallard broods accompany their mothers on foraging trips. These ducklings were feasting on Black Flies emerging from the water at a beaver dam while behind them a Moose sought a very different food.

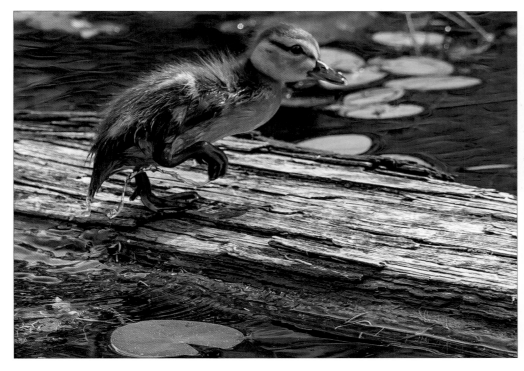

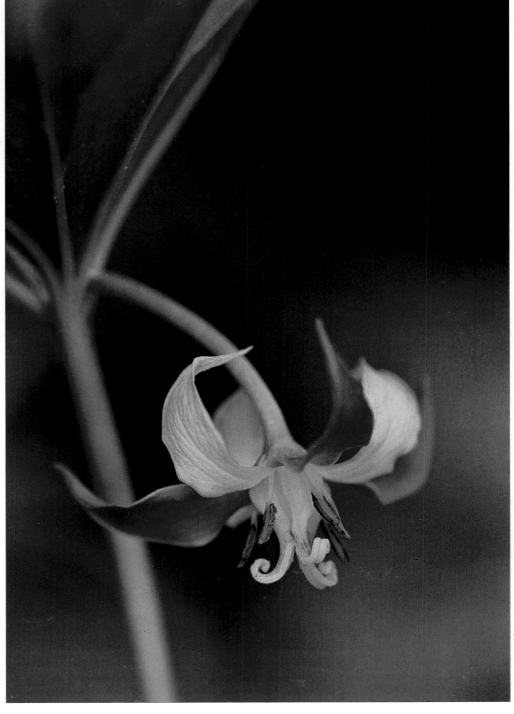

(top) When young ducklings such as this baby Mallard get separated from their mother, their odds of reaching adulthood are greatly diminished, in fact they are about nil.

(right) By the time Nodding Trilliums demonstrate how they acquired their name, spring is quietly slipping into summer.

SUMMER

Water is the most powerful force to have shaped Algonquin in the past and that continues to affect it today. As a frozen wall of ice nearly two kilometres high, it scoured the landscape, removing all signs of life and setting the land back to "ground zero." When the glaciers retreated, they left behind a legacy of scattered debris consisting of rock, sand, and silt. And they left behind water. Lots of water, water that flowed with ferocity across the eastern third of Algonquin, sorting and depositing its cargo as its current surged and ebbed. And they left behind water that founded today's lakes and ponds. Lakes that became separated through time eventually developed genetically distinct populations of Brook and

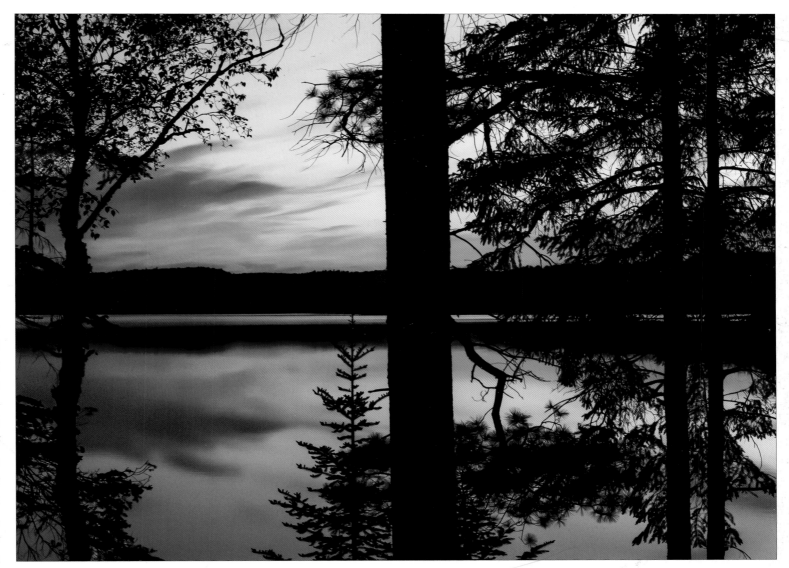

Lake trout. Smaller bodies of water eventually harboured Sphagnum Moss that encroached their surface, gradually forming floating carpets that became Black Spruce peatlands.

Today's waters are nurseries for myriad insects that as larvae fuel the appetites of fish and other aquatic animals, and as airborne adults feed regiments of larger insects, birds, and even a few mammals. In summer, the myriad streams, rivers, ponds, lakes, and peatlands provide habitat for many fascinating plants and animals, with all life forms displaying specialized adaptations for their preferred aquatic domains.

From mighty Muskellunge to tiny dace, 54 species of fish inhabit Park waters that range from shallow and warm to deep and frigid. The richness of fish attracts an array of predators including River Otters that are technically weasels but behaviourally, fresh-

water seals. They slip and slide through the water with ease, catching Brown Bullheads and Yellow Perch at will. Mink, their smaller cousins, patrol the shores for frogs but also swim and dive in shallow water to capture smaller finned prey.

Fish that venture near the water's sur-

face can be snatched by Bald Eagles, once rarely encountered anywhere in their range because of the devastating effects of DDT, a persistent poison used to control insects in the mid 1900s. Decades earlier, eagles suffered setbacks in Algonquin when they ate meat laced with poison in a misdirected

(top) Lakes take on many personalities; at times they are calm and peaceful, and stunningly beautiful at dawn or sunset.

(opposite) Mesmerizing shows occur when northern lights unite sky and water, a thousand stars looking on in admiration.

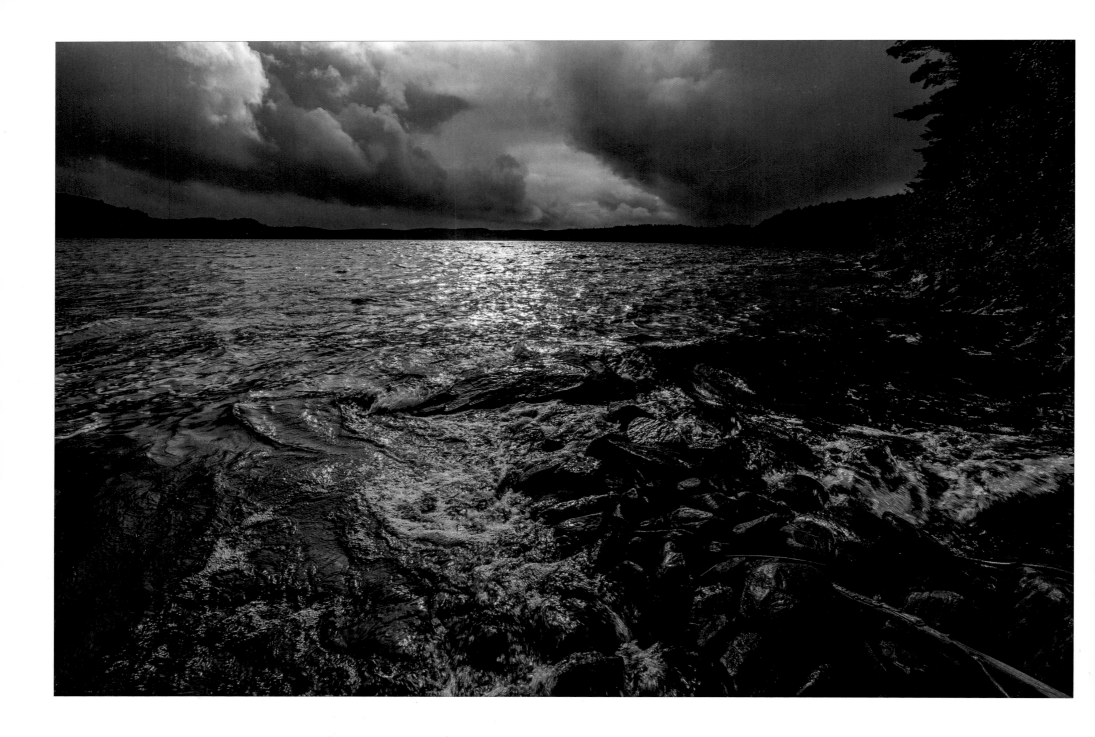

At times lakes display a violent, even frightening side.

of cormorants nest on five of the larger lakes in Algonquin, some fly in from waterways outside its borders to catch fish.

Many of the Park's ponds are present courtesy of Beavers. A keystone species, by building dams and creating habitat for themselves, Beavers provide habitat for myriad other organisms. Through time, the warm water of a beaver pond becomes richer in nutrients, and soon supports a garden of White Water-lily, Yellow Pond-lily, and Water-shield. The latter is of particular interest to Moose because of its richness in sodium, a mineral that Moose fail to acquire in winter. Sodium is the reason Moose spend countless hours wading in beaver ponds and shallow lake bays in summer.

Smaller animals find the aquatic plants also to their liking, and rare is the leaf that does not display swirls and blotches of graffiti chewed by Water Lily Leaf Beetles and other insects. Some insects find a different source of food present in beaver ponds. Water Boatmen, Water Striders, and Whirligigs scurry across the water's surface, looking for ripples that tell them smaller insects are available as meals. Whirligigs congregate in enormous groups that, like miniature bumper cars, spin wildly in dizzying motion.

Many animals live under the ceiling of floating leaves. A plethora of mites, leeches, minnows, turtles, and aquatic insects roam the underwater world. Ponds are nurseries for many species of odonates, the large bodied Skimmers being a particularly

wolf control programme. After receiving official protection, Bald Eagles made a remarkable comeback, and currently are not only regularly encountered in Algonquin in all seasons, but also nest on at least nine lakes.

Ospreys, however, are not overjoyed by the increase in eagles because Bald Eagles regularly rob them of their hard-earned catch. After hovering to precisely locate a target's position, an Osprey dives feet first to catch it, using a reversible toe on each foot to turn the fish and carry it headfirst in the air. Below the water's surface, fish face another barrage of attacks from Common Loons, Common Mergansers, and Double-crested Cormorants, the latter relative newcomers to Algonquin. While a number

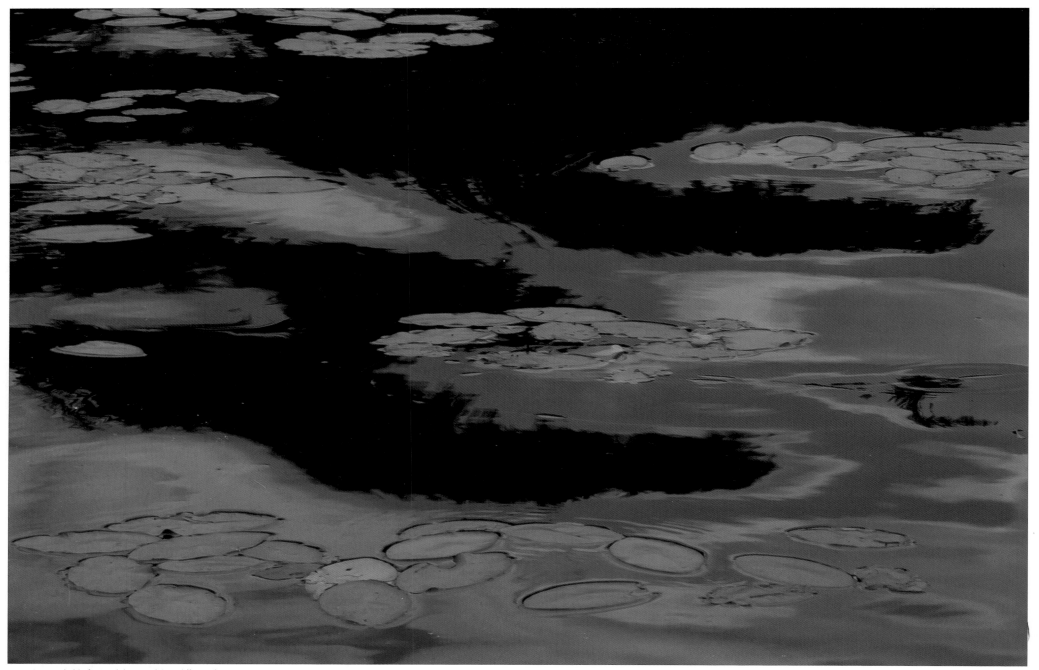

Water is remarkable for its ability to take on different forms and appearances. Here, reflections of pines and clouds join the floating leaves of Water-shield.

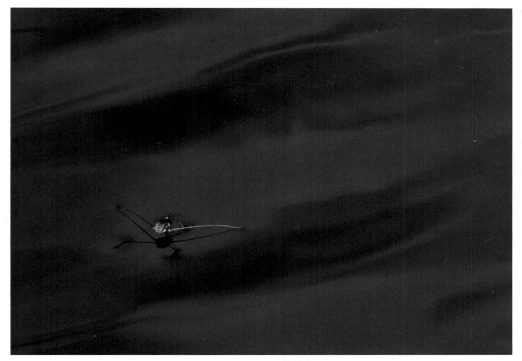

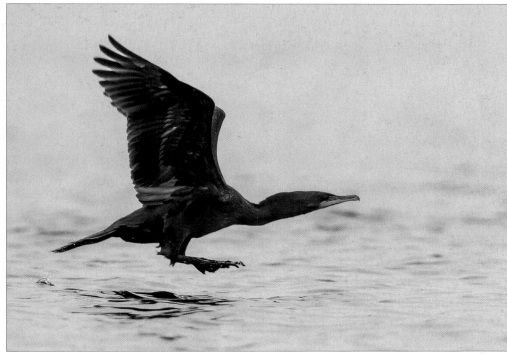

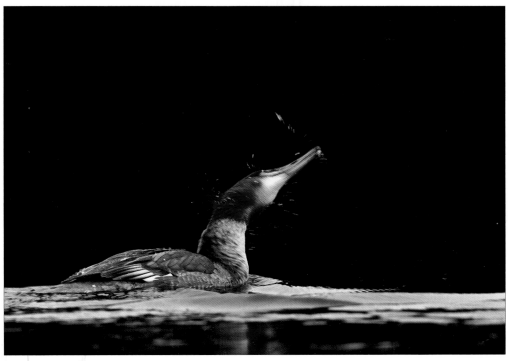

well-represented group. As aquatic nymphs they are fierce predators, an attribute they carry with them when as adult dragonflies they take to the air.

The dying trees provide food and nesting opportunities for Black-backed Woodpeckers, northern birds that strip the bark from spruces to access Bark Beetles in the wood. Ground-foraging Northern Flickers may not find their food in dead trees but they commonly excavate their nests in them. A great many animals including Tree Swallows, Great Crested Flycatchers, Northern Saw-whet Owls, and Northern Flying Squirrels usurp abandoned wood-pecker nest cavities. The dead trees provide elevated perches for Belted Kingfishers, which scan the water for small fish that they

(top left) Water Striders scurry across the water's surface, searching for ripples created by potential prey.

(top right) In recent years, Double-crested Cormorants have started nesting in Algonquin but only on a few of the larger lakes. At Grand Lake in eastern Algonquin, a large inbound flight of up to 100 cormorants takes place at dawn in late summer, undoubtedly involving birds that nest outside of the Park.

(bottom) Only female Common Mergansers and their young (here, a juvenile) are present in Algonquin in summer. After mating, the adult males head north to James and Hudson bays where they congregate, catch fish, and perhaps swap stories of their earlier conquests.

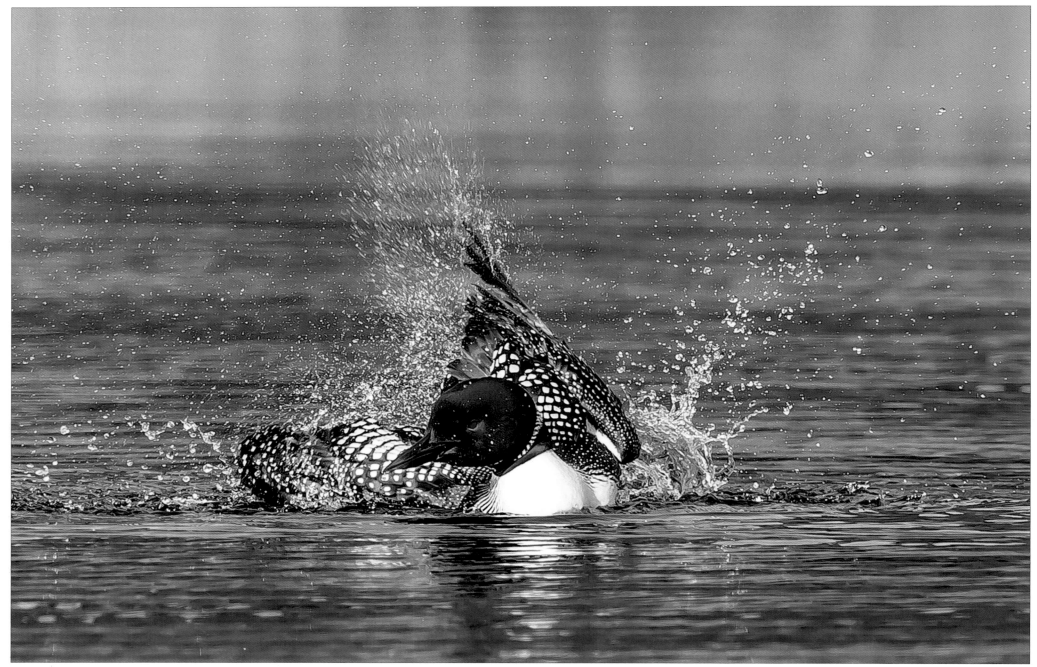

Even though Common Loons are encountered by sight and sound on virtually all Algonquin lakes few people have seen one taking a bath as this one was doing on Costello Lake.

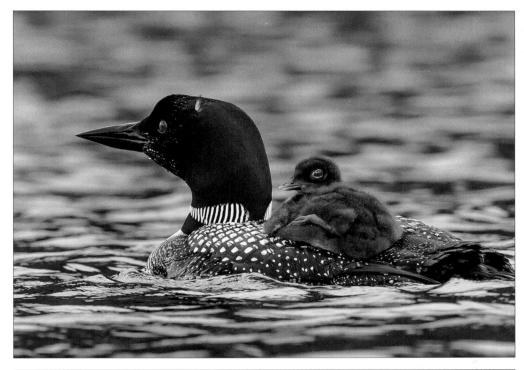

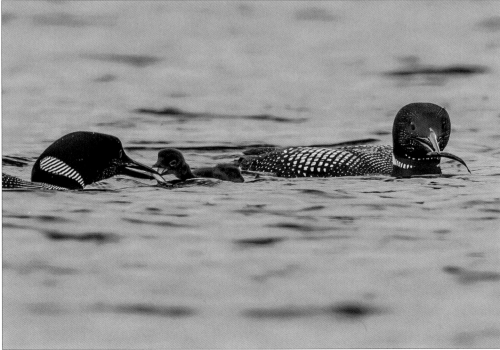

(top) After they hatch, baby loons abandon their nest and stay close to their parents, often riding and sleeping on their backs.

(bottom) Loons are consummate parents, with both taking part in the protection and feeding of their precious young.

dive headfirst to capture. Eastern Kingbirds and Olive-sided Flycatchers sally out from their lofty lookouts to snatch flying insects from the air. From the dead branches, Broad-winged Hawks drop down on frogs and snakes below.

Dragonflies and their smaller relatives, damselflies inhabit almost every type of aquatic habitat, with some like Lake Darners and Stream Cruisers bearing the name of their preferred one. Faster flowing water is home to many species of Clubtails, colourful dragonflies that are the speedsters of their kind. Bogs and fens harbour some of the smallest members of the Odonata; usually only those who venture onto their floating worlds encounter the diminutive Sphagnum Sprites and Elfin Skimmers.

Peatlands are home to an unusual blend of plants, with hardy northerners such as Labrador Tea and Leatherleaf joined by Rose Pogonia and Grass Pink, colourful orchids that bring more than stunning colour to their world. Both species use deceit in the form of false promises of food to bring Bumble Bees calling. While their visits might leave their search for pollen unfulfilled, the beguiled insects unknowingly satisfy the orchids' reproductive needs.

In addition to great beauty there are silent killers living on the floating mat of moss. Pitcher-plants and sundews capture insects with modified leaf traps, using the nutrients housed in their victims' tiny bodies as supplements to the meagre supply found in the bed of peat from which they arise. Bladderworts set their suction traps in the wet soil or in water, the location depending on the species that owns them.

While there is a paucity of wildflowers blooming in the summer shade of forests, the same is not true for meadows and other clearings. Many of the sun-loving wildflowers are not native to Algonquin but that does not lessen the beauty of Ox-eye Daisy, Chicory, Orange Hawkweed, Yellow Toadflax, and Mullein. Along with those of native plants such as Common Milkweed and Spreading Dogbane, their attractive blooms attract bustles of butterflies, with the yellow of swallowtails and sulphurs, and the orange of fritillaries and skippers dominating the lepidopteran colour scheme. Visitors to the flowers of summer include Syrphids (Hover Flies) and many bees, as well as the peculiar Clearwings, which are moths that hover like little hummingbirds as they sip nectar through their uncoiled proboscises.

As summer wanes, blue is added to the floral colour scheme. While some of the blue comes from the petals of Bottle Gentian and Wild Iris, much of it comes from

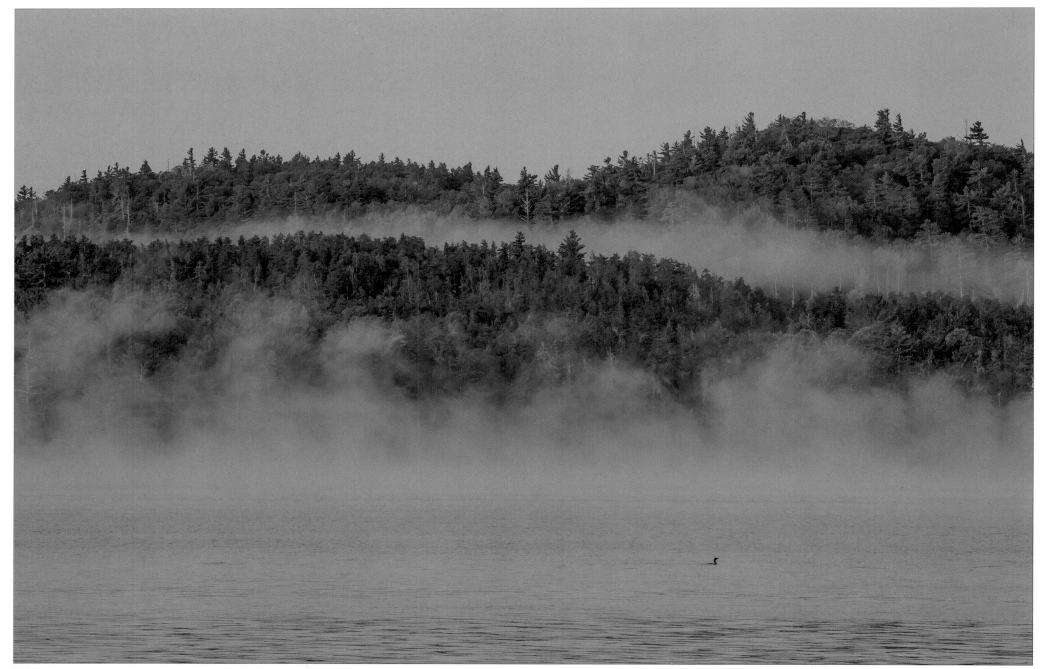

Morning mists dance across the water and caress the hills until the sun banishes them for the day.
Note the Double-crested Cormorant on the water, now a regular sight on Grand Lake.

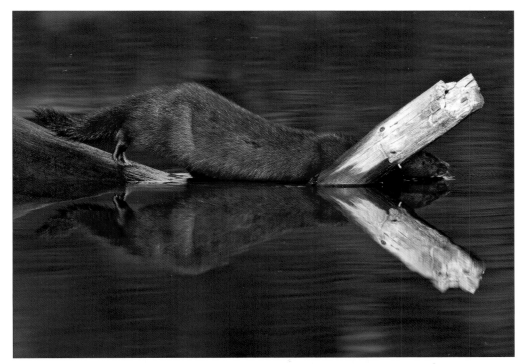

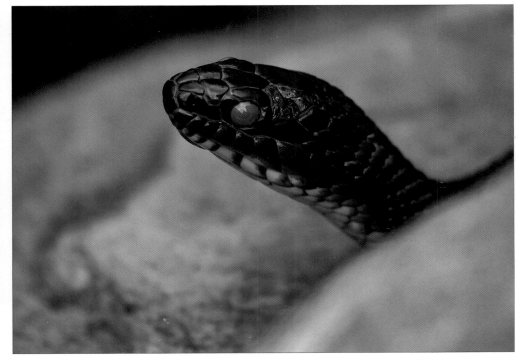

ripening fruit. When blueberries signal their maturity by changing their colour from yellow-green to blue, they immediately attract attention from birds, as well as Raccoons and other mammals including our species. Black Bears are especially fond of the sweet fruit, spending hours each day pulling berries from the plants with their thick, rough tongues. The berries provide carbohydrates that become converted into fat as the bears prepare for their long winter dormancy spent under fallen trees and in other crude dens.

Black Bears also have a sweet tooth for Chokecherries, trees that often bear (no pun intended) tangles of broken limbs as evidence of a visit by one of these large mammals.

(top) The shorelines of lakes, rivers, and beaver ponds are patrolled by Mink, which readily take to the water to capture fish and other prey as large as Muskrats.

(bottom left) Rocky shorelines and beaver ponds are habitat for Spotted Sandpipers, one of the few shorebirds that nest in Algonquin. While only breeding adults bear name-giving breast spots, unspotted juveniles are easily identified by their species' characteristic bobbing up and down of their back end.

(bottom right) The milky eye of this Northern Watersnake reveals that the animal is about to shed its skin. This snake is regularly encountered only in Algonquin's eastern waters because the Petawawa River flows into the Ottawa River where this species is common; connectivity increases biodiversity.

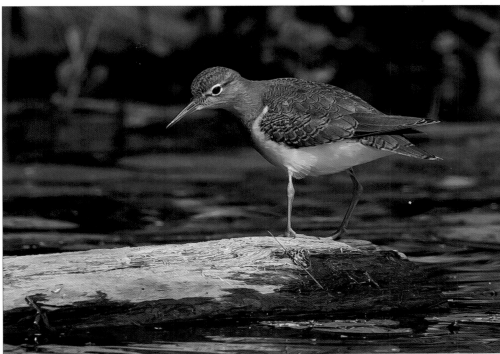

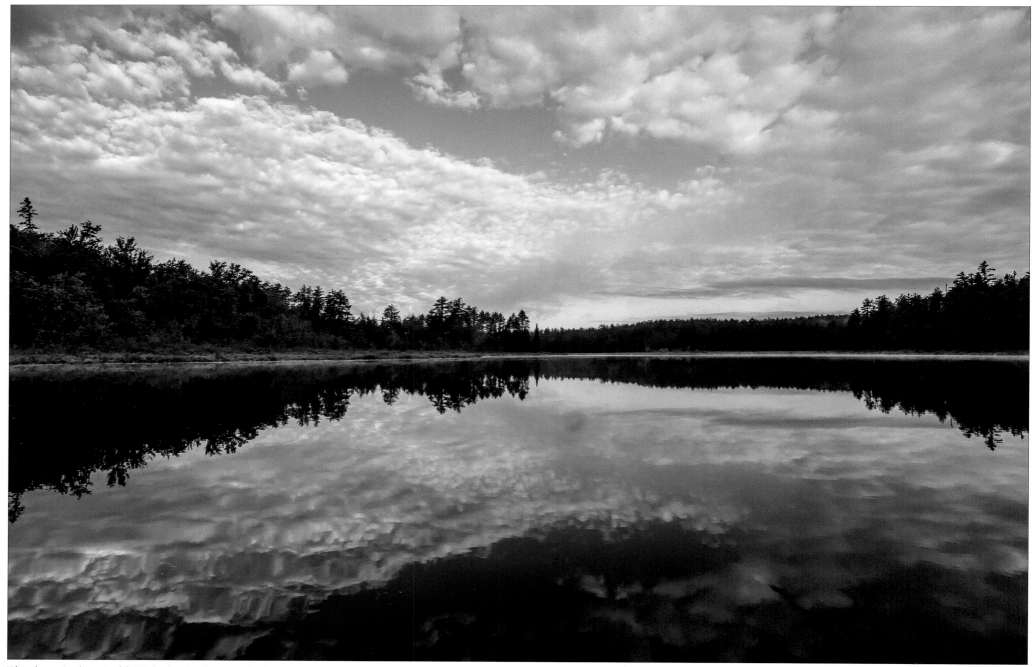

When does a river become a lake? Only when it widens enough to be assigned
a name. At this location the Barron River remains just a river

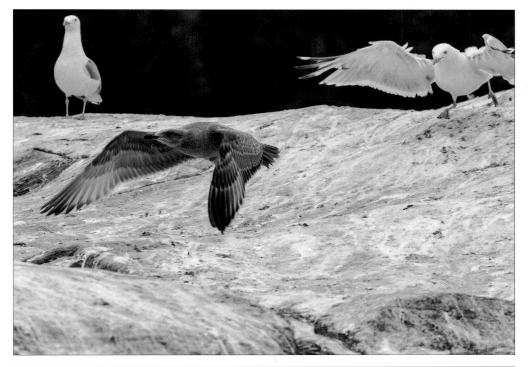

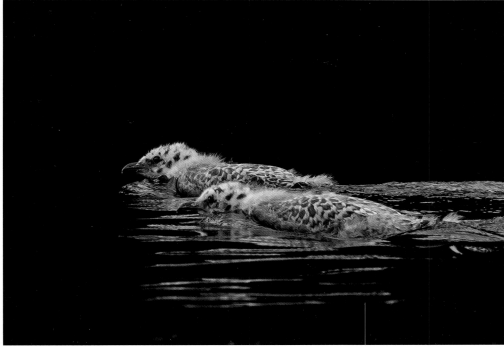

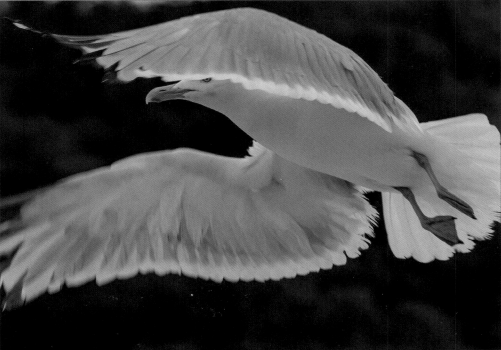

(top left) Rocky islands provide safe nest sites for Herring Gulls, the only species of gull to nest in the Park.

(top right) Even when still flightless, Herring Gull chicks are strong swimmers..

(bottom) When humans or any other intruder approaches their nests, Herring Gulls greet them with an aerial bombardment of verbal abuse.

Cedar Waxwings and Eastern Chipmunks also visit Chokecherries for their fruit. The birds eat on site while the chipmunks transport the pit-containing fruit back to their dens for winter consumption; apart from berryless branches neither animal leaves evidence of their visits.

With August come two very different natural history phenomena. One occurs when low water levels in the Petawawa River combine with cold, wet weather to produce birds seldom seen in Algonquin. Arctic shorebirds on their way south are forced to land when inclement weather, especially heavy rain associated with a cold front's arrival, is encountered. In particular, exposed sand on Radiant Lake seems to hold particular appeal to their eye. On Au-

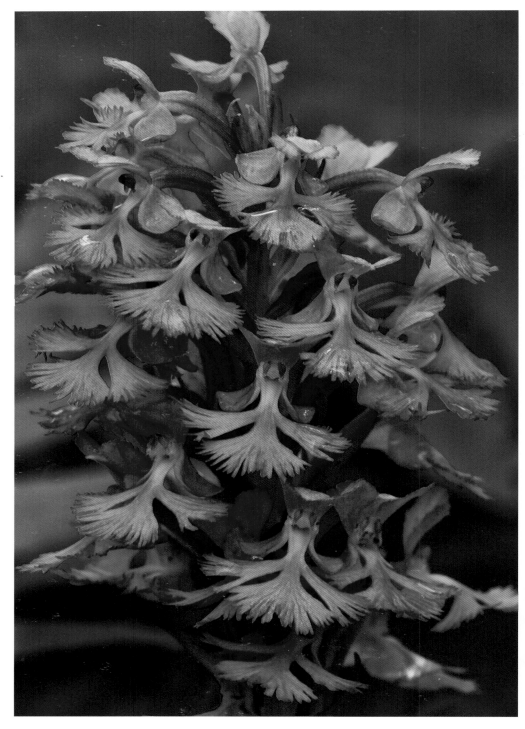
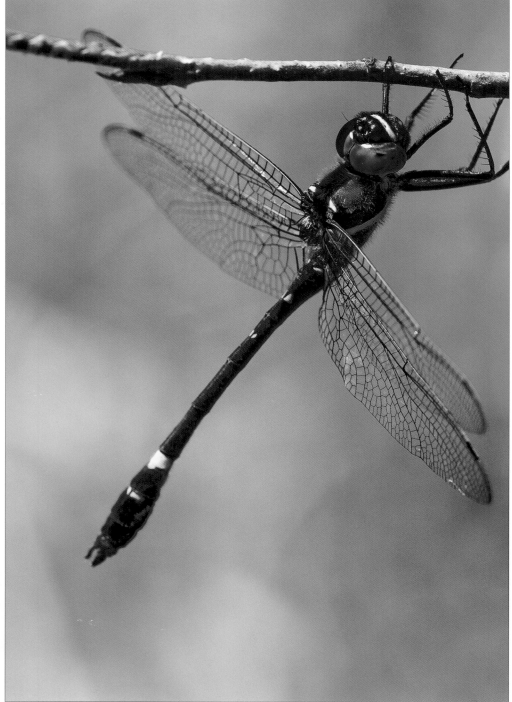

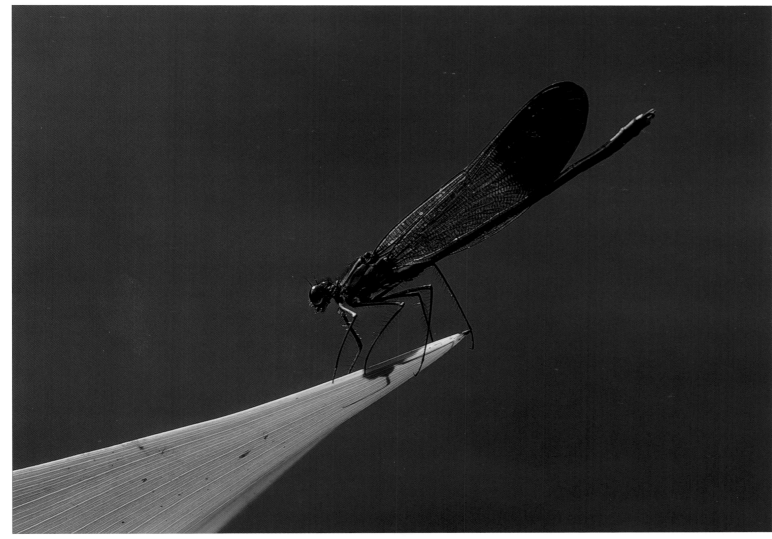

(opposite left) Purple-fringed Orchids, an East Side specialty, grow along the shores of the Barron and Petawawa rivers.

(opposite right) Just like birds, many odonates (dragonflies and damselflies) are specific in their habitat requirements. The Swift River Cruiser frequents larger rivers and lakes.

(top) One of the largest damselflies, the River Jewelwing prefers the edges of small rivers and larger streams where current is present.

gust 18, 1990 (an especially memorable day for the author), sixteen species of shorebirds landed at Radiant Lake during heavy rain. In the group were Stilt Sandpipers, Short-billed Dowitchers, and Hudsonian Godwits, species previously recorded in Algonquin at best only a handful of times. Shorebirds that land on the expanded shorelines of the Petawawa seldom stay long for their sand

contains little food, and Merlins, smaller versions of Peregrine Falcons, hunt the shorebirds relentlessly.

The second phenomenon involves wolves. In summer, Eastern Wolf packs abandon their dens (which are often dug into hillsides or the banks of creeks) and bring their pups to new homes, usually open areas near water and surrounded by

trees. Especially favoured are the meadows that develop where beaver ponds once lay. Here, the pups play while the adults go off hunting, returning with meat that is regurgitated for them (a behaviour I call "meals on heels"). By August, the pups at "rendezvous sites" become very vocal, which is the reason Algonquin holds their world-famous Public Wolf Howls in this month. Two smaller and considerably more intimate Wolf Howls are conducted by the author in Algonquin in late August; one takes place along the Basin Depot Road (it is held for Bonnechere Provincial Park, with their first Howl taking place in 1993); the other occurs along the Barron Canyon Road (this one is held for the Ontario Ministry of Natural Resources and Forestry personnel at Achray). Nothing is more soul stirring than to hear the howls of wild wolves rising from the dark, the excited yipping and yapping of the pups accompanying the deep, sustained howls of the adults. My favourite time to howl for wolves is in the predawn glow when mists slowly rise from the land. Oft times an adult comes in to inspect the presumed intruder, the sound of a stick snapping underfoot the only announcement of its otherwise silent arrival.

Late August dews create spider web tiaras on the low vegetation while early morning frosts add dramatic highlights to their leaves. At this time there is urgent purpose to the foraging of warblers as they fatten in preparation for their short migratory flights. Bull Moose also become

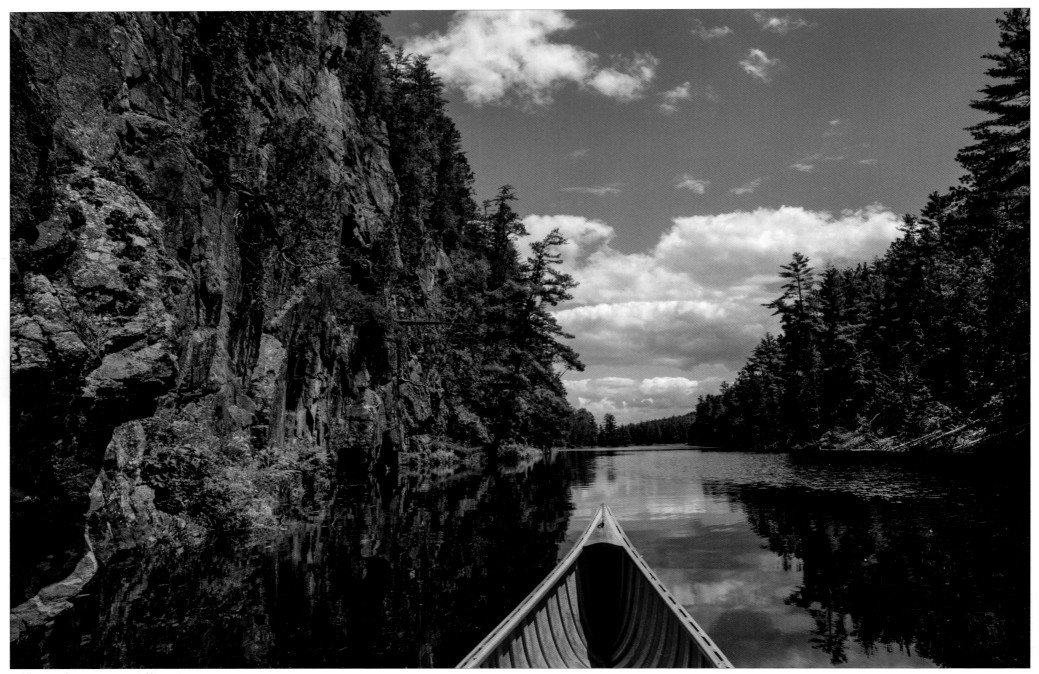

Paddling into the Barron Canyon is like passing
through a gateway into a world from long ago.

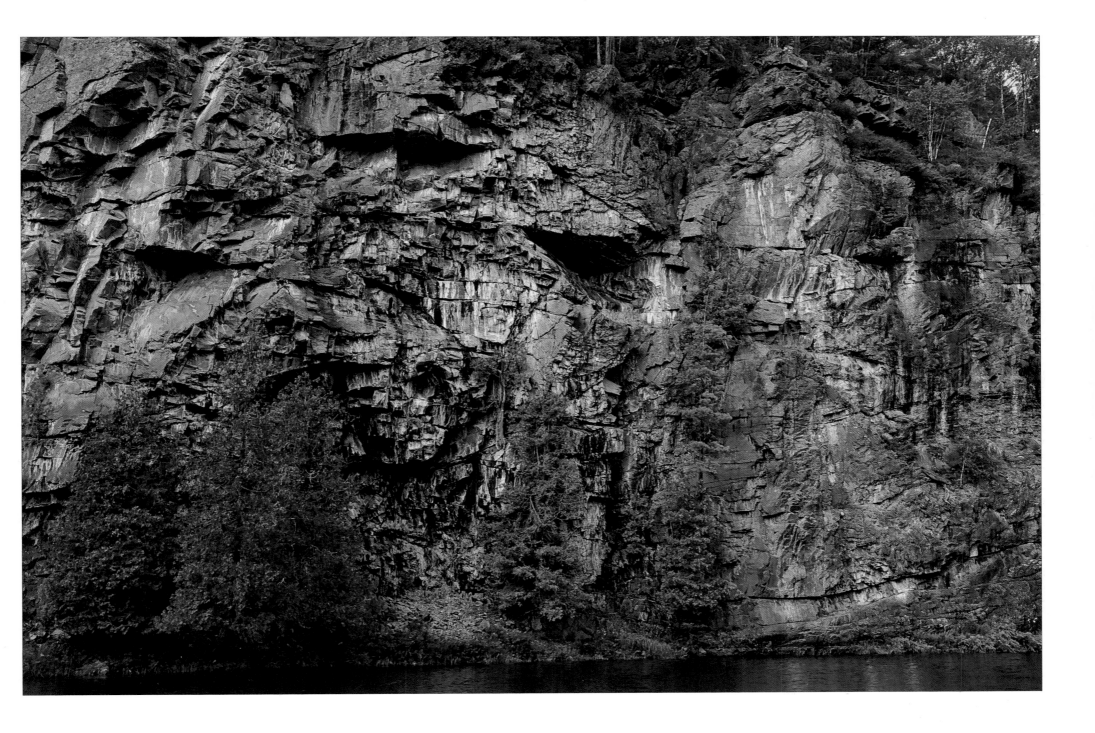

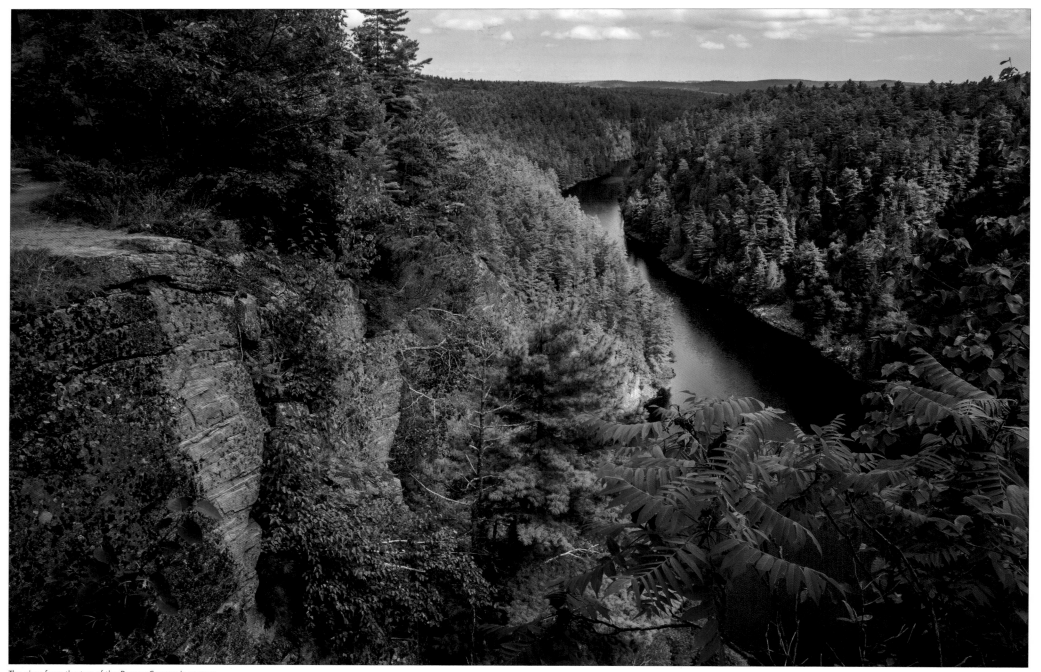

The view from the top of the Barron Canyon is as awe-inspiring as the view looking up from below.

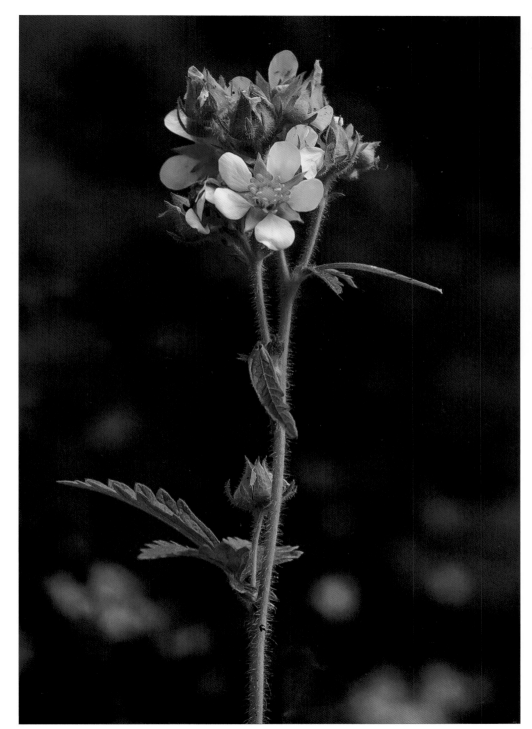

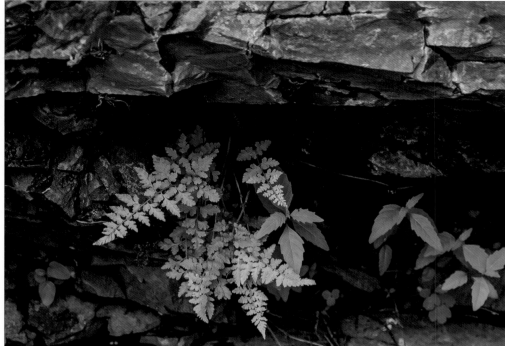

increasingly active as their antlers' thick velvet comes off in ragged strips, a process accelerated by vigorously rubbing of the now dead bone against shrubs and small trees. By September, the antlers of the largest bulls glow orange with the mix of blood from the removal of the velvet and stains from broken plant tissues. Their owners are now ready to heed the love calls of females, but it will be much closer to the autumnal equinox before any invitation to a sexual tryst will be heard.

(left) Many interesting plants inhabit the Barron Canyon including this Tall Cinquefoil, which commonly grows in western prairie habitats.

(top) The Barron Canyon is a hot spot for cliff-dwelling ferns, one of which is Fragile Fern.

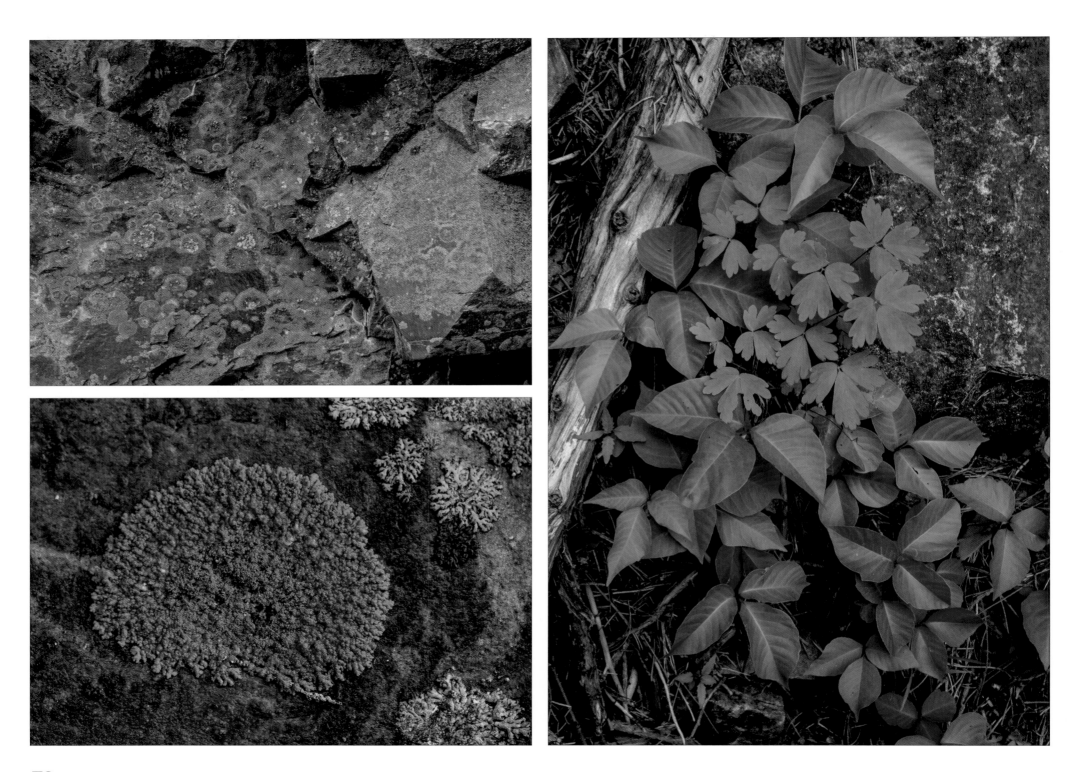

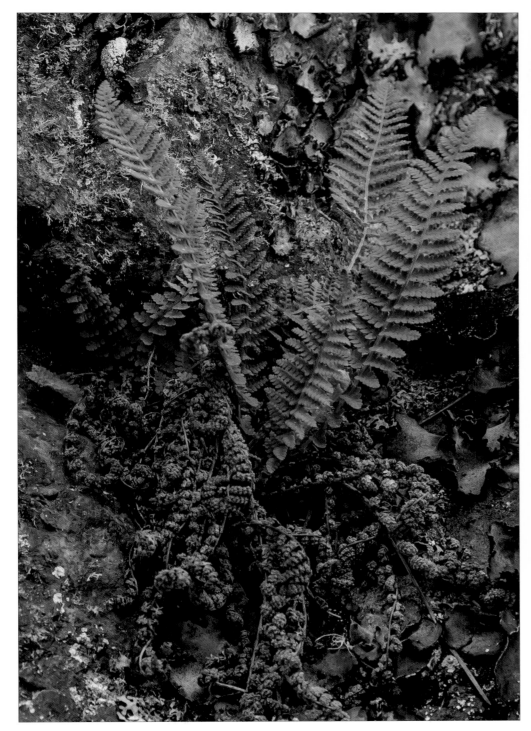

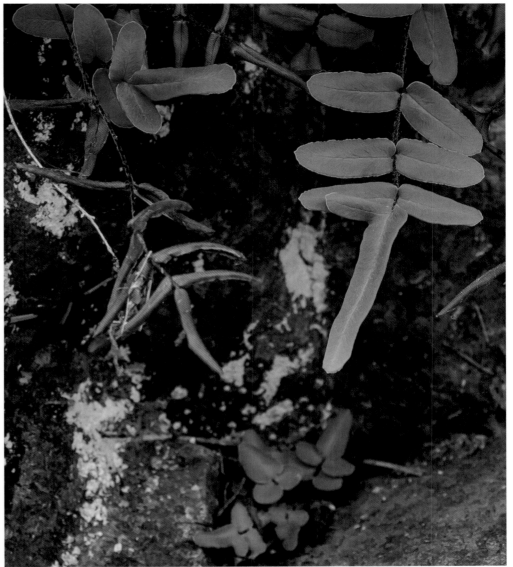

(opposite top left) Fault lines like the one forming the Barron Canyon often have lime percolating from crevices.

(opposite bottom left) The lime allows for the presence of the calciphilic Sunburst Lichen and (opposite right) Poison Ivy.

While Fragrant Fern (left) is common in the Barron Canyon, Purple-stemmed Cliffbrake (right) is not. In fact, it is one of the rarest plants in Algonquin!

Crevices with overhanging rock are ideal nesting habitat for Eastern Phoebes, which camouflage their nests with moss, making them blend in perfectly with their background

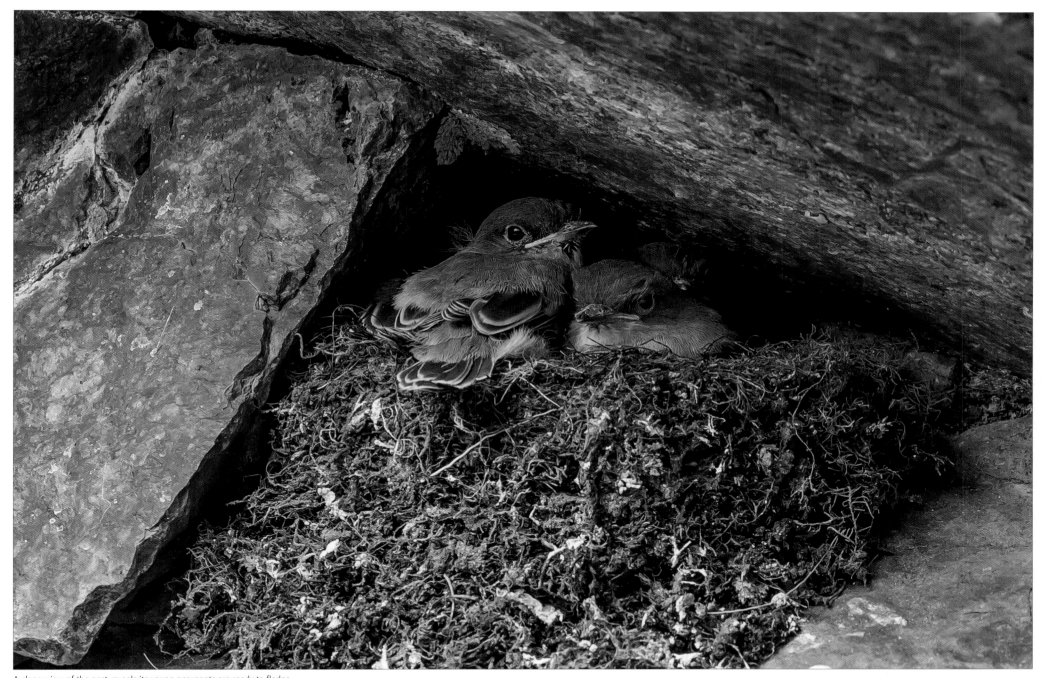

A closer view of the nest reveals its young occupants are ready to fledge.

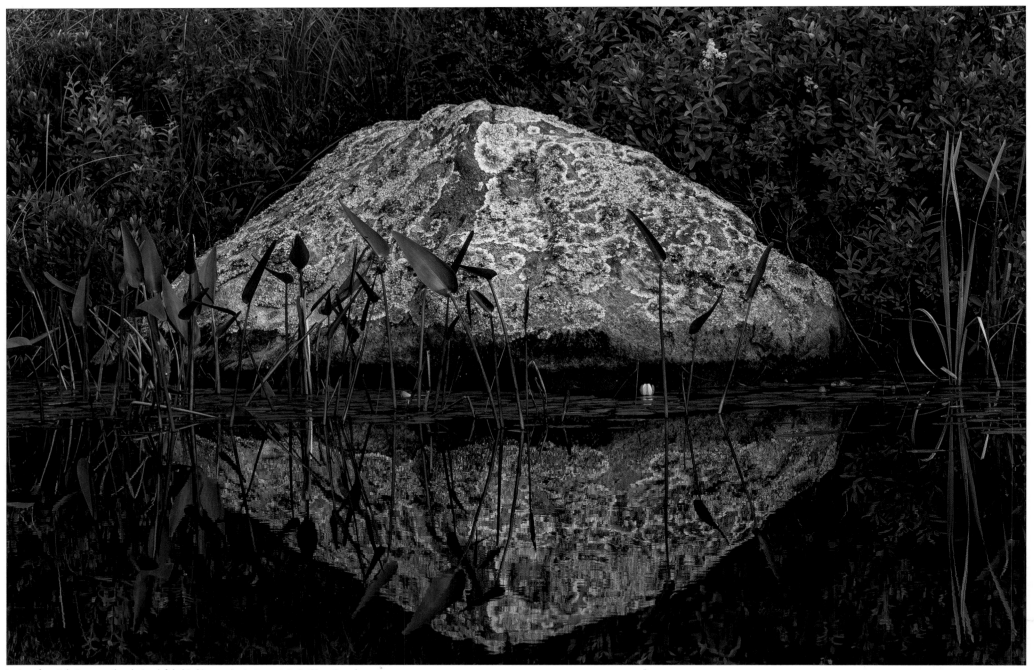

Lest we forget their power, the glaciers left behind impressive testaments to it. Gigantic rocks like this one in Costello Creek can also be encountered in the middle of a forest.

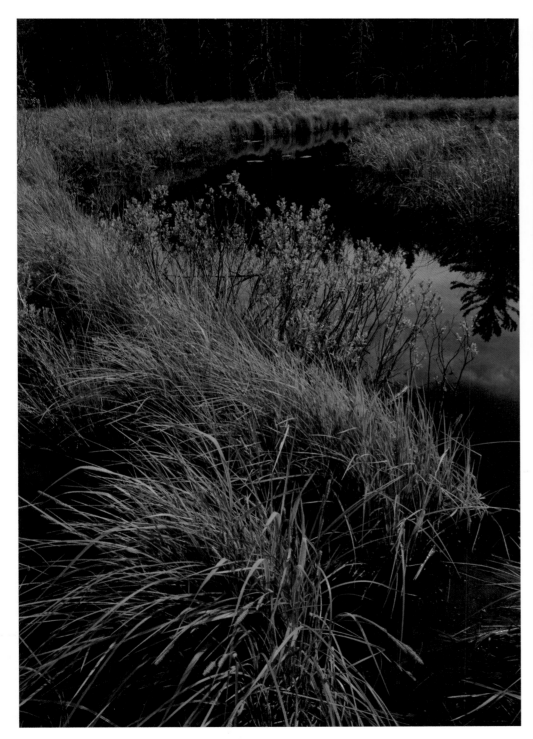

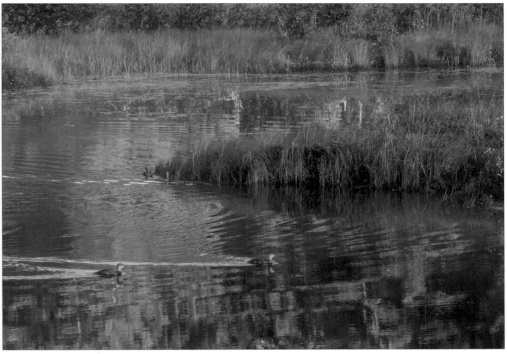

Algonquin gives rise to countless creeks and streams, some of which are the humble beginnings of the seven major rivers whose birthplace is the Park.

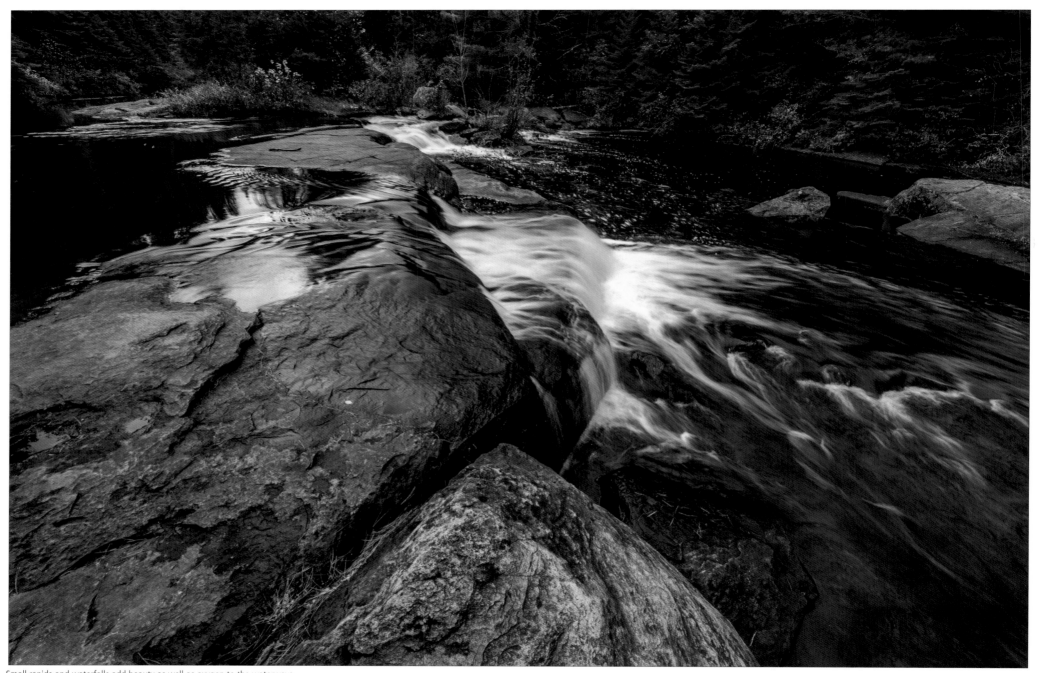

Small rapids and waterfalls add beauty as well as oxygen to the waterways.

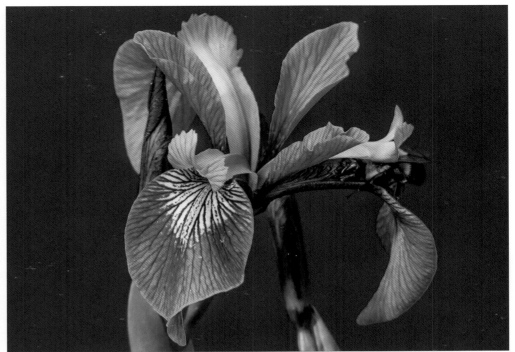

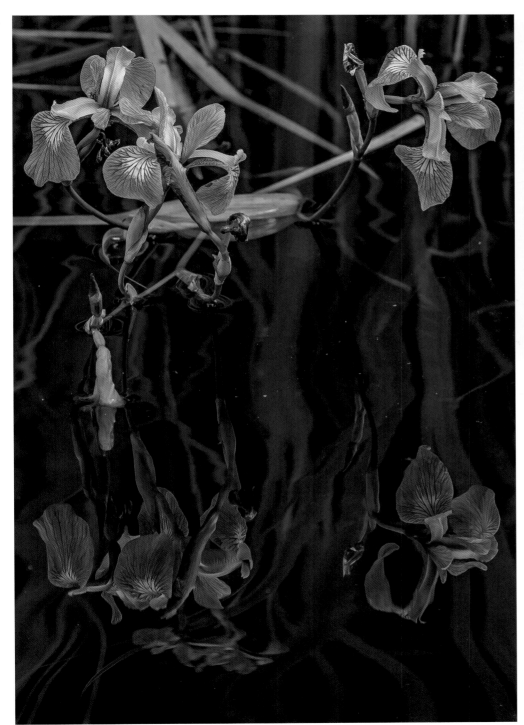

(left) Blue Flag (Wild Iris) is a common wildflower wherever a bit of current caresses its roots.

(top) Its exquisite design is not meant to catch our eye (which it certainly does) but the eye of a Bumble Bee.

On the bottom of shallow flowing water reside some of the Park's most unusual animals. Freshwater Sponges are colonial animals that filter food from water flowing through their prickly structure. They can appear finger-like when attached to submerged branches or mound-like when clinging to rocks.

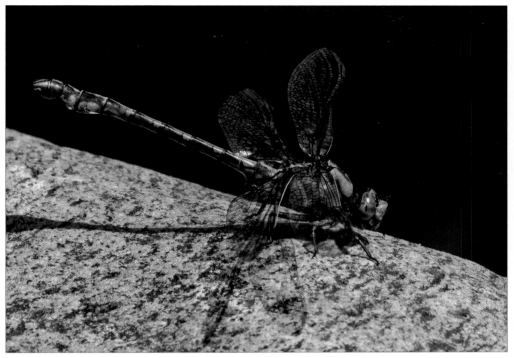

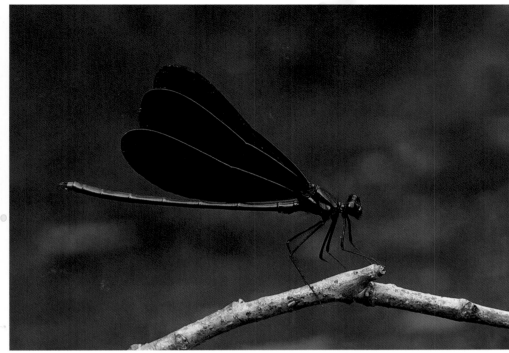

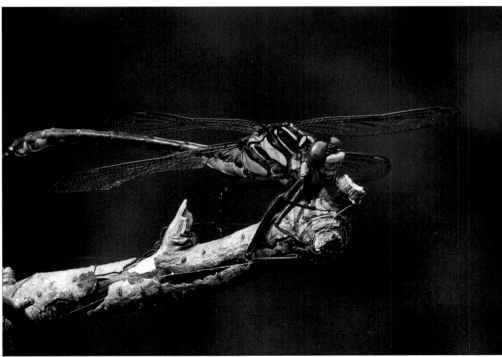

(top right) The male Ebony Jewelwing, Algonquin's largest and arguably most beautiful damselfly, performs delightful aerial dances to impress potential mates.

(top left) Associated with faster water are some of the Park's most beautiful speedsters, the Clubtail dragonflies. This one is a male Rusty Snaketail.

(bottom) The Dragonhunter, the Park's largest dragonfly, is named for its penchant for eating other members of its group.

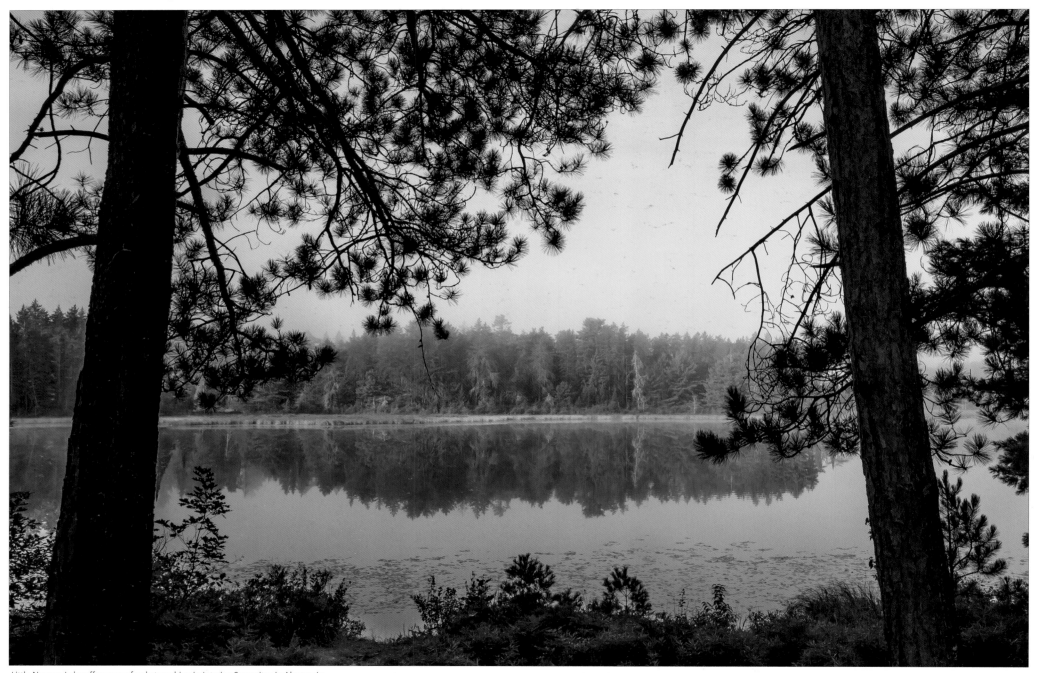

Little Norway Lake offers one of only two drive-in Interior Campsites in Algonquin.

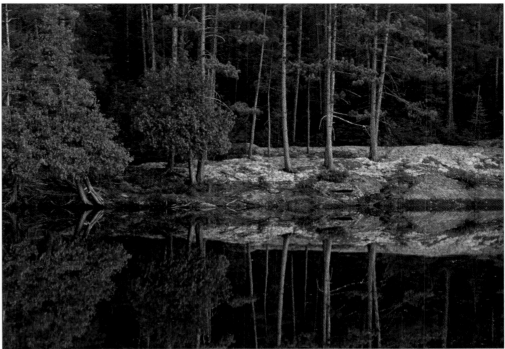

(top left) Although most of the Park's rock is ancient igneous (granitic) or metamorphic (gneissic), there is some sedimentary limestone along the north shore of Cedar Lake, and in the bottom of the nearby Brent Crater where a giant meteorite crashed some 450 million years ago.

(top right) Red Pines towering over Reindeer Lichens are common sights along sections of the mighty Petawawa.

(bottom) As their name suggests, Pine Warblers live in pine forests, which is why they are extremely common in eastern Algonquin

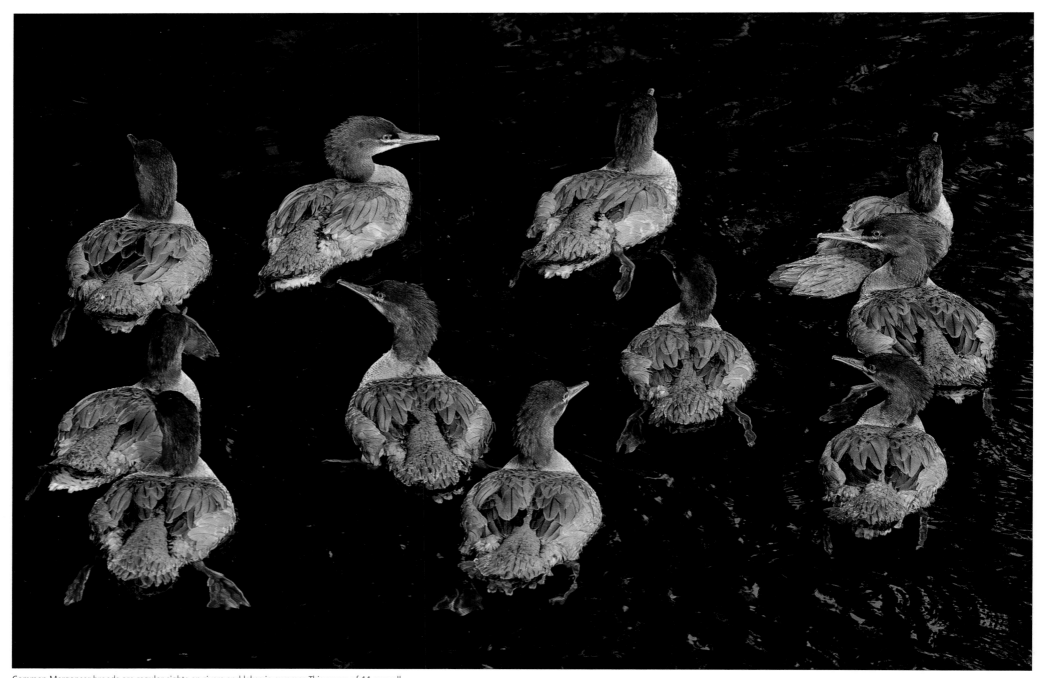

Common Merganser broods are regular sights on rivers and lakes in summer. This group of 11 may all be siblings or they may not, for female mergansers often lay an egg in another female's nest. As well, broods of different females commonly coalesce to form a larger group known as a crèche.

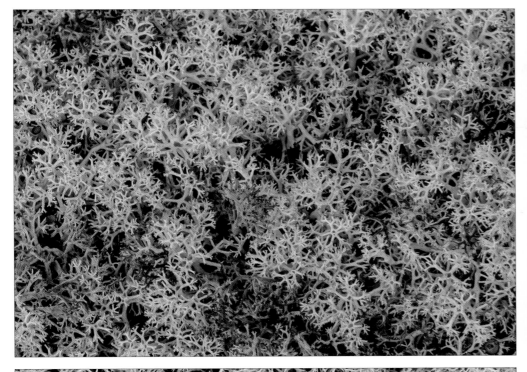

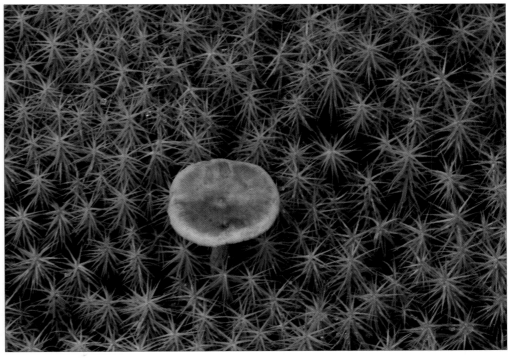

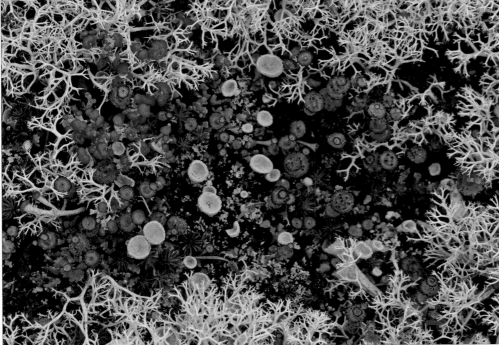

(top left) Reindeer Lichens are sun-loving colonizers of open, rocky terrain. Unfortunately, there are no Woodland Caribou in Algonquin to take advantage of their presence.

(top right) The Grayling is a small gray mushroom that only grows in mosses like this Juniper Haircap Moss.

(bottom) Lichens can be quite beautiful as this living tapestry reveals.

Pine needles add more acidity to the already acidic soils of Algonquin but that is not a problem for Pipsissewa, a plant that gets some of its nutrition from other plants through mycorrhizal fungi associated with its roots. The unusual downward-pointing flowers are pollinated by Bumble Bees that vibrate their wings to shake pollen from the stamen tubes.

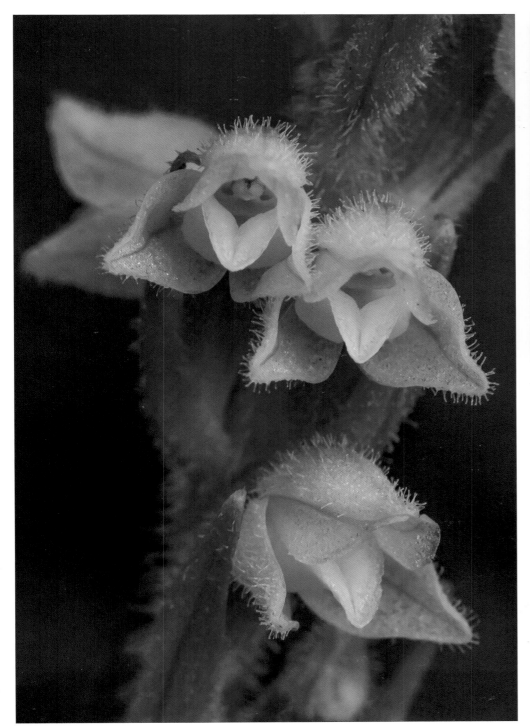

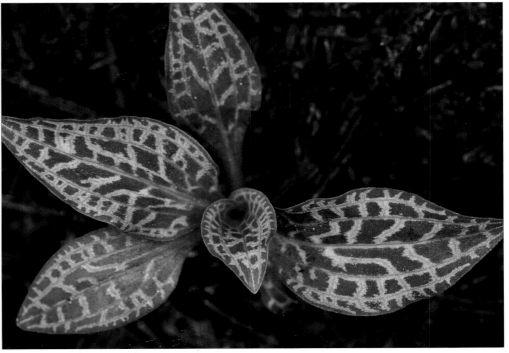

(left) Checkered Rattlesnake-plantain is an orchid that, like many others that grow in the shade of coniferous forests, is a mixotroph. This means that, in addition to manufacturing some of its carbon products through photosynthesis, it also steals some from other plants with the help of mycorrhizae.

(top) The most beautiful part of a Rattlesnake-plantain is arguably its leaves.

One word best describes Algonquin's western hills in summer: "Green."

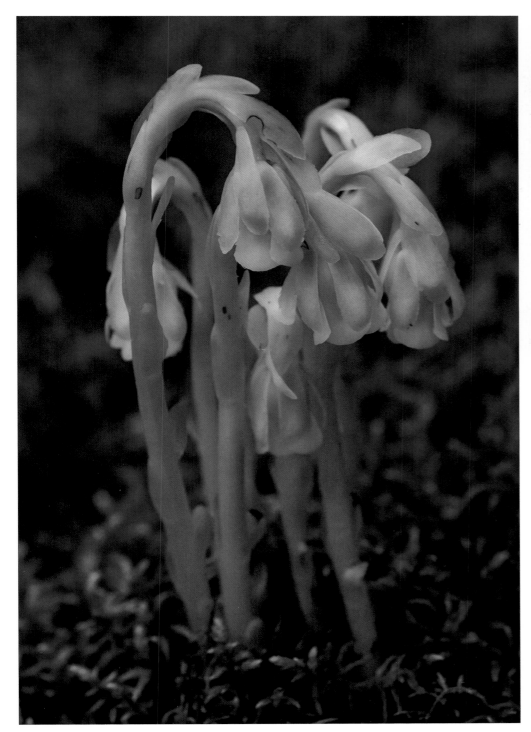

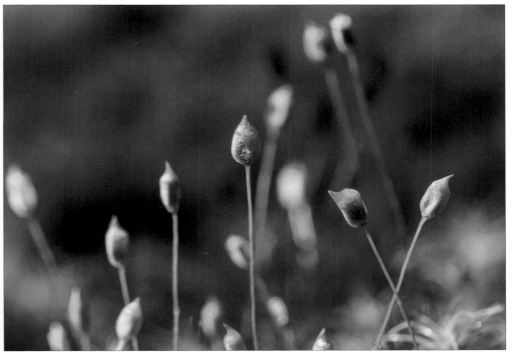

(left) Indian Pipe has no leaves and requires no sunlight because it doesn't make its own food. It lives as a thief, stealing food from trees with the help of mycorrhizal fungi on its roots.

(top) Mosses reproduce by spores that are held inside little capsules. The cap of those structures keeps the microscopic spores from escaping and falls off when they are ready for dispersal.

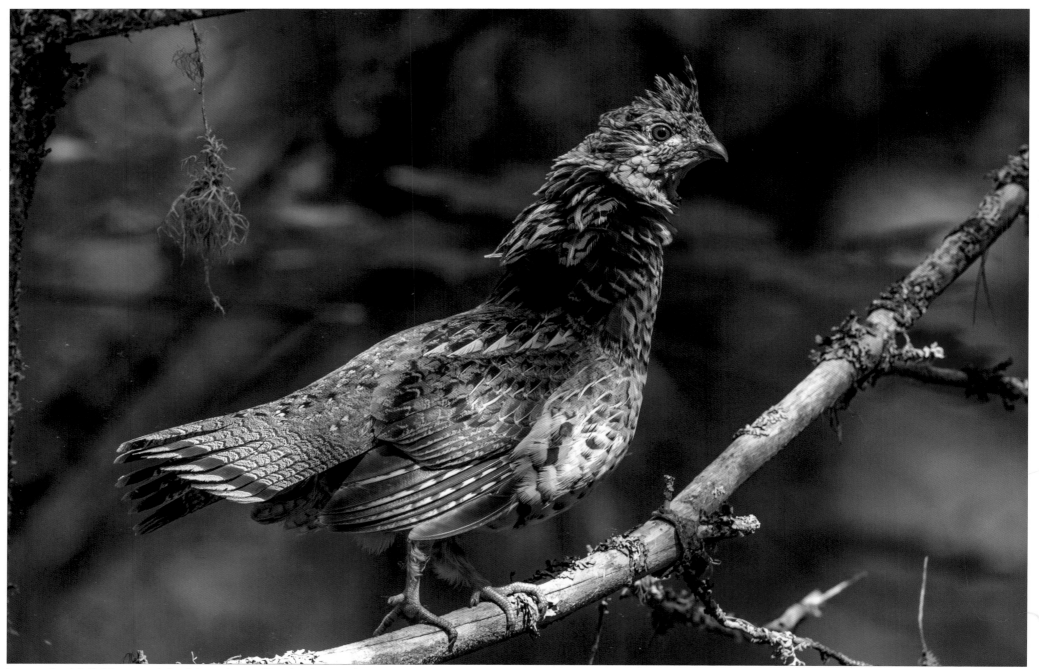

In summer, female Ruffed Grouse spend a lot of time on the ground but when their young face potential danger, they go to great lengths (even heights) to distract intruders away from their hidden chicks.

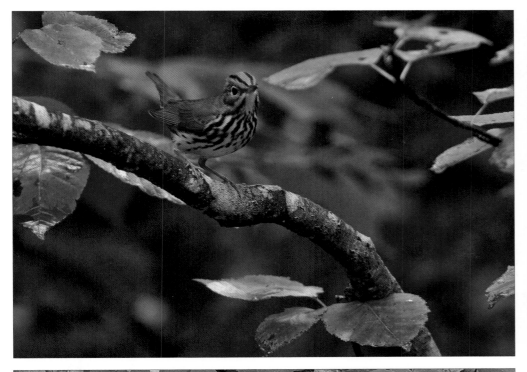

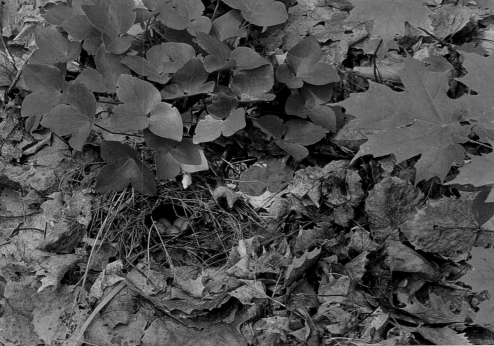

(top left) Ovenbirds with their strident "teacher, teacher, teacher" songs are more often heard than seen.

(top right) Ichneumons are parasitoid wasps that use their long ovipositors to insert eggs onto or into larvae that become living meals for the young wasps. Some ovipositors penetrate wood to access wood-eating larvae hidden under the bark.

(bottom) Even more difficult to view are their ground nests, which have an opening on the side like an old Dutch oven.

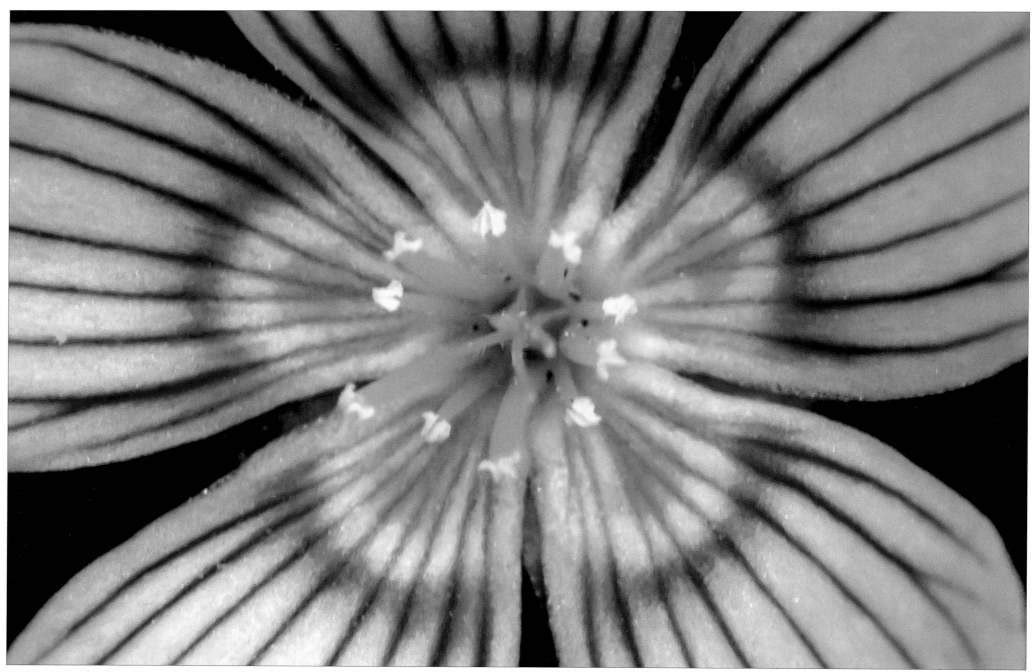

Wood Sorrel is one of the few wildflowers that bloom in the shade of summer hardwoods. From a distance its flowers seem to be pale nothings, but up close they contain spectacular nectar guides, patterns that visually lead insects to their tasty reward and by no accident, the flower's sexual parts where pollination occurs.

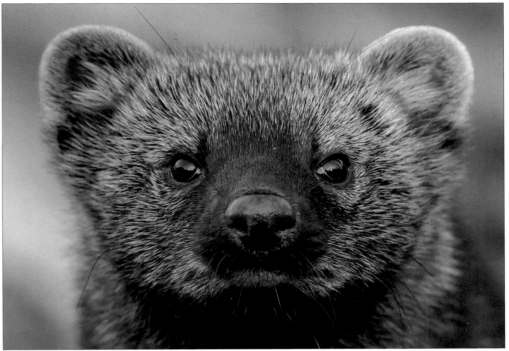

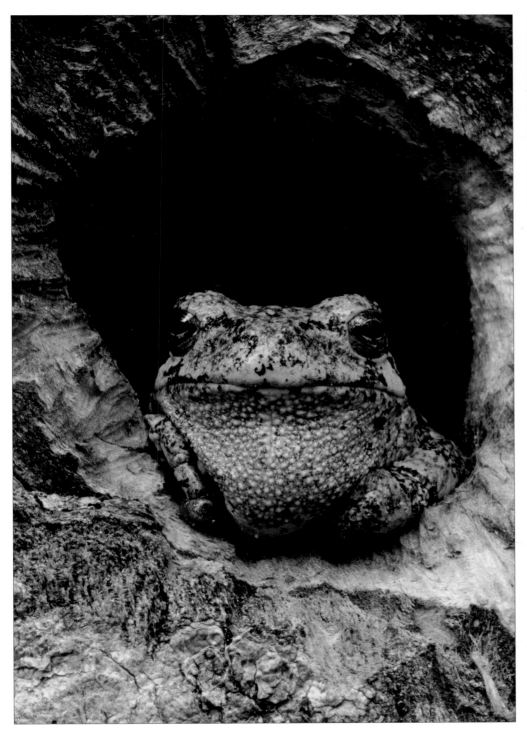

(left) Cavities in trees are homes for flying squirrels (Northern and occasionally Southern), and a variety of birds, but Gray Treefrogs also use them. These nocturnal frogs whose hollow trills are common sounds in summer hardwood forests are remarkable for many reasons. They live in trees, they change their colour from gray to brown to green to match their background, and in fall they bury themselves in the forest floor and freeze in winter, with half their body water turning to ice. In spring they perform amazing Lazarus acts by thawing back into life once again.

(top) Of all the weasels residing in Algonquin, none has a more varied diet than the Fisher. These tree-climbing predators eat fruit as well as birds, squirrels and mice, but they also eat Snowshoe Hares and Porcupines, the latter reputed to be a favourite.

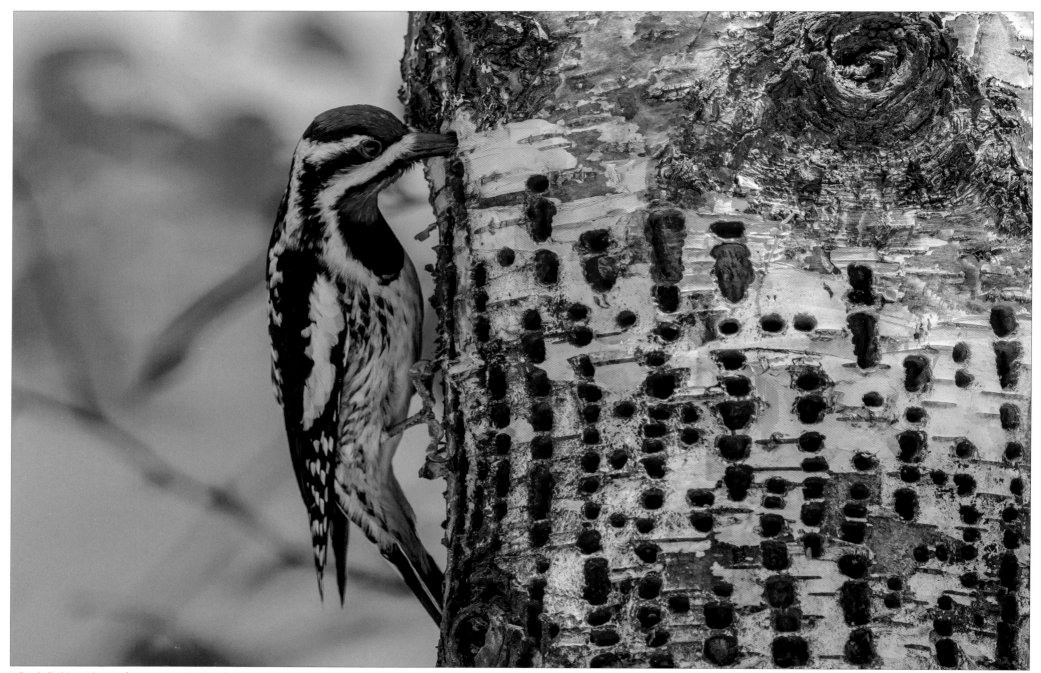

Yellow-bellied Sapsuckers are fascinating woodpeckers for they drink sap from columns of wells they drill and maintain in trees.
White Birch is a favoured sap tree, with American Beech, Eastern Hemlock, and Speckled Alder also commonly used. Spring
wells tend to be round and tap into xylem sap while summer wells are more rectangular (like these) and reach phloem sap.

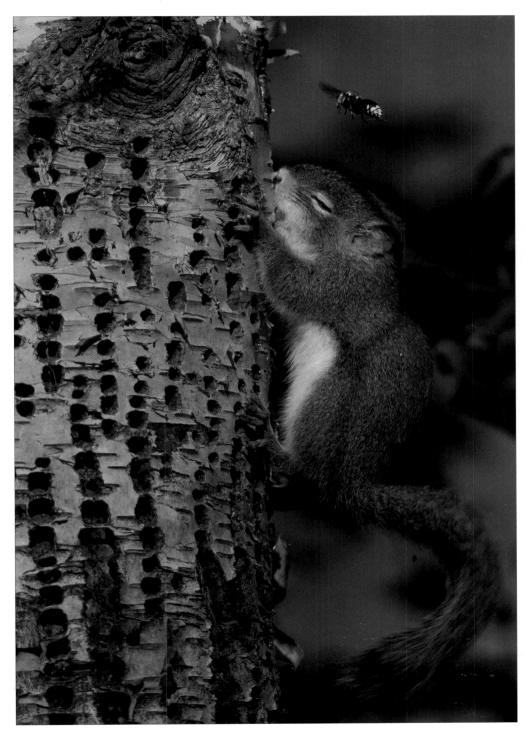

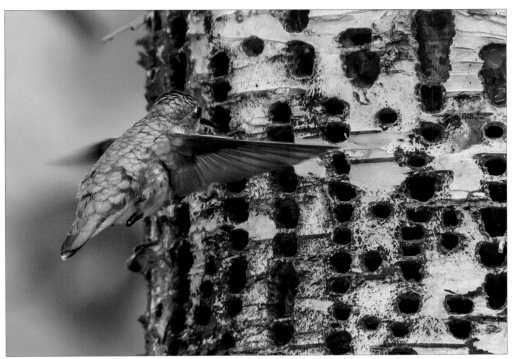

(top) Sapsucker wells provide food for more than just sapsuckers. A common sap pirate is the Ruby-throated Hummingbird, a speedster that the slow-moving sapsuckers are unable to keep away from their precious wells.

(left) Red Squirrels also appear to own a sweet tooth (or tongue)!

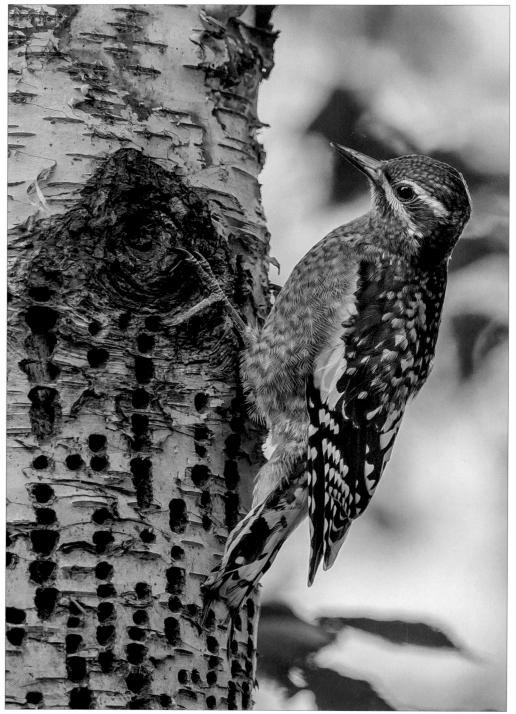

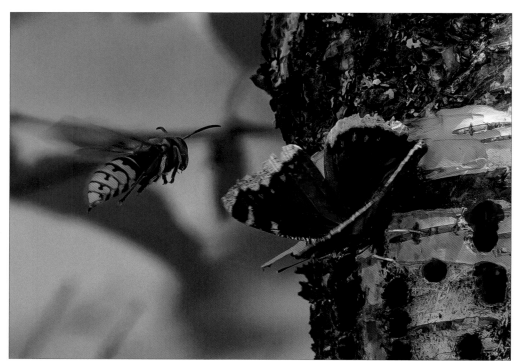

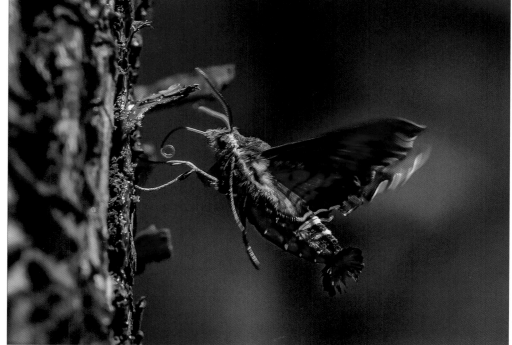

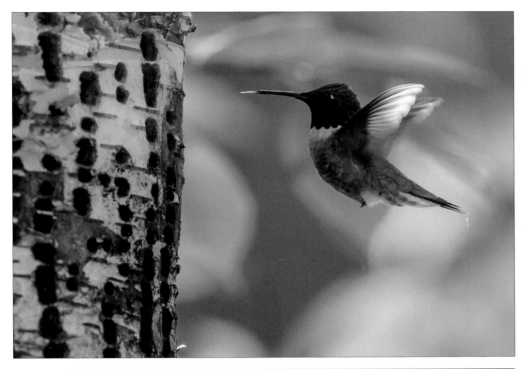

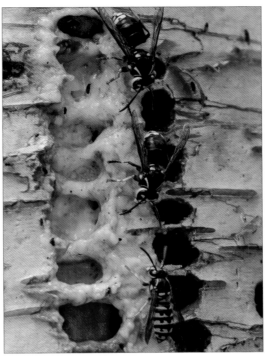

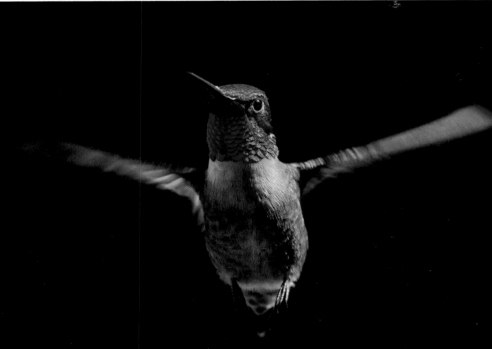

(top left) Only male hummingbirds sport the name-giving throat gorget, which due to iridescent feathers looks black until (bottom) it reflects light at an appropriate angle.

(top right) Insects including Bald-faced Hornets and Yellowjacket Wasps are regular patrons of the Sapsucker Café.

(opposite top right) An even greater surprise was this giant European Hornet, a non-native insect that only moments before approaching this Mourning Cloak had chased away a hummingbird. While feeding on sap, the butterfly's wings were closed but they opened when the hornet approached. The hornet quickly backed off, obviously startled by the sudden change in the butterfly's appearance. Seemingly satisfied at the result, the Mourning Cloak closed its wings. When the hornet approached again, the butterfly's wings opened. This time, the hornet - the first one recorded in Algonquin - flew away!

(opposite bottom right) A Nessus Sphinx was a surprise visitor to this Café. This day-active moth, which usually gets nectar from flowers, keeps its long tongue coiled up until needed.

(opposite left) After they fledge, young sapsuckers become beneficiaries of their parent's efforts.

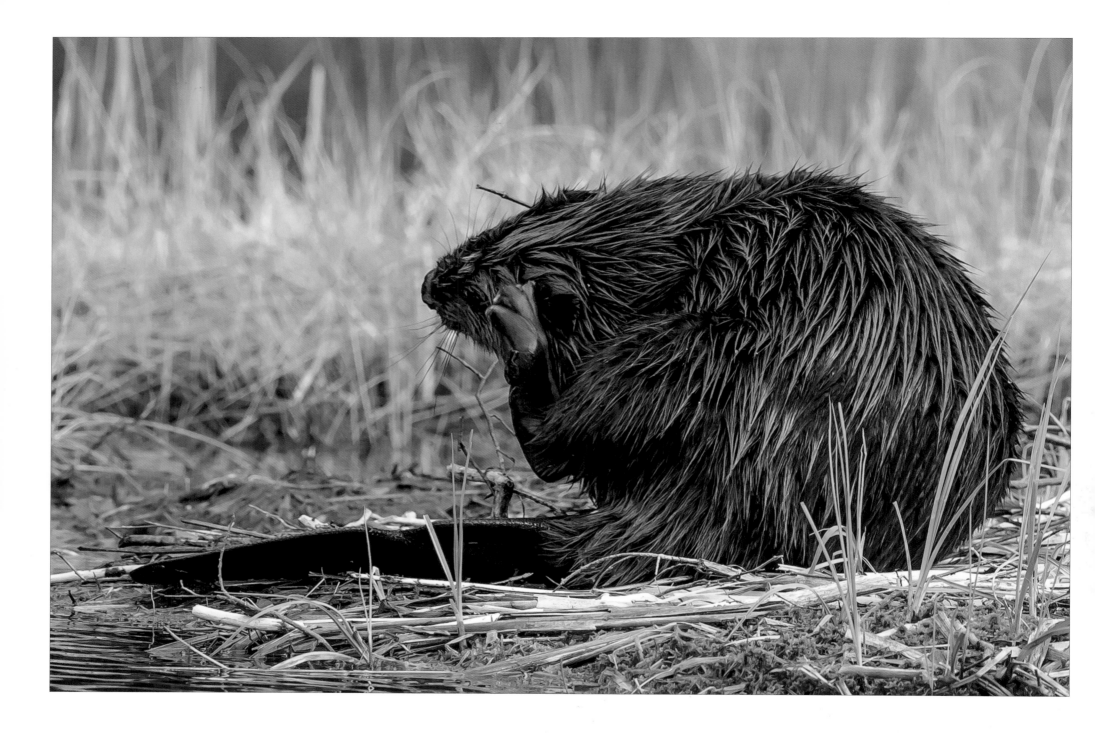

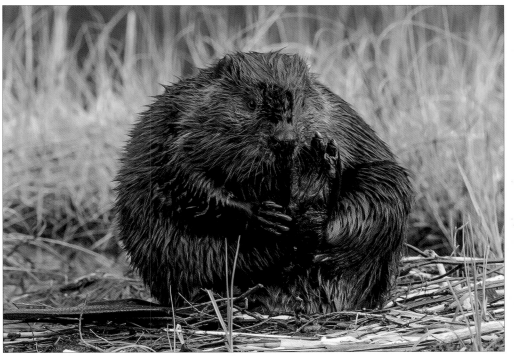

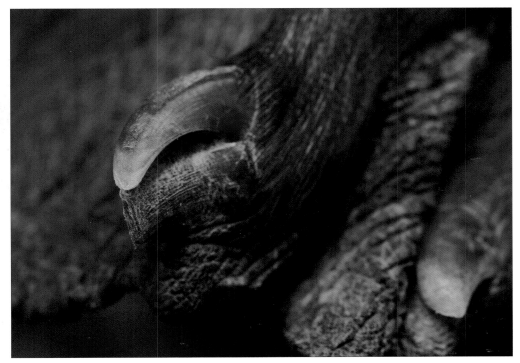

(top left) A Beaver's massive, webbed hind feet propel it when swimming.

(top right) Before the construction of a new lodge is complete, a Beaver must sleep somewhere!

(bottom) The hind feet play another important role. The two innermost toes on each foot bear a double claw that in some unknown way is used to groom their thick fur (opposite).

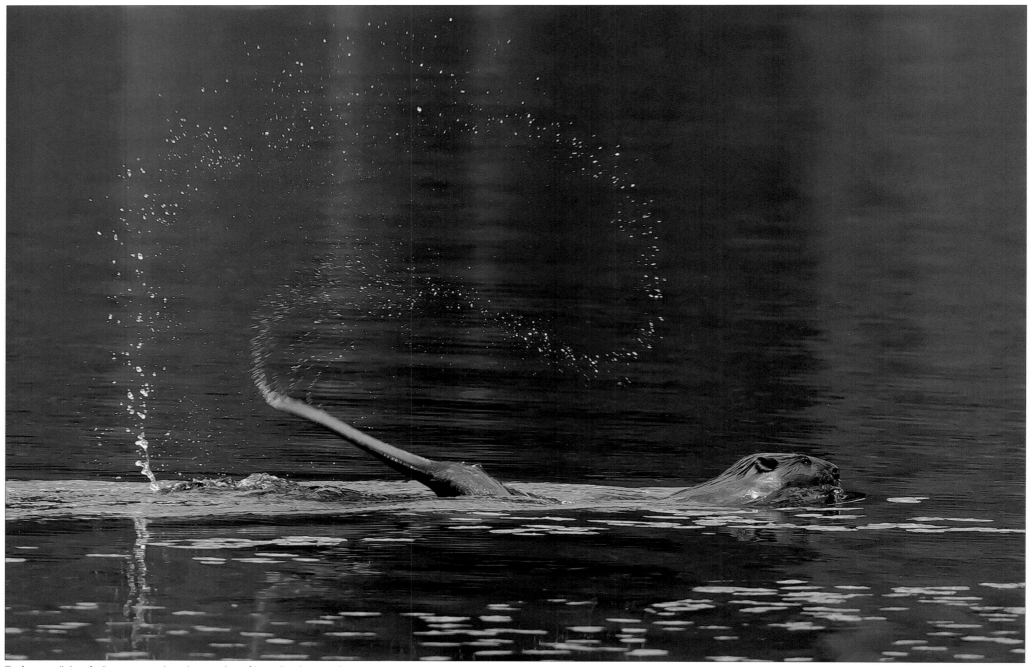

The famous tail slap of a Beaver warns other colony members of impending danger and no doubt startles the predator, providing the Beaver with ample time to escape.

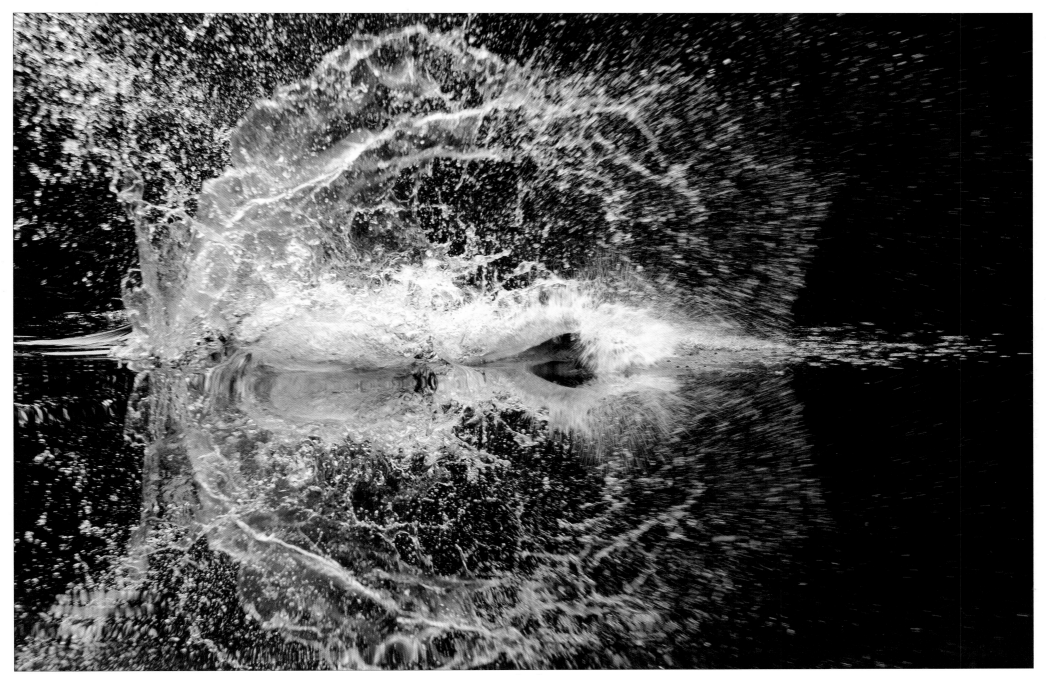

It is remarkable how much water a Beaver's tail slap can displace. Here, some of the elevated water is from the tail hitting the pond's surface while the rest is from the tail throwing it up from below the surface when the Beaver dove, using the water for leverage.

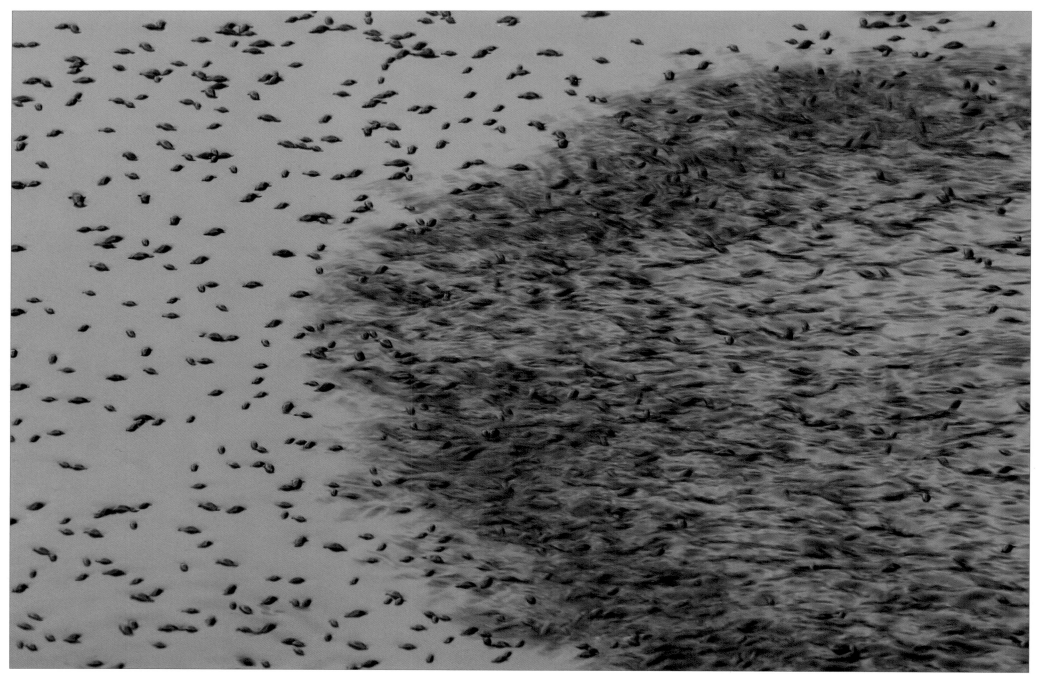

Swarms of Whirligigs, predatory aquatic beetles, turn a pond's surface into an abstract of frenzied activity when they begin their name-giving motion.

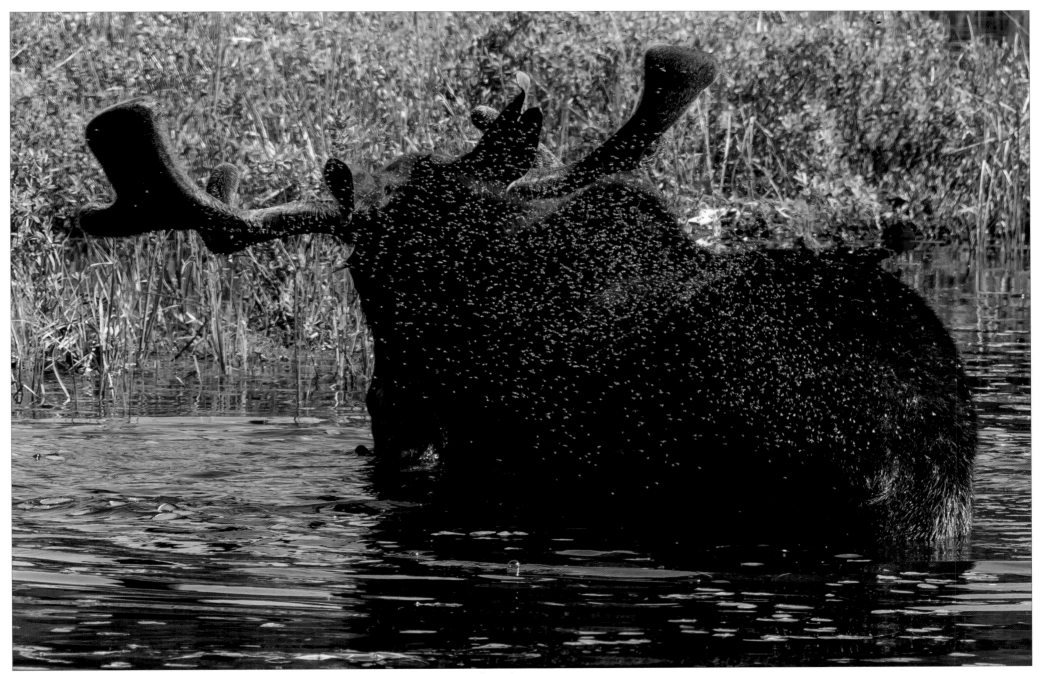

When a Moose shakes itself after a brief submergence, hordes of its passengers become briefly visible. Moose Flies are well named because the adult flies (both sexes) are only found on Moose, feeding on their host's blood and skin debris. The larvae depend on Moose as well. A female's eggs are laid only in Moose droppings with the ensuing larvae eating, well, you know what!

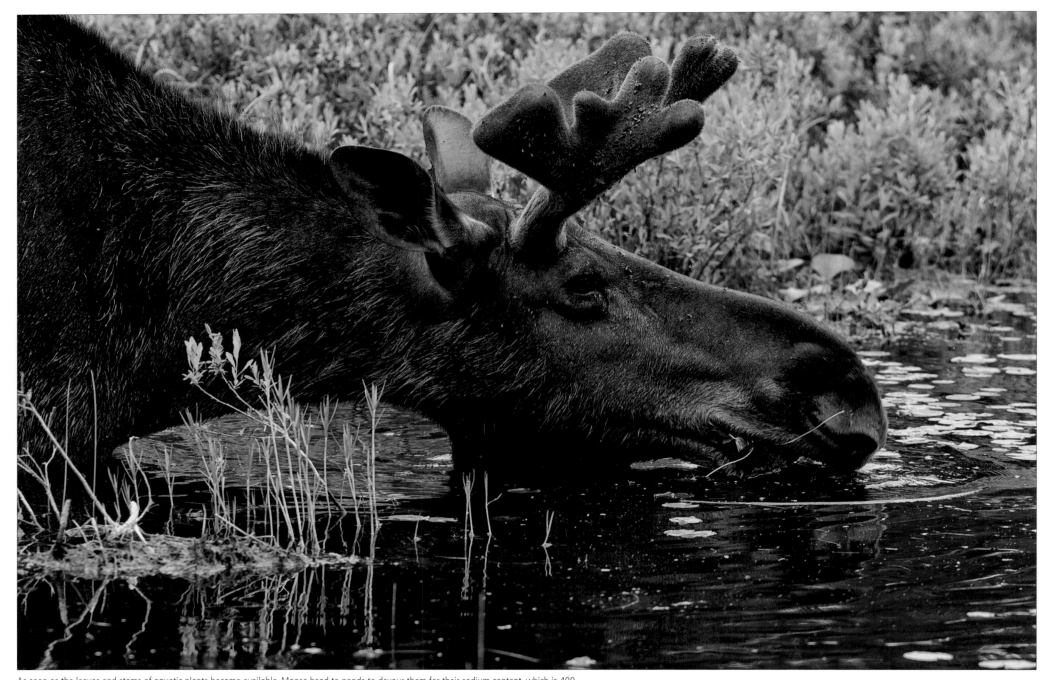

As soon as the leaves and stems of aquatic plants become available, Moose head to ponds to devour them for their sodium content, which is 400 to 500 times greater than that of the plants on shore. While a bull's antlers are developing (they fall off each winter) they are covered in a thick skin called velvet that brings blood to the growing bone beneath. Moose antlers are the fastest growing bone tissue in the world.

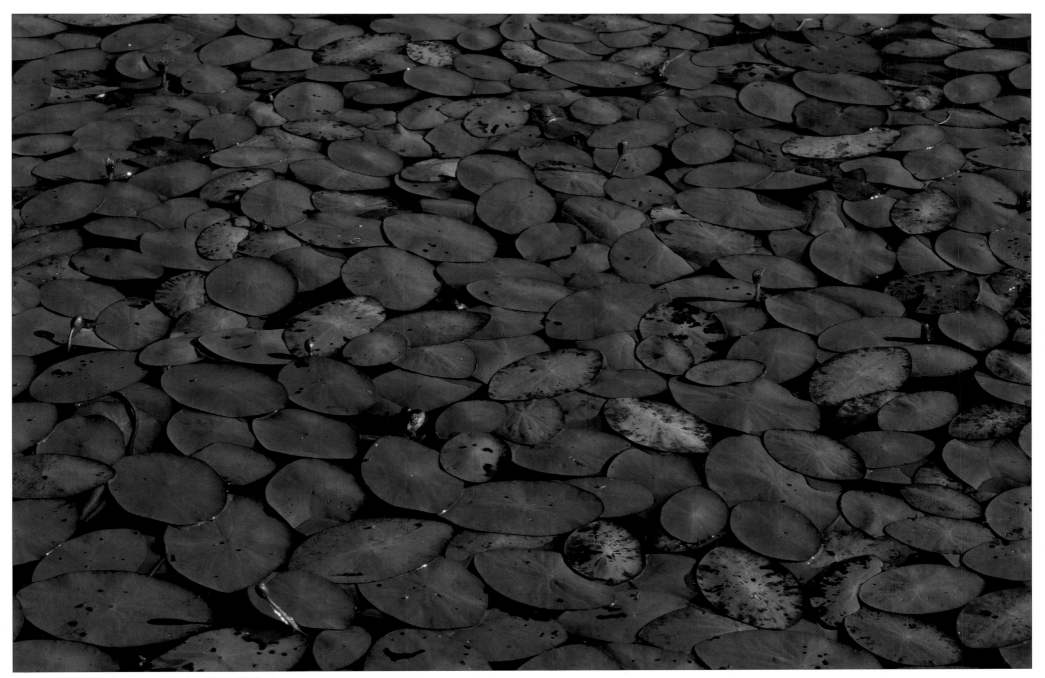

Through time beaver ponds become gardens full of Water-shield and
other aquatic plants, perfect habitat for this Mink Frog

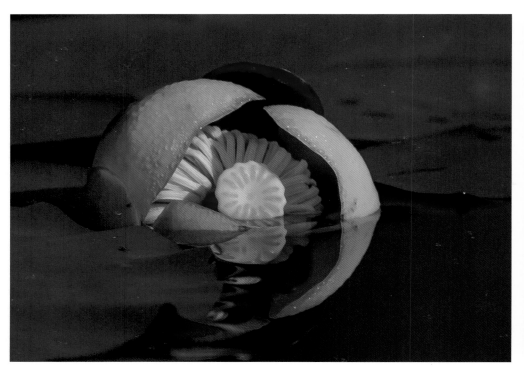

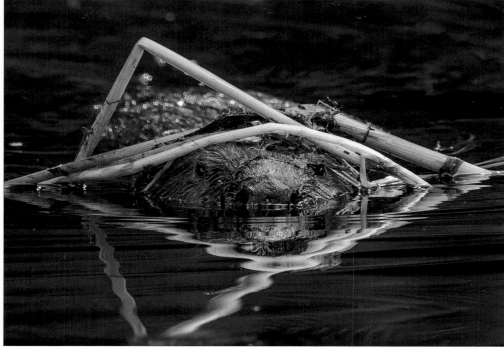

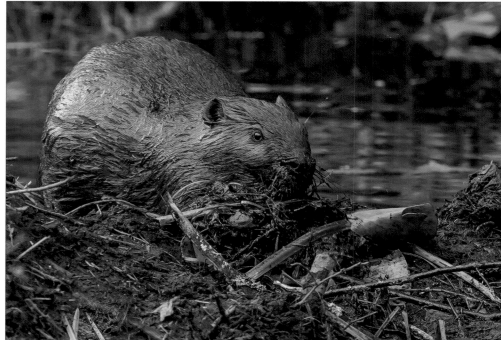

(top left) Yellow Pond-lilies are one of a Beaver's regular foods, with all parts consumed.

(top right and bottom) Plants growing in a beaver pond are often used to plug leaking dams.

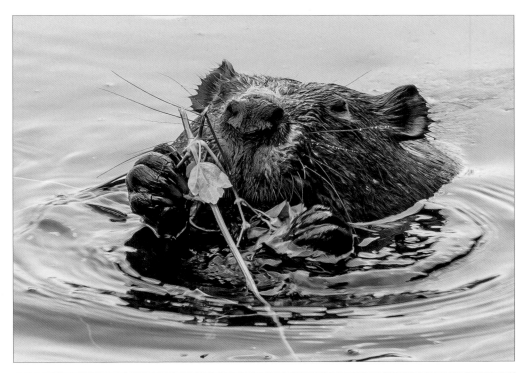

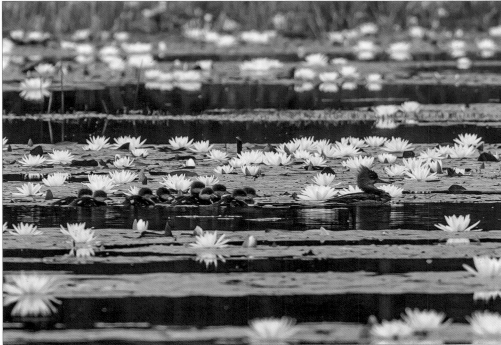

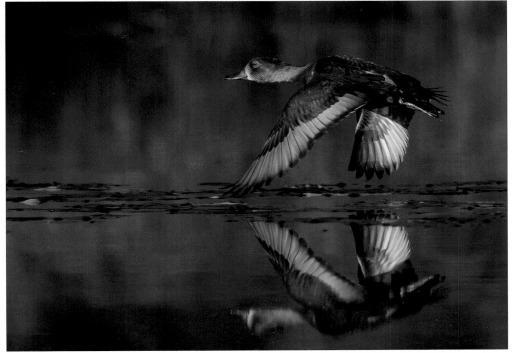

(top left) Beavers eat all of their meals, including terrestrial plants like this Virgin's Bower, in or near the safety of water.

(top right) Hooded Mergansers are among the multitude of organisms that benefit from the activities of Beavers.

(bottom) Ring-necked Ducks (here a female) are a common sight on many Algonquin beaver ponds.

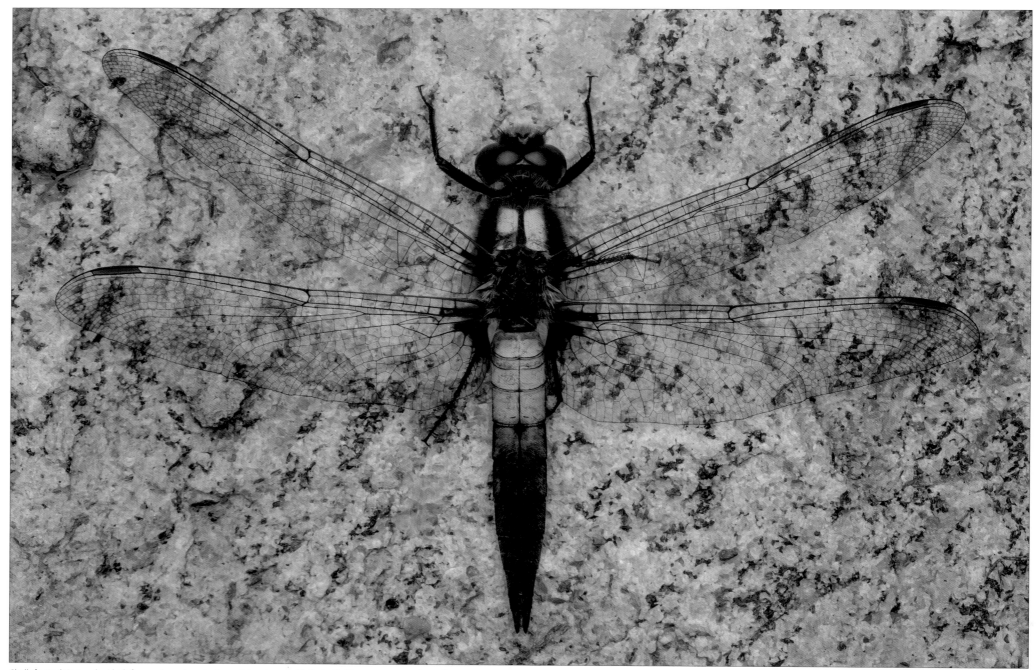

Chalk-fronted Corporals, which frequent ponds and other quiet waters, are likely the Park's most common dragonfly.

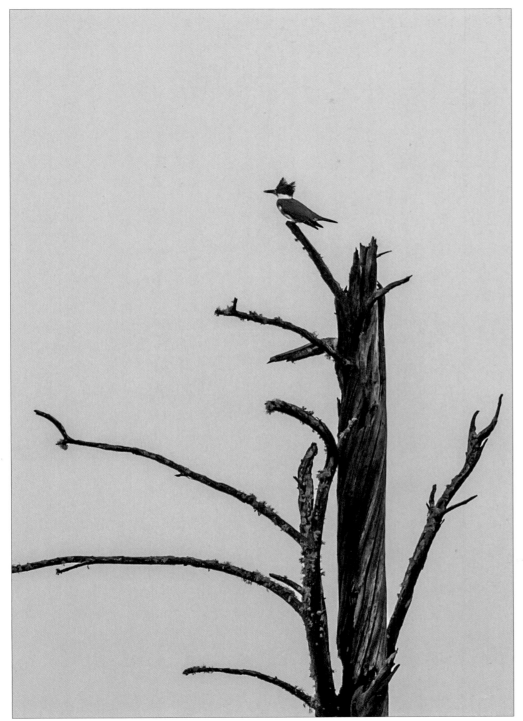

(far left) From its lofty perch a Belted Kingfisher watches for signs of a potential fish meal.

(left) Olive-sided Flycatchers are best found by listening for their emphatic "quick, three beers" songs delivered from the very tops of dead trees in beaver ponds.

(top right) Tree Swallows nest in cavities in dead trees, often using the abandoned homes of woodpeckers. Alarmingly, swallows, flycatchers, and other birds that eat flying insects have become much less common in recent years not only in Algonquin but also all through their range.

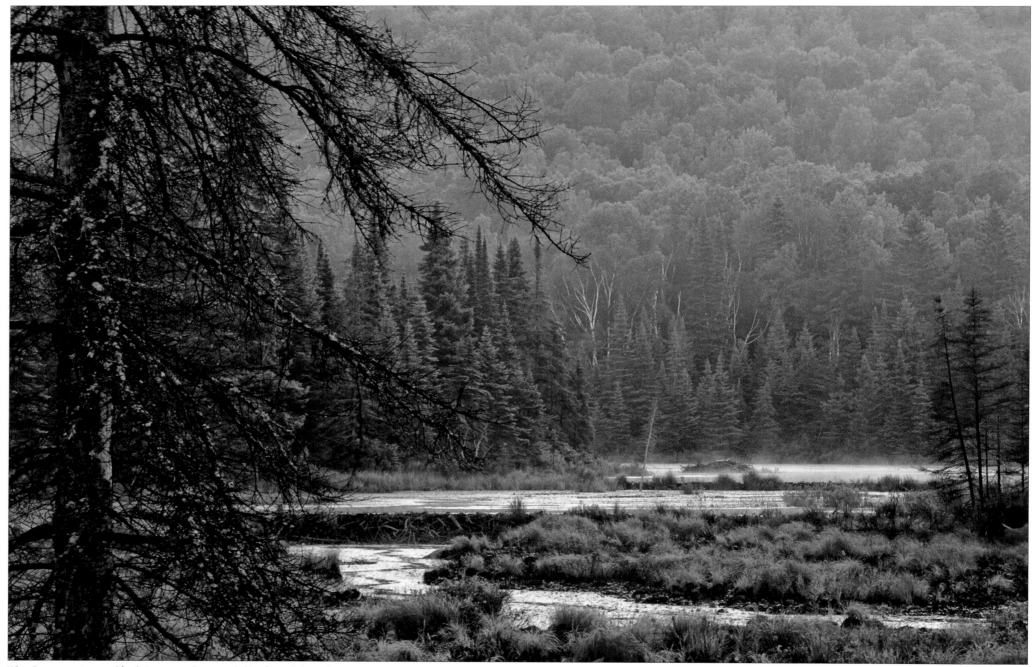

When Beavers create a pond for their own use, they create habitat for myriad organisms.
Drowned trees not only provide important habitat, they add an element of beauty.

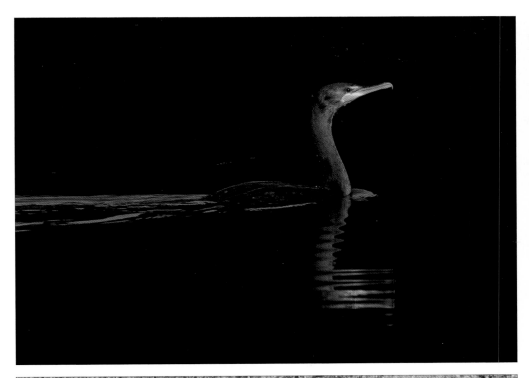

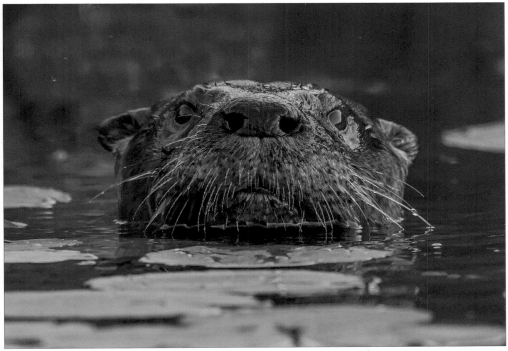

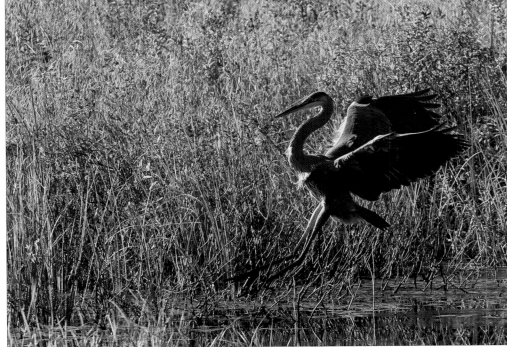

(top left) Usually encountered in larger bodies of water, Double-crested Cormorants are now regular visitors to Algonquin's beaver ponds where they catch fish.

(top right) River Otters eat fish and frogs but pose no danger to the pond's makers.

(bottom) Rare is the beaver pond not visited by Great Blue Herons.

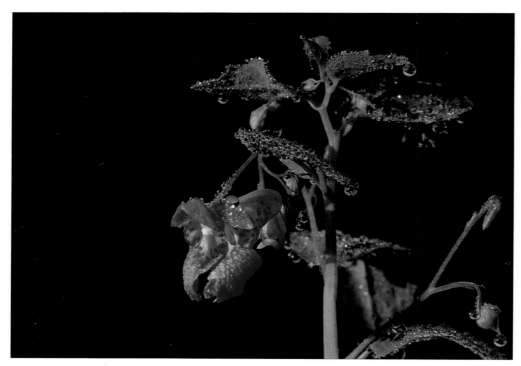

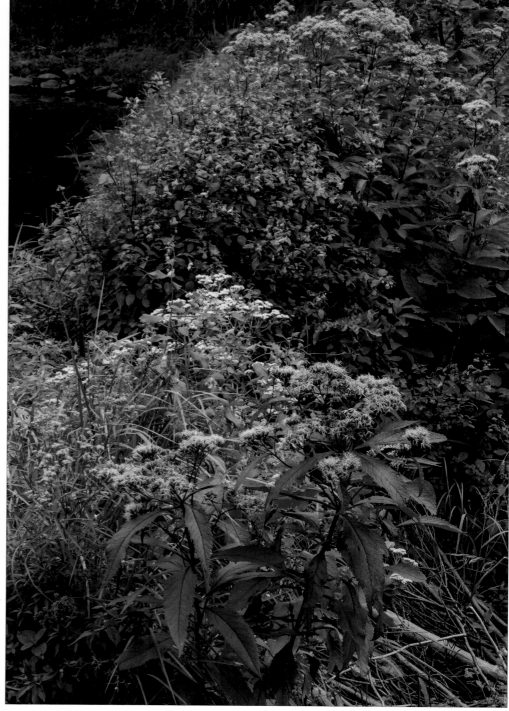

(right) Through time, beaver dams become wildflower gardens with Joe Pye Weed, Orange Jewelweed, Boneset, and Grass-leaved Goldenrod being common components.

(top) The flowers of Orange Jewelweed first open as male flowers but after losing their pollen, change sexes. Morning dew accentuates the beauty of this common wildflower.

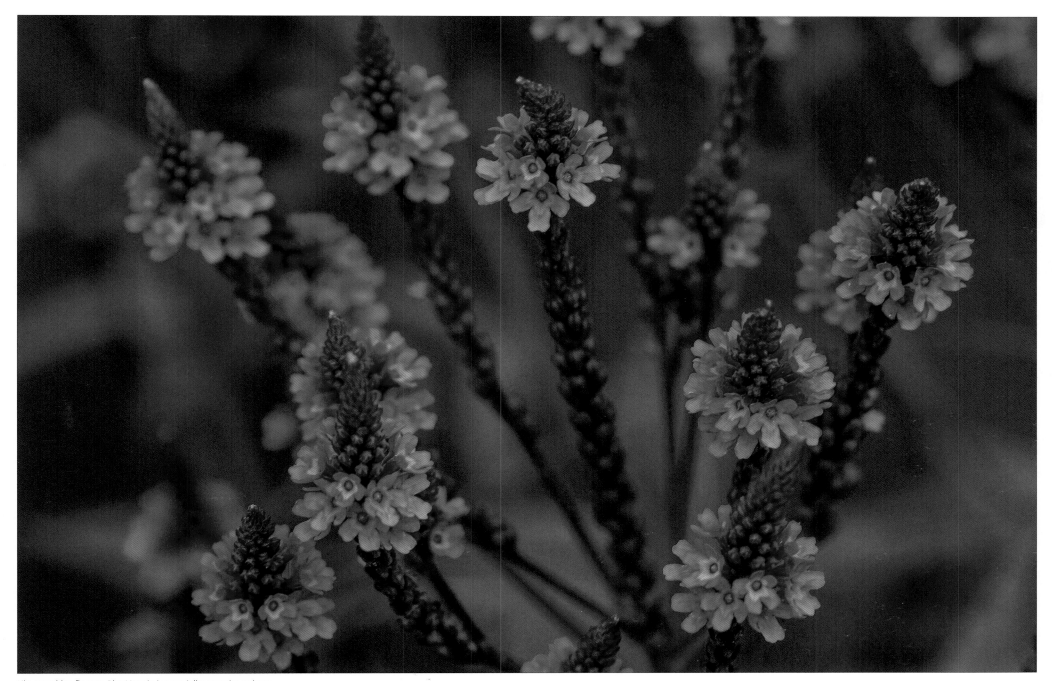

Like most blue flowers, Blue Vervain is especially attractive to bees.

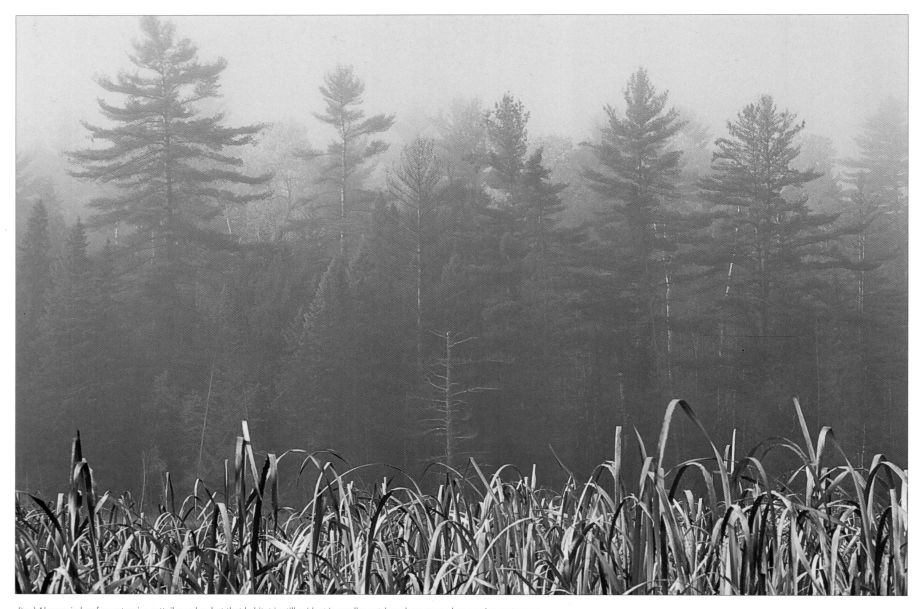

(top) Algonquin has few extensive cattail marshes but that habitat is still evident in smaller patches along many slow-moving waterways.

(opposite left) Swamp Sparrows might be better named "Cattail Sparrows" or "Marsh Sparrows" because of their preference for cattail-dominated habitats.

(opposite right) With vertical stripes on their breasts and the habit of pointing their head in the air and remaining motionless when frightened, American Bitterns blend in perfectly with the vertical lines of their cattail backgrounds. Flight is their next line of defence.

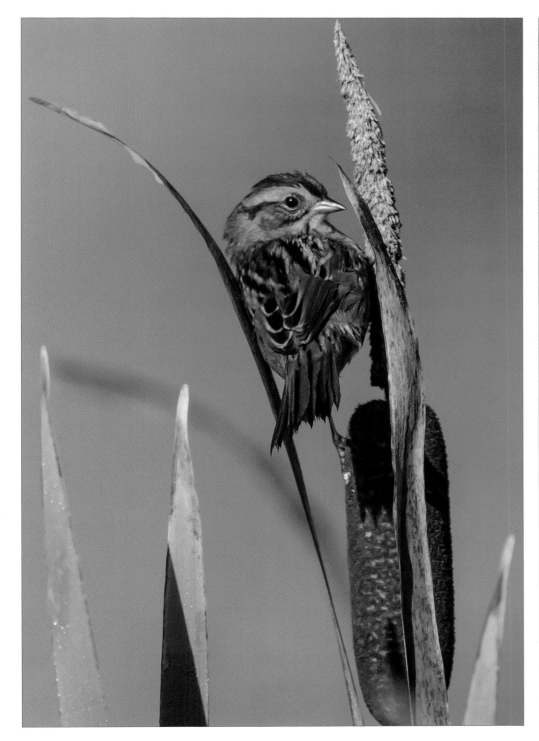

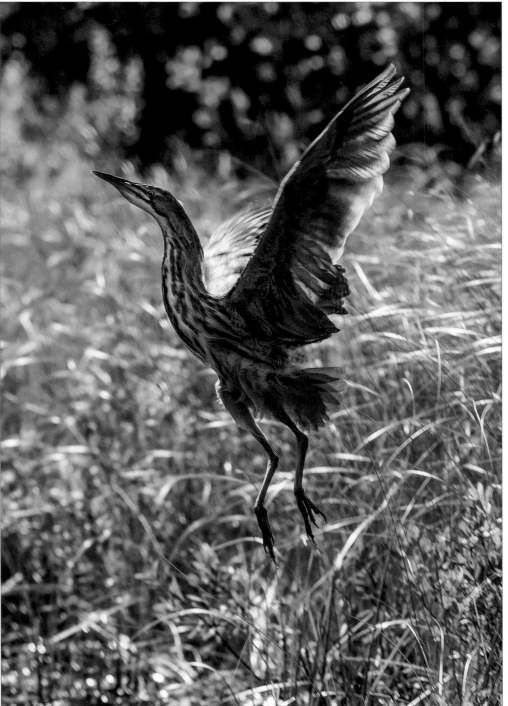

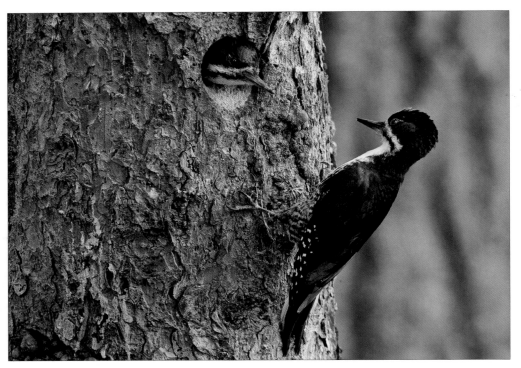

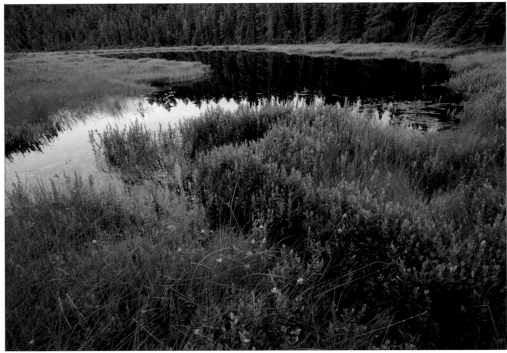

(top left) Algonquin's northern habitats are home to Black-backed Woodpeckers. These boreal forest birds excavate their nest cavities in live or dead trees, with males incubating the eggs at night and the pair taking shifts during the day.

(top right) Bogs and fens are the two main types of peatlands in Algonquin. This "bog" near Berm Lake is technically a poor quality fen because a stream flows into it (true bogs acquire nutrients only from rainfall while fens get theirs from flowing water).

(bottom) Sphagnum Moss is not only the dominant plant in a peatland; it is one of the most powerful plants anywhere. Sphagnum colonizes open water and creates its own soil (peat) by growing on top of itself, the mat becoming thicker through time. Additionally, sphagnum modifies its environment, making it more acidic and poorer in oxygen and nutrients.

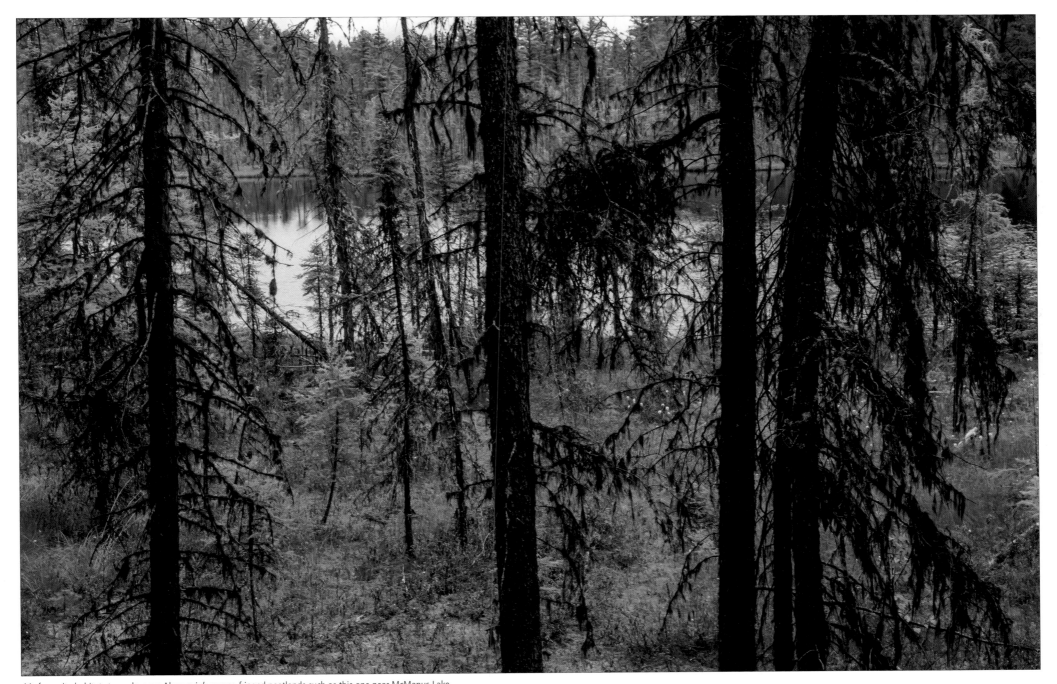

My favourite habitats to explore are Algonquin's spruce-fringed peatlands such as this one near McManus Lake.

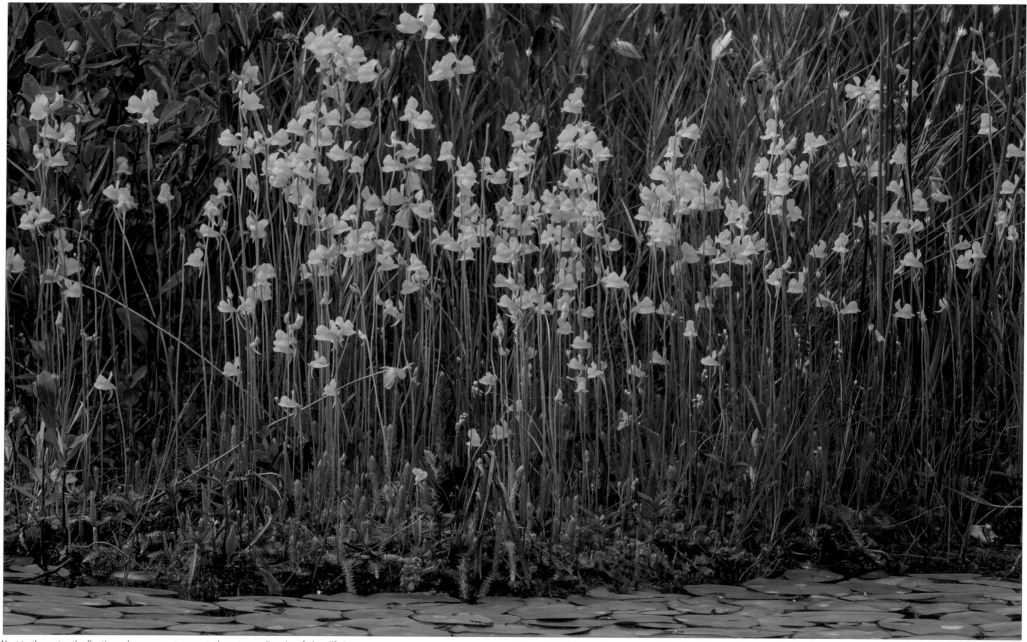

Next to the water, the floating sphagnum mat supports the greatest diversity of plant life in a peatland. Here, Horned Bladderwort, Round-leaved Sundew, and Bog Clubmoss fringe the water's edge while the blossoms of Rose Pogonia, a stunning orchid, peer out from behind.

(opposite left) Spruce Grouse are year-round residents of Algonquin's cool, dark spruce woods on the West Side, but also inhabit Jack Pine stands on the East Side.

(opposite right) The peculiar flower of a Pitcher-plant towers over the plant's deadly leaf traps.

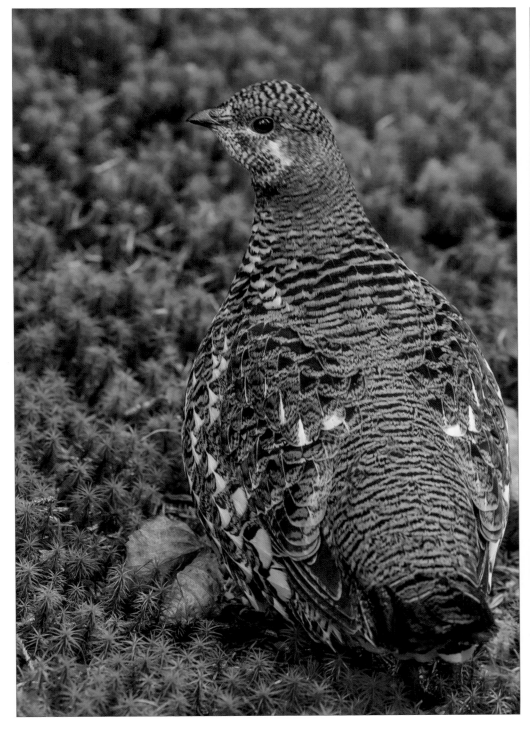

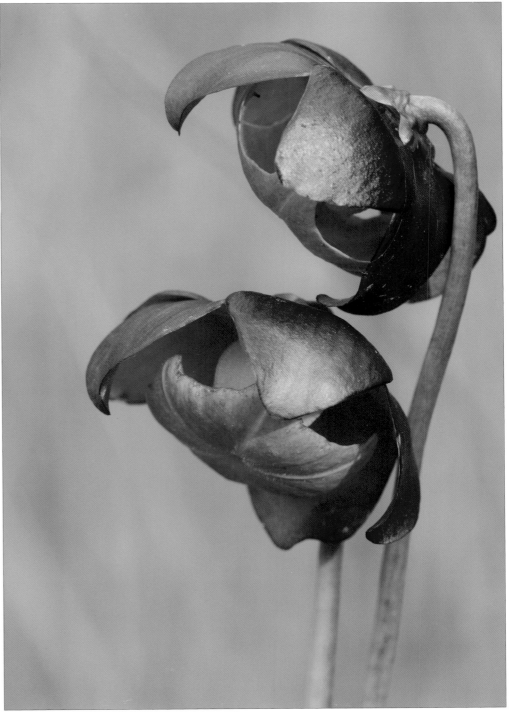

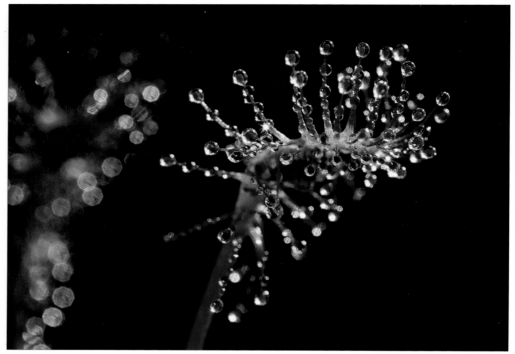

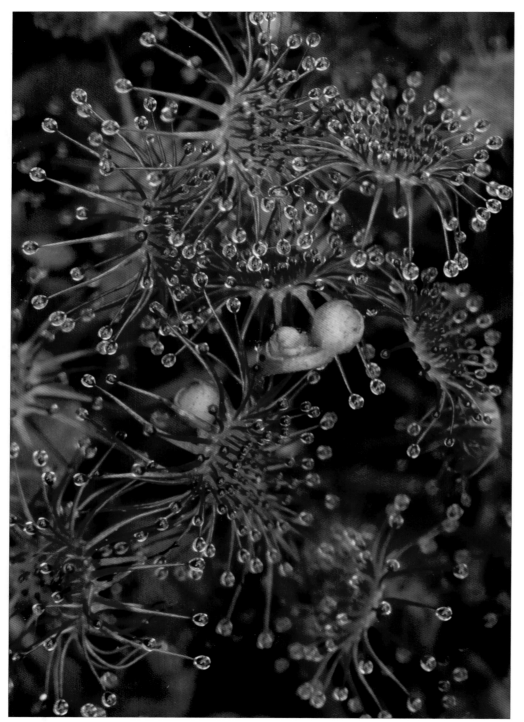

(opposite left) The leaves of pitcher-plants hold rain water and act as pitfall traps for insects that dare enter their open hoods.

(opposite right) Downward-pointing hairs lining the inside of a pitcher-plant's hood prevent insects from walking back out to freedom. The hairs end abruptly and the travellers step onto a waxy surface down which they slide, their ride ending in water at the bottom of the pitcher. After drowning, their bodies become dissolved by enzymes and bacteria, with the liberated nutrients becoming absorbed by the leaf's inner surface.

(left) Because peatlands are nutrient-poor habitats, "carnivorous" plants that attain some of their nutrients from the bodies of insects are common. Round-leaved Sundews with their adhesive leaf traps may be tiny but to insects and other small animals they are lethal.

(top) Spatulate-leaved Sundew and its relatives get their name from the shiny globs of glue exuded from knobs on special leaf hairs. The sticky traps act like flypaper, holding the prey while the leaf slowly folds over it, allowing the digestive enzymes released by other hairs to do their work.

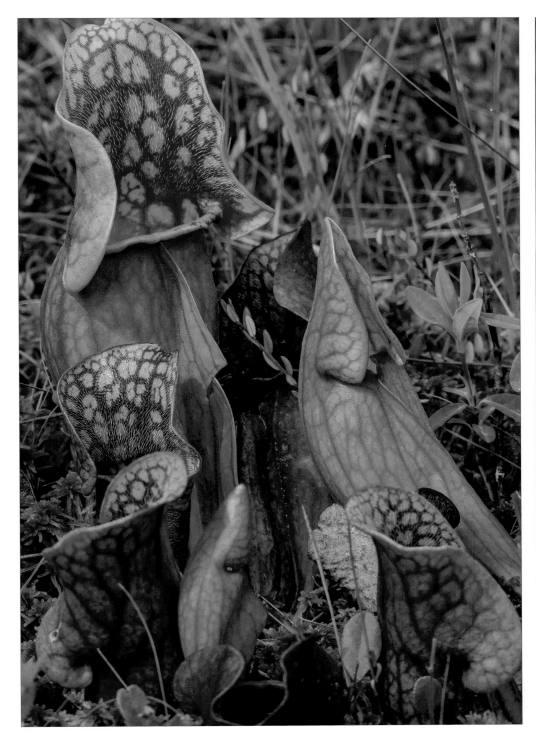
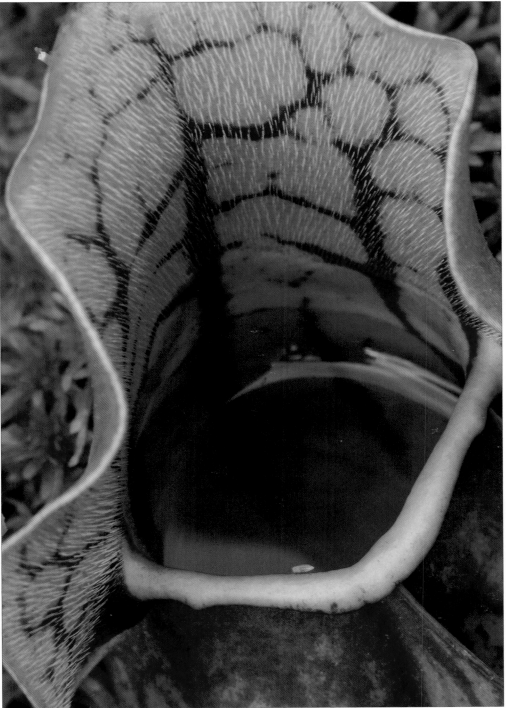

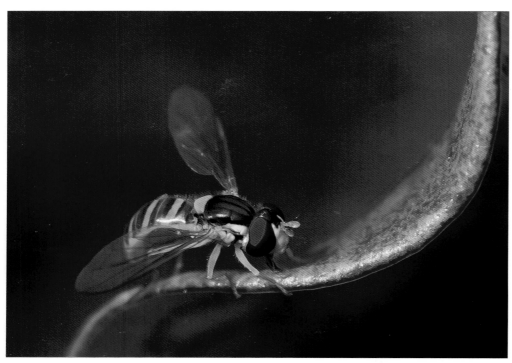

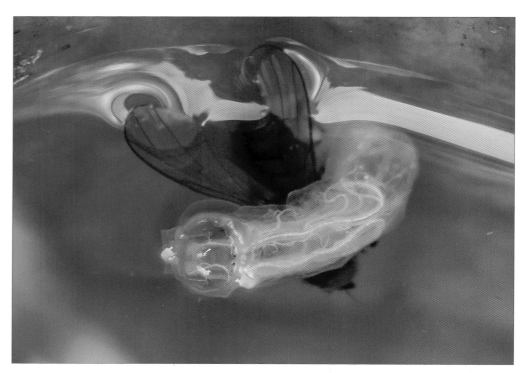

(top left) Tiny drops of nectar on the outer part of the pitcher attract ants and other insects (here, a tiny Hover Fly).

(top right) One species of Flesh Fly is immune to the Pitcher-plant's deadly trickery and lays a single egg in each leaf pitcher. After it hatches, the transparent grub (here you can see its tracheal breathing tubes) devours the victims of its host plant, a grand example of how Nature exploits each and every opportunity!

(bottom left) Growing in only one Algonquin peatland is an extremely inconspicuous orchid and one of the Park's rarest plants, the Southern Twayblade. Mere centimetres in height, it is also one of the Park's smallest wildflowers.

(bottom right) When an insect walks along the petal of a twayblade, it creates vibrations that cause an overhead canon to shoot glue and pollen onto its back. After the canon discharges (and the undoubtedly surprised visitor flies away), the flower becomes functionally female and can receive pollen from the next visitor bearing a pollen backpack.

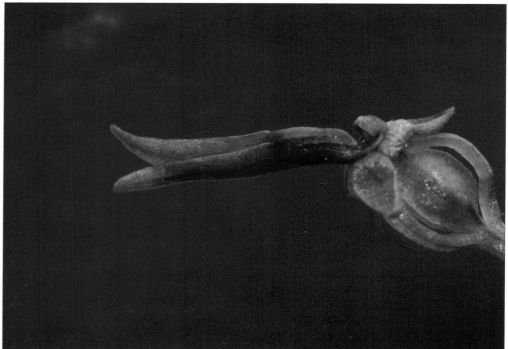

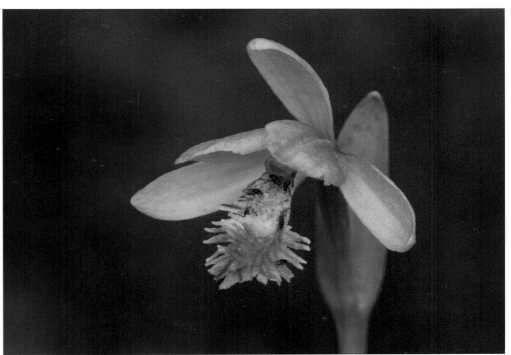

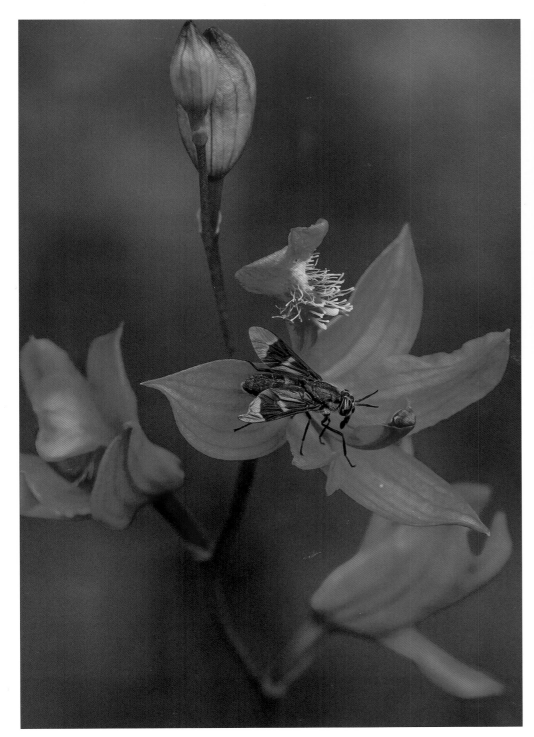

(top) Peatlands also harbour great beauty. Rose Pogonia is a common peatland orchid that deceives pollinators into visiting it by offering false promises of food.

(left) This Deer Fly could be in for quite a surprise for a Grass Pink offers more than false promises of food. Its uppermost petal is hinged and collapses when an insect lands on it, slam-dunking the visitor onto the flower's sexual organs.

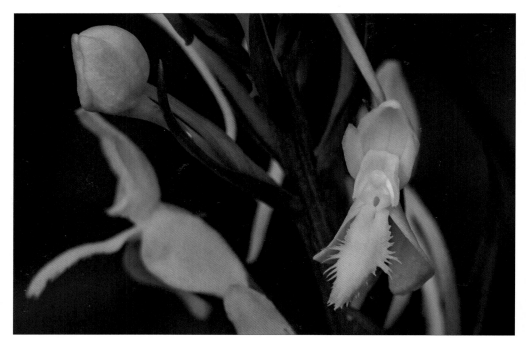

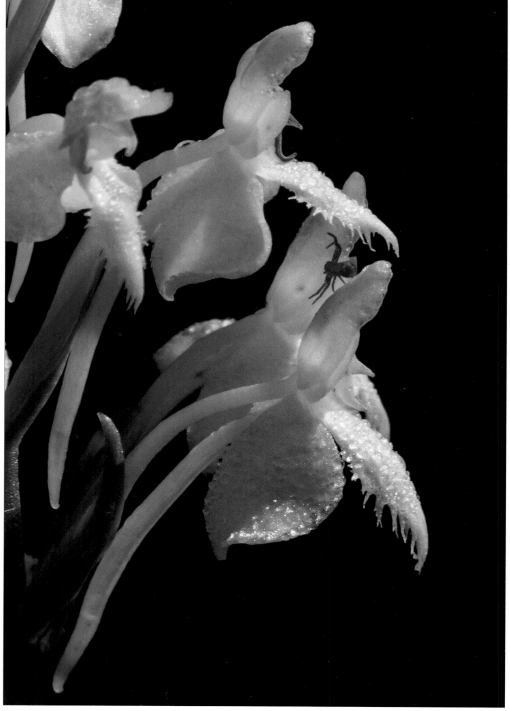

(right) Growing in the same peatland as Southern Twayblade is another provincially rare plant, the stunning White-fringed Orchid. Its long nectar spur and pale coloration indicate that the flower's pollinator is a long-tongued insect that flies in near darkness, thus likely a moth. A tiny Crab Spider awaits smaller visitors to arrive for a very different reason.

(top) Do you see Edvard Munch's "*The Scream*" in this image?

(far right) Peatlands are habitat for tiny damselflies. The Sphagnum Sprite (right) is often found near the water's edge while the nearly identical but considerably more common Sedge Sprite is present throughout the peatland.

(right) Bog Coppers might be better named "Cranberry Coppers" for the butterflies sip nectar from that plant's flowers and the caterpillars eat its leaves. These tiny butterflies are uncommon in Algonquin, and are only found in peatlands, which, of course, is where cranberries thrive.

(top) In winter a Common Raven's massive bill tears open frozen carcasses but this one was adept in plucking large caterpillars from peatland plants, which it did for several hours at Wolf Howl Pond.

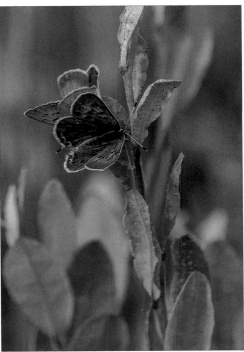

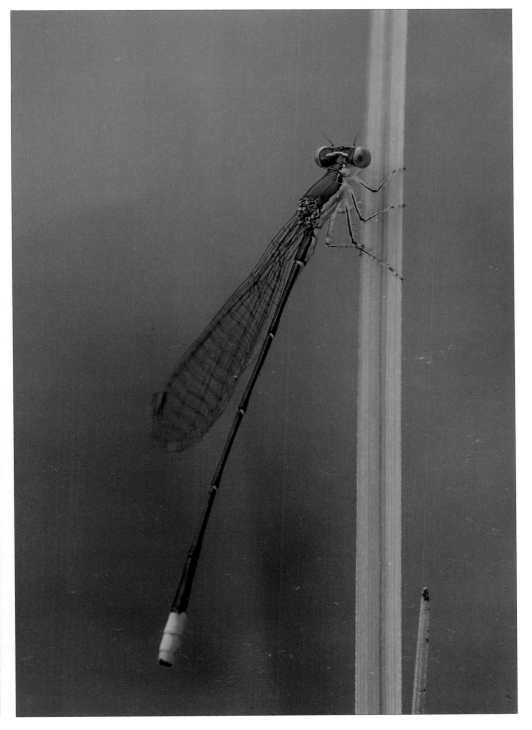

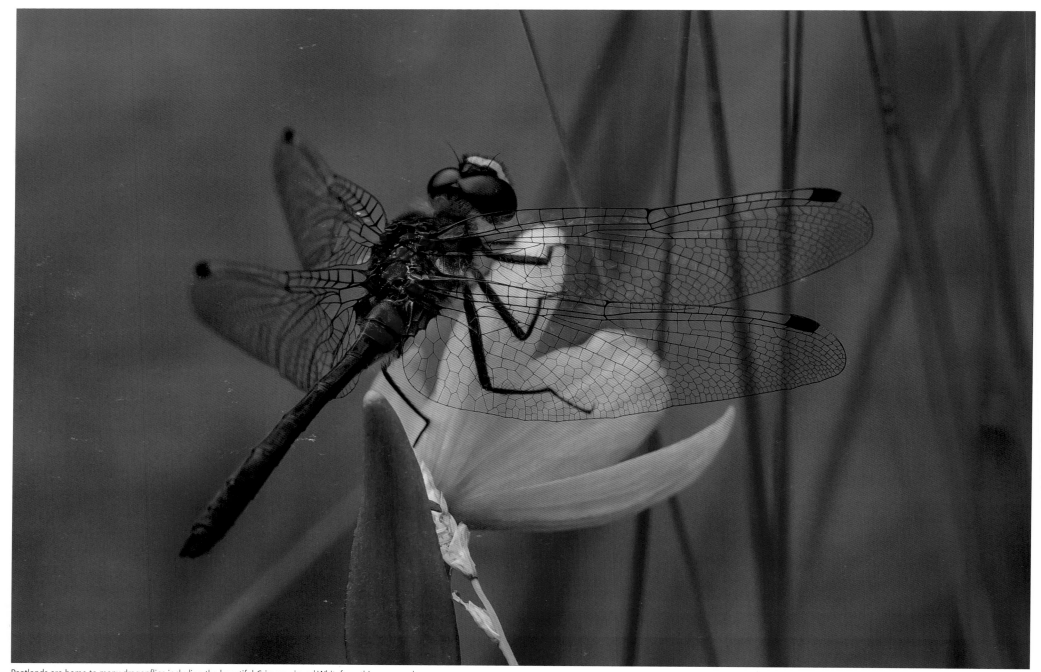

Peatlands are home to many dragonflies including the beautiful Crimson-ringed Whiteface, this one a male.

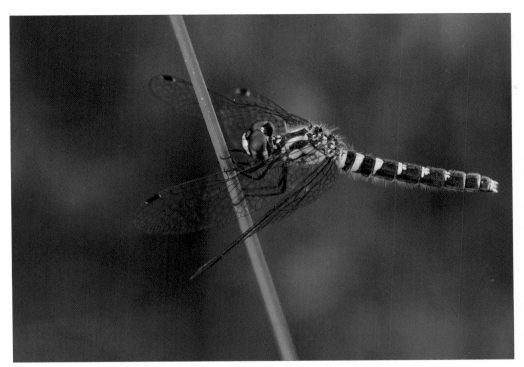

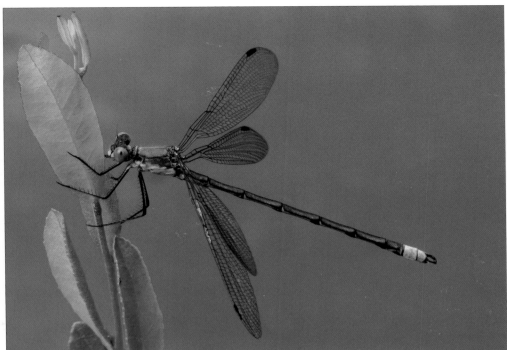

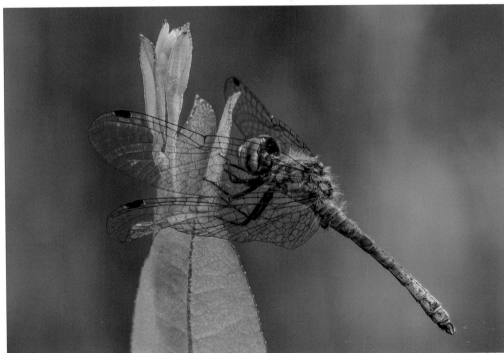

(top left and bottom) Elfin Skimmers are the smallest dragonflies in North America and the second smallest in the world. Because they stay close to the floating mat, you must look down to spot them. Females look like wasps (an appearance that undoubtedly provides protection) while the blue males develop a lovely white blush called pruinosity.

(top right) Unlike most damselflies, Amber-winged Spreadwings don't close their wings over their back, nor do they hold them open flat as do dragonflies.

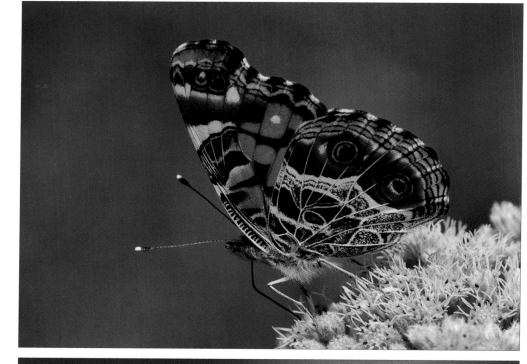

(top) Boneset attracts many butterflies including the American Lady, a species that migrates to Algonquin each year. They look quite like the Painted Lady, another migratory species, especially when their wings are open. When the wings close, however, two massive eyespots on the underside of American Lady wings make this species readily distinguishable. More importantly, the eyespots might fool predators into thinking they are encountering a much larger and therefore more dangerous animal..

(bottom) Dun Skippers may be one of the smallest and least colourful butterflies, but their chosen nectar plant, Swamp Milkweed, is anything but dull.

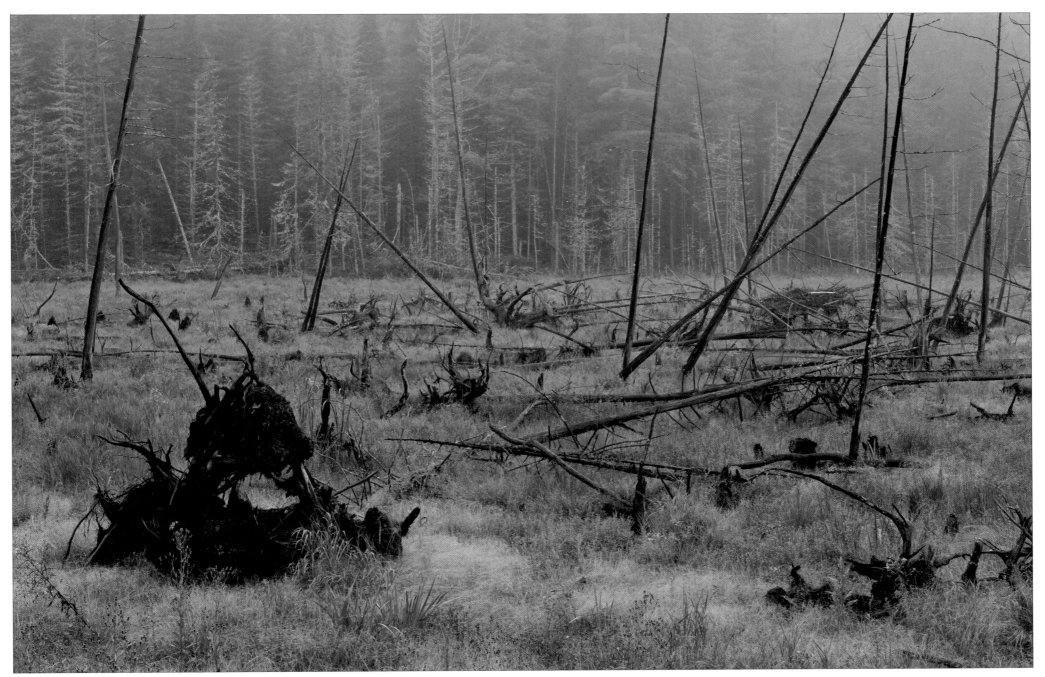

Lush meadows form when beaver ponds drain and their rich bottom sediments become exposed to the air. The once-active beaver lodge is visible in the back right corner of this meadow located along the Basin Depot Road.

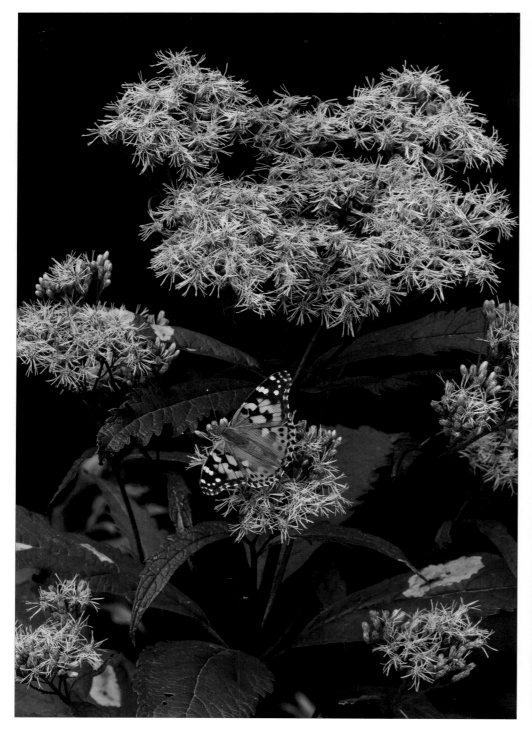

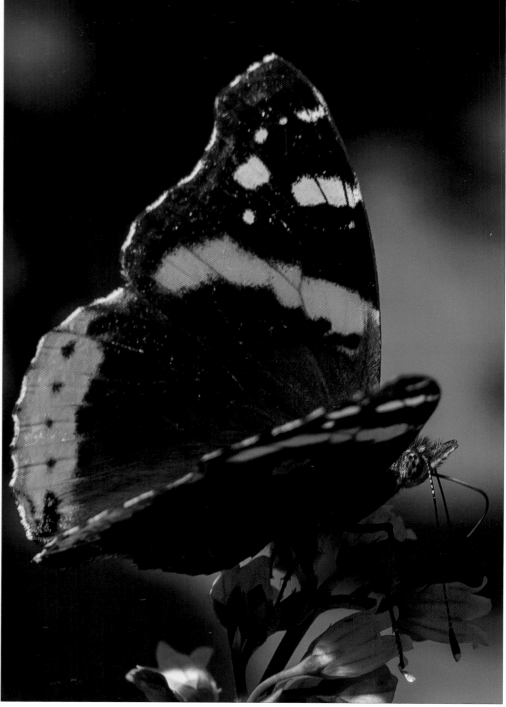

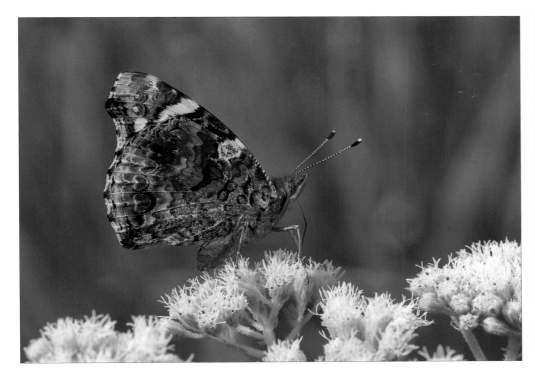

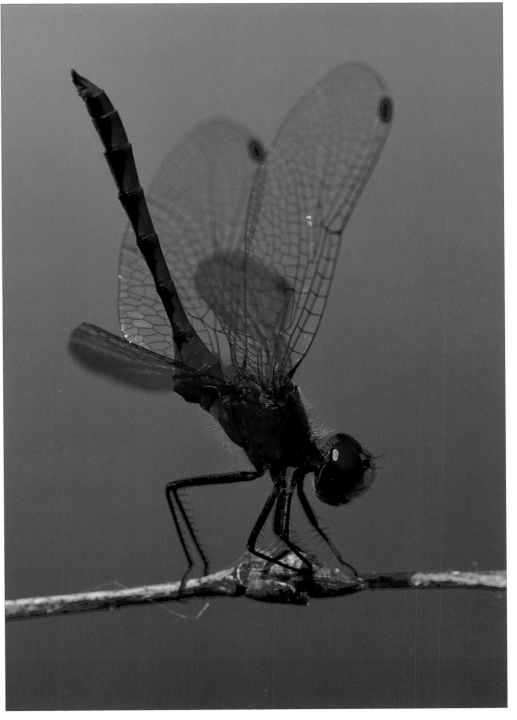

(opposite left) Joe Pye Weed is a misnamed plant for this beautiful wildflower is not only native (most "weeds" are not) but also is an important element of its habitat, with its flowers being very popular with butterflies, to which this migratory Painted Lady will attest. Painted Ladies occur in greatly variable numbers over the years, with particularly large influxes known as irruptions.

(opposite right) Red Admirals are admired for the striking colour of their opened wings.

(top) However, the undersides of those wings contain intricate patterns for camouflage that make this view an equally beautiful one. Red Admirals are not always found in Algonquin because nettles, the food plant of their larvae, are rare here, and only during major immigrations from the south are these beautiful butterflies commonly encountered.

(right) This White-faced Meadowhawk is keeping cool by raising its abdomen to reduce its exposure to the sun, a posture called the obelisk.

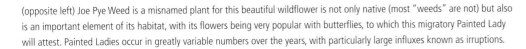

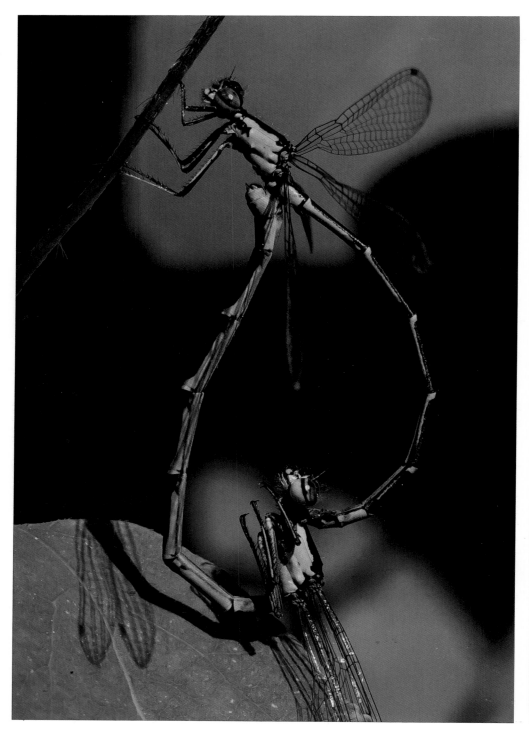
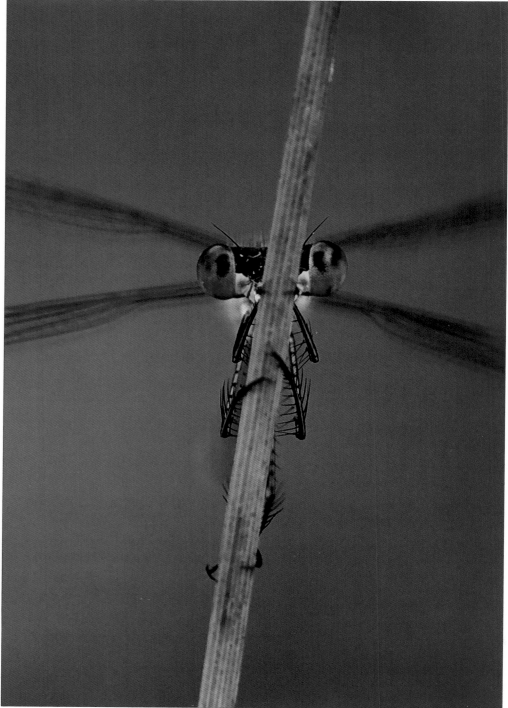

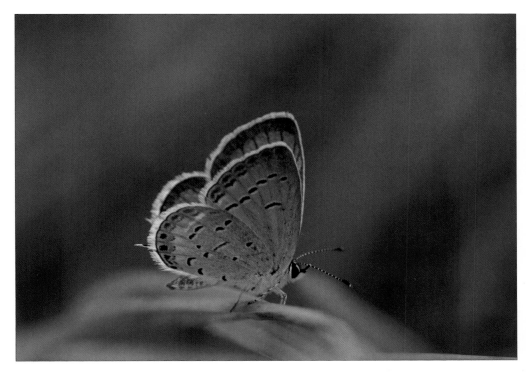

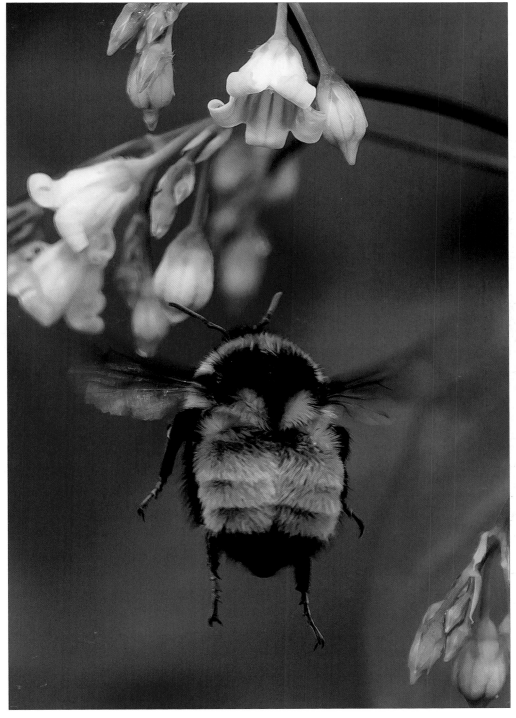

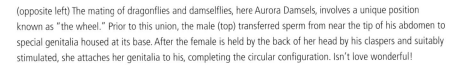

(opposite left) The mating of dragonflies and damselflies, here Aurora Damsels, involves a unique position known as "the wheel." Prior to this union, the male (top) transferred sperm from near the tip of his abdomen to special genitalia housed at its base. After the female is held by the back of her head by his claspers and suitably stimulated, she attaches her genitalia to his, completing the circular configuration. Isn't love wonderful!

(opposite right) Swamp Spreadwings do not appear to be very adept at hiding.

(top) There is more to a butterfly than meets the eye. The colourful spots and tiny tails on the hind wings of this Eastern Tailed Blue (encountered at Basin Depot, likely the first record for eastern Algonquin) are thought to make attackers believe those are its eyes and antennae. If attacked at this area, the butterfly escapes tail-less but alive!

(right) How Bumble Bees keep their heavy bodies airborne might seem puzzling, but there is no mystery as to their attraction to the nectar-rich blooms of Spreading Dogbane.

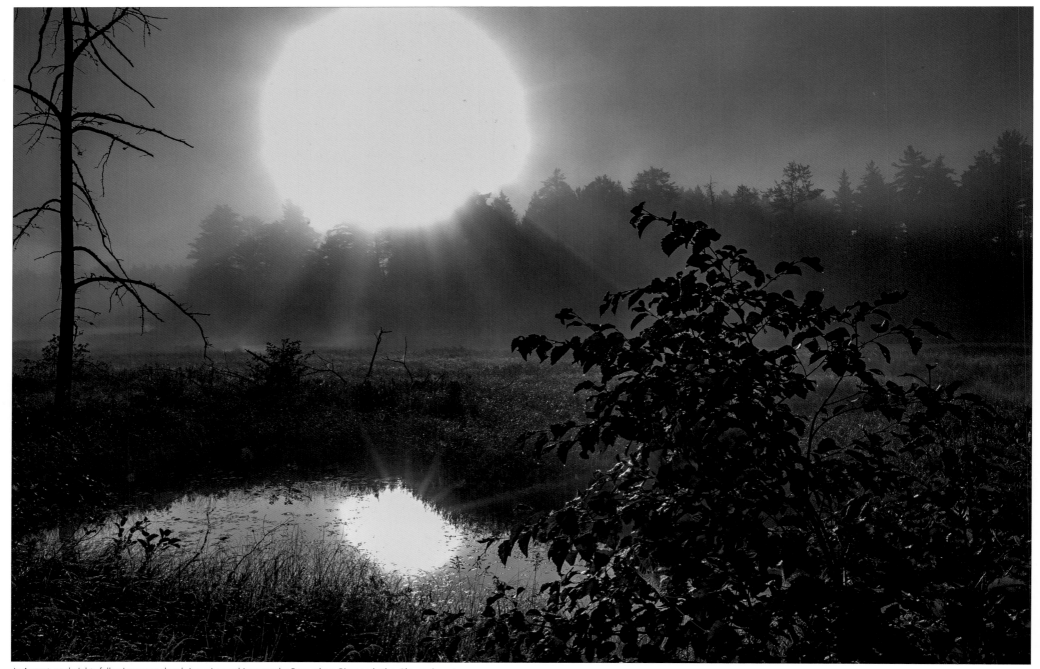

In August, cool nights following warm days bring misty ambience to the Bonnechere River and other Algonquin waters.

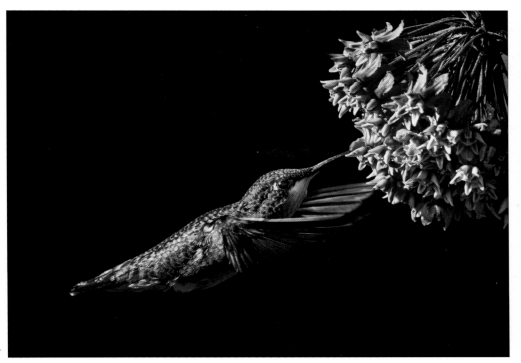

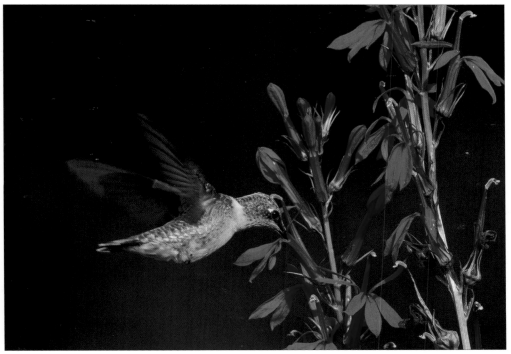

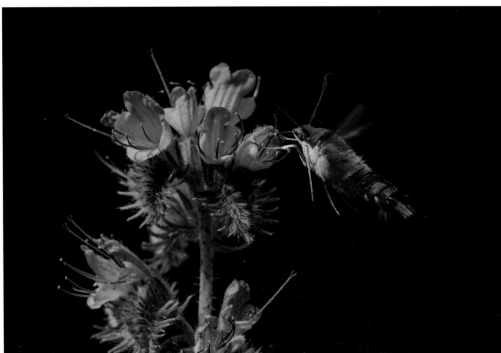

(top left) Common Milkweed attracts the interest of a large diversity of insects and even hummingbirds. However, this feathered visitor will do the plant no favours for it will not transfer the flower's saddlebags of pollen, which clamp onto the legs of its six-legged visitors.

(top right) By late July the shores of the Petawawa and Barron rivers flame with Cardinal-flowers. Red wildflowers are rare because most insects can't see that colour. However, hummingbirds do, which is why they are the only known pollinators of these gorgeous blooms.

(bottom) Blueweed or Viper's Bugloss is not a native plant but that is of no consequence to this Hummingbird Clearwing, a day-flying moth that hovers like its namesakes when getting nectar from flowers.

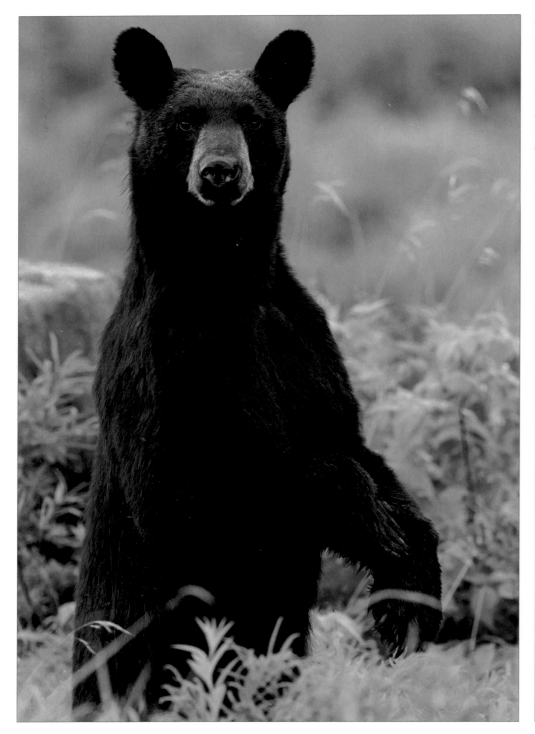

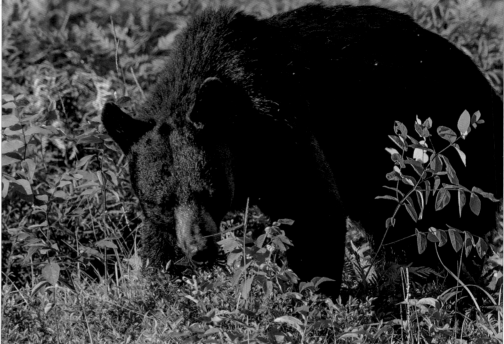

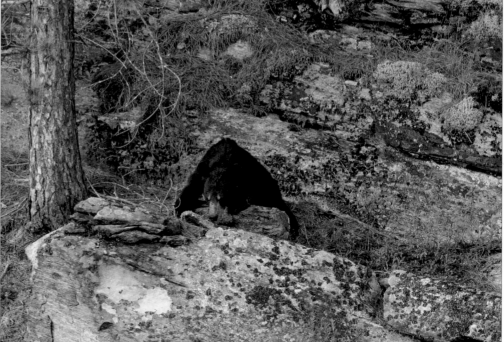

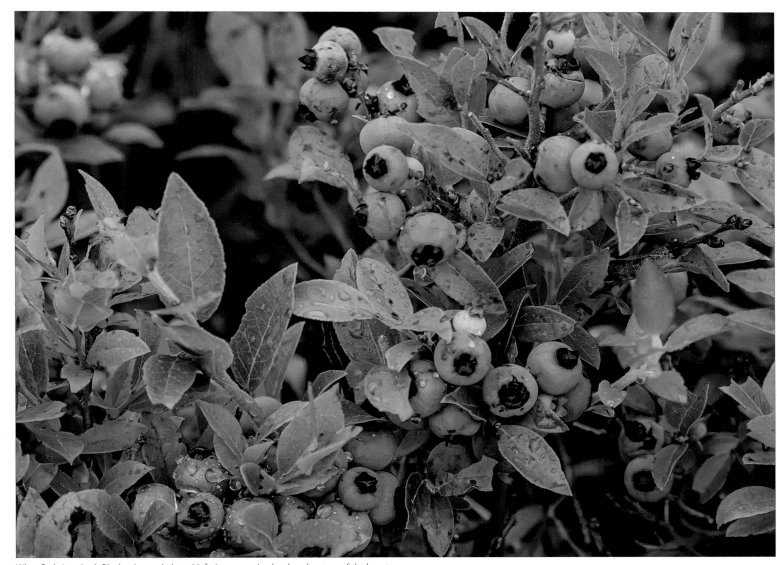

When Early Low-bush Blueberries are laden with fruit, many animals take advantage of the bounty.

(opposite left) When danger is sensed, bears will stand up on their hind feet for a better view.

(opposte top right) Black Bears love blueberries, using their tough tongues to pull the fruit from the plants. But as they do to other animals that eat berries, it is the plants exploiting the bears by using them to disperse their seeds to new locations.

(opposite bottom right) A Black Bear's diet is extremely varied and includes fruit, fish, and Moose calves, as well as wasp larvae and other insects found under rocks.

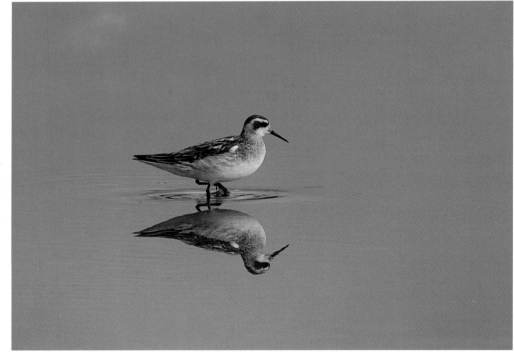

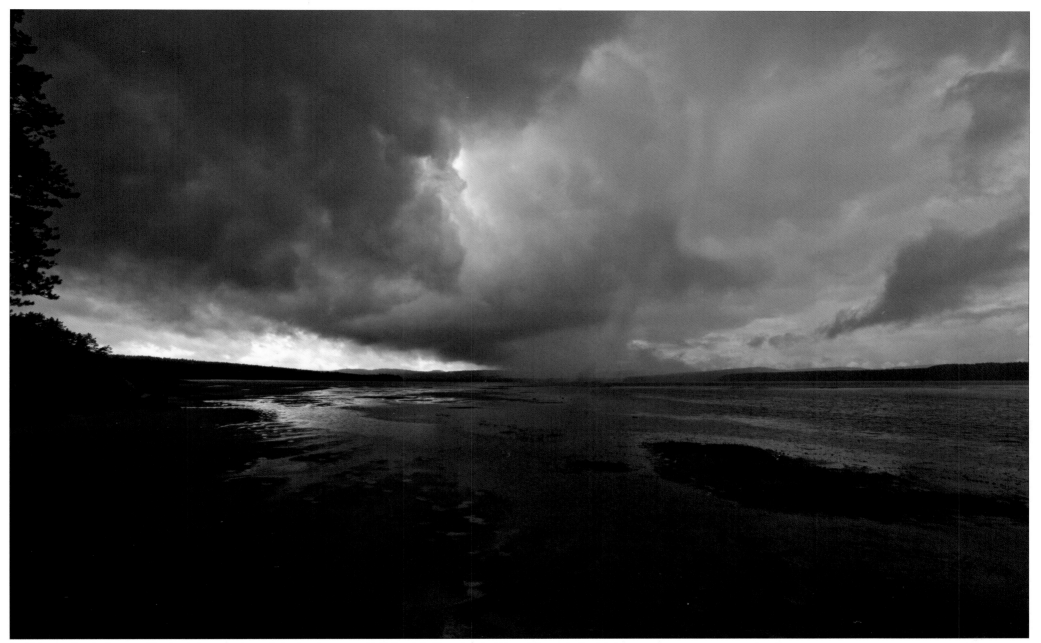

In mid-August when the Petawawa River is at its lowest level, great beds of sand are exposed in Radiant Lake. The arrival of cold fronts brings not only rain but also migrating shorebirds such as (opposite far left) Semipalmated Plovers and (opposite top) Least Sandpipers. The sand is not as rich in invertebrates as are the coastal mudflats where the Arctic-nesting shorebirds fatten up on their migration south, but they do offer a place to land during inclement weather. . Occasionally, rare visitors such as this Red-necked Phalarope (opposite bottom) make an appearance but with little to eat, they seldom linger long.

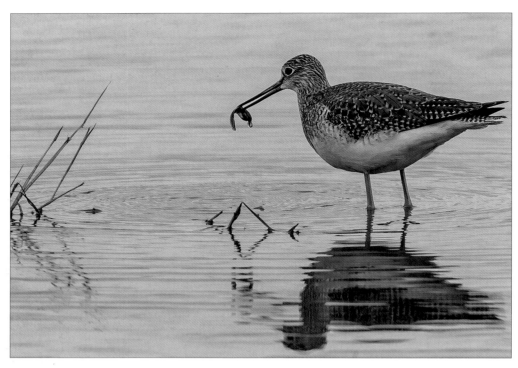

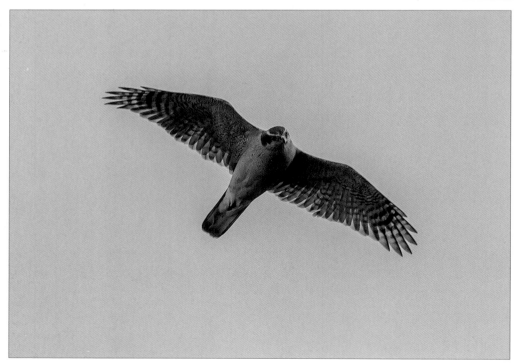

(top left) Greater Yellowlegs nest in Boreal Forest peatlands but during their migration are regular visitors to Algonquin. This one at Lake Travers was eating tadpoles.

(top right) The yellowlegs suddenly crouched down in the water and became motionless.

(bottom right) The reason for its alarm soon became apparent. Flying over the marsh was this Northern Goshawk, a resident species that captures prey as large as hares and grouse. It landed in a nearby tree and after scanning the marsh for several minutes, flew off, the sandpiper's defensive pose apparently rendering it invisible to the hawk's sharp eyes.

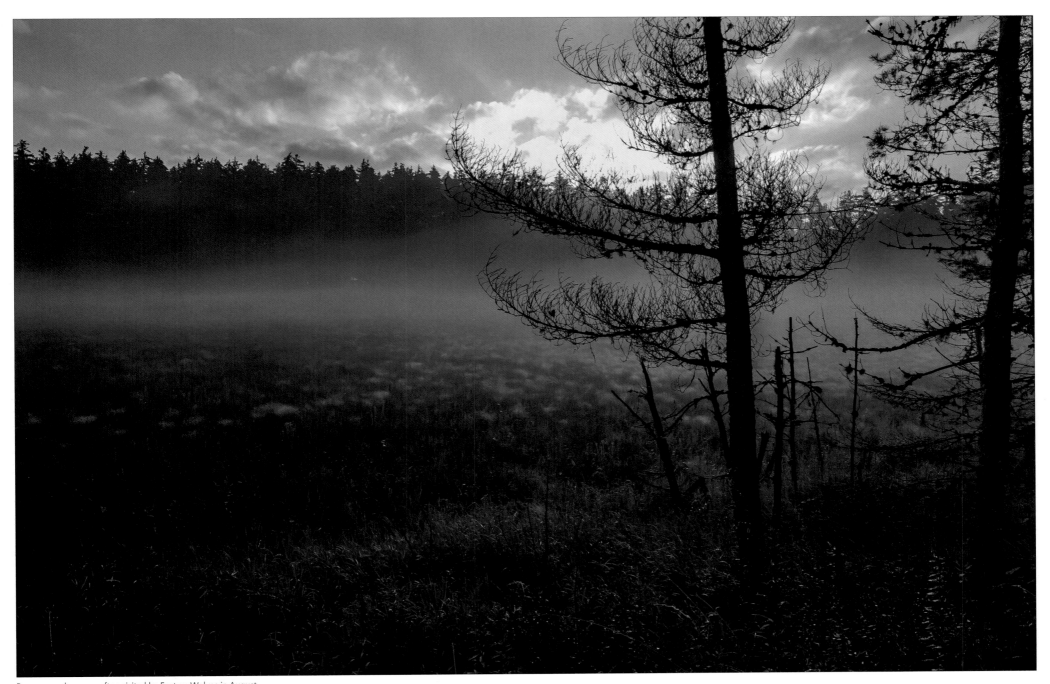

Beaver meadows are often visited by Eastern Wolves in August.

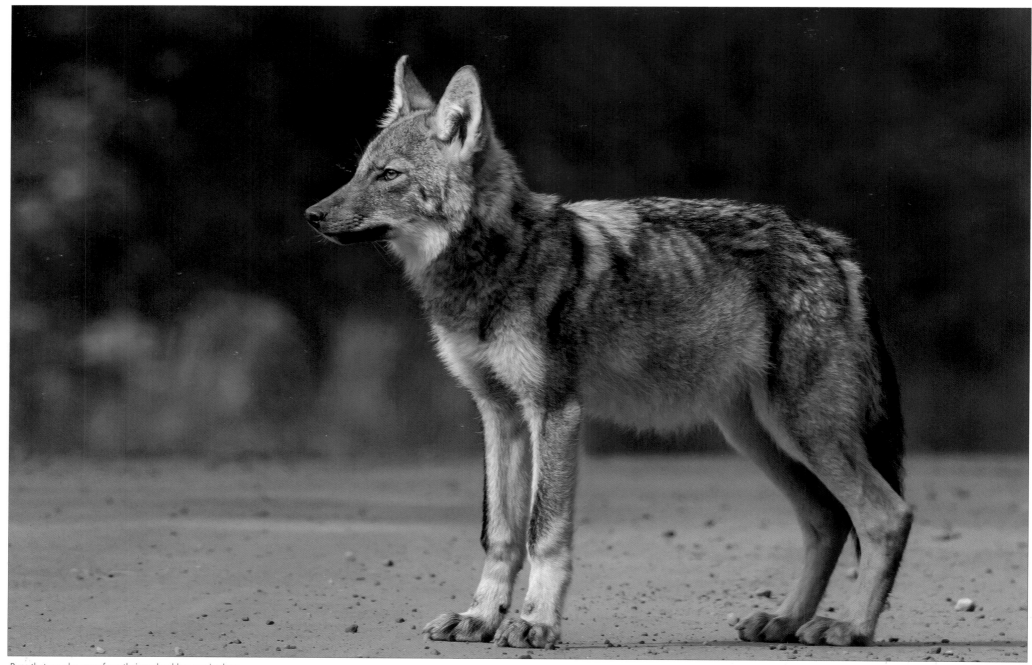

.Pups that wander away from their pack seldom survive long.

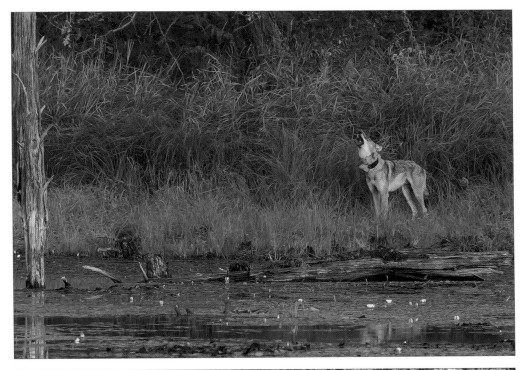

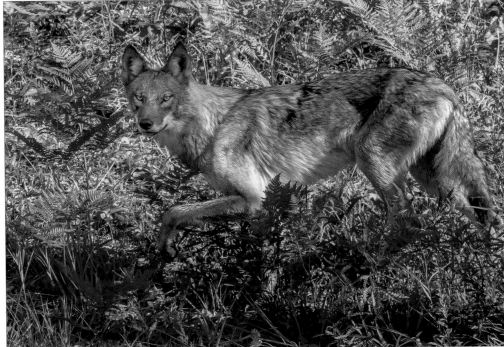

(top) Since the late 1950s, Algonquin's wolves have been well studied. Current research involves the use of collars bearing radio transmitters that allow researchers to track the wolves' movements, as well as locate their dens and kills.

(bottom) Sometimes called "Algonquin Wolves," Eastern Wolves were once thought to be a small race of Gray Wolves but were found to be genetically different and more closely related to the endangered Red Wolves in the southern United States. Around 35 packs with approximately seven or more members call Algonquin home for at least part of the year.

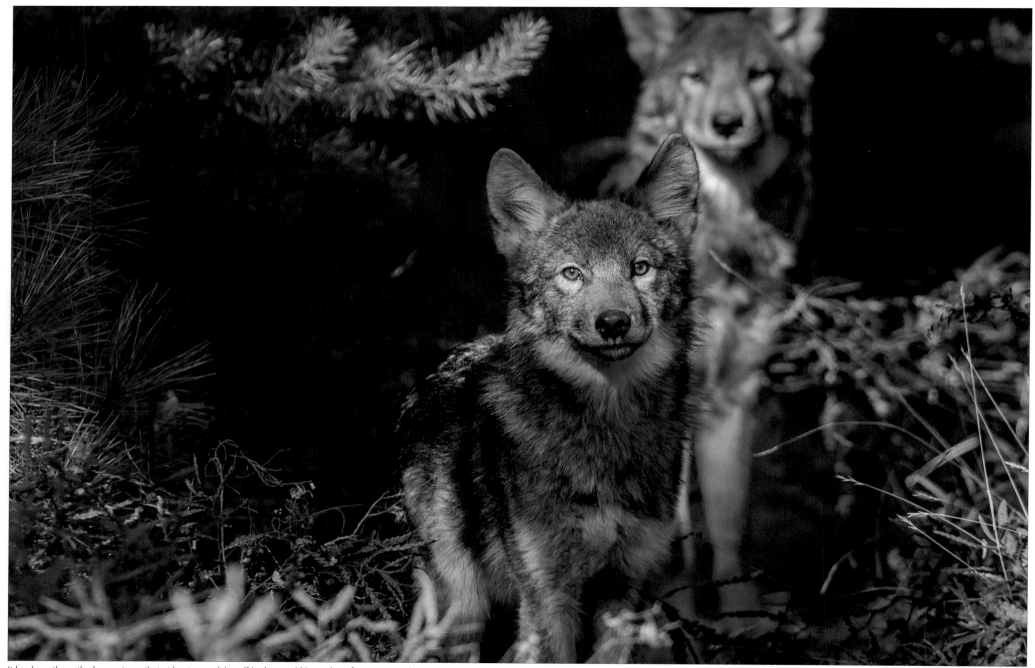

It has been the author's experience that at least one adult wolf is always within earshot of pups at a rendezvous site.

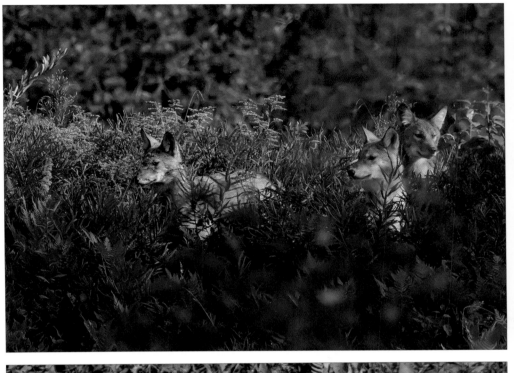

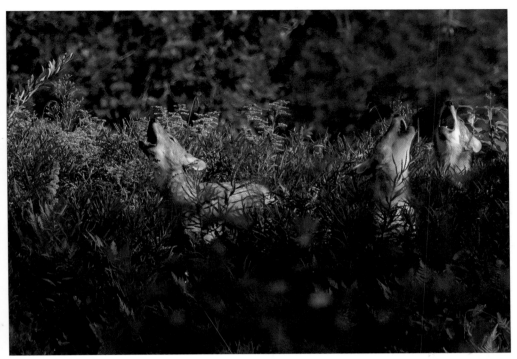

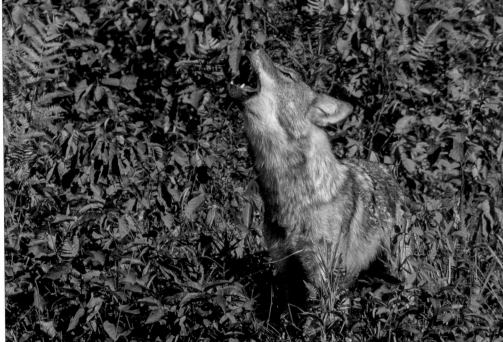

(top left) Wolf packs use beaver meadows as rendezvous sites, places where the pups are left when the adults go off hunting. Here, the pups play and eagerly await the return of the food-bearing adults with which they reconvene or "rendezvous."

(top right) Pups are always eager to howl.

(bottom) Wolves communicate by howling. Howls are low frequency calls that travel great distances, important for animals living in hilly, forested country. Howls serve, among other things, to tell fellow pack members where the caller is, and to warn strangers to stay out of a pack's territory, which can be as large as 150 km².

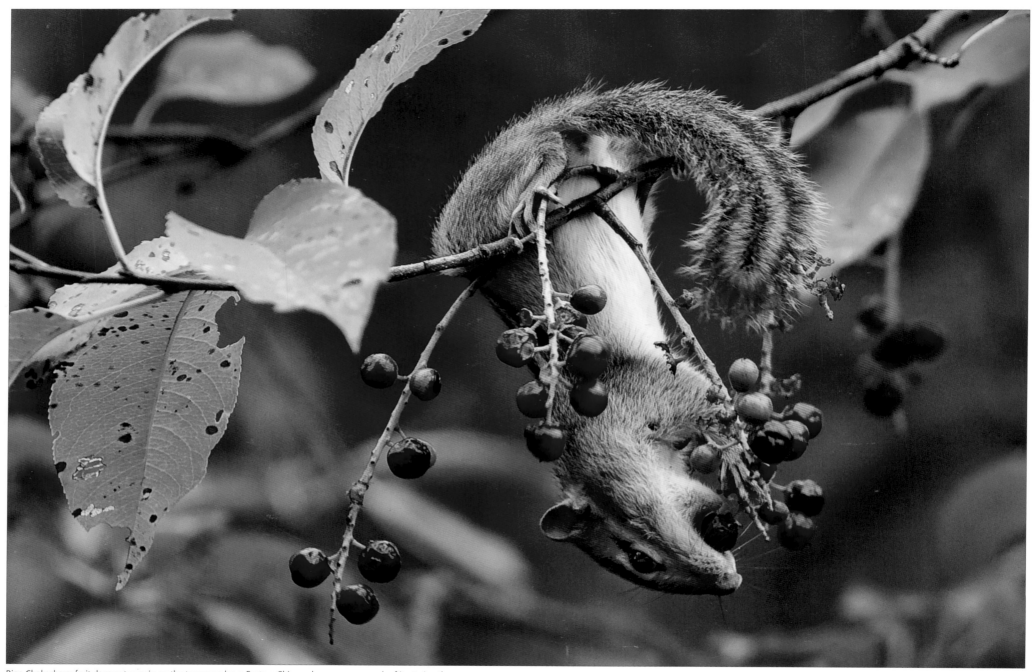

Ripe Chokecherry fruit does not remain on the trees very long. Eastern Chipmunks carry away much of it, storing the pits for winter consumption. They stuff as many cherries into their expandable cheeks as they can, making each trip to their underground caches energetically more efficient. Black Bears are also very fond of the sugar-rich fruit.

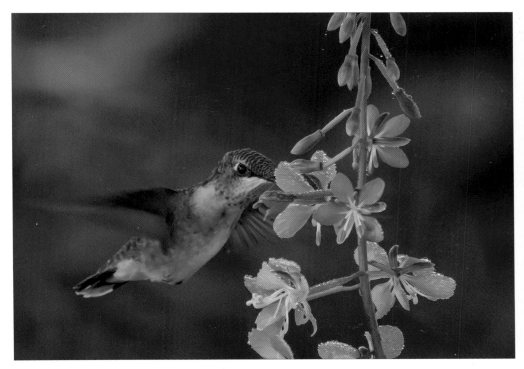

(top) While especially attractive to late summer insects including Bumble Bees, the beautiful blooms of Fireweed also attract hummingbirds.

(right) Fireweed gets its name from how it quickly colonizes burnt lands. It also grows quite well in other sunny, disturbed sites such as the edges of Algonquin roads.

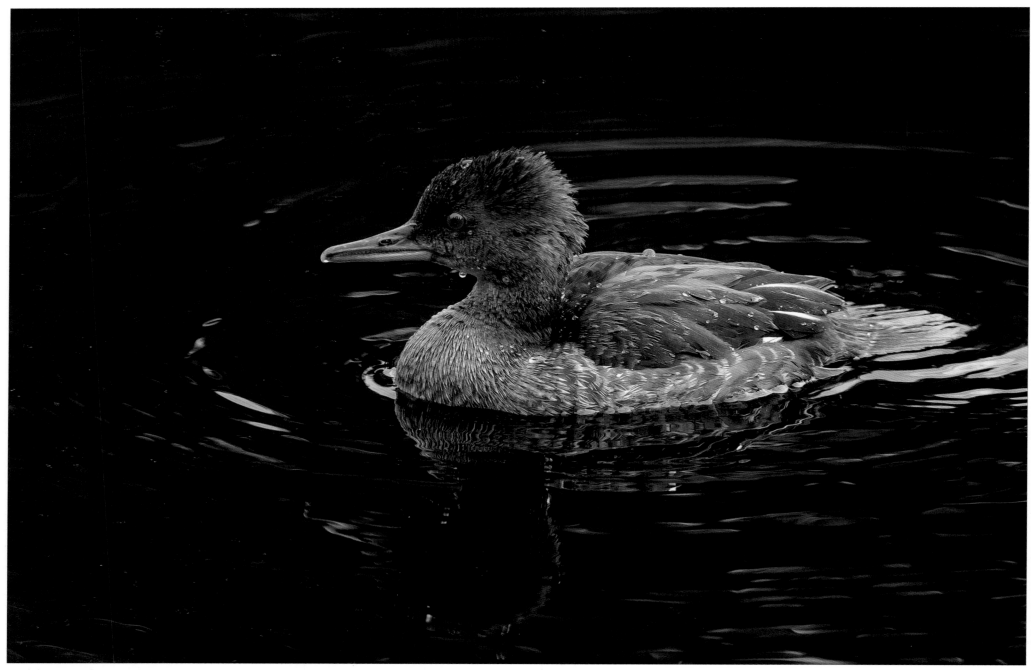

Hooded Mergansers (here, a youngster) eat aquatic insects as well as small fish and tadpoles. When they dive to catch a meal, the density of their feathers, which are treated with water-proofing compounds from their preen gland, keep water at bay so that when they emerge, it rolls off them just like, say, water off a duck's back!

(top left) Unlike chipmunks that destroy the plant's seeds, Cedar Waxwings do Chokecherries and other fruit-bearing trees a favour by passing out their seeds when they defecate, thereby acting as seed dispersers. This individual is at least two years old, its age revealed by the presence of the name-giving red wax-like barbs on its wings.

(top right) Common Branded Skippers are northern butterflies that range in Ontario no farther south than Algonquin. As do other butterflies, they use their long tongues to acquire salt and other minerals from moist soil.

(bottom) By the end of August this young Broad-winged Hawk, which dines primarily on reptiles and amphibians, will be on its way to South America where it will spend the winter.

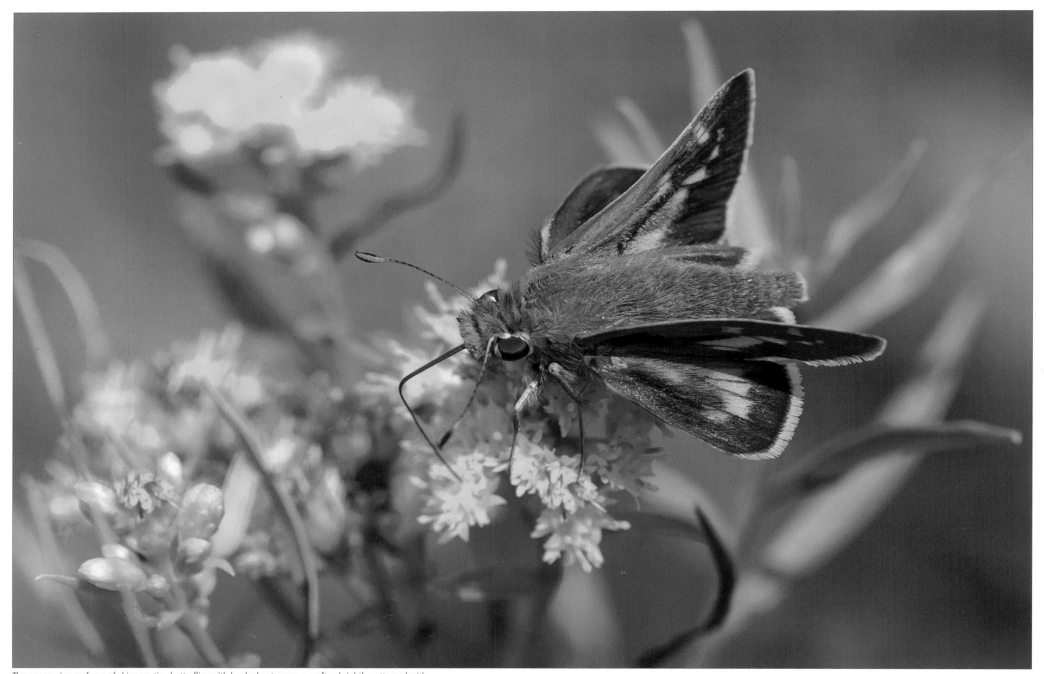

The upper wing surfaces of skippers, tiny butterflies with hooked antennae, are often brightly patterned with orange and black, like those of this male Leonard's Skipper, one of the last butterflies to fly each year.

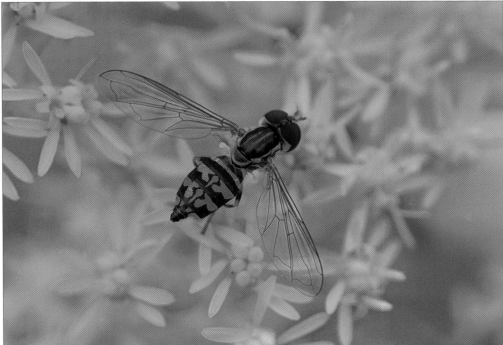

(top left) Goldenrods, being one of the last wildflowers to bloom, attract many late summer insects including butterflies such as this Common Branded Skipper.

(top right) Hay-scented Ferns are well worth a look when they start to lose their mask of green.

(bottom) Many Hover Flies, which are harmless insects, look like stinging wasps and bees. This visual similarity provides the flies with a certain degree of protection from other animals.

When touched by early frosts, the fronds of sun-loving Bracken, one of the most common and best chemically-defended plants in the world, turn to gold. Nearby, the dark green clumps of Sweet-fern, which are not ferns like Bracken but flowering shrubs, reveal that they are much hardier plants.

(top left) To remain elastic, spider silk attracts moisture from the air. In late summer, heavy dews coupled with an abundance of adult web-building spiders result in early morning displays of spectacular sculptures, such as these created by Sheet-web Spiders.

(top right) Many plants that retain their leaves through the winter, like this Wintergreen, contain dark anthocyanin pigments that help protect them from the cold.

(bottom) The first frosts add a touch of beauty to the leaves of blueberries and sedges.

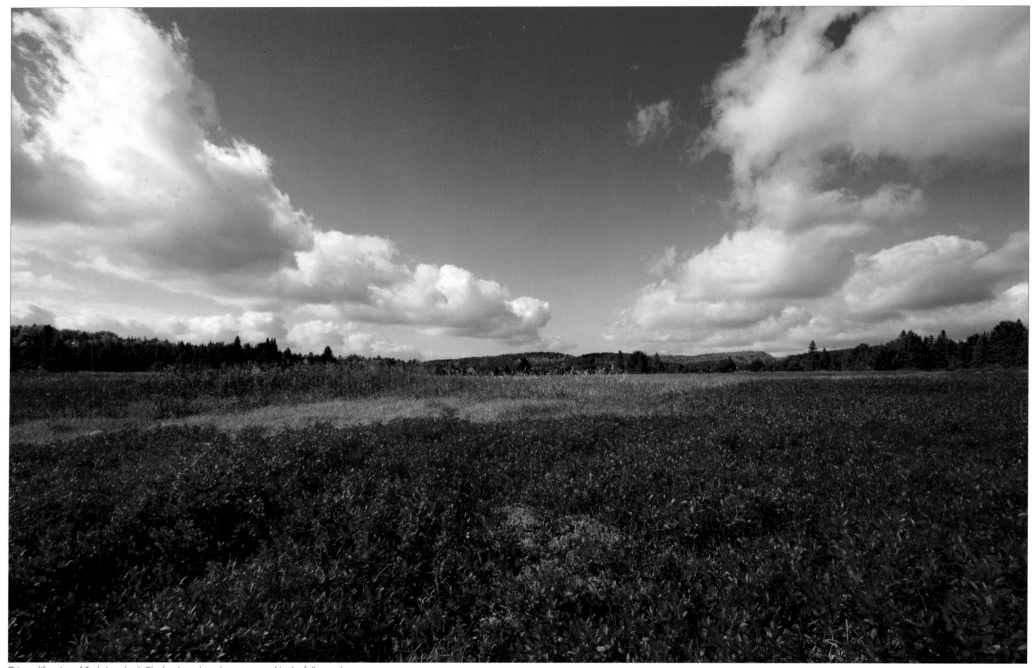

This proliferation of Early Low-bush Blueberries, whose leaves turn red in the fall, was due to a controlled burn performed on the Old Airfield near Mew Lake in April 2012.

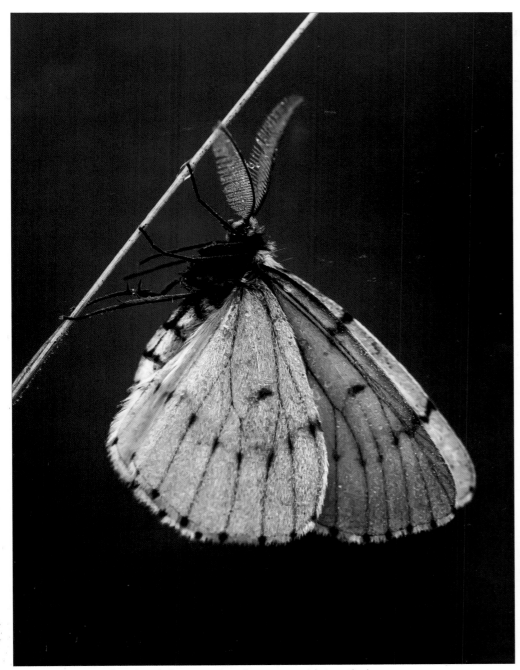

Chain-dotted Geometers fly at the end of summer and are often a common sight in peatlands because a number of plants eaten by the moth's caterpillars grow in that habitat.

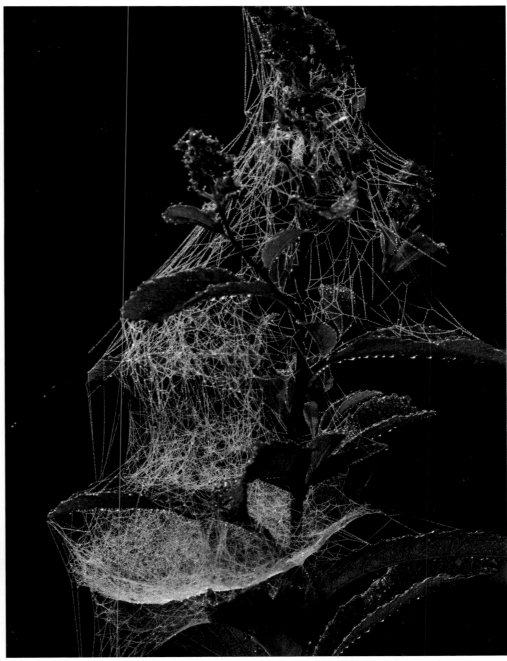

The vertical silk strands in a Sheet-web Spider's web knock down flying insects, which tumble into the sticky bowl beneath. As the dew evaporates from the silk, the web becomes invisible, allowing it to do its lethal work even better.

CHAPTER 4

AUTUMN

I love autumn in Algonquin. The night air is deliciously crisp but not freezing, the days warm but seldom hot. At night the bottomless darkness is punctuated by countless brilliant stars and the wide belt of the Milky Way, with the aurora borealis occasionally stealing the show. During the day the Park is alive with activity. Migrating birds, many recently arrived from the north, are busy fuelling up for their journey south. The fruit of Wild Raisin is popular with many of them; larger birds such as Hermit Thrushes and American Robins swallow the fruit whole, later acting as agents of dispersal when they void the seeds from their bodies. Smaller birds including White-crowned Sparrows devour the fruit's flesh. Chipmunks offer compe-

tition for the fruit but they mainly seek the pits, which they store for winter consumption. While Wild Raisin's fruit adds colour to the autumn scenery, its aging leaves bring distinctive odours. To some, their smell is pungent and unpleasant, but to me it is one of Algonquin's elixirs.

By mid-September, most bull Moose have lost the desire to eat; however, a very different appetite now replaces that need. Fall brings the mating season of Moose, the rut, a time when these giant animals break their silence and perform ritualized, elegant displays. The bulls roam widely, searching for cows that are nearing their oestrous, a condition announced by loud bawling calls and sexual perfumes released in their urine.

A bull's antlers play important roles during the rut. To a large extent their size and shape reflect their owner's health and maturity, thereby providing a basis for females to evaluate a suitor as well as for bulls to size up a rival. Bulls establish dominance through shoving contests called sparring. During such events, the combatants face each other, carefully touch antlers against

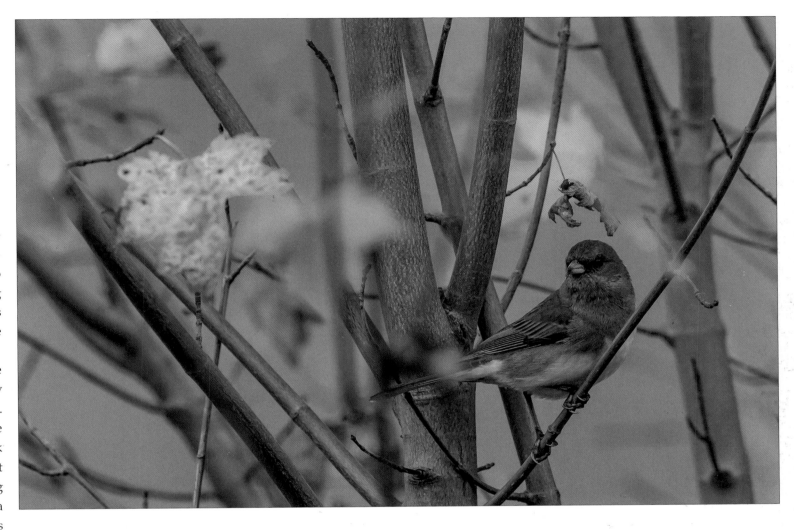

antlers, and then shove with all their might, their antlers clashing loudly as they slip, the sound resonating through the crisp autumn air. If neither bull breaks off the contest and signals defeat, gouged eyes or other painful injuries can result; on rare occasions death is the loser's penalty.

Although sparring occurs just before and during the rut, I have seen a fair amount take place after the rut is over. At this time

no prize awaits the winner, and the contests seem much less heated. When bulls spar in November or December, they push each other around for a while, then usually stop and eat side by side. I suspect that during these less serious contests the bulls learn who is who in the Moose world in terms of the power that lies behind their opponent's antlers, important knowledge to have when next year's rut arrives. Perhaps it is this

(opposite) The beauty of Algonquin's waterways such as Louisa Creek is further enriched when bordering trees turn their brilliant colours.

(top) By the time the leaves of summer have discarded their green veneer, Dark-eyed Juncos and other Park birds have begun their journey south.

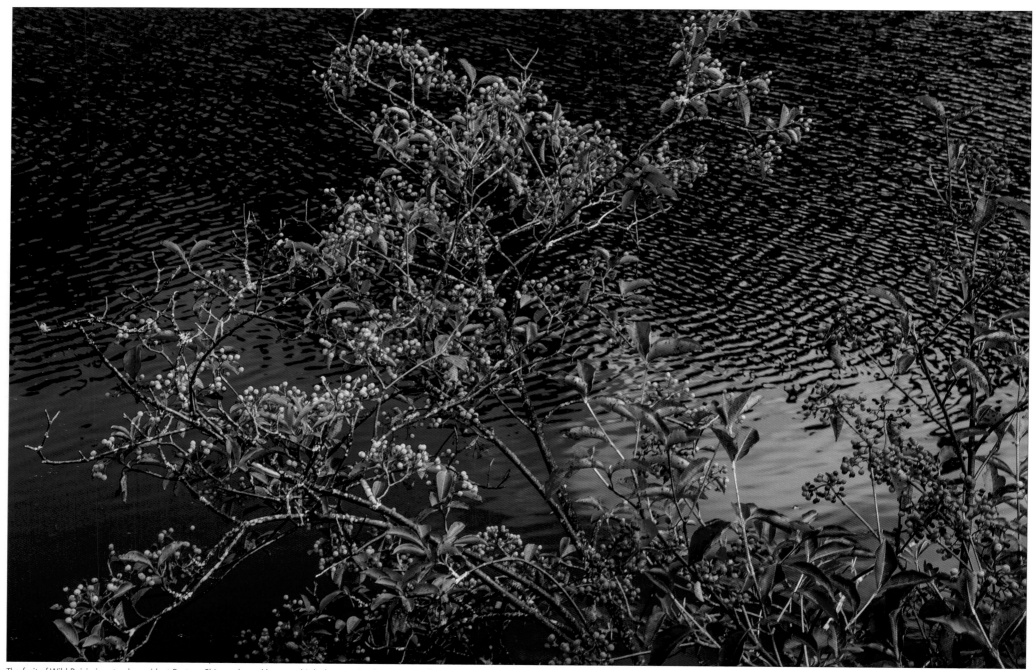

The fruit of Wild Raisin is eaten by resident Eastern Chipmunks and by many birds that stop in Algonquin to refuel during migration.

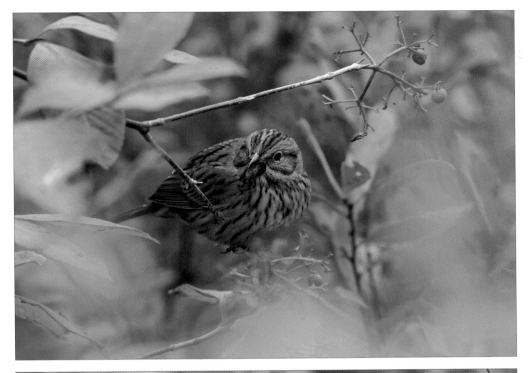

knowledge attained the previous year that causes a smaller-antlered bull to capitulate to a bull bearing larger antlers when it presents a challenge by slowly swaying its great head back and forth.

In autumn, most animals do not have mating on their minds. Many are busy storing food that will be their lifeline during the winter. Canada Jays stash thousands of edible morsels, using sticky saliva to glue them under bark and lichens. Later, during winter's long visit, they retrieve their caches with the aid of their remarkable memory. Blue Jays take advantage of their efforts by following them and stealing their stored food; Canada Jays do not take kindly to this thievery.

Eastern Chipmunks continue to harvest fruit and nuts through the early part of autumn, filling their expandable cheeks with multiple items to make each trip to their underground storage chambers energy-efficient ones. These little ground squirrels (which also are excellent climbers) vanish into their underground world by mid-fall. Hidden from view they spend

(top) Smaller birds like this Lincoln's Sparrow pick the flesh off the pits.

(bottom) American Robins and other thrushes swallow small fruit whole, and later poop out the seeds.

winter sleeping for a few days at a time, then awakening to visit their pantry and lavatory before returning to their slumber.

Red Squirrels remain fully active in winter and in preparation create numerous caches of pine and spruce cones under fallen trees and in underground crannies. Some of the pantries contain mushrooms that were first hung over branches to dry before they were stashed away.

As the days shorten and the nights lengthen, Beavers become increasingly active. Their lodges in which they will spend much of winter receive liberal coats of insulating mud dredged from the bottom of their pond. Beavers also spend a lot of time out of the water, harvesting woody material to be eaten in winter. Small shrubs and large branches are dragged down well-worn trails to the water where they are towed to a cache known as a food pile. Here, they dive to position poplar branches and other preferred items under the surface raft of sticks, which usually consists of less edible items and serves as ballast to keep the choice foods below the ice and accessible through winter. The food pile is created next to the lodge to keep short the Beavers' underwater journeys, thereby conserving their energy. When ice starts forming across the pond overnight, channels leading from the lodge to the shore and food pile are kept open. Beavers break the ice not with drinks and little sandwiches but by coming up from beneath the frozen surface and bumping

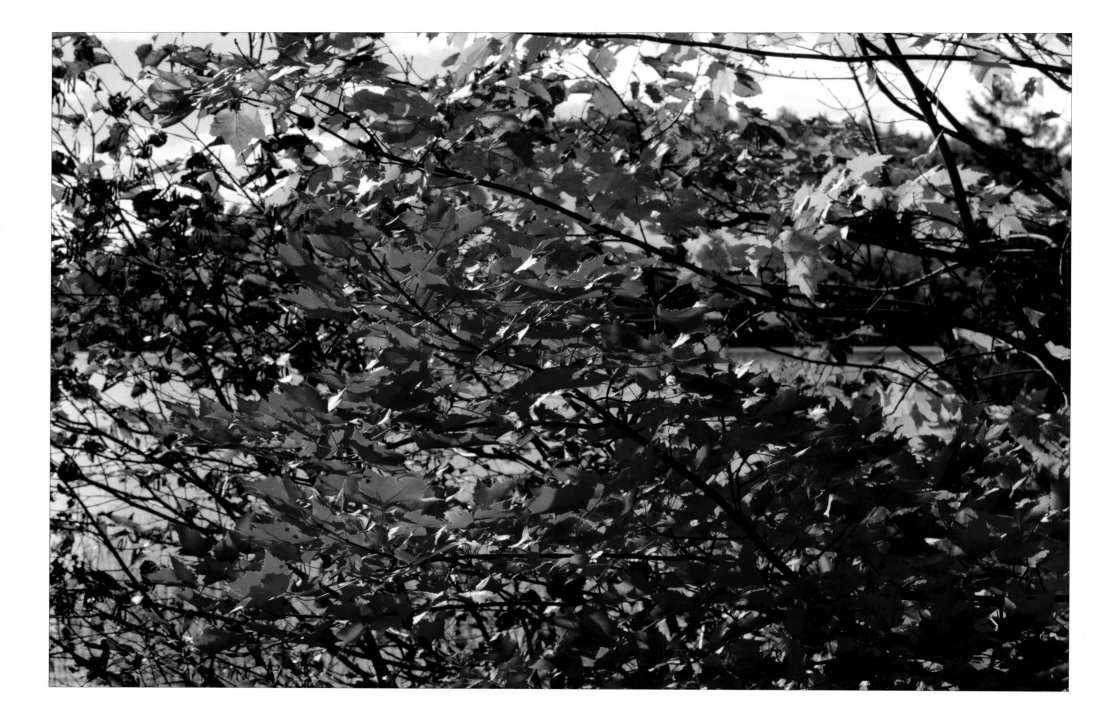

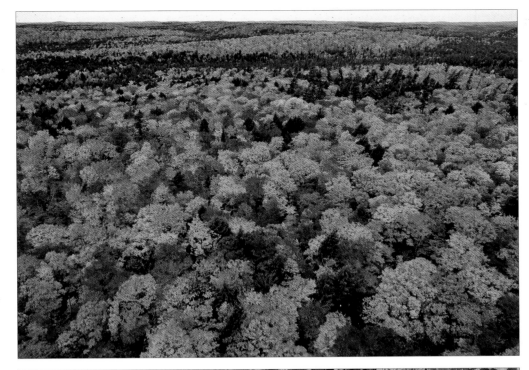

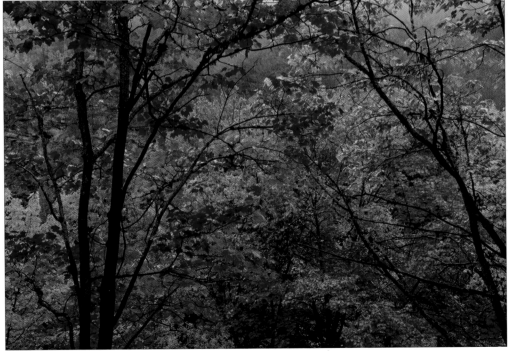

it with the back of their head. When the ice becomes too thick to break, they stop harvesting branches and spend much of their time inside the safety and comfort of their lodge, leaving it through one if its two underwater entrances to retrieve meals from the food pile or from the bottom of the pond (water-lily rhizomes are also eaten in winter).

Long before the ponds and lakes freeze over, dramatic changes take place in forests around them. By mid-September, the leaves of the hardwoods start to change colour, eventually putting on one of the most beautiful shows on Earth. Most of the leaf colour is present all summer but only becomes visible when the green veil of chlorophyll starts to break down. When the green in the leaves is completely gone, the hills blaze orange, yellow, and red, the latter colour often produced in the fall to prolong the life of the leaves, thereby providing more time for the tree to pull precious nutrients from the leaves before they drop lifelessly to the ground beneath. The timing and intensity of the peak of the fall colours varies from year to year, with several factors including temperature and amount of summer precipitation being part of the equation.

(opposite and bottom) Algonquin's fall
colours are unrivalled for their beauty.

(top) From the air, the extent of the western highland
hardwood forest is more than impressive.

The change in the photoperiod (the ratio of light to darkness) is one of the triggers that initiate cold-hardiness (the ability to survive sub-zero temperatures) in plants. Another occurs when overnight temperatures drop chillingly low but remain above the freezing point. After their acclimation is over, trees are ready for the onslaught of winter, some being able to survive temperatures as low as -80°C. Fortunately for trees and humans alike, Algonquin never sees temperatures quite that low!

A handful of special animals tolerate the formation of ice inside their bodies, an ability known as freeze tolerance. By late fall, Gray Treefrogs, Wood Frogs, and Spring Peepers lie dormant near the soil's surface, with half their body water eventually turning to ice. Just as it does in plant tissue, ice forms between their body's cells, not inside them, which would be fatal. Hatchling Painted Turtles are the only reptiles to own this remarkable adaptation, one that allows them to remain over winter in the nests in which they hatch. Oddly, that ability is lost after the turtle's first winter.

Many ectothermic ("cold-blooded") animals avoid the lethal effects of sub-zero temperatures by escaping it. Snakes migrate below the frost line where they go dormant in a hibernaculum. Snapping Turtles and Green Frogs move to the bottom of ponds and lakes. Many insects spend the winter as eggs or pupae, using glycerol or other antifreezes to keep them unfrozen when the mercury plunges.

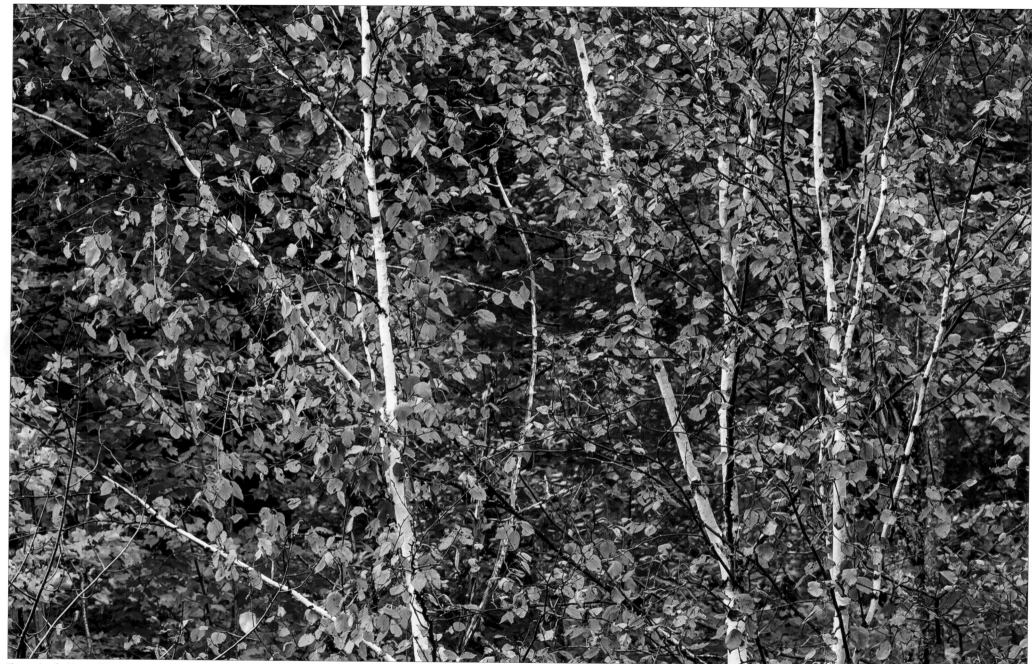

The trunks of White Birch add striking contrast to the palettes of autumn leaves.

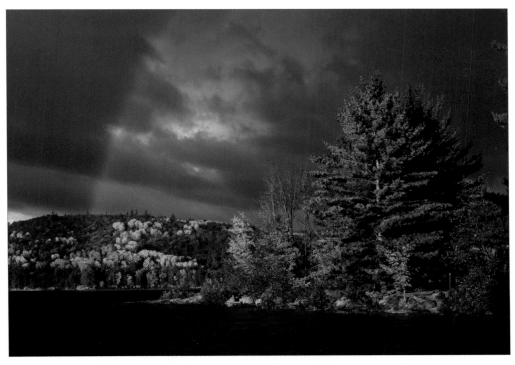

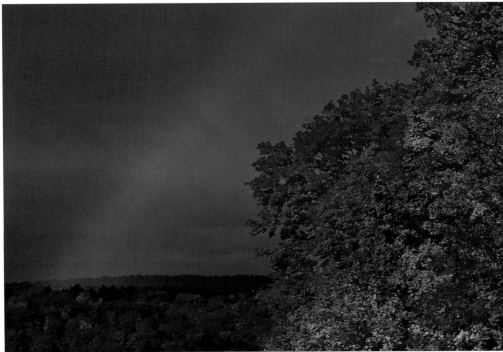

Whether a rainbow falls on the western or eastern hills of Algonquin, a pot of gold lies at its end.

However, some animals do remain active and face winter's killing temperatures. In fall, they prepare for the cold by putting on extra layers for warmth. Next to the skin of mammals develops a dense coat of underfur, which is analogous to the down coat of birds. Over this heat-retaining layer grows a thicker coat of guard hairs (in birds, contour feathers) that adds extra insulation as well protection from wind and blowing snow.

By the time November winds have torn all remaining leaves from the trees, and the gold of Tamaracks has faded, only a scant few of the Park's rich mixture of animals remain active. Those that do will soon face the severest of challenges, gruelling tests of survival that many will fail to pass.

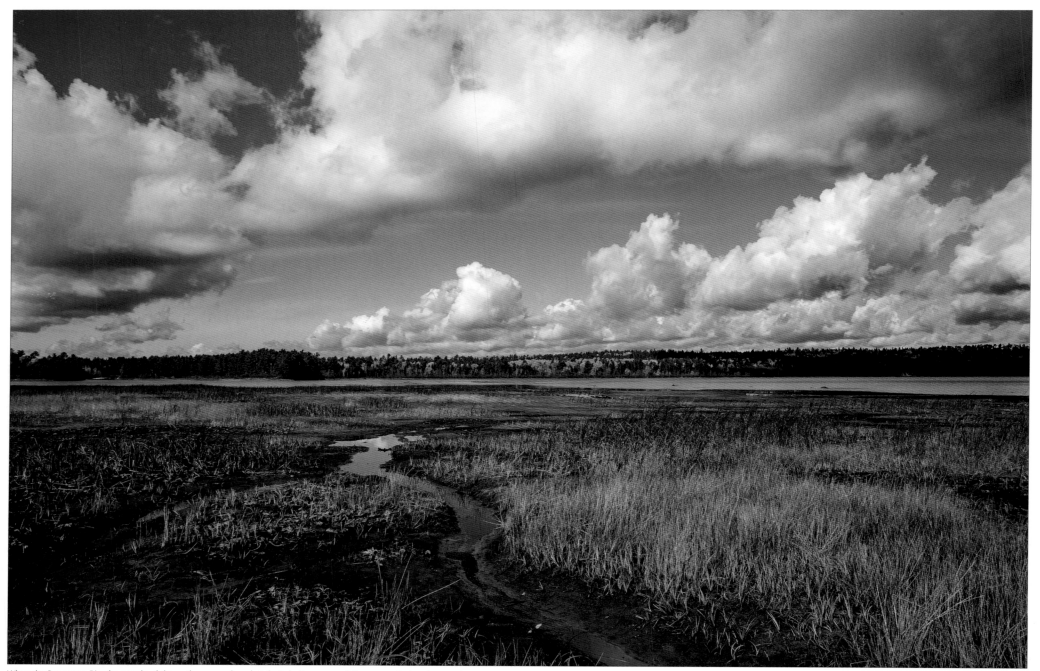

When the Petawawa River's water level drops, the exposed mud at the Lake Travers marsh becomes a lush sedge meadow.

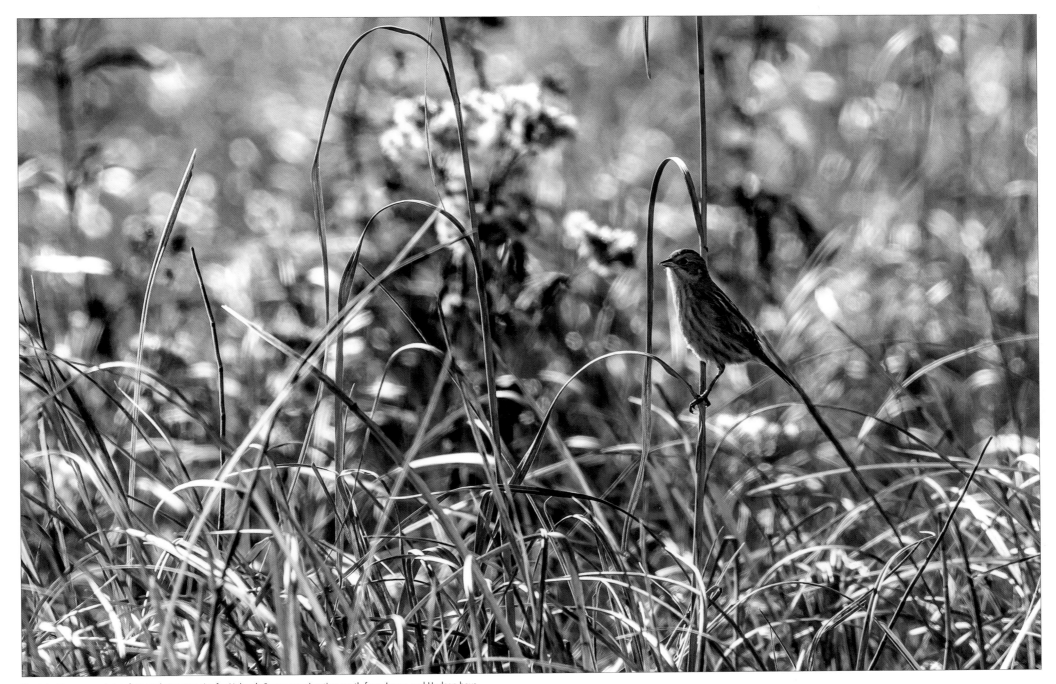

The Lake Travers marsh is a favoured stopover site for Nelson's Sparrows migrating south from James and Hudson bays.

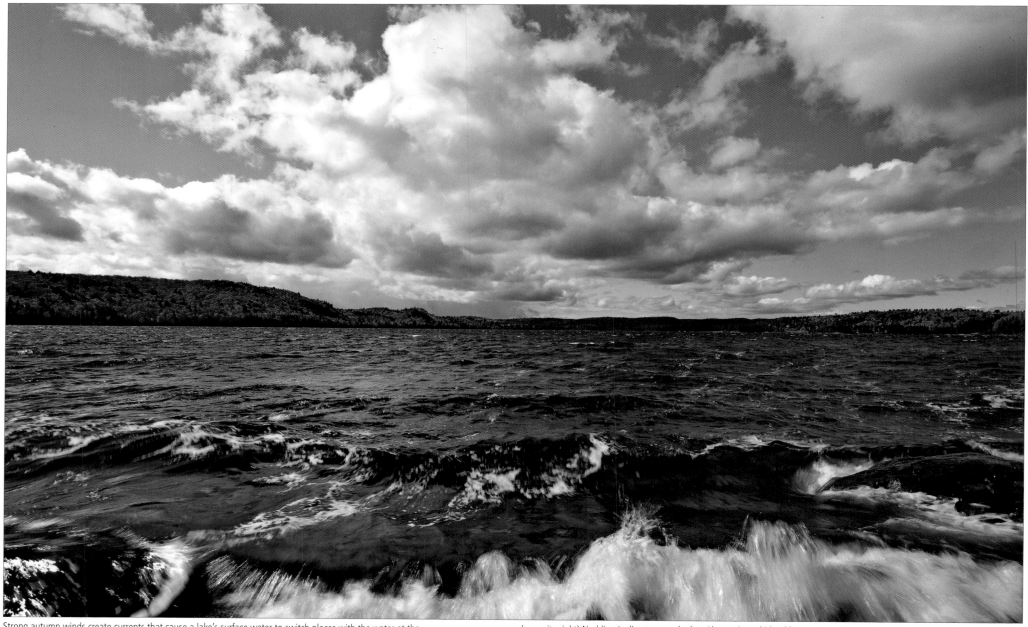

Strong autumn winds create currents that cause a lake's surface water to switch places with the water at the bottom, bringing oxygen down and nutrients up (a phenomenon that Dan Strickland called a lake taking a "deep breath"). The fall turnover has a spring counterpart that is called, of course, the spring turnover!

(opposite right) Nodding Ladies-tresses, the last Algonquin orchid to bloom, are sun lovers that thrive in the seasonally exposed shore along the edge of the Lake Travers marsh. They also grow in other damp, sun-drenched habitats through the Park, even roadside ditches.

(opposite left) If an insect doesn't visit the blooms of a Nodding Ladies-tress, pollination still occurs since this species and its close relatives self-pollinate, a feature that allows these orchids to quickly colonize new habitats.

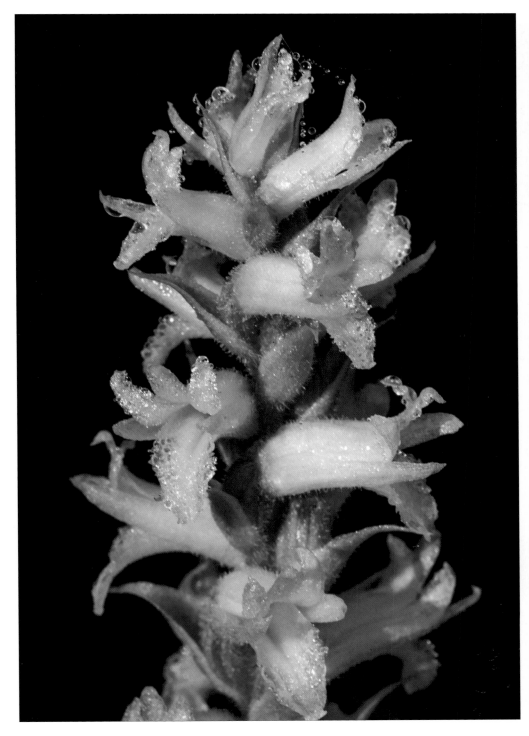

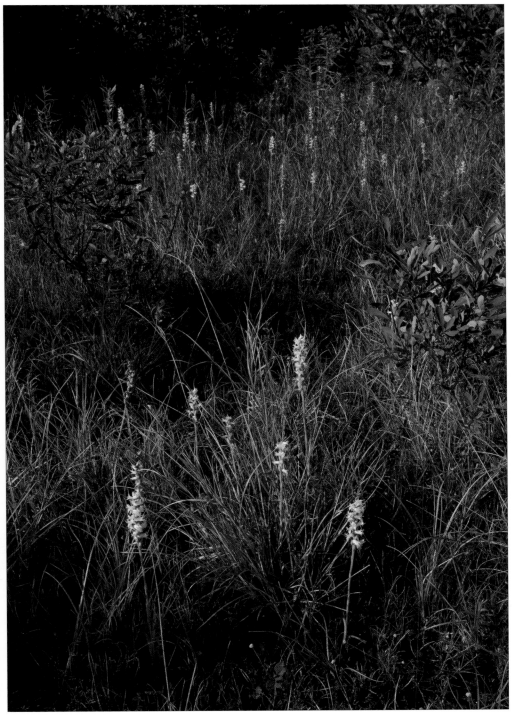

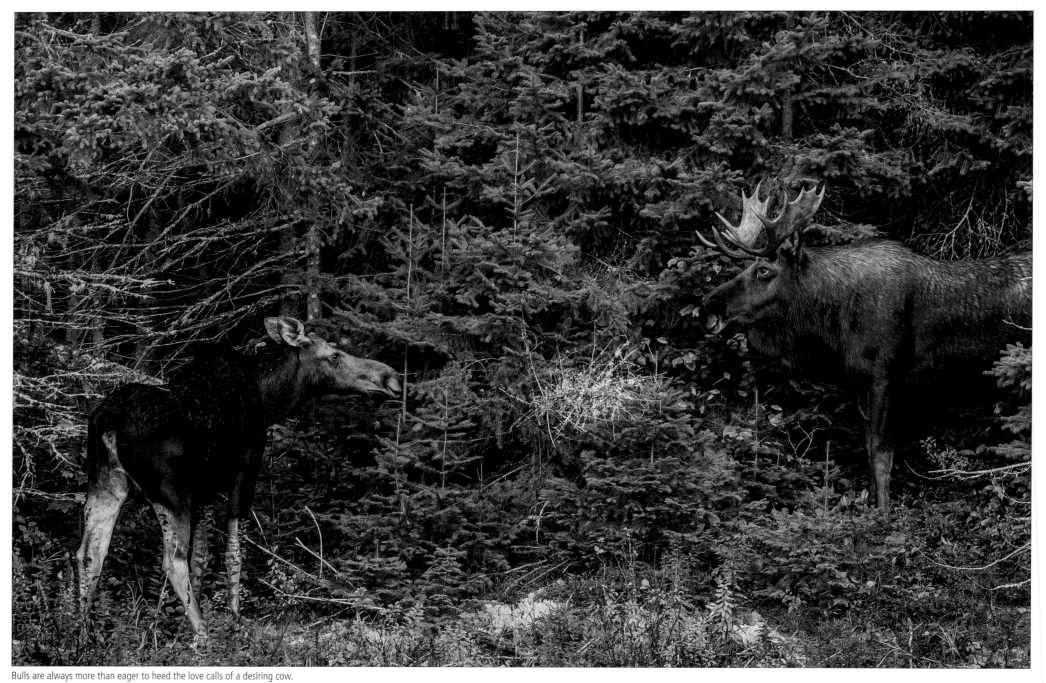

Bulls are always more than eager to heed the love calls of a desiring cow.

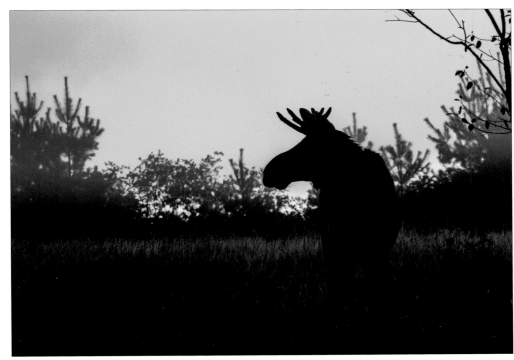

Young bulls like this one seldom get to breed but they certainly would like to try.

(right) Autumn brings the rut, the Moose mating season. The cows advertise their readiness to mate by calling through the night into the dawn from open sites like this beaver meadow.

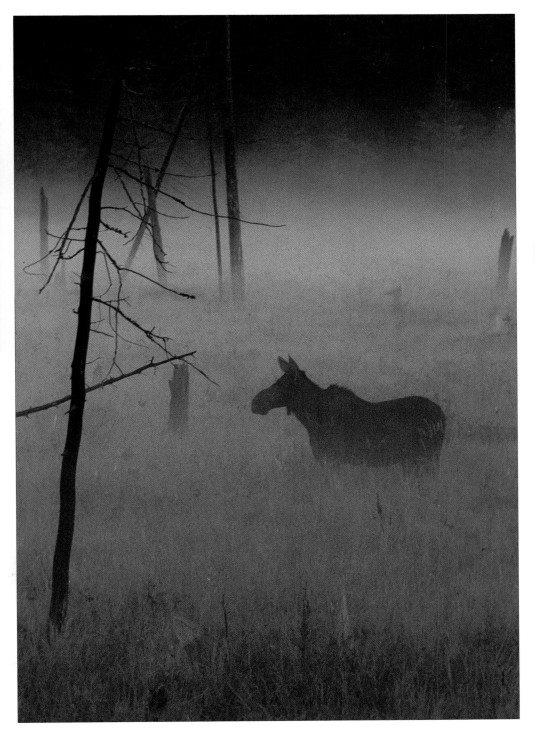

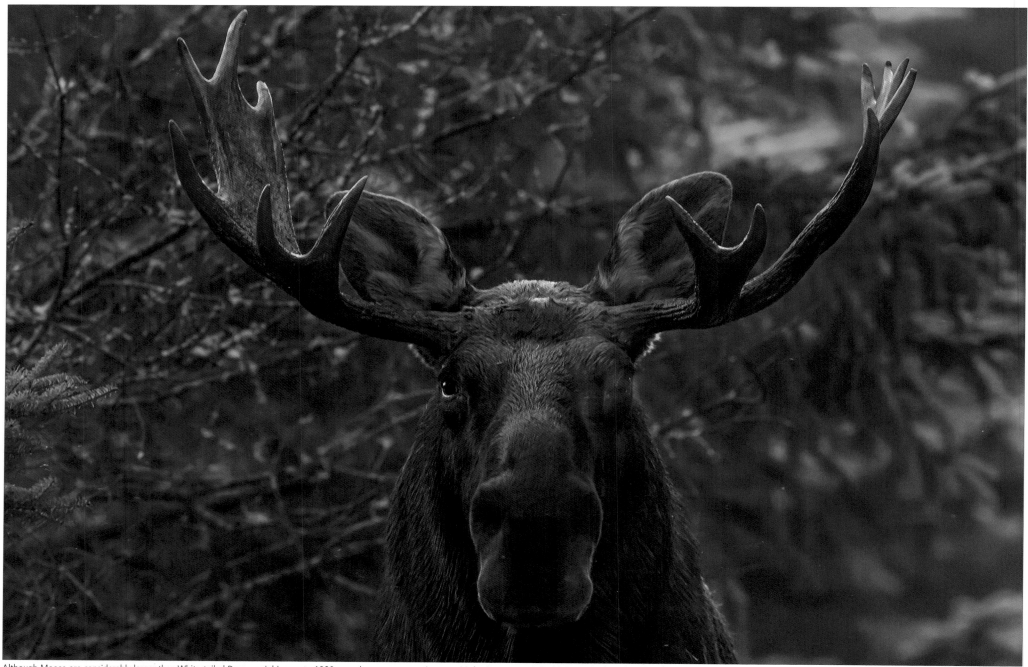

Although Moose are considerably larger than White-tailed Deer - weighing up to 1000 pounds or more - one tiny parasitic brainworm carried with immunity by a deer can kill even huge bulls like this one. When deer became abundant, Moose all but vanished from Algonquin and when deer declined, Moose rebounded, the parasite undoubtedly playing a role in the population changes. Over the past two decades, Moose have declined dramatically not only in Algonquin but all through their eastern range, with parasites being only one of several reasons suggested.

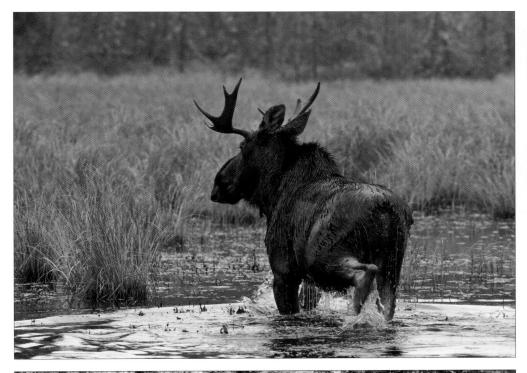

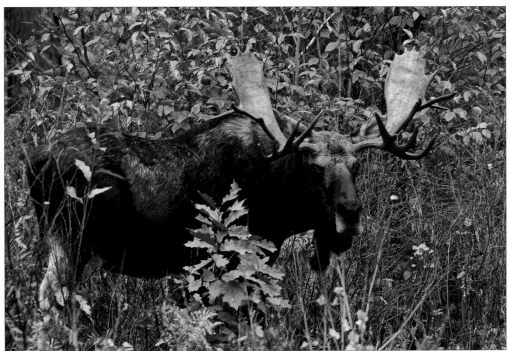

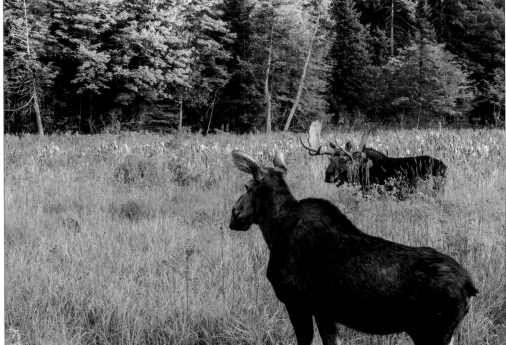

(top left and top right) A healthy bull Moose's antlers grow larger and more impressive each year, until he reaches his prime, which is roughly between his seventh and tenth year. The size and shape of a bull's antlers help determine if he will be successful in passing on his genes.

(bottom) While this bull might be a bit past his prime - his age indicated by the shortness of the antler tines (points) on the upper part of the antler palms (flats) - that appears to matter little to this cow. .

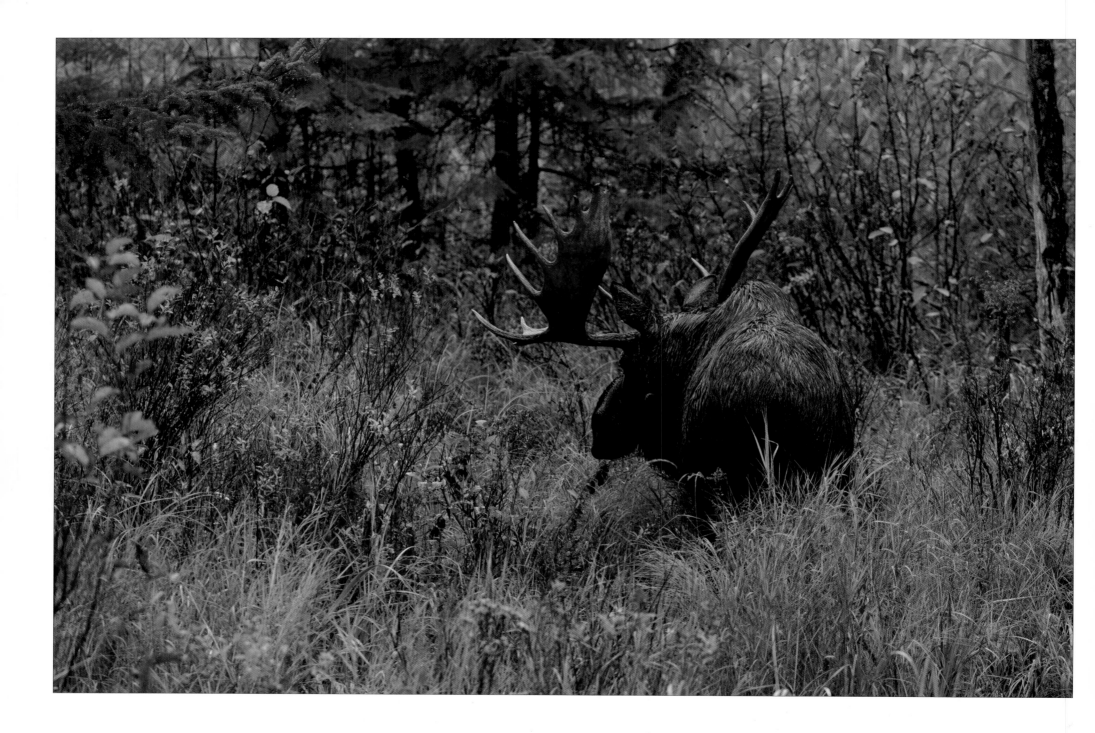

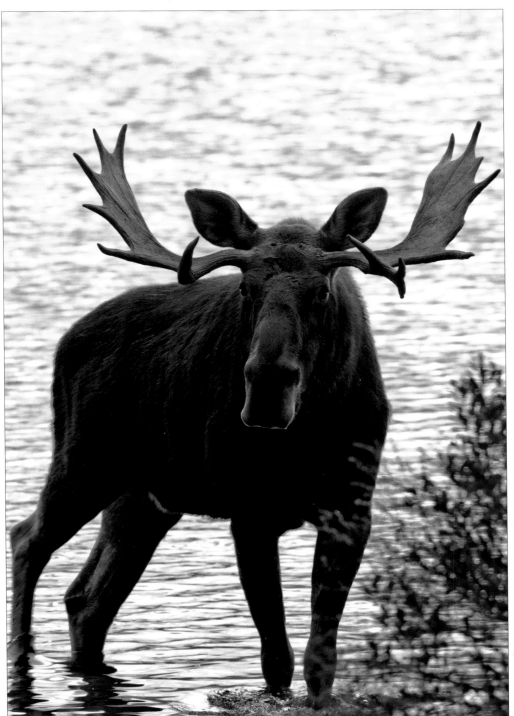

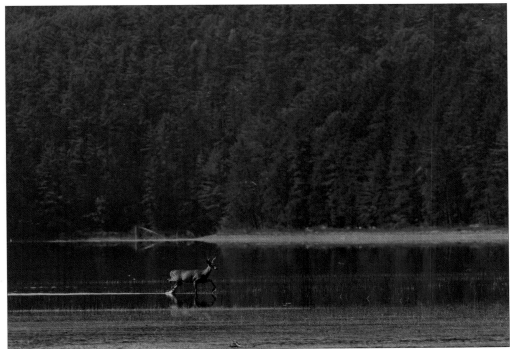

(opposite and left) The antlers of mature bulls not only impress potential mates but also, like parabolic dishes, pick up sounds and direct them to their owner's ears.

(top) White-tailed Deer were originally absent from Algonquin but moved in from the south in the late 1800s and early 1900s after logging and fires undoubtedly improved habitat for them, and most importantly, the persecution of wolves had reduced the numbers of their main predator. Deer became abundant, but as the forest matured, fires became controlled, and wolves increased under new protection, their numbers fell. Today, deer are much less commonly encountered.

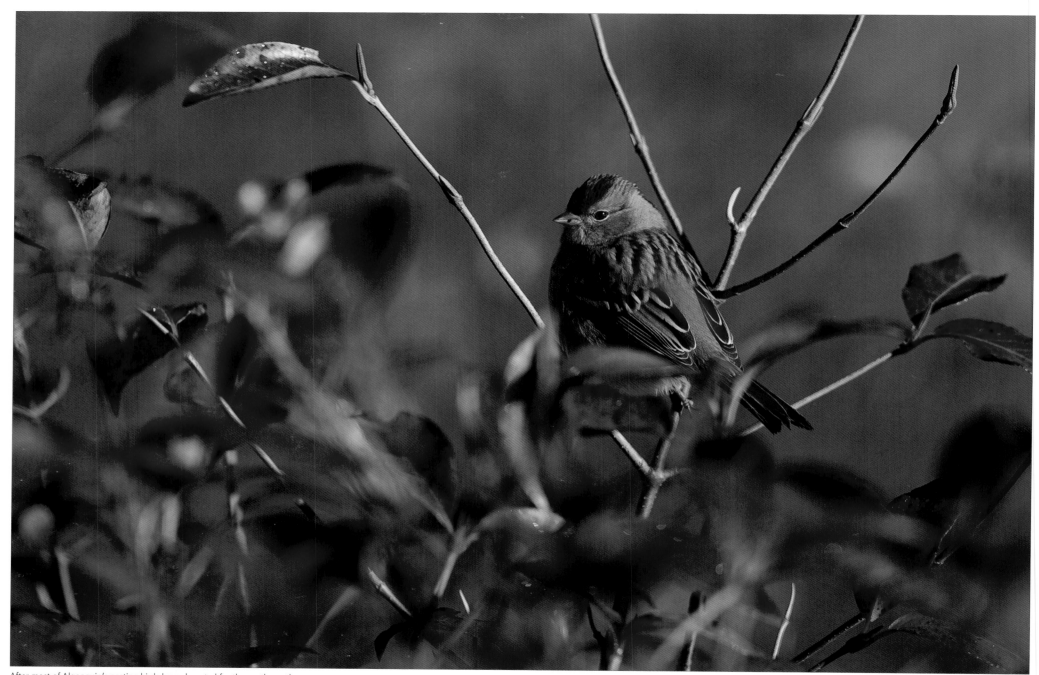

After most of Algonquin's nesting birds have departed for the south, northern migrants like this young White-crowned Sparrow begin arriving.

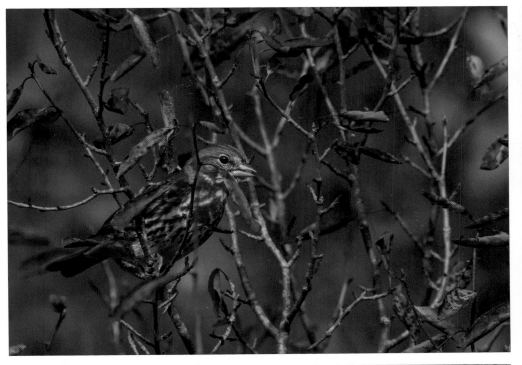

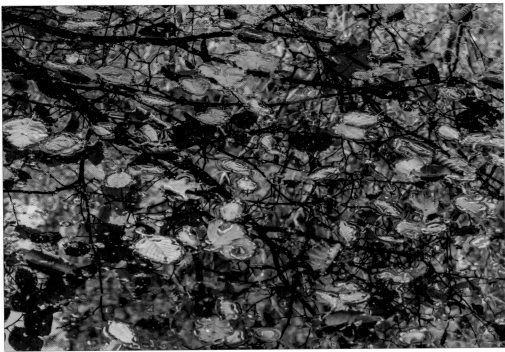

(top left) Also visitors from the north, Fox Sparrows seldom stay long, blending in very well with the alders that they frequent.

(top right) Alder leaves floating on autumn reflections create Nature's stained glass.

(bottom) Why do sapling American Beeches retain their leaves through the winter, a feature known as marcescence? One theory is that the leaves hide the buds from large herbivores such as White-tailed Deer and Moose. Perhaps they do, but instead could they be sending a visual warning to herbivores that their buds and twigs are unpalatable, or that they would have a bad dining experience if they ate the leaves that blocked access to those items?

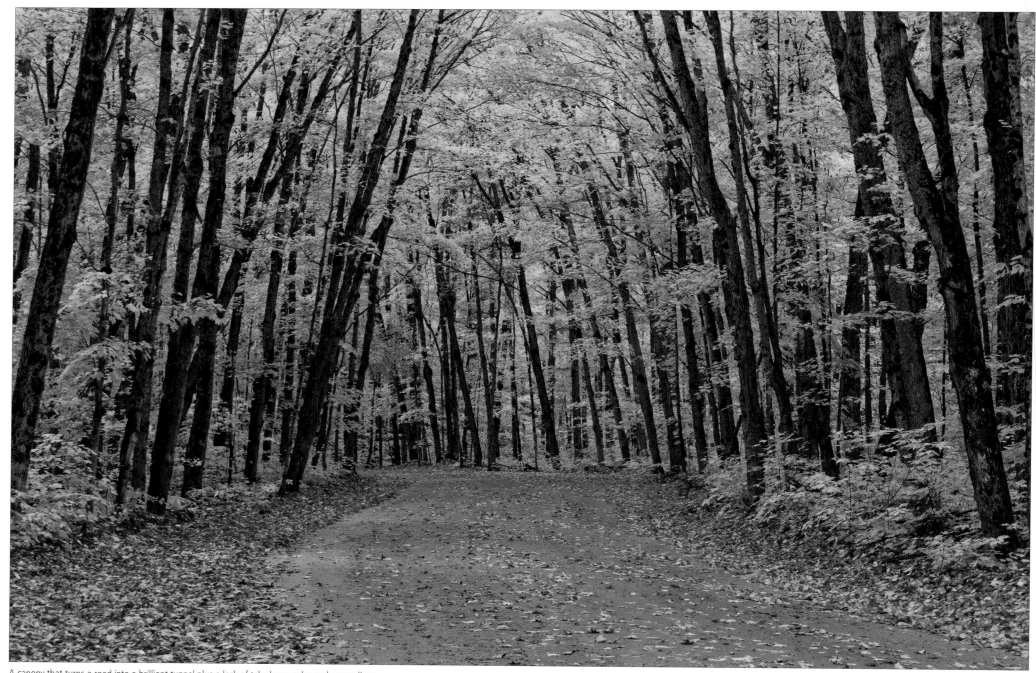

A canopy that turns a road into a brilliant tunnel plus a lack of telephone poles and power lines
makes an autumn drive along the Arowhon Road an extraordinary experience

One of the greatest shows on Earth is nearing its end when Red Oaks don their farewell-to-summer garb. .

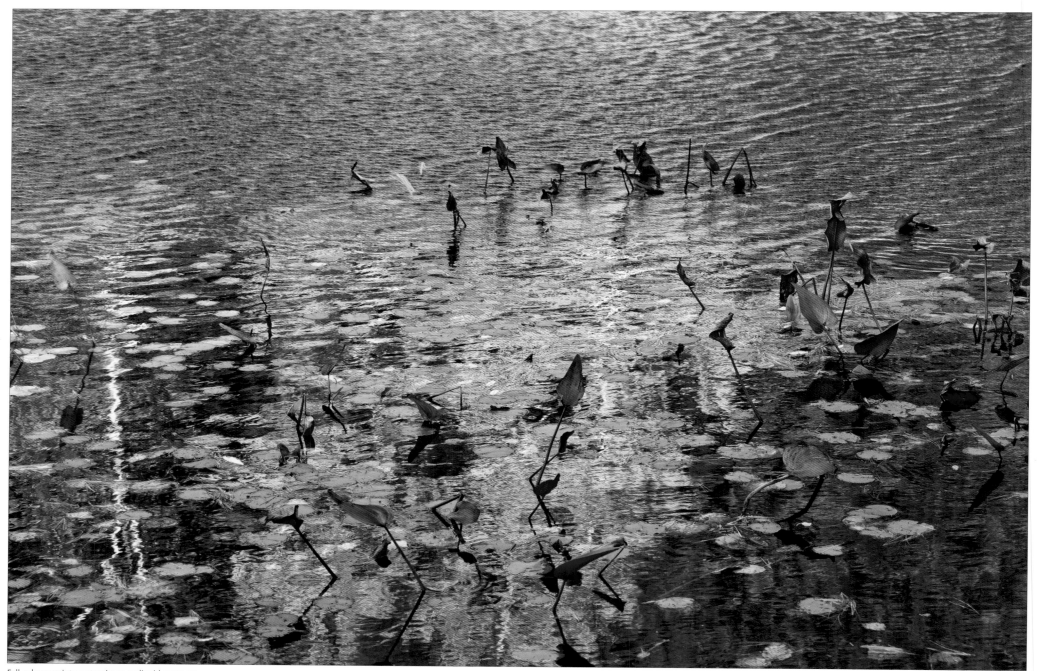

Fall colours paint masterpieces on liquid canvases.

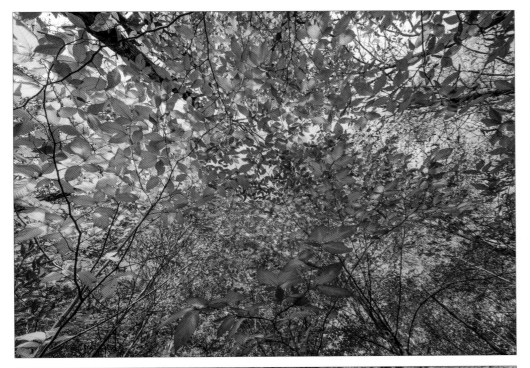

(top left) As their chlorophyll breaks down, American Beech leaves change to tones of rich copper.

(top right) October winds rip the now lifeless leaves from the trees, posting a stark declaration of harsh conditions to come.

(bottom) After the hardwood trees have had their seasonal moment of glory, Tamaracks (Larches) take the spotlight, their needles changing from soft green to brilliant gold. Unlike the Black Spruce with which they keep company, Tamaracks are coniferous trees that are not evergreen, discarding their needles in late autumn.

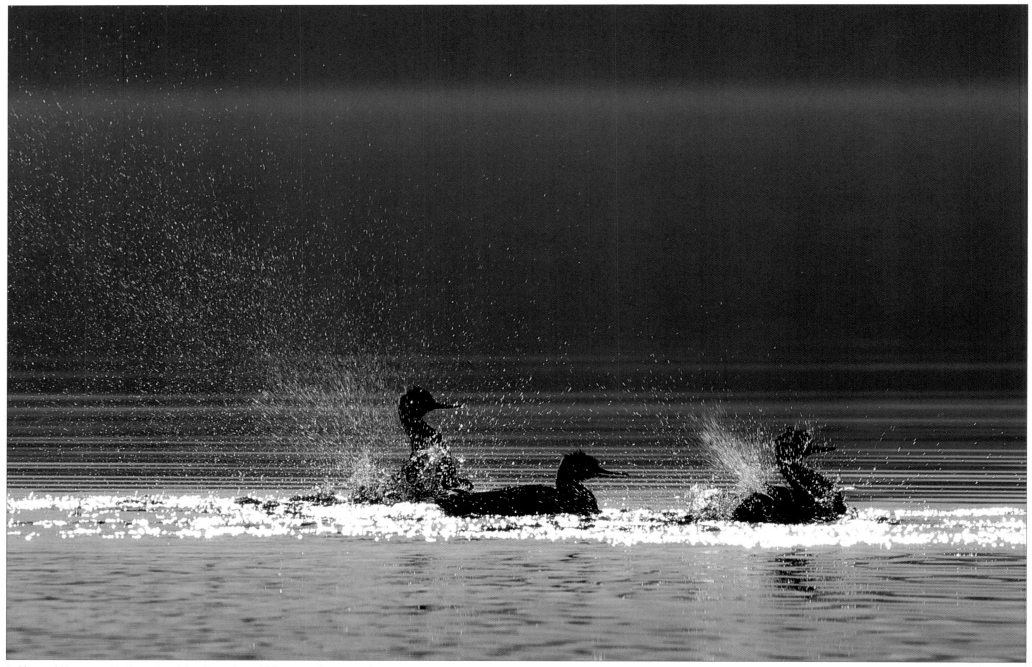

Red-breasted Mergansers visit Algonquin mainly as late spring and fall migrants. This trio on Lake Travers was enjoying a bath before continuing their journey to the Great Lakes or the Atlantic coastline where they will spend the winter.

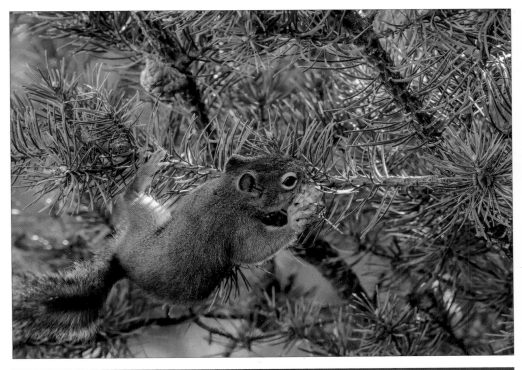

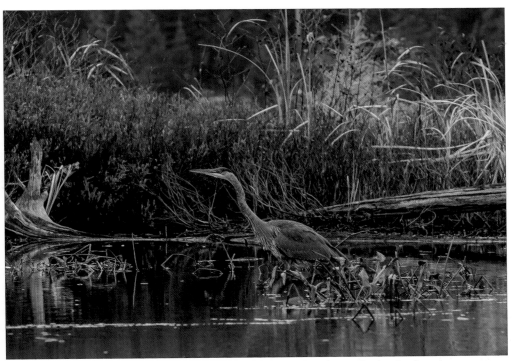

(top left) Red Squirrels are at their busiest in the fall, collecting cones to store in underground caches that they exhume through the winter. They don't eat the cones, just the nutritious seeds housed inside. Because cones (and seeds) are produced in variable numbers from year to year, these tree squirrels undergo population cycles that correlate to the crop size. However, the cones of Jack Pine, a northern tree growing with abundance only on Algonquin's East Side, are seldom harvested for they are extremely hard and their scales cemented closed with a resin that requires the heat of fire (or prolonged exposure to direct sunlight) to melt it and liberate the seeds. This scene indicates that at the time of the photograph other coniferous trees bore very few cones and that a tough winter likely lay ahead for this little fellow.

(top right) When a Great Blue Heron allows close approach by canoe, it most likely will be sporting a solid gray cap atop its head. Young birds, which own such crowns, are considerably less wary of humans than are the adults, which sport black-and-white striped crowns.

(bottom) Spruces and White Pines provide a Red Squirrel's preferred winter meals, which are accessed when the squirrel uses its remarkably sharp and strong incisors to nip off the cones' protective scales.

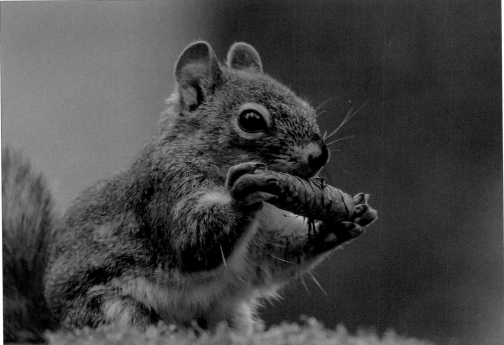

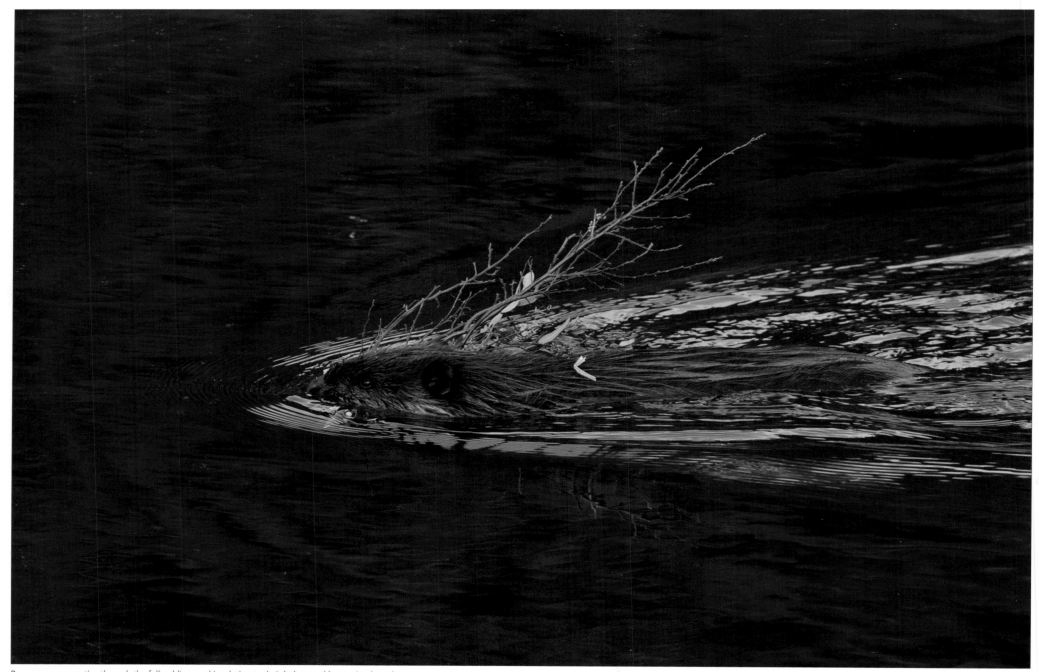

Beavers are very active through the fall, adding mud insulation to their lodges and harvesting branches to store for winter consumption. Even young colony members such as this one participate in the tasks.

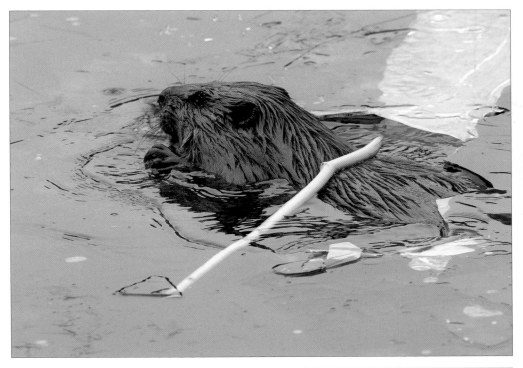

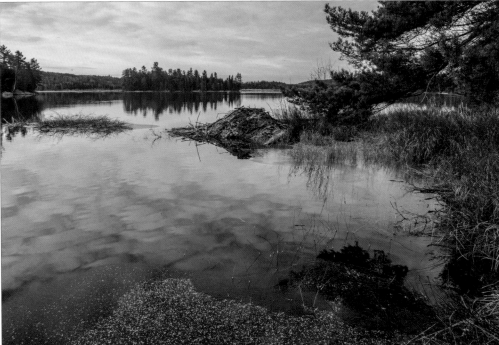

(top left) Until the ice becomes too thick to break with their heads, Beavers keep open their routes to the shore and food pile because it is easier to tow branches on the water's surface than beneath it.

(top right) At first the freeze-up seems tentative, with ice forming at night only to melt the next day and then freeze again the following night. That cycle creates little ice snowshoes on sedges that live in slow-moving water.

(bottom) Branches for winter consumption are stored in a massive heap called the food pile near the Beaver's lodge, with the pile continuing to grow in size through autumn.

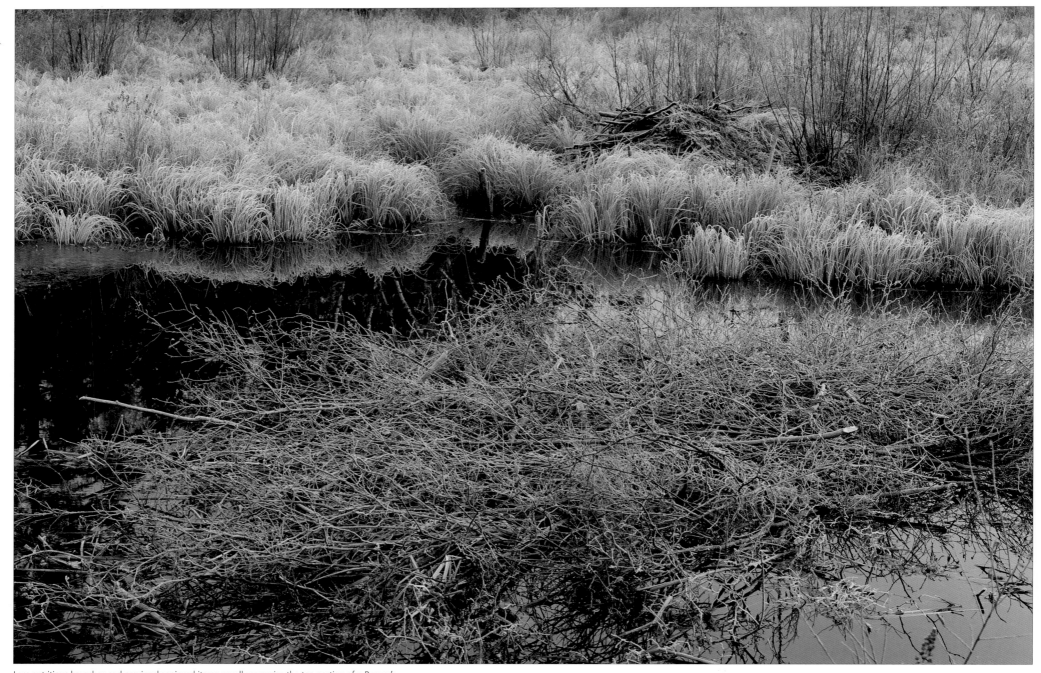

Less nutritious branches and previously enjoyed items usually comprise the top portion of a Beaver's food pile. This part becomes locked in ice and inaccessible, but it still serves a purpose: it keeps the choice items submerged below the ice and available to the Beavers all through winter.

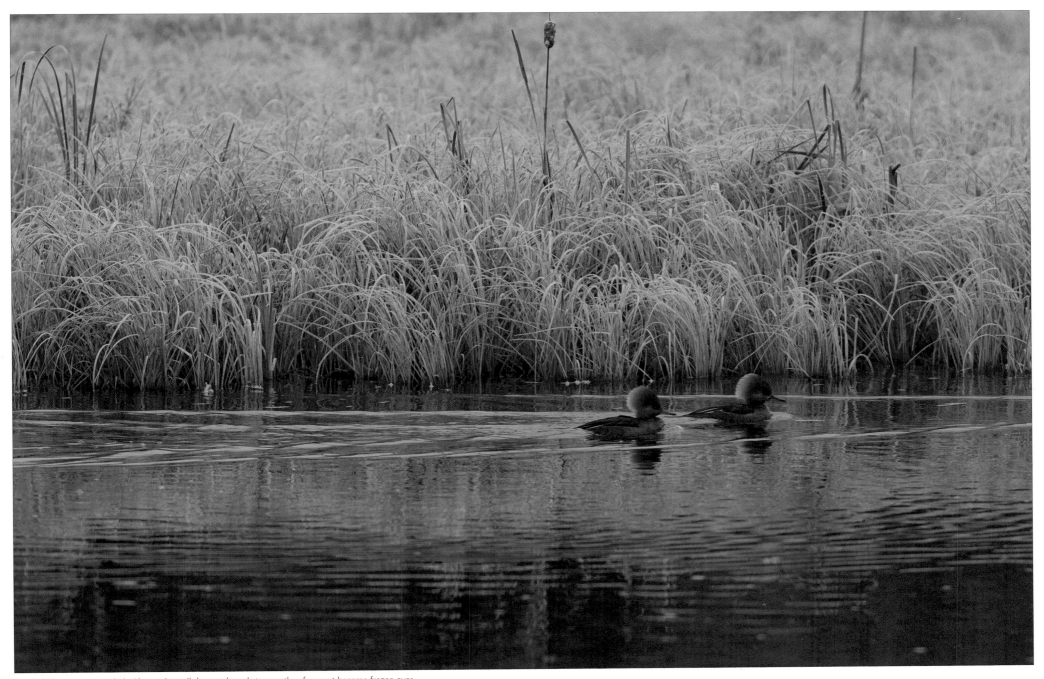

Hooded Mergansers remain in Algonquin until the ponds and streams they frequent become frozen over.

WINTER

Winter is one of the most beautiful of seasons. Each snowfall refreshes the canvas, painting the landscape immaculate white and making the green of conifers even greener. On clear days the new snow makes the sky so blue it looks heavy. The crisp air is full of oxygen; any outing leaves one feeling alive and invigorated.

But winter is also the most demanding of seasons. It brings killing cold that challenges all plants as well as any animal that dares to remain active. At times temperatures plunge so low that the trees in the hardwood forest crack loudly in protest, and underfed birds fail

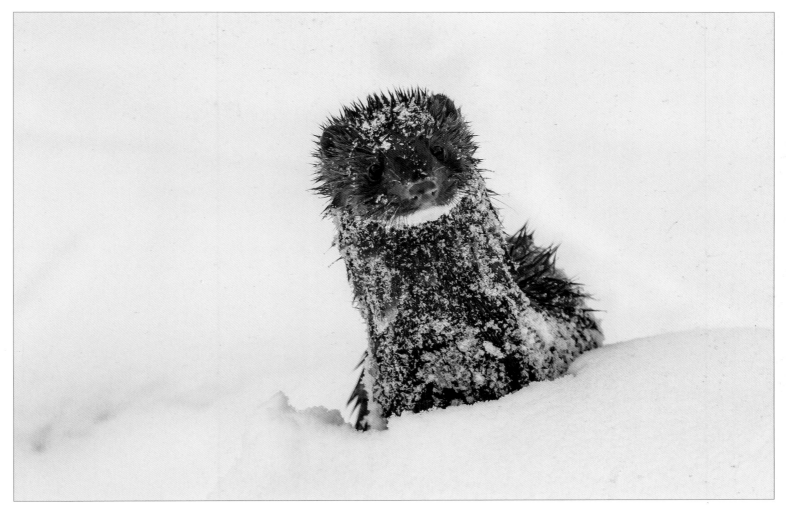

to waken from their sleep. On wind-swept days the biting cold cuts through feather and fur, robbing bodies large and small of their precious heat. Under these trying conditions only the fit survive.

But many do survive. Moose, wolves, Fishers, and other winter-active mammals had earlier replaced their cooler coats of summer with dense, heat-trapping underfur and thick, luxurious guard hairs. Birds also developed two thicker and warmer layers, a down layer next to the skin and an overcoat of contour feathers. The white winter coat of Snowshoe Hares certainly provides important camouflage but because the white hairs contain air spaces, not dark pigments as did hairs in the summer coat, considerably less body heat escapes and therefore life-saving energy is conserved.

A few birds, notably Black-capped Chickadees, lower their body core temperature on cold nights by as much as 12°C, entering a deep sleep called torpor. This drop reduces the temperature gradient that exists between a bird's body and the outside air, thereby conserving valuable energy, as less is needed to maintain a lower internal temperature. But if the bird's temperature continued to fall past its desired level, just as a thermostat triggers a furnace to start up, the bird's pectoral muscles start quivering and generating heat, raising the bird's temperature to a safe level.

None of Algonquin's birds hibernate but three species of mammals do. Groundhogs and Woodland and Meadow jumping mice are the only true hibernators with both their body core temperature and heart rate falling to near death-like levels. Raccoons vanish into hollow trees for the winter but

(opposite) As the cold of winter takes firm grip on the land and still waters, faster moving rivers retain their freedom, but that too is usually short-lived.

(top) A handful of mammals escape winter's trials by entering some form of dormancy but the Mink is not one of them. These semi-aquatic weasels patrol shores until the water freezes over, and then find new ways of getting beneath the ice to capture fish and other prey.

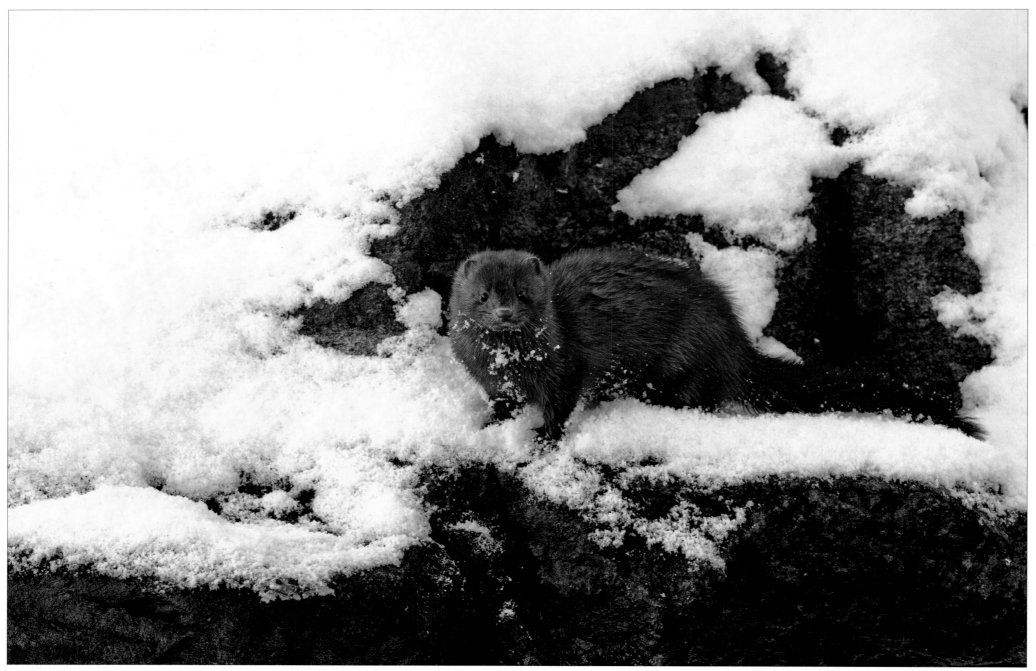

Algonquin winters bring demanding conditions that test Mink and all other living things to their limits. Many will not survive to enjoy the relief that spring eventually brings.

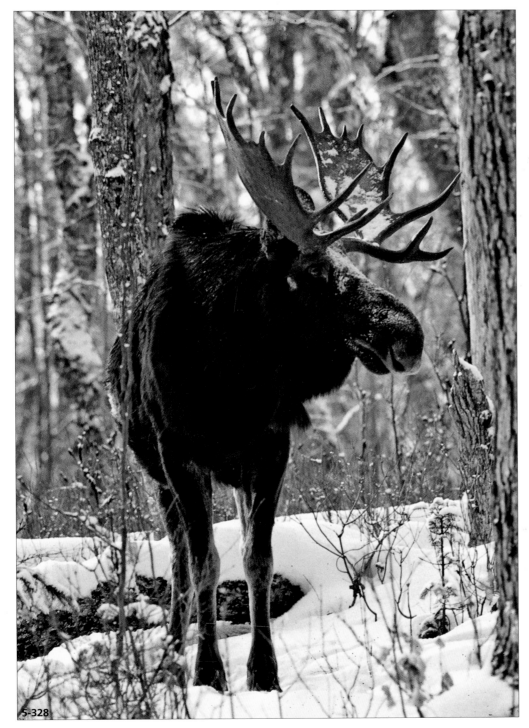

5-328

5-326

(top) Leatherleaf and other peatland plants live in a nutrient-poor environment so to conserve nutrients they retain their leaves in winter. Desiccation becomes a problem so to retain water the leaves' stomata (pores for gas exchange) are closed. Additionally, hairs on the underside of the leaves disrupt airflow, which also helps prevent water loss.

(left) Having served their purpose as sexual ornaments, the antlers of this magnificent bull now function only as excess baggage and soon will be shed. With legs nearly two metres high at the shoulder, legs that can be lifted almost vertically because of a short femur with remarkable mobility, Moose are built for walking in deep snow (which obviously has not yet arrived).

they do become active on warm nights, their easily broken dormancy a form called lethargy. Black Bears also vanish for the winter, with their heart rate dropping to a mere eight beats per minute but their body temperature remaining high, near summer levels. Easily aroused from their winter slumber, the females give birth in the heart of winter, an event that occurs every second year. Some will have their young from last year with them, curling up together to conserve body heat. Their "dens" are often little more than depressions under fallen trees, and sometimes only hollows in the ground.

While animals can be found almost anywhere in the Park, far fewer inhabit the leafless hardwood forests. Still, a scattering of woodpeckers visits the naked trees to

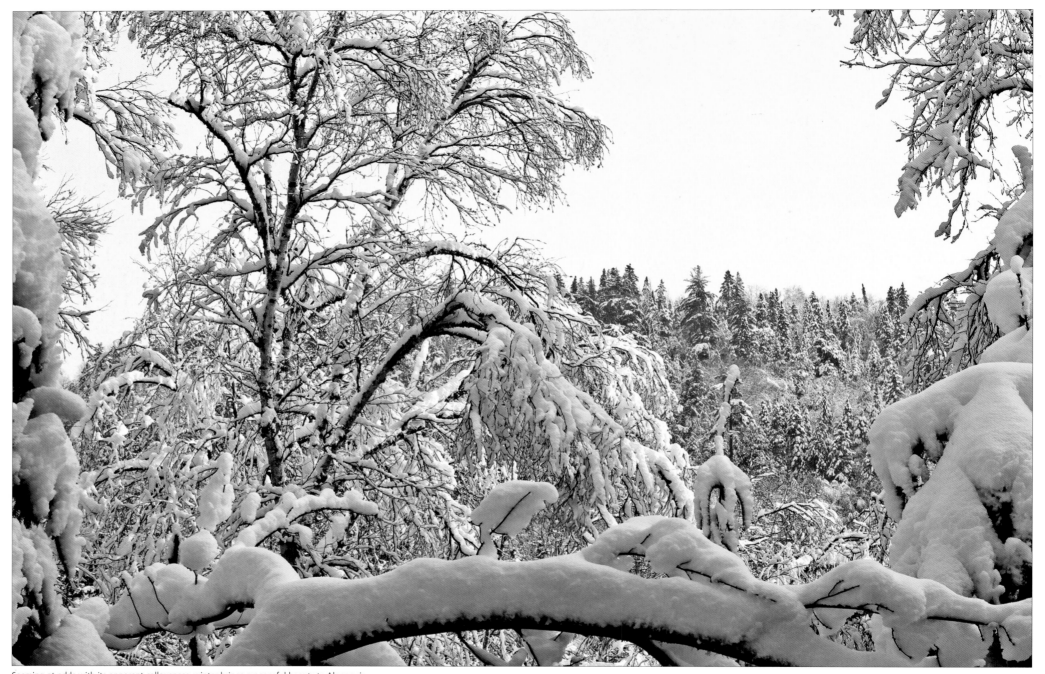

Seeming at odds with its apparent callousness, winter brings a peaceful beauty to Algonquin.

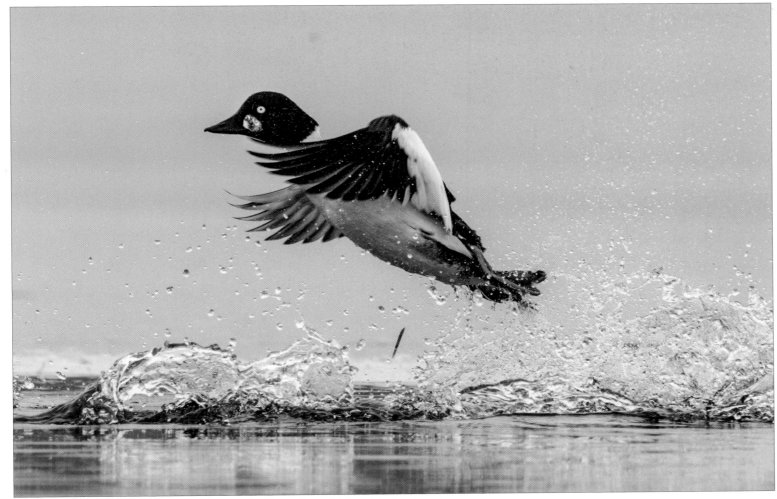

Common Goldeneyes, like this male on Lake Travers, are regular visitors to Algonquin's larger lakes in spring and late fall, sometimes remaining until freeze-up. Goldeneyes and loons and other diving birds have their legs placed near the back of their body for better propulsion underwater. That placement creates one problem; they cannot jump into the air for flight. Instead, they must run across the water's surface to gain sufficient lift for takeoff.

exhume dormant grubs from under their bark. With their hefty chisel-bills Pileated Woodpeckers excavate impressive chasms to access colonies of Carpenter Ants hidden deep in the heart of older trees. Hairy and Downy woodpeckers use their much less impressive bills to chip away shallow bark to reveal what lies beneath; Hairy Wood-peckers, having longer bills than Downy Woodpeckers, can dig farther into wood, accessing the deeper-boring grubs of Long-horn Beetle. Not only do different species of woodpeckers forage in different ways, allowing a diversity of these birds to inhabit the same woods, within a species the sexes can also divvy up resources; male Downy Woodpeckers often forage on tree trunks while females prefer to look for food held in smaller branches. Joining the wood-peckers in their search for hidden meals are White-breasted Nuthatches, which search for grubs from an upside-down perspec-tive, and Brown Creepers, which creep in a spiral up a tree, peering sideways under loose bark. Black-capped Chickadees join the brigade, using their stubby bills to dig out insects from shallow crevices and half rotten wood. The various foraging tech-niques provide access to different insects allowing a variety of grub-seeking birds to inhabit the same forest, a phenomenon known as resource partitioning.

Sugar Maples, the dominant trees in Algonquin's western hardwood forests, disperse their winged seeds before the snow flies but Yellow Birches typically

A blanket of snow soon covers all but the tallest of plants. By insulating the ground and keeping it only a few degrees below the freezing point, the snow helps protect seeds as well as dormant plants and animals. When next to the ground the snow pack crystallizes, small animals roam through the "subnivean space" in relative warmth and safety.

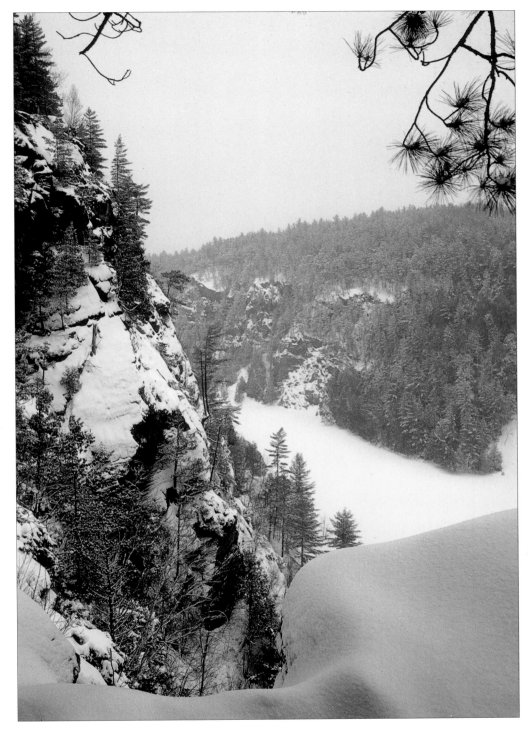

hold their seeds through the winter. If the birches produce a large seed crop, flocks of Purple Finches and American Goldfinches are usually present in winter, their soft calls revealing their location high overhead. But if those trees are barren, apart from the determined tapping of woodpeckers, the winter hardwoods are generally silent.

In winter, most active animals whether feathered or furred are associated with the coniferous forests. Conifers, especially when snow adorns their evergreen branches, provide warmer roosting sites not only to birds that snuggle in the dense cover but also to larger mammals like Moose that lie down beneath the trees. More importantly, conifers offer food. Spruce Grouse devour spruce needles. Red Squirrels feast on the caches of pine and spruce cones they created in the fall, nipping off the scales with their razor-sharp incisors to reach the seeds hidden beneath them. Piles of scales atop the snow reveal where one of these belligerent creatures has feasted.

Lacking teeth, birds use different techniques to access seeds in cones. Red-breasted Nuthatches utilize their tiny forceps bills to pluck seeds from their hiding places. Crossbills use their uniquely-shaped, name-giving bills to lift cone scales apart while their long tongue retrieves the seeds.

Winter snows soften the landscape, even the hard mien of rocky outcrops such as the Barron Canyon.

White-winged Crossbills, the nomads of the boreal forest, are spruce specialists that will nest in any month if a particularly large crop of seeds is encountered. Resident Red Crossbills, which are more common in eastern Algonquin due to the prevalence of conifers there, are drawn to the larger cones of pines; occasionally small-billed Red Crossbills from the northwest join White-winged Crossbills on the spruces. But seed-eating birds are never found in Algonquin in the same numbers each winter. They subscribe to a boom and bust principle, one that is intricately tied to the size of the cone crops. If cones are absent, the birds are absent. If cones are abundant, the finches are present in astounding numbers, their lively chatter filling the air from dawn to dusk. The fluctuation in seed crop size is not an accident for it is a tree's way of producing progeny. If trees produced the same volume of seeds every year, the seed predators would devour them all. But by creating droughts by having years of low production and then unpredictably flooding the market with seeds in a "mast crop" year, they overwhelm the predators and many seeds will escape detection. This game of ecological chess is never ending, however, and new strategies evolve through time; Red Squirrels are able to detect when a large seed crop is coming and produce more young in anticipation of its arrival!

Although they share with White-winged Crossbills an indissoluble connection to spruces, Canada Jays and Spruce

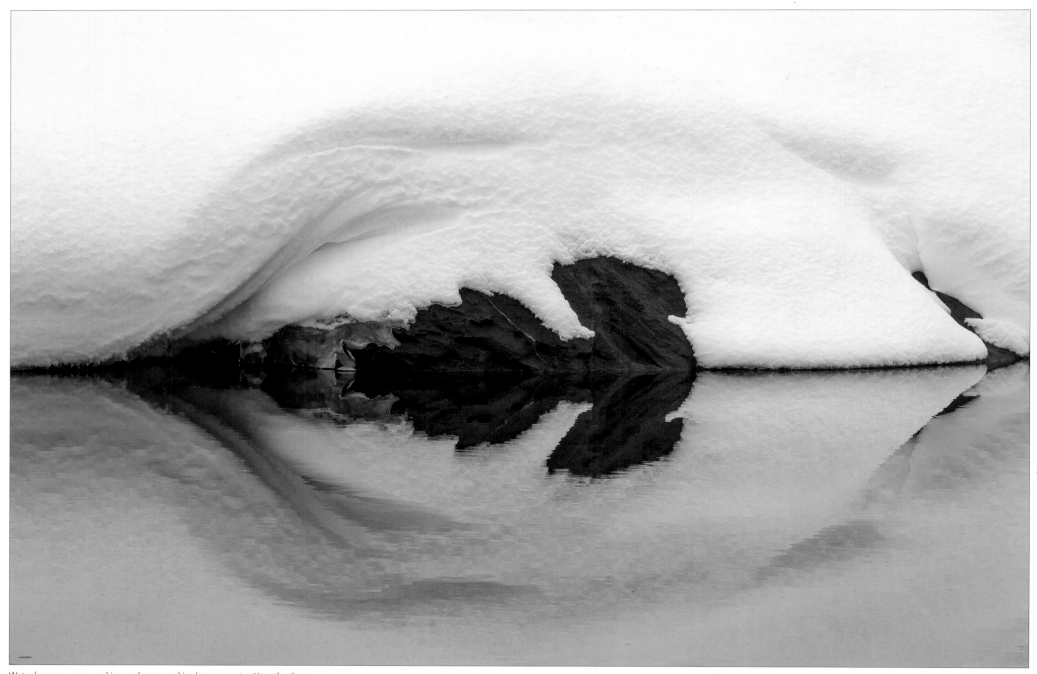

Water becomes snow and ice, and snow and ice become water. Here the three forms of H_2O parley while Precambrian bedrock plays mediator.

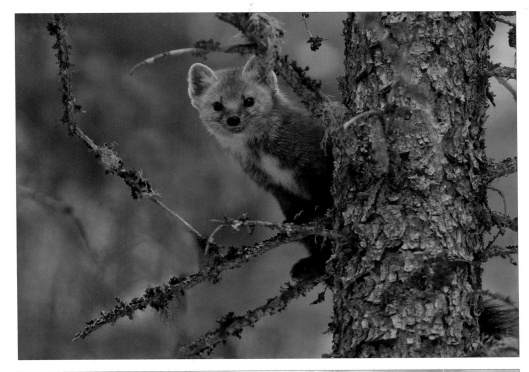

Grouse do not possess the apparent fickleness of those nomadic finches. They entertain no thoughts of leaving Algonquin for their association with conifers is of a more permanent nature. Spruce Grouse devour the needles of spruces while Canada Jays store their autumn caches under loose bark of those trees, depending on cold storage to keep them edible even past the end of winter.

Finches may come and go but they are not the only animals to travel more widely in winter. Predatory mammals hunt over greater distances, leaving their tracks as visible records of their movements and successes. Each snowfall wipes the story slate clean, with new narratives written on a daily and nightly basis.

Eastern Wolves also expand their zone of hunting, with some eastern packs leaving the Park to hunt deer in their large winter yards such as those near Round Lake. Wolves are a keystone species in Algonquin for when they kill to eat, they inadvertently sustain the lives of many other creatures

in winter. In addition to killing prey, most predatory animals also scavenge, especially in winter when meals are few and far between. American Marten, Fisher, Red Fox, Canada Jay, Common Raven, Bald and Golden eagles – the list of those animals that indirectly benefit from wolves is long (and here, incomplete). Ravens primarily survive Algonquin winters because of wolves, and are known to follow packs around to gain a meal. If a resident pair of ravens discovers a kill, they dine in silence. But if a group of juveniles finds one, their raucous screams attract more of their peers. The gang grows larger and their resulting cacophony makes locating a wolf kill in winter an easy task. The youngsters do more than share a meal at carcasses, their social interactions help establish pair bonds. In that unusual way, a wolf-killed Moose or White-tailed Deer serves as a singles bar for these hardy northern birds!

As winter slowly passes, the days become longer and warmer. When during the day the thermometer registers above freezing, the surface of the snow becomes a stage on which an unusual ensemble magically makes an appearance. Unfortunately, the players are so tiny that only in the magnification of a hand lens (or binoculars held backwards) can their curious appearances be appreciated.

Pepper grain dots that suddenly vanish with new ones mysteriously appearing reveal the presence of Snow Fleas, animals that are not fleas and not even insects but

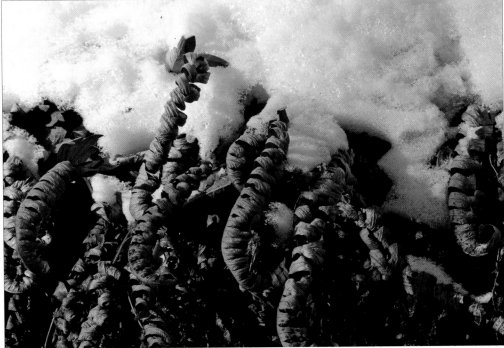

(top) Like other weasels, American Marten remain active through the year. Much of their winter diet consists of Snowshoe Hares, voles, and other small mammals that they catch on the ground. While they are reputed to climb trees in pursuit of Red Squirrels, there is little, if any, evidence of that.

(bottom) Evergreen ferns like this Rock Polypody curl up their fronds to avoid desiccation. Its penchant for growing on rocks is reflected in its name.

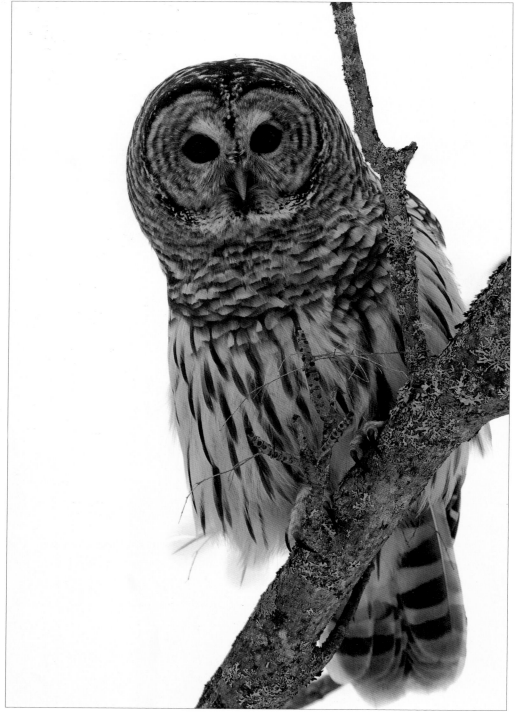

remarkable leaping creatures. Little more than a millimetre in length, they look not unlike a miniature black Michelin Man. Snow Fleas are Springtails, miniscule soil-living animals whose springboard situated under their abdomen allows them to leap up to 100 times their body length. They can appear in such remarkable numbers that they darken the snow, especially when they gather in Moose tracks and other depressions. Why they appear atop the snow in late winter is not fully resolved but it might involve looking for a mate or dispersing to a new location; either way, travel for the little leapers is easier on top of the snow than beneath it.

If one looks closely at the hordes of Snow Fleas, occasionally a much larger Snow Fly or Snow Scorpionfly, two fascinating wingless insects, can be discerned. Snow Scorpionflies, which eat mosses, deserve an award for being the Park's most unusual-looking animals, although Snow Flies place a close second.

The warmth of the March sun inspires the buds of alders and trees to swell. Red Squirrels love eating the flower buds of conifers but as the tree's outer branches, which possess the buds, will not support their weight, the squirrels are content to sit on stronger branches and nip off the newest twigs. After manipulating the severed twigs in their paws, the squirrels devour their swollen buds. After a twig has been gleaned of its buds, it is discarded, joining the many others that litter the snow below.

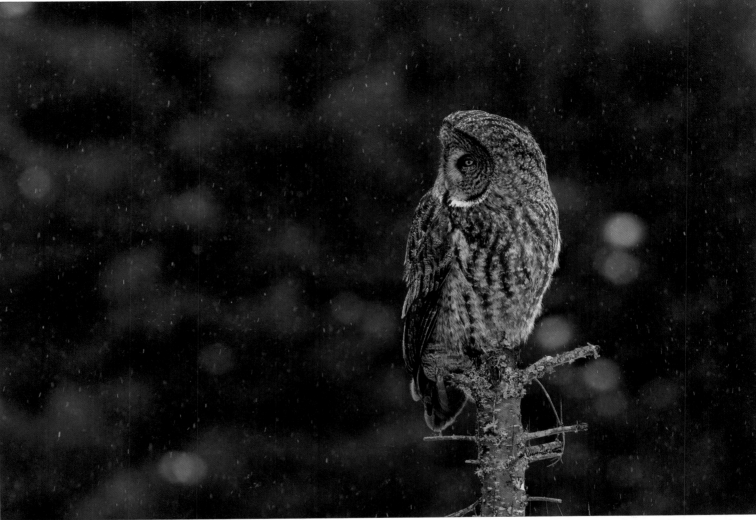

Warmer temperatures weaken the icy mantle of creeks and rivers and open water soon appears. Otters make regular appearances in these openings, climbing onto the adjoining ice to devour a hapless Brown Bullhead, or to roll around as they anoint their bodies with sexual perfumes, a prelude to their rough love. Beavers also enjoy meals in the open-air atmosphere of an outdoor café.

As winter dissolves into spring, Canada Jays once again begin the task of raising young. Male Spruce Grouse start strutting their stuff and Black Bears stir more frequently in their dens. The animals that have successfully passed the severest of Algonquin's tests can now enjoy the relief that the new season brings.

(opposite left) Wind, snow, and ice combine to create abstract patterns on lakes and rivers. Do you see a wolf in this image?

(opposite right) Barred Owls, the only common owl in Algonquin, are present year-round. Their large dark eyes separate them from their closest relative, the Great Gray Owl.

(top) Birds of the boreal forest, Great Gray Owls were once thought to be only rare winter visitors to Algonquin. However, it is now known that these huge owls occasionally nest in the Park, so it may well be that winter sightings do not always involve individuals coming from afar.

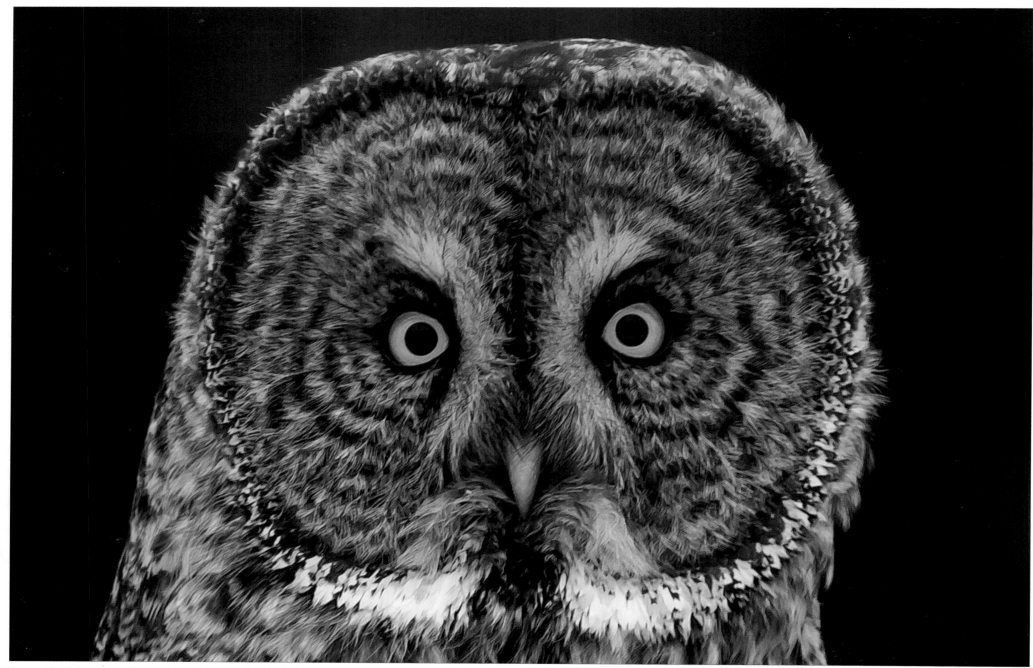

The round facial discs of Great Gray and other owls are specialized feathers for capturing and directing sound to the large, asymmetrical ear canal openings on the sides of the head. The asymmetry of the openings and their vertically offset placement on the skull, coupled with their great horizontal separation due to the width of the owl's head, provide auditory crosshairs for precisely pinpointing the location of mice, voles, and shrews, even those under the snow. The strongly hooked bill is short in order to prevent interference with incoming sound.

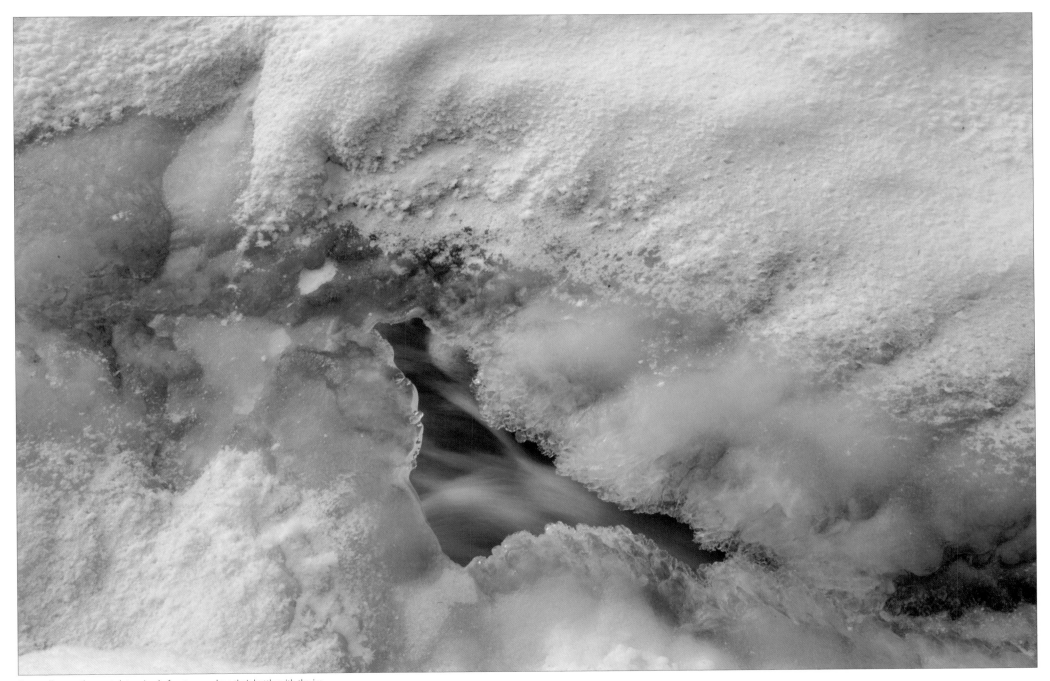

Eventually even the most determined of waterways lose their battle with the ice.

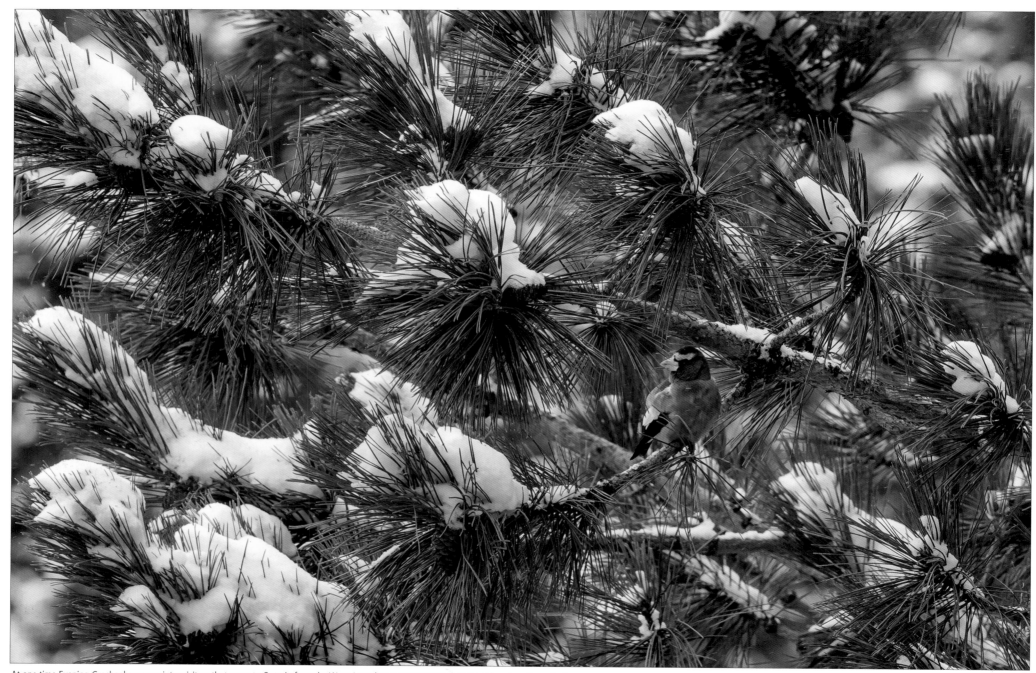

At one time Evening Grosbeaks were winter visitors that came to Ontario from the West. Less than a century ago, they moved east, and eventually started nesting in Algonquin, becoming relatively common. In recent years, however, their numbers have dramatically dropped, and while a few still nest in Algonquin, in current winters Evening Grosbeaks are regularly encountered only at Algonquin's Visitor Centre birdfeeders.

On sunny days when winds blow snow from the tops of spruces, magic fills the air.

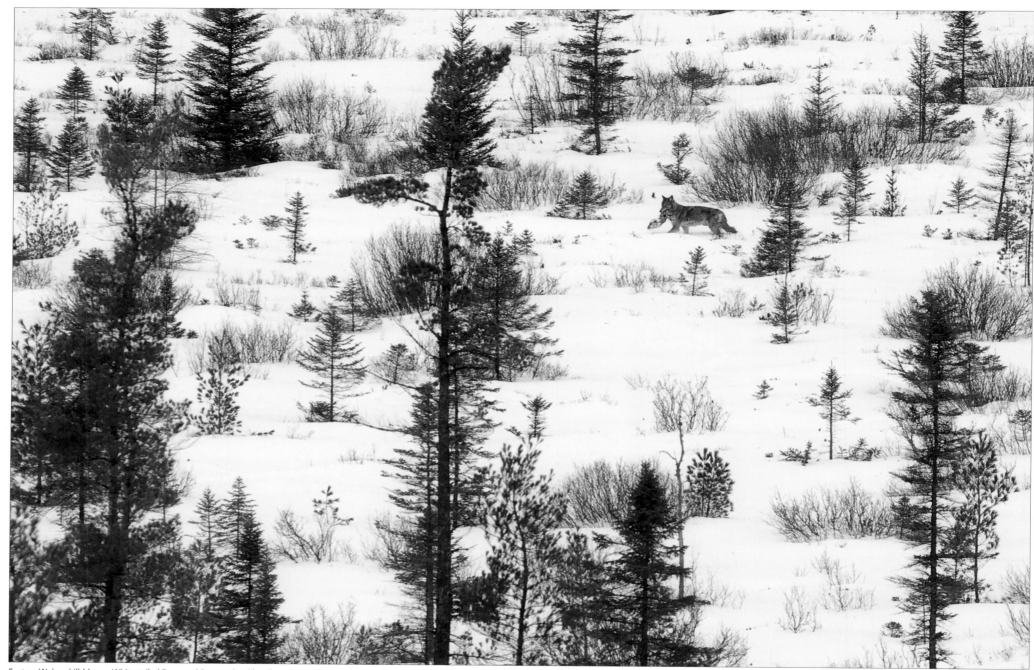

Eastern Wolves kill Moose, White-tailed Deer, and Beavers but like all predators, they readily scavenge in winter. This wolf is carrying off a chunk of meat taken from a Moose carcass.

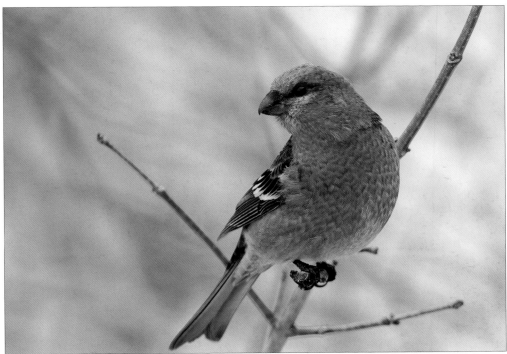

(top left) Despite being close relatives, Canada Jays have no love for Blue Jays. Canada Jays store food in thousands of individual caches for the winter and Blue Jays rob those caches, hence the lack of cousinly love exhibited here.

(top right) Like many other finches, male Pine Grosbeaks sport red plumage. Because this colour is derived from plant pigments acquired in the diet, the intensity of a male's plumage could allow a female to identify a good forager from a poor one, useful information when choosing a mate that helps feed her young.

(bottom) With their wheezy calls, Boreal Chickadees are more likely to be heard than seen as they forage deep in the foliage of northern conifers. Like Canada Jays and Spruce Grouse, Boreal Chickadees are at the southern edge of their Ontario range in Algonquin. Also like Canada Jays, they seem to be going through a population decline, perhaps due to climate change.

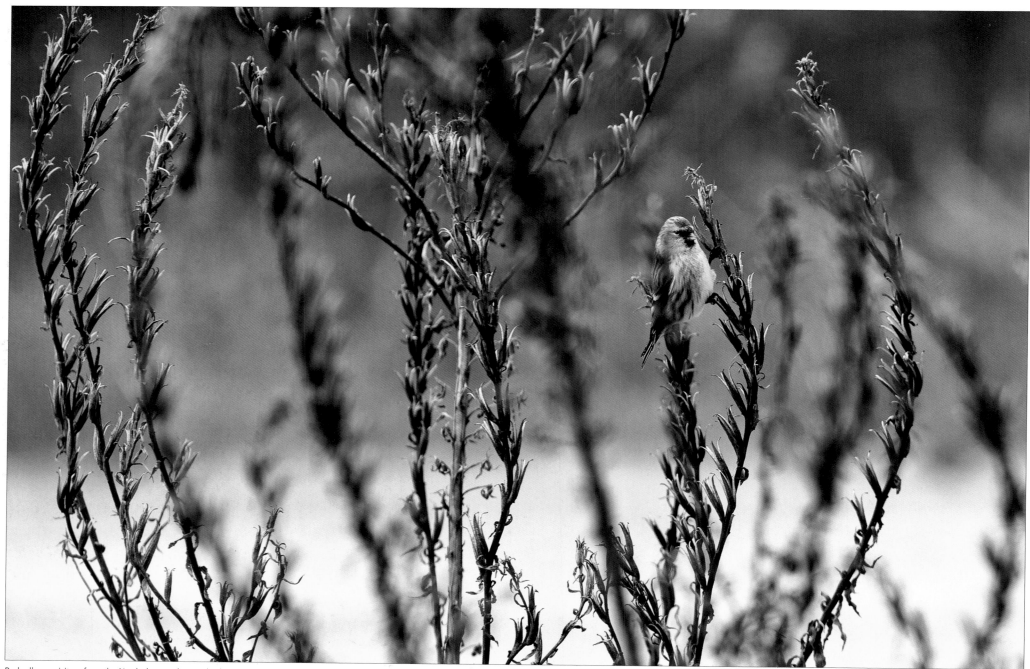

Redpolls are visitors from the North that can be nearly absent some winters and extremely abundant in others, depending on what the seed crop is like farther north. If it is a good crop, they don't come south. If it is not, Common Redpolls may arrive by the thousands, sometimes bringing with them the more rarely seen Hoary Redpoll, which this pale individual eating Evening Primrose seeds near Lake Travers might well be.

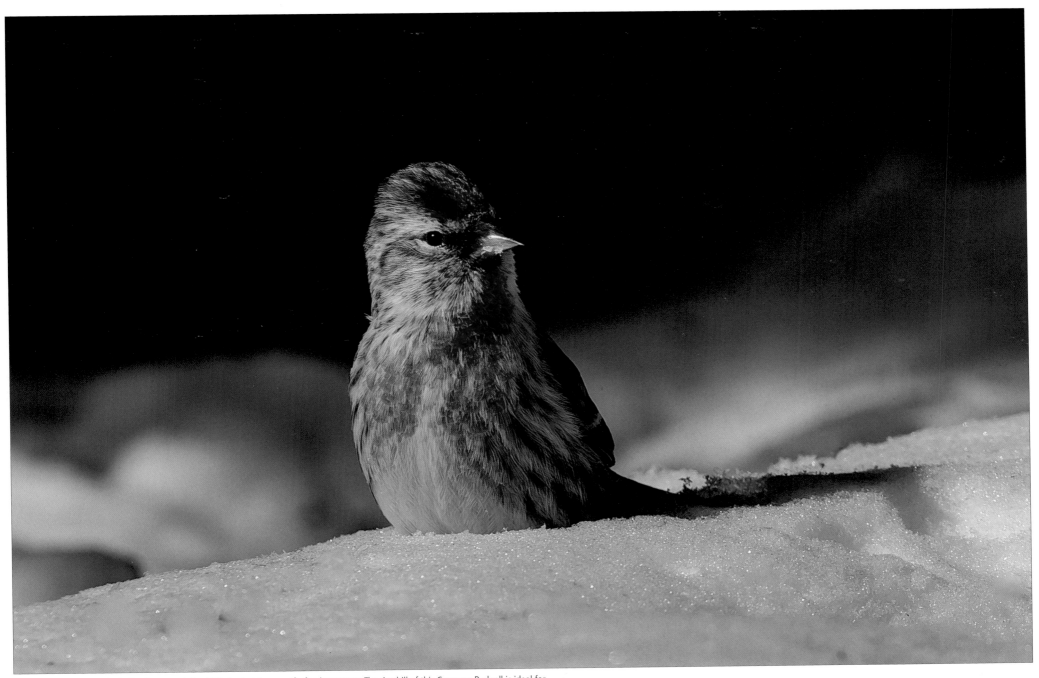

Finches are seed-eating birds that have specialized bills for tackling specific food resources. The tiny bill of this Common Redpoll is ideal for extracting seeds from the seed heads of tall wildflowers as well as from small cones like those on Speckled Alder.

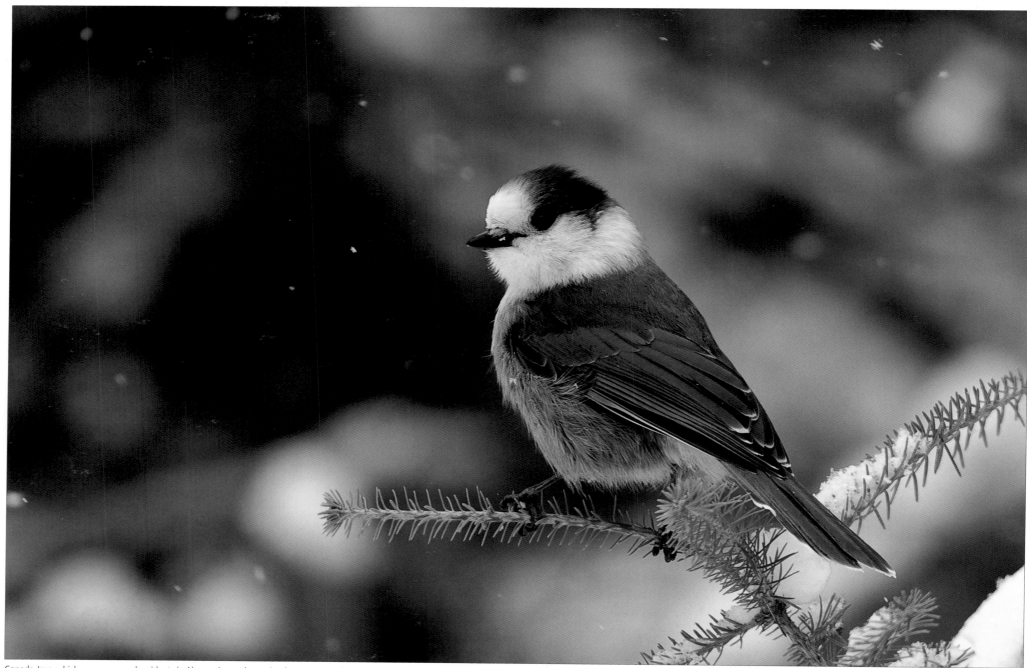

Canada Jays, which are year-round residents in Algonquin, are becoming less common; the decay of their stored food due to climate change has been implicated in their decline.

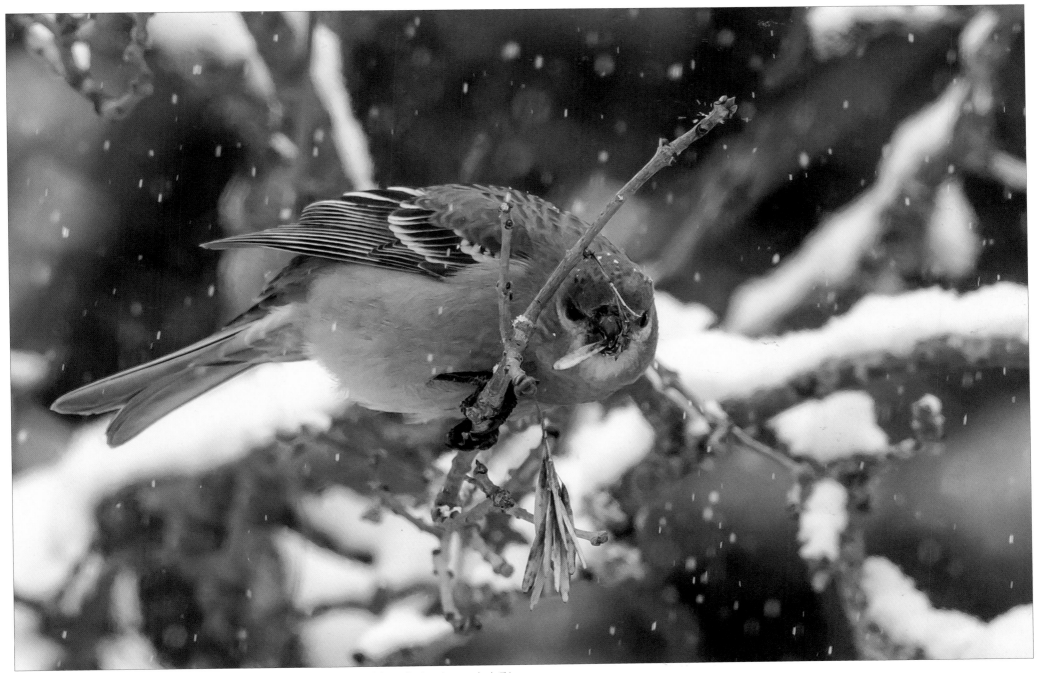

The more substantial bill of a Pine Grosbeak, another winter visitor to Algonquin, can deal with larger foods such as tree buds. This female is eating the winged seeds (samaras) of Green (Red) Ash, a tree commonly planted in campgrounds and parking lots. Green Ash is a native tree but is found growing wild in the Park only along the eastern reaches of the Petawawa River.

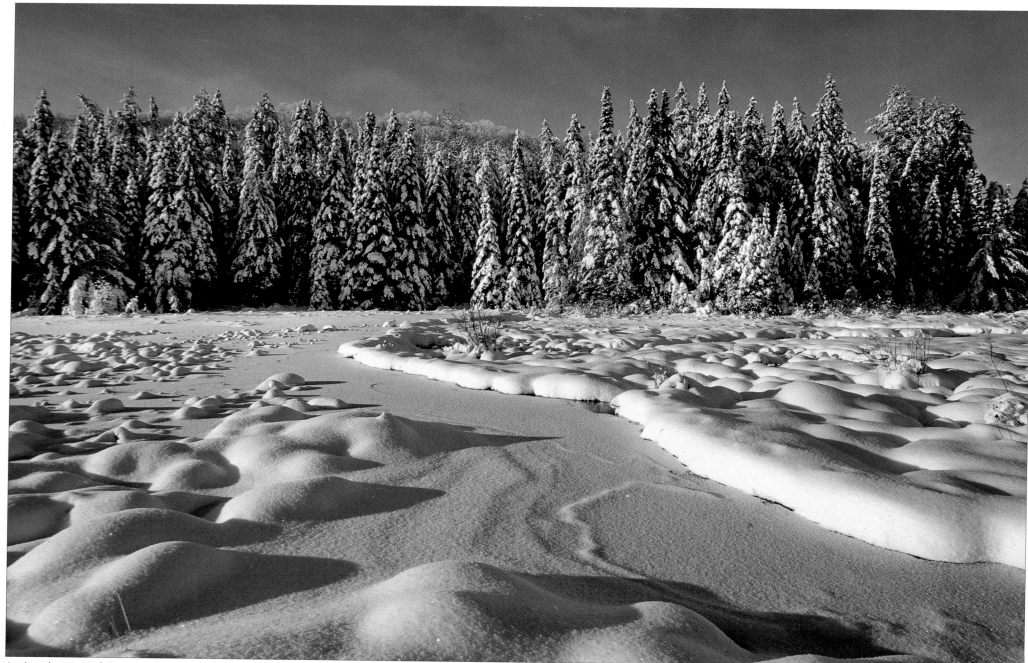

In winter, the majority of Algonquin's birds are usually found in the fringe of spruce and fir that adorns the edges of waterways. Conifers provide better shelter than do leafless hardwoods, and, more importantly, coniferous trees offer more food, especially to seed-eating finches.

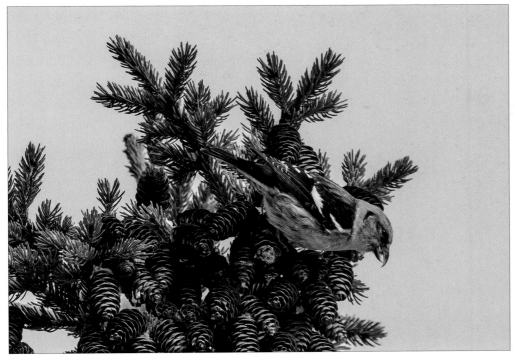

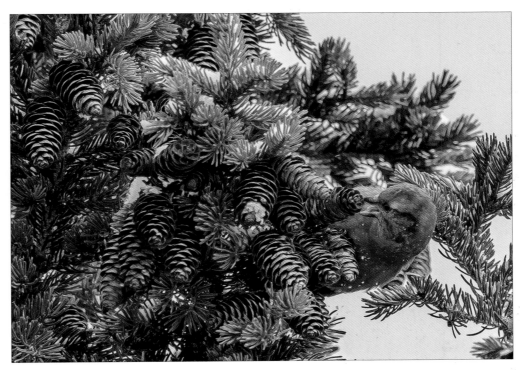

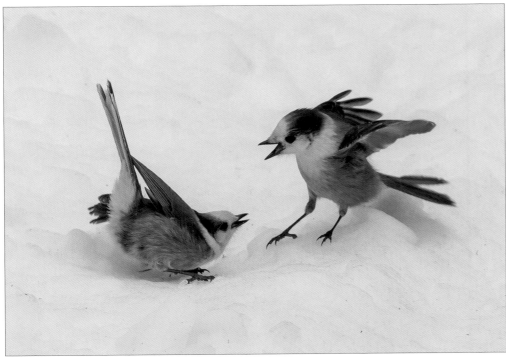

(top left) White-winged Crossbills are nomadic finches that can be absent from Algonquin in years of low conifer seed production, and present in astounding numbers when seeds are plentiful. In years of high seed production, crossbills can nest in any month, even during the cold of winter.

(top right) A crossbill's odd beak configuration poses no puzzle when its owner (here, a Red Crossbill) eats seeds. The bird inserts its bill between adjoining scales of a cone and opens it sideways. After the sharp tips separate the two scales, the bird's long tongue is inserted between them and pulls out an energy-rich seed. Algonquin provides food resources for at least two "types" of Red Crossbills. One is a large-billed form (Type 1) that extracts seeds from White Pine cones, and is resident on the East Side. The other, seen here, is a small-billed vagrant (Type 3), which arrives from the Northwest when food is scarce there. Its smaller bill provides access to seeds in small cones like those of this spruce.

(bottom) Before the vernal equinox arrives, Canada Jays are usually nesting, and rarely a few are even feeding nestlings. The dominant young from the previous year remains in its parents' territory but is strongly discouraged from approaching their current nest. This little squabble is likely taking place over food, not because of a violation of restricted air space.

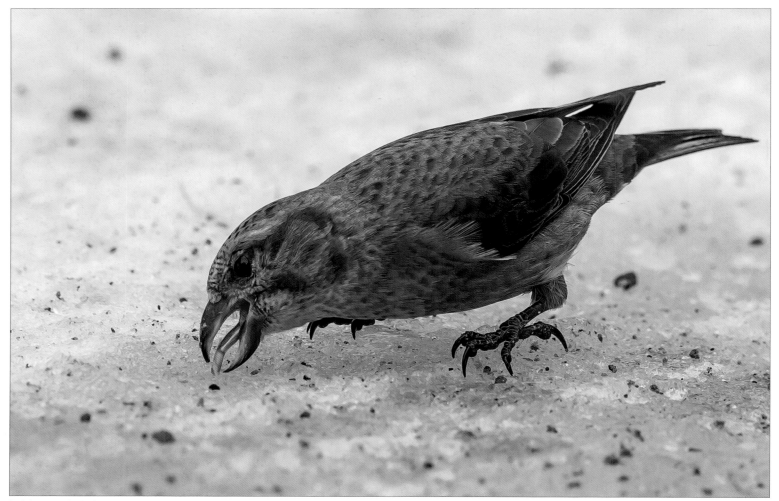

(right) One might think quite correctly that the unusual bill of a crossbill (here, a female Red) would present a terrible impediment when the bird tried to pick up grit to add to its grindstone gizzard for seed processing, or to attain minerals to aid in the detoxification of seed toxins.

(top) However, a highly extensible tongue more than compensates for any shortfall the bill might present.

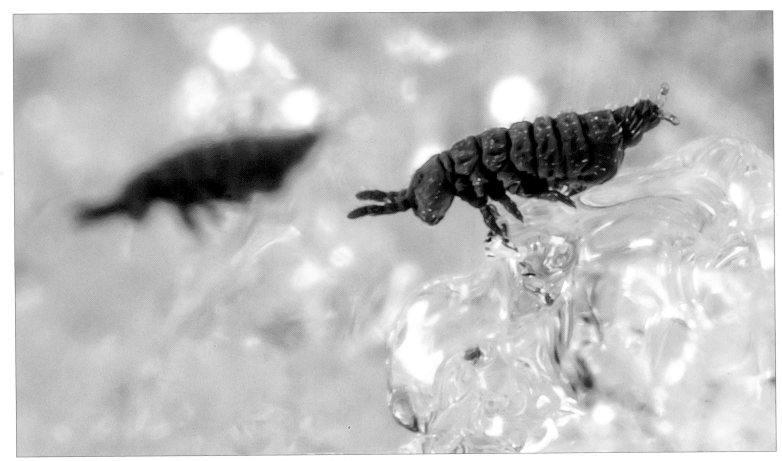

(top) Springtails can jump nearly 100 times their own body length with the aid of their furcula, a springboard (visible here just behind this animal's last leg). Immediately before the furcula is employed, a three-parted, eversible sac emerges from the little animal's back end. This structure is sticky and adheres to any surface regardless of how slippery it is. Under their belly Springtails have another sticky and eversible structure, the collophore. After leaping uncontrollably for remarkable distances over hard terrain, it makes sense that Snow Fleas would have good landing gear!

(right) Little more than a millimetre in length, Snow Fleas are among the smallest animals in Algonquin. They are also one of the most abundant, appearing atop the snow in mind-boggling numbers that at times darken Moose tracks and other depressions. Snow Fleas are not fleas nor are they even insects; they belong to their own group, the Collembola or Springtails, the latter moniker arising from their proclivity for jumping. Numerous species of Springtails live in the soil and leaf litter where they eat organic detritus and fungal mycelia; the ones we call Snow Fleas miraculously work their way up through the snow to its surface on warm days in late winter.

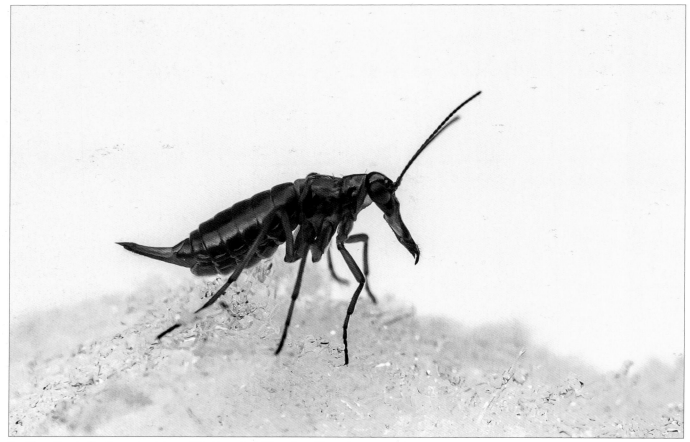

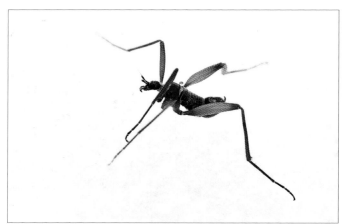

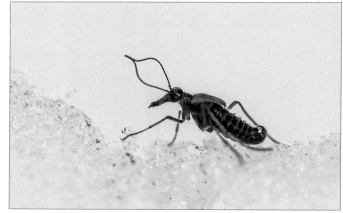

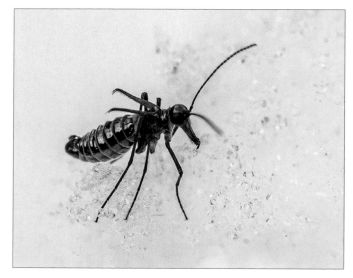

(top) Snow Scorpionflies (here, a female) are odd-looking animals! These five-millimetre long, moss-eating, flightless insects appear atop the snow on warm winter days, possibly looking for mates.

(top right) At seven millimetres long, Snow Flies are the giants of the snow insects. In summer these wingless crane flies frequent underground mice burrows but in late winter they are commonly seen wandering across the snow. Their reason for doing so remains unclear but it might involve finding mates or dispersing to new areas, or both.

(middle right) While female Snow Scorpionflies may not offer any clue as to the origin of their name, the males certainly do.

(bottom) The odd structures sticking out from the back of this male Snow Scorpionfly are modified wings that serve to hold and carry a female on his back while mating with her, an act that apparently can last two days or longer!

(opposite left) As winter slowly gives way to spring, rivers like the Petawawa begin to awaken. Along their frozen edges the tracks of River Otters frequently appear, the long furrows in their trails created when the otters tobogganed on their bellies.

(opposite right) Late winter freeze and thaw cycles bring dramatic adornments to roadside rock cuts.

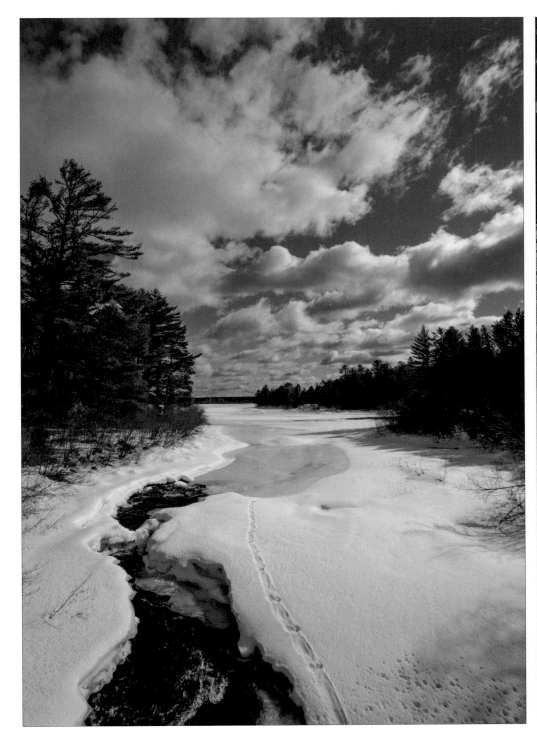
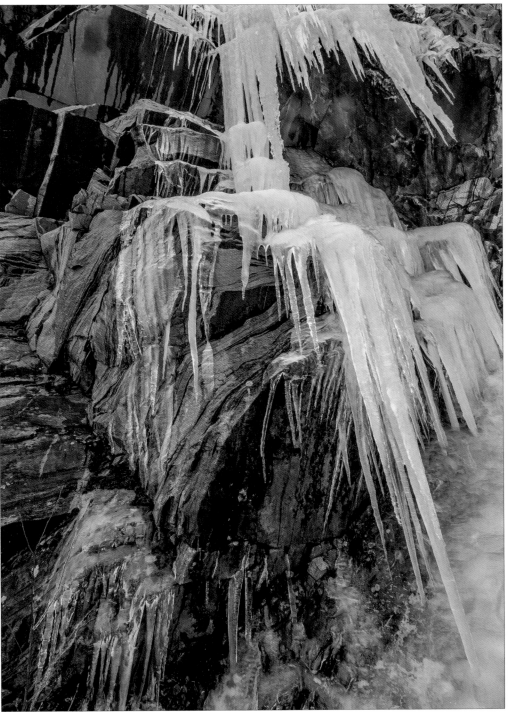

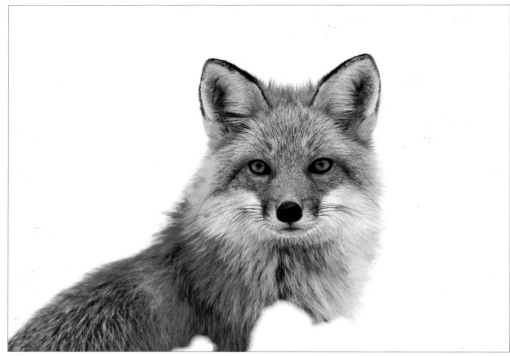

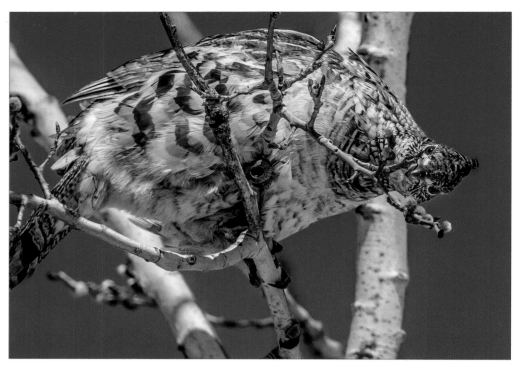

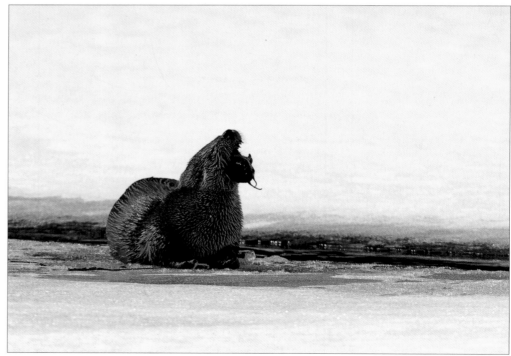

(top left) Its luxurious winter coat having served it well, this Red Fox will now have finding a mate on its agenda.

(top right) The opening flower buds of Trembling Aspen bring a welcome change in diet for Ruffed Grouse

(bottom) River Otters make increasingly regular appearances as ice retreats from the waterways. They carry their prizes (here, a Brown Bullhead) to the nearest ice table on which they recline and contentedly dine.

Cliffs like this one bordering Fisher Lake are silent in winter but by late spring echo with the screams of young Common Ravens. The bulky stick nests of ravens are placed in trees and even on human structures but elevated ledges of cliffs are preferred sites. In Ron Tozer's *Birds of Algonquin Park*, one of the finest bird books ever written, March 9 is given as the average date for the initiation of raven nest construction in Algonquin.

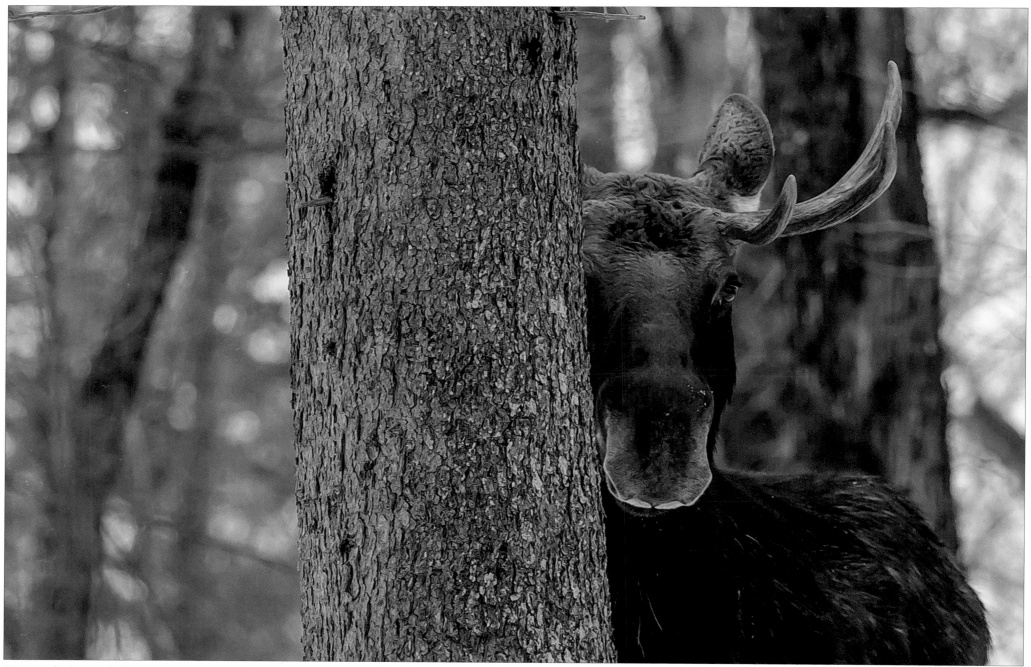

Testosterone levels are involved in antler retention, with low levels resulting in their shedding. Young bulls that don't breed in the fall keep their head ornaments through much of winter, sometimes into March. Fortunately for their owners, puny antlers don't present much of a burden to carry.

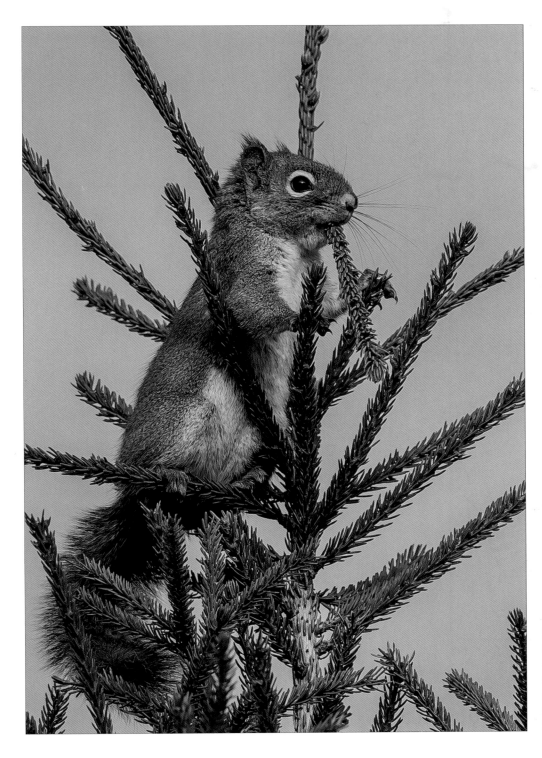

In late winter Red Squirrels eat the flower buds of Black Spruce and other conifers, accessing them by cutting off the tips of the outermost branches that contain the buds but do not support a squirrel's weight. Some feature, perhaps the abundance or quality of the buds, reveals to the squirrels that a large seed crop is coming later that year. They respond by having larger and extra litters in the months prior to its arrival!

With its eyes placed on the side of its face, a Snowshoe Hare can see a full 360° around its body without moving its head. Brown hair starts appearing in its white pelage about the time snow begins retreating from the land. A white coat in winter has greater significance than just camouflage; it retains more body heat than summer's brown coat, providing its owner with about 26% in energy savings, an important consideration when winter's chill sets in.

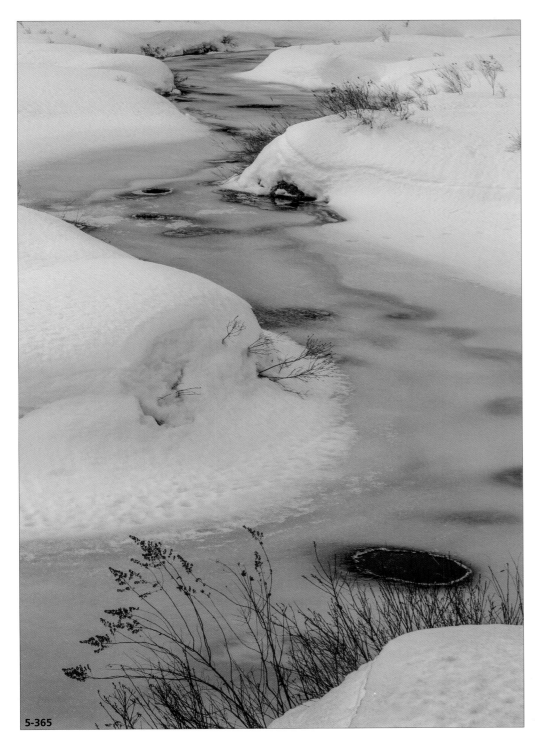

5-365

The ice on creeks weakens under the sun's warmth, with round holes appearing where otters punched through the now soft film to grab a breath of fresh air.

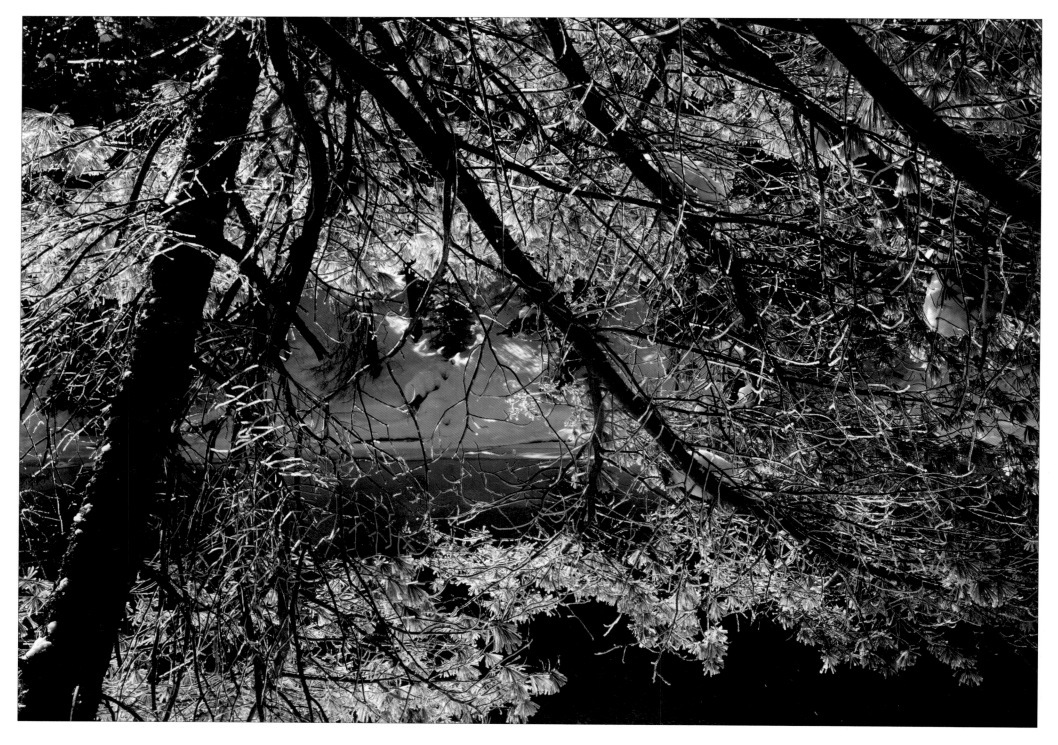

(opposite) As the March sun liberates rivers from
their shackles of ice, its warmth melts the hoar frost
decorating the boughs of shoreline pines, bringing
promise once again of spring's imminent return.

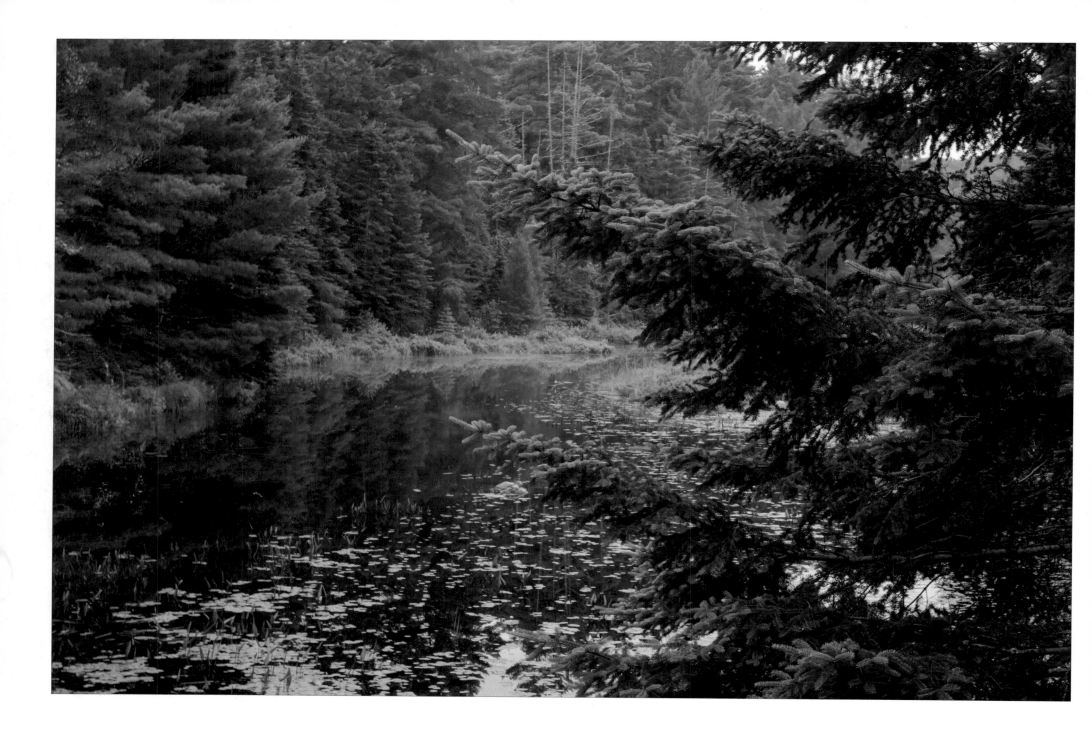

INDEX

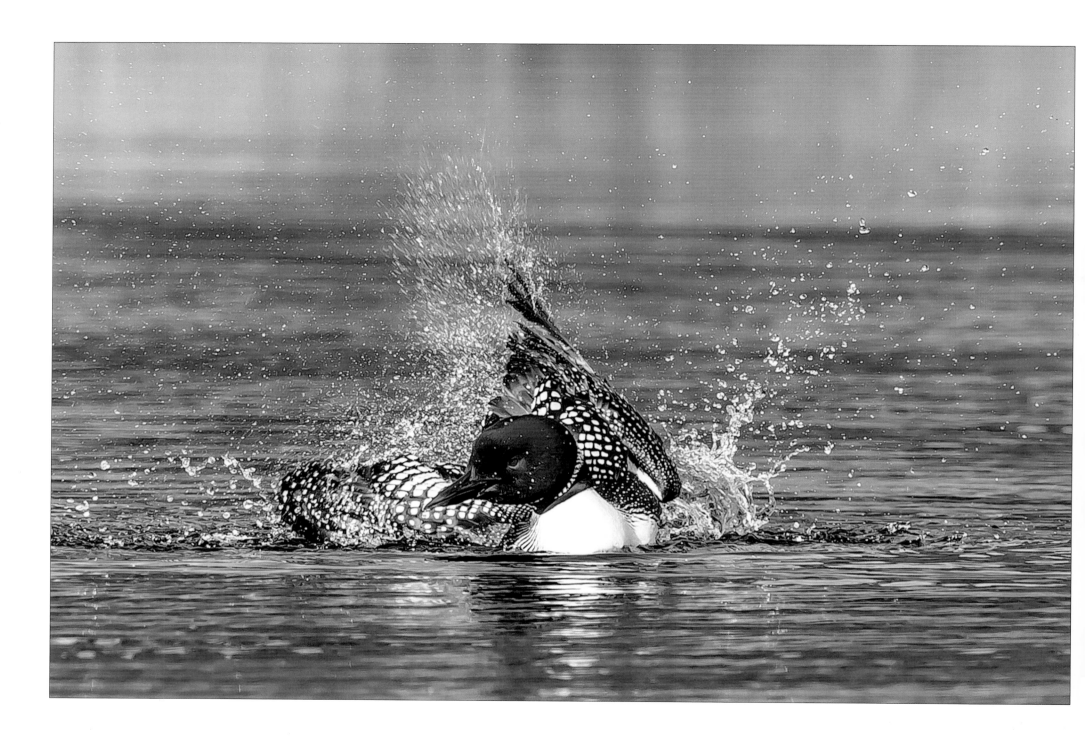

ACKNOWLEDGEMENTS

First and foremost, I want to thank retired Chief Park Naturalist Dan Strickland and retired Park Naturalist Ron Tozer. You both were instrumental in developing my knowledge of Algonquin over the many years in which I had the honour of working under you as a seasonal naturalist. You also played a role in my other career; by making me reach for the bar you set as the standard for nature interpretation, you gave me the foundation for teaching at university and writing popular articles and books on natural history topics. You are remarkable naturalists, interpreters, teachers, authors, mentors, and friends. Thanks also, Ron, for your editorial comments; your suggestions have improved this book immensely. Also, a heartfelt thank you for writing the book's Introduction.

Next, I must thank Ron Pittaway, birder extraordinaire, who was instrumental in getting me hired as an Algonquin seasonal naturalist. Ron, your knowledge of and enthusiasm for birds and all things wild have been an inspiration all my life. You are one of a kind and I am privileged to know you as a friend.

A special thanks goes to long-time friends Rory MacKay and Bill Crins, who I met during my first year in Algonquin. Rory, who wears many hats including those of author, historian, teacher, blacksmith, artist, and naturalist, many thanks for the wealth of information you provided concerning Algonquin's human history, your companionship on countless outings in the Park, and your encouragement over the years. I treasure the memories of time spent at your cottage on Lake of Two Rivers. Bill, botanist and naturalist supreme, and only other member of "The Team," thank you for teaching me so much more than "sedges have edges," and for sharing so many memorable hours in Algonquin.

I would like to thank the many skilled naturalists with whom I have had the honour of spending time in Algonquin. From you I have learned much. Thank you Sean Blaney, Dan Brunton, Peter Burke, Mike Burrell, Howard Coneybeare, Jason Dombroskie, Marc Johnson, Colin Jones, Paul Keddy, Hugo Kitching, Peter Mills, Steven O'Donnell, Paul Pratt, Carl Rothfels, Jeff Skevington, Don Sutherland, Doug Tozer, and all others who I regretfully have forgotten to name.

I would also like to thank Brent Frederick, Jeff Moss, Larry Cobb, Jeremy Inglis, and Larry Weller of the Ontario Ministry of Natural Resources and Forestry who have kindly provided accommodation or granted access to otherwise inaccessible parts of Algonquin, and who have generously shared their hard-earned knowledge and love of the Park.

My thanks to Jason Mask, Superintendent of Bonnechere Provincial Park, for providing accommodation while I was naturalizing or conducting Annual Wolf Howls in the Basin Depot region of Algonquin. Additionally, I would like to thank Brent Patterson, Nancy Checko, Dawn Sherman, and Rick Stronks of the Ontario Ministry of Natural Resources and Forestry (or one of its earlier designations) for your assistance over the years.

To Robert Bateman, the consummate naturalist/artist, thank you for once again honouring me with your words. You bring to the world's eye the artistry of Nature that most would otherwise never see.

Last but certainly not least, thank you to my long-time love Ann Mayall, who has accompanied me on so many Algonquin outings including our annual snowshoe "death walk" on the Algonquin Christmas Bird Count. Your eye has led me to moments of beauty that I otherwise might have missed, and you have steadied my canoe during our many years together.